Entering Cultural Communities

Rutgers Series on the Public Life of the Arts

A SERIES EDITED BY RUTH ANN STEWART,
MARGARET JANE WYSZOMIRSKI, AND JONI MAYA CHERBO

Entering Cultural Communities

DIVERSITY AND CHANGE IN THE NONPROFIT ARTS

EDITED BY DIANE GRAMS
AND BETTY FARRELL

Rutgers University Press
NEW BRUNSWICK, NEW JERSEY, AND LONDON

ISBN 978-0-8135-4216-4 (hardcover : alk. paper)
ISBN 978-0-8135-4217-1 (pbk. : alk. paper)

Cataloging-in-Publication data for this book is available from the Library of Congress.

A British Cataloging-in-Publication record for this book is available from the British Library.

Visit our Web site: http://rutgerspress.rutgers.edu

Manufactured in the United States of America

This book is dedicated to all those people who work to provide greater access to the arts in communities large and small, urban and rural, throughout the United States.

Contents

Figures and Tables

FIGURES

TABLES

Acknowledgments

This book would not have been possible without the support and involvement of the Cultural Policy Center at the University of Chicago and the ongoing support of the Center by the Irving Harris Foundation. As a joint initiative of the Irving B. Harris Graduate School of Public Policy Studies and the Division of the Humanities, the Cultural Policy Center is a nationally recognized leader in the emerging field of cultural policy research and education. Its mission is to provide research and inform policy that affects the arts, humanities, and cultural heritage. It serves as an incubator for new ways of understanding what the arts and culture are, as well as what they do and how they can be affected by a range of policies in the public and private sectors.

Several people played crucial roles as allies and advisors throughout this project. The contributors to this book, D. Carroll Joynes, David Karraker, Morris Fred, and Wendy Leigh Norris, were our close collaborators throughout the research process, and they continued to provide valued input through the final edited manuscript. Margaret J. Wyszomirski, professor of art education, public policy, and management, and director of the cultural policy and arts administration program at Ohio State University, and Steven Rathgeb Smith, professor of public affairs at the Daniel J. Evans School of Public Affairs at the University of Washington, both played crucial early roles drafting the research design. While she is quite possibly the busiest person on the planet, Margaret Wyszomirski consistently set aside time and energy to serve as a trusted advisor throughout the project.

In addition, a number of research assistants made significant contributions in data gathering and management, as well as in writing sections of this study. A qualitative study of this size and scope would not have been possible without their contributions to this effort. Rosemary Polanco deserves particular recognition for her assistance in laying in place much of the data-gathering groundwork and in playing a crucial leading role

conducting early interviews. Susan George also provided early assistance in conducting interviews. The following research assistants performed a variety of important roles in this research, from transcribing and coding interviews to gathering support materials to contributing to various sections of the final chapters. In alphabetical order we thank these assistants, whom we depended upon for these duties: Ligaya Beebe, Brian Bettenhausen, Michele Dubuisson, Alaina Jasinevicius, Jeffrey Kirkwood, Sarah Lawrence, Christina Le, Helen Li, Zohar Lechman, Lindsey Michelotti, Nathan Paufve, Jamie Smith, Emily Walsh, Blake Ward, and Stephanie Williams. In addition to general research assistant duties, Alaina Jasinevicius played a critical role managing and organizing the qualitative data sets so they could be shared among the research team members. Several of these researchers contributed to the preparation of specific chapters of the book, and we would like to give them additional recognition here: Ligaya Beebe (chapter 7); Jeffrey Kirkwood (chapter 4), and Lindsey Michelotti (chapter 8). Without the support of the time and the benefit of the analytic minds of each of these emerging scholars, this project would not have been possible.

Robert LaLonde, and Colm O'Muircheartaigh, both professors at Harris School, shared their valued expertise as advisors throughout the project. We thank our manuscript readers: Ellen Rosewall, associate professor of arts management at the University of Wisconsin—Green Bay; David Halle, professor of sociology at the University of California, Los Angeles; Linda Myers, executive director of the Loft Literary Center; and Julia Perkins, principal at MBMD Consultants, a Chicago-based arts consulting firm. They each read earlier versions of this manuscript and provided insightful comments as we prepared our final manuscript. Susan Allan, managing editor of the *American Journal of Sociology*, played a critical role in challenging some of the early drafts we presented and editing text of our first drafts. Our heartfelt thanks go to each of these people for their valuable contributions that helped to shape this study. We also thank Marlie Wasserman, director of Rutgers University Press, for her early enthusiasm about the topic and her ongoing interest and support of this book. Her assistant, Christina Brianik, played a vital and valuable role overseeing the editorial process.

We thank the Wallace Foundation for its funding of this research. We also valued the input of individual staff members who shared their expertise throughout the research process. As with so many of the projects accounted for in this book, our labor-intensive and costly research could not have been conducted without this support.

The staff at the Cultural Policy Center played important roles throughout the two-year project. We thank Faculty Director Lawrence Rothfield.

Several former staff also played important roles, including Public Events Coordinator Katherine S. Claussen, Assistant Directors for Communications Michael Washburn and Kimberly McCullough, and Assistant Director for Public Information Stefanie White.

Finally, we thank the 183 people who set aside time in their busy schedules to speak and to think with us. Their openness—sharing their successes as well as their struggles—is a testament to their ongoing commitment to being part of the changes we discuss in this book. On a technical note, all of the people interviewed provided informed consent to participate in the study. Those people who are identified by name, title, and organization authorized this identification when the interview was completed. Interviewees who preferred to have their identity remain confidential are identified with a pseudonym, which is noted after they are first named. Many people contributed to this project, although not all of their names appear in the text. Nevertheless, their insights were vital to our understanding. Our goal as researchers has been to ensure that the stories we heard were aligned with the data we gathered and would ring true not only to the persons who participated in the study but also to other cultural organizations that are looking to build their own models of increased participation in the arts.

As a final note, we offer a general disclaimer: as the researchers and authors of this report, we are solely responsible for the content and the interpretations contained here. The content of this book does not represent the opinions of any foundation, arts organization, or educational institution named or featured.

Entering Cultural Communities

Introduction

DIANE GRAMS AND BETTY FARRELL

It takes more than a building, good art, or an interesting program to attract people to the arts. In fact, the adage "if you build it they will come" might make a good storyline for a movie, but it doesn't describe how people are drawn to participate in the arts. It takes much more than the awesome sight of a majestic building, the titillation of an arts controversy, or the advertising for a blockbuster show for the arts to come alive to a wide variety of people and, in turn, to become part of their daily lives. When it happens, though, it can be magic. When a museum, symphony hall, theater, arts learning center, or a community cultural center comes alive with people engaging in creative pursuits, confronting new perspectives, talking, laughing, or just enjoying themselves, the arts realize their potential. Of course, there is much work required behind the scenes in order to achieve this kind of experience. To create it involves a building project of a different sort—one that invites long-term and sustained participation in an array of cultural communities.

This book focuses on a number of arts leaders and cultural practitioners who have recognized that today's changing cultural environment presents not only challenges but also an important opportunity for the arts to contribute to the livelihood and liveliness of their local communities. These leaders recognize and value the commitment of their traditional audience and patrons, but they are also looking beyond them to embrace the needs, interests, and spending habits of a broader American public. Over the long term, their work has the potential to enhance the arts as a valuable and recognized public good by encouraging the involvement of a broader range of participants and developing more financially stable organizational structures.

LONG-TERM PROJECTS, NOT SHORT-TERM SOLUTIONS

Building participation in the arts is a long-term project that requires vision about the changing cultural field and the possibilities that such change

holds. It is also a project that requires leadership, widespread institutional commitment, and considerable skill. Take Kathy Halbreich, former director of the Walker Art Center in Minneapolis, Minnesota. When she took the helm in 1991, she brought with her a keen personal interest in the creative potential of youth. The question was how a contemporary arts organization could reach and involve young people. "How could we make the life of the mind, or the life of the artist, or the life of the creative spirit, as engaging as the right jacket or the right gym shoe?" Halbreich recounted asking. The establishment of WACTAC, the Walker Art Center's Teen Advisory Council, was one outcome of her vision and leadership.

Or take Carlos Tortolero, a Chicago-based educator, activist, and museum director, whose vision was to build a world-class ethnic museum that would celebrate the rich artistic traditions of Mexicans and Mexican Americans and that would simultaneously serve as a community center for the rapidly growing Mexican American community in Chicago. His message was that "you have to be *a part of* the community, not *apart from* it." The outcome was the establishment of the renowned Mexican Fine Arts Center Museum in 1987 and its transformation twenty years later into the National Museum of Mexican Art.

In looking at many different types of cultural organizations, large and small, urban and rural, we found projects that were stimulating increased cultural participation by empowering the very people they seek to involve. Appalshop, a multidisciplinary arts and education center located in rural Kentucky, is preserving and enhancing local culture by providing the people of Appalachia with the resources and technologies to tell their own stories. The Village of Arts and Humanities, located in inner-city North Philadelphia, works to build a sense of community by creating art parks out of vacant lots. Instead of bringing new audiences to established cultural settings, this organization is harnessing the power of the arts to address the desolate landscape and social isolation that are symptomatic of urban poverty.

These are some of the kinds of cultural projects—involving creative approaches, local community understanding, and day-to-day activities, as well as long-term personal commitments and institutional investments—that we found animating a wealth of practices to build greater participation in the arts. To investigate them, we talked with the practitioners who are leading these efforts in many different types of cultural organizations across the country. We examined changes in organizational practices and looked for evidence of results to date, as well as the potential these practices hold for allowing cultural organizations to make and sustain long-term change. We have gathered the stories of many of the leaders in participation-building efforts in the art world to illustrate a range of

practices that promise to engage a new and more diverse set of audiences, consumers, and local community members.

What the arts practitioners we interviewed have in common, across the great array of innovative projects they have developed and nurtured, is the vision to see the changing world around them as rich with opportunities to engage people in their local communities and to help reshape the broader cultural terrain in the United States. Whether these efforts involve taking art outside traditional institutional walls to new people or bringing new or different kinds of people into an arts organization, the leaders who undertook the projects to build participation testify to the need for a variety of resources. In the end, the most important resource might well be a personal one. According to Lonnie Bunch, the former president of the Chicago Historical Society and now the founding director of the National Museum of African American History and Culture at the Smithsonian Institution, the most important resource a leader needs can be summed up in one word: "*stamina*; you need to really believe in your vision and have the stamina to make it work."

Changing Organizations and Changing Communities

The problem of arts participation is not just a problem of "graying" audiences—the scenario in which the core audience for some art forms is aging without being renewed by younger circles of ticket buyers, subscribers, and patrons. A very different problem faces organizations located in communities that have not been served by the arts in the past, requiring them to address many kinds of pressing social issues at the same time that they are building a local cultural infrastructure. The challenge becomes more complex for all cultural organizations once they begin to look closely at their own communities and to take account of the changing world around them. With such a variety of needs, challenges, and opportunities, it is clear that there is not a one-size-fits-all solution to participation building.

Inside arts organizations, we found a variety of changes underway— from the enhancement of core cultural programs to additions of auxiliary programs, expanded programs, and reinvented programs with broad appeal. Many organizations are restructuring themselves internally and externally to meet their new participation-building goals. Internally, they are adding new departments, positions, and personnel, especially community relations departments and advisory committees that now exist alongside more established education and marketing departments. They are working in new ways across divisions. Externally, they are carrying out community-engagement activities geared toward attracting newcomers to the arts and toward offering products that customers want to sample and, ultimately, support through their consumer dollars. Organizations

3

are also accessing new resources by engaging in structural partnerships with schools, libraries, park districts, and an array of community, social service, and religious groups. Many are making new investments in technology that allow for more effective organizational practices and the kind of data collection that will ultimately help build the cultural field. An important finding presented in this book is that there is not just one kind of arts participation. Even within a single organization, there will be a wide variety of arts participants with a range of cultural tastes and preferences that a single set of practices cannot hope to satisfy.

In the process of changing the practices within their own walls and across the institutional sector, arts organizations are also finding new ways to be part of their changing communities. Cultural practitioners today find themselves working in local contexts that have been profoundly affected by large-scale social forces of change well beyond their control. For example, there are now greater concentrations of the traditionally largest minority groups—African Americans, Hispanics, and Asians—living in urban and suburban areas, alongside an influx of new groups of immigrants. Many cities in the United States now have sizable communities of Somalis, Nigerians, Guatemalans, Mayans, Hmong, and Cambodians, among others, making up their diverse populations. In fact, according to the U.S. Census, the size of the foreign-born population in the United States has steadily grown from 4.8 percent of the total in 1970 (its lowest point in U.S. history) to 12.4 percent in 2005. The foreign-born population today, at nearly 36 million persons, is three times greater than at any other period in the nation's history. Racial and ethnic diversity is now characteristic not only of large metropolitan areas such as New York, Chicago, Minneapolis, Houston, Los Angeles, San Francisco, and Seattle, but of smaller urban areas—such as Des Moines, Iowa, and Portland, Maine—as well as of rural communities that were once mostly white and culturally homogeneous.

The increasing diversity of the population calls for a broader recognition of cultural traditions, but it also challenges cultural organizations to interact in new ways with the communities in which they are located. This often involves a process of relationship building with communities that have traditionally been underserved or never served by cultural institutions. Building long-term, community-based relationships of trust and reciprocity replaces what, in the worst case scenario, might be described as the "aerial drop" method of cultural distribution, in which short-term projects and programs seem to fall from the air and disappear just as fast as they have descended. By contrast, the arts organizations that are more in tune with their local communities are making long-term commitments of staff, money, and time to establish the same sense of trust, reciprocity,

4

and shared interests that have long characterized their relationships with core supporters. Whereas in the past such relationships were reserved for the most valued wealthy donors, today arts organizations are looking for new ways to build core supporters among broader segments of their local communities. In the process, they are discovering whole reservoirs of culture previously left untapped, and they are becoming more effective in distributing these valued resources to a broader community of potential cultural supporters. Indeed, the pressure to serve local communities—pressure that is increasingly attached to arts funding—has encouraged many cultural organizations to reactivate or extend their mission as civic-minded institutions entrusted with a valuable public good that deserves to be more widely shared.

Through the kind of extended community connections that have become part of the relationship-building process, arts organizations are providing a reinvigorated form of civic leadership. Arts administrators and practitioners concerned with building a broader and more diverse base of cultural participants have been positioning themselves at the table with other public-minded stakeholders who, in considering the questions of civic engagement and public value, are expressing a willingness to tackle some of the most important social and cultural issues of the twenty-first century.

The Changing Place of Culture in the World

Beyond the organizational incentives for change and the many compelling reasons for cultural organizations to become active civic leaders in crafting the future of the arts in their local communities, there is also the structural context of global forces that are promoting change. Globalization has transformed the political economy of the United States and many other countries around the world, making cities more dependent on their service industries and consumption economies. In this context, local politicians and policy makers have welcomed the potential for the city's cultural resources to play an expanded role in economic and social growth (Molotch 1976). In some communities, arts organizations have been part of the economic transformation process in which old manufacturing economies have been transformed into postindustrial finance- and service-based economies (Zukin 1982). The arts are seen as one part of an amenities package that can lure the "creative class" of new, young, urban residents and tourists to the city (Florida 2002) and that can provide fuel for the city's "entertainment machine" in attracting tourist dollars (Clark 2004).

Culture, therefore, is becoming increasingly recognized as a useful tool that cities and states can employ to stimulate their local economies. The expansion of the cultural infrastructure in many cities since the 1970s has led to new types of arts organizations, such as those with media- and

genre-specific projects, or those that engage ethnic- and community-based groups, all of which are now deeply rooted in the cultural landscape. All over the United States, there has been an arts-building boom that has added or expanded major performing arts centers and museums. In Wisconsin alone, the construction, renovation, or expansion of nearly one hundred performing and visual arts facilities since the early 1990s represents public and private investment of over $500 million dollars (Rosewall 2006). The powerful economic, social, and political forces at work behind the expansion of the cultural infrastructure locally, nationally, and globally are among the complex forces that have encouraged arts organizations to become more attractive and accessible to a broader spectrum of the public and to become more effective in their efforts to engage these publics.

A BOOK WITH A DIFFERENT APPROACH

Although much research on the general topic of arts participation has been sponsored by government agencies, national arts policy groups, foundations, university research centers, and individual scholars, there are still very few studies that have started with what organizations themselves are doing to attract and engage a wider array of participants. Our study, therefore, begins with those people most closely engaged in such efforts—the directors, staff members, and volunteers inside cultural organizations who have been thinking about, planning for, and implementing participation-building projects. We wanted to understand what a range of efforts looks like from the perspectives of insiders in the cultural world and, ultimately, to learn from them *what works* and *why?*

To this end, we gathered data from a core group of arts organizations throughout the United States that are considered to be leaders in participation-building efforts, many of which have been publicly recognized for this work by receiving one or more grants in support of their organizational efforts. A number of national organizations have provided funding to building participation in the arts, including the Ford Foundation, the National Arts Marketing Project, the National Endowment for the Arts, Pew Charitable Trusts, and the Wallace Foundation. In the final count, we gathered data from 85 organizations and interviewed 183 people (see table A.1). What emerged were some consistent patterns amidst the rich array of narrative detail that characterized individual stories and unique institutional efforts. In presenting the stories, we have attempted to include the most compelling accounts of participation-building practices, including organizational-change projects, leadership strategies, partnerships, technology uses, reinvention projects that resulted from the sharing of ideas, and strategies to achieve success. These themes have allowed us to

draw from a range of organizational practices, sometimes presented as an extended case study or a particularly illuminating exemplar, at other times mentioned more briefly to convey the rich variety of practices that are underway in the cultural world. Many organizations therefore appear in this book, although not all that we investigated are profiled or presented in the same depth.

Covering the Field: Types and Eras of Cultural Organizations

In our selection process, then, we consciously sought to investigate organizations of various types, sizes, and ages from multiple kinds of social contexts. Mindful of the vastly different kinds of communities stretching across the United States, we included organizations from cities with populations divided nearly equally among whites, blacks, and Latinos (Chicago, New York, and Houston); cities that featured two dominant groups (Los Angeles, San Francisco, and Philadelphia); and half a dozen other cities that had a single dominant population (Minneapolis, Seattle, New Orleans, Newark, St. Louis, and Washington, D.C.) (see figure A.1). In addition to the cultural organizations in these major metropolitan centers, we included others that represent smaller urban settings and rural communities found in every region of the United States.

We intended our study to cover the widest variety of organizations found in the cultural landscape of the contemporary United States. Therefore, we identified the following types:

- ➤ Hybrid cultural organizations, which include community cultural centers, arts learning centers, literary and media centers, and social service and other non-arts organizations with an arts component. Many of these represent new organizational and art forms, cross-disciplinary and interdisciplinary groups, and ethnic and community-based groups (32 included in this study).
- ➤ Museums (19 included in this study).
- ➤ Theaters (12 included in this study).
- ➤ Music and dance organizations, including symphony orchestras, operas, and other music groups; dance companies; and arts presenters (22 included in this study).

In addition to the types of organizations and artistic genres that represent the breadth of the cultural field, this study includes cultural organizations that were founded in three different periods of the twentieth century: before the 1930s; between the 1930s and the mid-1960s; and from the mid-1960s to the present. Numerous museums, symphonies, operas, and dance companies founded before the 1930s are primarily defined by canon art collections, repertoires, or traditions. They face a unique set of challenges

7

as they attempt to move beyond the canon and their own particular historical legacies. By contrast, most of the hybrid cultural organizations and theaters in our study were founded since the mid-1960s, an era of expansion in the cultural sector, which created a different set of challenges for participation building, including increased competition for audience leisure time, changing tastes and technologies, and a new economic and political environment for the arts.

Clues to What's Working

The bulk of this study is narrative and drawn from interview accounts by leading practitioners who are working in the cultural field. Because our goal was to understand the specific programs and efforts designed by individual arts organizations, we placed particular emphasis on listening to and understanding what the practitioners themselves understand to be successful participation-building tactics and strategies. In extensive and sometimes repeated interviews with 183 individuals, we asked them to draw from their perspectives and experience to answer the questions "What is working?"; "What is not working?"; and "Why?"

We also analyzed a range of documentary sources available for each of the organizations in our study, especially those that specified their mission, their short-term and long-term plans, their program structure, and their finances. With the help of these documents, we sought to understand what the organization's core program was and how its core activities related to efforts to increase participation. We asked about efforts to expand existing programs, to create auxiliary programs, and to share ideas across organizations so that programs that worked in one setting could be reinvented for another. In short, we wanted to know about successes, failures, insights, and cautionary tales from those practitioners who are currently engaged in participation-building efforts in their organizations. In general, our interviewees reported that the kinds of practices that worked were those that set in place organizational mechanisms to build participation over the long term. Such practices need to be planned and organized, either in partnership with representatives from the target audience or informed by their participation. Among the practices that were reported as not working were those that were short-term, those that did not have organization-wide commitment, or those that tried to attract one-time paying customers to a single event.

In addition to asking cultural practitioners about projects they have undertaken to build participation in their organizations, we also looked for other kinds of evidence and financial data that could confirm the practitioners' claims. Audience surveys and focus groups, coupled with observation of activities underway, provide a good source of qualitative information

about participant experiences. But many organizations have also made efforts to capture their success at participation building through more quantitative measures. The numbers that result are often problematic. Take, for example, the calculation of organizational attendance figures. Organizations might calculate this by memberships or subscriptions, single-ticket purchases, free admissions, group admissions, and free off-site programs. But the data collection is often inconsistent, with different goals at stake, thus limiting the usefulness of the numbers as a gauge of change in participation over time, both within and across organizational boundaries. How this might be addressed through greater consensus across the cultural field as a whole is addressed in the final chapter of this book.

Finally, we also used publicly available financial data as another kind of indicator of success. What we found was that overall these cultural organizations had sustained modest financial gains of 8 to 14 percent annually in their contributions, program, and membership revenues in the five-year period from 1999 to 2004. These figures are particularly striking, since many participation-building efforts initially cost more than they can generate, and since many cultural organizations saw large declines in their revenues following the September 11, 2001, terrorist attacks and the subsequent economic recession (see figure A.2). These financial gains are relatively small compared to the overall operational budgets of many cultural organizations, but they can be substantial when sustained over five-, ten-, or even twenty-year periods, as accounts in this book attest.

STRUCTURE OF THE BOOK

In the chapters that follow, we focus on key themes: the multiple meanings of building participation, organizational change, leadership, partnership, efforts to engage youth and more ethnically diverse audiences, technology, idea sharing, and what it means to achieve success in participation-building efforts. The chapters follow a logic and progression similar to what many arts organizations have experienced as they have begun the process of building participation—from thinking about and envisioning change, to making significant institutional changes within their own organization, and then to reaching out to a broader community beyond their core constituency. The stories are rich and varied, yet most share the common thread of an organization's openness to experimentation and willingness to embrace change. Some of these changes have already resulted in an exponential expansion of arts participation in ways and in places never thought possible before.

Chapter 1 sets the stage for the themes of the book by constructing two distinct models of organizational effort underway in cultural institutions

in the United States—one consumerist, or transactional, the other humanist, or relational. Organizational efforts to build participation can be understood as these two analytically distinct yet often interwoven kinds of effort. The first, "transactional practices," involve the process of seeking to create new consumer markets for cultural products by capturing and tracking consumer interaction. The second, "relational practices," concern the building of relationships with localized communities. Whereas relationship building might engage people in arts programs that are offered at no charge, transaction-building efforts encourage people to sign up, try out, or select from a range of cultural purchasing options. Relationship building seeks to tap into and present the depth and breadth of human experience that is so central to the arts; by contrast, transaction building seeks to scale up the economic value of the interaction between the cultural provider and the participant, shifting a one-time visitor into a more engaged, return participant who, through the transaction, is more committed to the organization's services and programs.

Chapters 2 and 3 focus on the conditions within organizations that are necessary for launching new participation-building projects. Here, we examine the role and distribution of leadership throughout organizations and the kinds of organizational changes that help create more welcoming environments, greater staff communication and participation, and an expanded capacity and commitment to change across the organization. One of the common themes of chapters 2 and 3 is that "leadership for change" is crucial in building the necessary support of board and staff members. This leadership for new participation-building projects can be found—in fact, must be found—not only in the office of the executive director but throughout the organization, at a variety of other levels and in other offices and divisions. New projects and initiatives that are launched within organizations rarely remain isolated or self-contained efforts. Often they have consequences that lead to restructuring throughout the organization. Internal organizational change is always an ongoing process, and the experiences of the cultural organizations included in this book demonstrate in dramatic ways that, once it begins, the process of change can have some unintended consequences in terms of radically changing an organization's culture and practices.

Chapters 4 through 6 describe how relationships are being built with new groups and communities. Establishing reciprocal relationships through partnership with a wide variety of non-arts-specific organizations, such as schools, libraries, and social service agencies, is one strategy through which cultural organizations can leverage new resources in their efforts to reach new people. Among these new potential audiences, young people and underrepresented racial and ethnic groups have been identified as crucial

participants that cultural organizations hope to reach through their new approaches and expanded programs. Although there are many people that arts organizations hope to attract and retain, two of the most important demographic groups currently underrepresented among art world audiences are highlighted in chapters 5 and 6.

In chapters 7 through 9, we show how reaching new audiences involves multiple strategies and the creative use of new tools. Chapter 7 touches on some of the new technologies that have the potential to improve communication and the management of arts programming, even as they pose financial and human resource challenges for cultural organizations. Chapter 8 suggests that reinvention—the creative reuse and remixing of ideas and projects—is another means by which participation-building projects can proliferate. Chapter 9 presents three distinct exemplars of organizational success. The chapter explores several long-term efforts to build participation that take into account the difference between the institutional goals of building cultural legitimacy, building relationships, and building transactions. We will argue that success in building greater participation is the culmination of a supportive environment appropriate to particular goals, rather than an achievement measured by specific metrics. Also part of success are the occasional failure to meet organizational expectations and some ineffective organizational efforts, which can nevertheless provide valuable insights for those organizations willing to learn from them. Chapter 9 also highlights some of the problems that arise when individual organizations, rather than the field-at-large, develop their own tools and mechanisms for gathering data on cultural participation. Developing a more consistent set of standards by which to measure success remains a challenge for the cultural sector.

A brief postscript takes a broad look at what we have learned and where we might go from here. We did not identify a single determining factor that makes for a successful participation-building effort. Rather, the information and insights we have gathered show that success at building participation is part of a larger organizational project affected by money, time, leadership (which includes knowledge, skill, and scope of authority), size and type of target audience, technology, and organizational alliances.

Whether organizations are national or local in scope, large or small, the current efforts to build arts participation span all cultural genres and many diverse locales. The stories presented in this study are often inspiring, but they also prompt the cautionary note that efforts to build participation can pose unexpected challenges in terms of financial, human, and artistic resources. Engaging more people in the arts does not necessarily bring an organization more money. In fact, even successful organizations show relatively small gains when compared to overall organizational

budgets; participation-building activities may, at least initially, cost more than they earn. As such, they are not efforts that will save a struggling organization, and they are not the answer to any organization's immediate financial problems. They suggest, however, that, over time, sustained efforts can lead to more and different kinds of people participating in cultural activities and potentially providing the income to maintain and expand those programs.

The themes in this book have emerged from our interviews with arts practitioners and through our observations of individuals and organizations in action. The practices that many cultural organizations have undertaken represent different starting points, different stages of development, and, needless to say, no ending point. The stories in this book therefore offer more clues about than solutions to the challenges that may lie ahead. They show that no single effort can account for success or failure. We hope, however, that they will suggest the tenor and character of what the future might hold in their portrayal of the promise that art can be produced and experienced by all types of people, and that cultural institutions should be more accessible and available to all. In gathering these accounts, we have often been inspired by these projects, by the individuals who have created them and worked to carry them out, and by the visions of the future they encompass. They are powerful accounts of how the work being done by cultural practitioners today is shaping the future landscape for participation in the arts.

1 Building Arts Participation through Transactions, Relationships, or Both

DIANE GRAMS

Arts organizations today find themselves in a dilemma. The artistic mission essentially involves a long-term proposition: that is, to make an important and lasting contribution to the creation and preservation of culture. Yet participation-building strategies until recently have largely been conceived as target-driven, strategic operations—essentially short-term activities designed to identify and convert new audiences. In theory, arts organizations identify desirable groups to add to or more deeply involve in the work of their organizations, then set a course to reach their goals. But just like sailing a boat into the wind, arts organizations have at times found themselves tacking, or zigzagging toward shorter and shorter interim goals as they encounter forces of external resistance; at other times, the weight of institutional constraint slows progress like a dragging anchor.

While touching on the work of numerous organizations, this chapter shows how several different types of organizations—the Smithsonian Institution in Washington, D.C. (est. 1846), the San Francisco Symphony (est. 1911), the Old Town School of Music in Chicago (est. 1957), and Intermedia Arts in Minneapolis (est. 1973)—are crafting long-term participation-building practices to enable consistent and sustainable change. Their stories reveal two distinct strands of organizational effort, both developed to achieve long-term goals of reaching more people, different kinds of people, and more sources of income. The first strand follows a consumerist orientation and involves transactional practices—the process of capturing and tracking consumer interaction in order to build consumer markets for cultural products. The second has a humanist orientation and involves relational practices—the building of relationships with participants from

local communities that may or may not lead to consumer or donor relationships. But, just like strands of DNA, these sets of practices have distinct characteristics but intersect; they are interactive and interdependent in ways that are important to the participation-building process.

EMERGING FROM AN INSTITUTIONAL BASE

With more than a century of development in the United States and more than five hundred years of development in Europe, Asia, and Africa, the cultural field today is rooted in historic, institutional routines (see Meyer and Rowan 1977; Scott 1991). However, through two strands of effort—relational and transactional practices—arts organizations are challenging long-held institutionalized routines that have been developed according to the aesthetic preferences of patrons who were traditionally drawn from well-educated and wealthy elites (see Bourdieu 1984; DiMaggio and Useem 1978; DiMaggio and Ostrower 1992; Halle 1992). These organizations are tapping the knowledge, values, and spending habits of a wider spectrum of people and tastes in order to build new kinds of participation and attract new participants (see Grams and Warr 2003; Cherbo and Wyszomirski 2000; Peterson 1980; Peterson and Rossman 2005). In this chapter, consistent with the language established by sociologist Howard Becker in *Art Worlds* (1982), standardized practices that are embedded in institutional routines are referred to as "conventions." The transaction is the smallest unit of one type of participation based in economic values and geared toward building consumer markets; the relationship is another type of participation, this one based in humanistic values such as respect, appreciation, trust, and shared interests all geared toward building cultural communities (table 1.1).

With the increased emphasis on marketing and consumer relations since the early 1990s, many arts organizations have been building their own organizational capacity to generate and manage consumer transactions. Most research focuses on the marketing message or on the characteristics of markets themselves rather than on the human interaction

TABLE 1.1. TYPES OF PARTICIPATION-BUILDING PRACTICES

Types of practices	Goal	Environment	Exchanges	Target of activity	Success indicators
Conventional	Legitimacy	Institutional	Authoritative	Experts	Recognition
Transactional	Sales	Technical	Consumerist	Markets	Income
Relational	Human	Participatory	Collaborative	Communities	Range of involvement

that takes place during and after the transaction. As illustrated in table 1.1, transaction building requires an increasingly technological environment to attract consumers, to document and manage the transactions, and to guide the consumer through the range of purchasing choices. The goal is sales, and the measure of success is earned income. This kind of participation building begins with an organization identifying the kinds of products it can produce that consumers want to buy, then producing those items that appeal to local markets. They set in motion a series of economic exchanges with consumers who collectively make up a market. Organizational effort is invested to track and scale up the economic value of the transaction between the cultural provider and participant, shifting a one-time visitor into a more engaged return participant who, through repeated transactions, becomes more involved in the organization, its services, programs, or products.

By contrast, relational practices are designed to produce and guide new forms of human interaction. The relational type of participation building focuses on establishing personal interactions, particularly with communities that cultural organizations have either underserved or never served in the past. Rather than the emphasis being exchanges of authority or money, relationship building is defined as a collaborative activity involving exchanges of trust, reciprocity, and shared interests that are often non-monetary. Relational practices are designed to set in motion social and cultural interaction geared toward building shared understanding among diverse people, with social and cultural equity as a guiding principle. Organizations that prioritize relationship building must create participatory environments, with staff members who are skillful at collaborative work and capable of involving the broadest possible range of people the organization seeks to attract. By establishing participatory environments involving relationships among the full range of people in their locale, these nonprofit organizations are tapping into, involving, and presenting the depth and breadth of human experience as only the cultural field can do.

UNPACKING THE MEANING OF TRANSACTIONAL PRACTICES: FINDING INCOME

The push in the 1990s for arts organizations to become savvier in their marketing practices led to the development of what has become a cottage industry of marketing classes, workshops, conferences, books, awards, and consulting expertise. This emphasis on marketing represents a change from conventional practices, as highlighted by Neil Kotler, former senior official at the Smithsonian Institution and now an independent museum consultant and co-author of *Museum Strategy and Marketing* (1998):

Up until, let's say, 20 years ago, the majority view among boards, museum boards and museum directors . . . focused on assembling treasures, superior collections and superior exhibitions. . . . [they believed] audiences would come on their own because of the artistic value and the attraction of such works. (Kotler interview 2004)

The research and organizational coordination that is typically referred to as marketing is a way of reducing the risk of failure by targeting people who have money to spend—that is, consumers—and learning more about their desires, interests, and needs before product development begins.

Some people regard marketing in a narrow sense as "selling." It's important to make this distinction. Selling is very narrow. It is about selling products that are produced by companies. [Salespeople] have the responsibility of selling and getting [products] off the company inventory. Marketing is a much broader function. That is [a process] of discovering and probing the needs, the wants, the desires of consumers and arranging for them, making the production of organizations, or the producers, responsive to their needs. So it's really quite opposite: one is trying to unload, if you will, products, and the other is researching the consumer and creating products that the consumer wants. (Kotler interview 2004)

What this might mean becomes evident when looking at the transformations that took place at the Smithsonian Institution over the past two decades. The Smithsonian is the nation's massive museum complex, founded in 1846 and operating in 2004 with a $430 million budget. At the Smithsonian, the practices that invite interactions with consumers, according to Kotler, exist in addition and parallel to its long-held conventional practices, which focus on preserving and presenting great art. The museum's financial data provide a snapshot of how these efforts have worked: in the five-year span from 1999 to 2004, the Smithsonian saw its earned income increase an average of $1 million annually; in 2004 earned income was nearly $110 million, or one-quarter of its total annual revenues.

> Institutions are not abandoning their core activities . . . but . . . adding a lot of other activities alongside . . .
>
> NEIL KOTLER

According to Kotler, the consumable recreational experience is constructed around and throughout everything that already exists within the cultural institution context. Recreational experiences become an add-on for cultural consumers, offering new opportunities to consume before, in-between, and after experiences with great art. At the Smithsonian's National Gallery of Art, for example, this has meant adding or upgrading dining facilities: creating several dining facilities that cater to different clienteles and adding outside entrances to restaurants so

that cultural consumers can dine *in* the museum without going *into* the museum; inserting cafés in lobby areas between galleries to give people a chance to pause from the regular core activities, to socialize, or just to rest; and placing comfortable leather couches with backs and arms in galleries in front of masterpieces, along with providing sample catalogs to review. It has meant adding sculpture gardens or other outdoor environments that allow cultural experiences independent of or in conjunction with indoor experiences. It has meant significantly expanding the size of the gift shop on the lower level of the museum and upgrading the quality of the merchandise while offering items for sale in locations throughout the museum. It has also meant redesigning the former cafeteria to be an extensive food court, including choices of salads, fresh grilled meat and fish, freshly made pastas, and trendy coffees and ice creams. The Smithsonian's new National Museum of the American Indian included from the beginning a substantial food court with selections representing foods from different Indian nations and cultural traditions as part of its original museum concept. The result is that cultural consumers have opportunities to literally consume American Indian culture in the form of an array of grilled, smoked, and steamed foods from various native traditions. In addition, the extensive gift shop includes a large selection of cookbooks, thus enabling museum visitors to cook such delights at home.

> The theory is this: giving visitors better seating, more restaurants, and shops keeps the visitors in the museums a longer time and improves the experience. They may go to dine after seeing an exhibit and then go back to see another gallery. They're spending more time in the shops and the dining facilities. . . . You want to keep visitors there longer. These institutions are not abandoning their core activities, education and so forth, but they are adding a lot of other activities alongside to increase the recreation and the attraction. (Kotler interview 2004)

Such practices also give consumers more opportunities to spend money, something particularly important in a museum system, such as the Smithsonian, where admission is free. Opportunities to consume throughout the museum experience ignite the possibility of multiple transactions—the purchase of catalogs, books, gifts, food, snacks, coffee, dessert, or tickets to special events. In addition, capturing a consumer's name and address through a purchase sets in motion the potential for off-site purchases and for scaling up the transaction to include a membership, gift subscription, donation, or more. This means multiple kinds of participation in the array of activities offered by the institution.

Such opportunities for consumer spending in the once-hallowed halls of the museum are a marked change from conventional practices that sought

to isolate aesthetic experiences from consumer experiences. Aesthetic experiences, akin to religious experiences, were designed to enable one to transcend daily life and experience beauty free from crass exchanges of money for services or for token mementos of the beautiful objects observed in the sacred space of the museum.

Building Long-Term Customers

The National Arts Marketing Project (NAMP), created through the Arts and Business Council of Chicago in mid-1990s, offers workshops and conferences to train and support organizations too small to have full marketing departments or to hire consultants to market their work as cultural products. According to NAMP director Julie Peeler the process involves training organizations first to complete a self-analysis to identify organizational strengths, weaknesses, opportunities, and threats (SWOT analysis) and then to embark on a planning process that includes identifying one or more target markets, conducting market research, creating profiles of target audiences, and developing organizational marketing strategies that include meetings, advertising, new programs, partnerships, and more. Successful efforts to build transactions must be carried out over the long term.

> The object of the game is loyal, long-term customers. If this is not your goal—you're just wasting your money. It's costing you three to six times more to bring in a new customer than to retain an old customer. And so, if you get yourself stuck in this idea that your job is to bring in a new audience today, then you're wasting your money. You're wasting the organization's precious resources by focusing only on the short term. (Peeler interview 2004)

Successful efforts to build transactions are not just about generating earned income. The real value involves capturing data and mining existing databases to encourage return customers, to build customer loyalty, and ultimately to build a new cadre of committed donors who first demonstrated their participation in the organization through a process of cultural consumption. While transactional practices ultimately build customer relationships, the process of assessment and valuation is expressed in economic terms: money is the medium of exchange, but one carrying powerful symbolic meaning. The transaction building often begins with the offer of a free experience that introduces the customer to a range of purchasing options that may eventually transform this individual into a member, ticket buyer, subscriber, or donor as illustrated here:

> We have a "Free at 3" series now where we're inviting families to come [at 3:00 p.m.] for free and to experience some art form. Building participation

means that they enroll in a class, that they buy a ticket or a subscription, that they attend more free events. The ultimate participant is one who comes to our family theatre series and is an education student and then becomes a donor as well. (Pollock interview 2005)

Money also provides a very simple tool for assessment and planning. With income as the gauge of success, organizations can think strategically about the consumer goals of retention, long-term loyalty, crossover spending, and scaling up the value of the exchange. Several organizations have very successfully used this form of participation building to capitalize upon their artistic products, not only building the long-term sustainability of their programs but also dramatically expanding their efforts and their local markets.

Market Dominance: The Case of the Old Town School of Folk Music

The Old Town School of Folk Music in Chicago provides a case study of a once-struggling arts organization that repositioned its identity as a learning center for traditional music and adopted a transaction-based approach to music programming. With an expansive roster of teaching artist/musicians and quite possibly the broadest repertoire of musical performance and course offerings available through a single organization, Old Town School not only sustained itself, it expanded and is now seen by many as the dominant provider of music lessons in Chicago. Founded in Chicago's Old Town neighborhood in 1957 by Win Stracke, it was from the beginning a music center that used the potential for music pedagogy to sustain the folk music performance tradition in all its rich history symbolized by such folk icons as Pete Seeger and Odetta. By 2004, the Old Town School's budget of $8.3 million was still derived from income-producing music lessons. By expanding the scope of its core artistic program—from one centered on folk music made popular in the 1950s and 1960s to one centered on the growing popularity of world music during the 1980s and 1990s—it vastly expanded its potential market. Its program is no longer based on a particular genre of music and music lessons; rather, today it strategically offers music geared to as many possible markets as can be identified. This market-based approach involves delivering a high-quality artistic product, initiating new transactions while strategically building upon current and past music-lesson customers. Such transactions are planned, initiated, captured, and cultivated for the assortment of consumer-oriented participation they enable and for the income they produce. Former executive director Jim Hirsch recounts the history:

I started as executive director there in 1982, and within a year it occurred to me that there were opportunities that were not being taken advantage of. And my thought process was really two fold. Number one, you know, Old Town School dealt in traditional music and every culture has its musical traditions and, you know, as I looked around the city and saw an increasingly more diverse city, I wasn't really seeing that programming represented most anywhere, but of particular interest to me, at Old Town. So, I felt from a philosophical standpoint that it was important that Old Town begin to broaden its product mix and thereby broaden its audience. The second reason for doing it was a very revenue-driven reason. I saw these audiences as potential money makers for Old Town. (Hirsch interview 2004)

The Old Town School's programming, which includes concerts and performances in addition to lessons, offers the organization different ways to access potential customers. Interaction often begins with a free "community engagement" event:

One [program] that Juan [Diés, director of community relations] developed for the Latino community still goes on today. It's a classic point of entry program, called *La Peña*. It's basically a Latin-based open stage night. And I think they run it every other Wednesday or so. It's free admission, even though I think they pass a hat to see if they can get contributions for the performers. They'll have usually one or two feature performers and then they'll have other performers who will come in and play for free. And they do it in the Old Town's beautiful concert space. And it is a wonderful way to be introduced to the organization. It costs nothing to walk in the door for the first time. I think we learned the lesson well, that you have to provide a really inviting, easy, kind of risk-free, point-of-entry opportunity. (Hirsch interview 2004)

This open-stage event introduces potential students to teachers, a variety of Latin music styles, and to a variety of opportunities to learn and to perform. Old Town School expanded its programming in nearly every direction in order to cover a broader range of the music-lesson market than any other music-lesson provider in Chicago. Through market research, Old Town was able to identify the needs and desires of each of its target audiences. For example, Old Town was interested in developing programs for parents and young children. Through its research, it found that location and time were both important variables affecting the decision to participate among people interested in early childhood programs:

With the early childhood programs it was really about geography. Parents were willing to travel about a mile and not a whole heck of a lot more

just because of how difficult it is to deal with a really young child and we were dealing with like, six-month-olds to, you know, three- and four-year-olds. So that sensitivity was a big piece of it. We really needed to come to understand just what their schedule issues were. We eventually learned that you don't schedule early childhood classes during nap time. (Hirsch interview 2004)

According to Hirsch, this research led to the development and expansion of the Wiggle Worms program, an early childhood program for mothers and babies. The program was offered throughout Chicago's suburbs, as well as in city neighborhoods. At Wiggle Worms, children sit on their mother's laps, sing songs, and perform hand motions. According to Hirsch, "It was a cash cow because there were not a whole lot of options for real, real young kids and their parents to do a music program together. The brand, Wiggle Worms, became known by word of mouth through mothers' networks. This program also led to many play dates for Old Town musicians as well."

Other branding efforts led to the dropping the "F word"—as Hirsch refers to "folk"—in much of its publicity. The organization often presents itself as "Old Town School" or "Old Town School of Music," thus allowing it to broaden its reach into other program areas (figure 1.1).

1.1 Advertisement for music lessons by Old Town School of Folk Music. Copyright Old Town School of Folk Music. Used by permission.

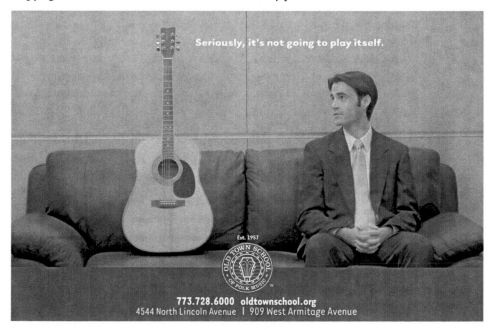

We really understood . . . a lot of the barrier and motivation issues, and so we were able to very closely target our message. We were able to obtain a position in the market that I think was pretty enviable. Among the universe of people that were considering taking music lessons, their interest would fit within the model of Old Town. So, it wasn't even a question of where [to take classes], because, once they were past the decision [of] "do I take music lessons?" they were ours. (Hirsch interview 2004)

The result was that a small, somewhat faltering organization, where Hirsch once taught guitar lessons in the early 1980s, grew to become a prosperous music school. In 2000, it was providing music lessons to about 5,000 students a week, with an overall audience of 400,000 to 500,000 annually in two locations. Under Hirsch's direction, the Old Town School in 2000 was earning 80 percent of its $7 million annual budget. Although the organization did a lot of marketing and programming of diverse musical traditions and engaged diverse audiences throughout the city, Hirsch does not refer to it as "diversity marketing." Rather, the two main motivations behind nearly every decision were "covering the field" and "space use."

And one of the interesting lessons that we learned—and this doesn't really have much to do with diversity marketing—is that . . . our percentage of space use in those buildings was just stratospheric. I mean, when I left, we were at 98 to 99 percent occupancy on space use, from nine in the morning until ten at night. And those spaces were absolutely pumping out dollars. They were open seven days a week. We had vocal classes, music theory classes; there were some craft classes—again, going with the idea of really making the tent as large as possible. We had percussion. And we had a whole drum program, for god's sakes. You know, the other stuff is just . . . product line extension. I mean, if you want to call it diversity you can, but that wasn't the motive. The motive was to try to cover the field as completely as we could and to try to attract the greatest [number] of students and participants we possibly could. (Hirsch interview 2004)

This decision-making process added up to the Old Town School of Music's dominance in the Chicago music-lesson market. Although Hirsch may be considered a prime example of a strong and farsighted leader, the organization's success was not solely tied to his leadership. Hirsch left the school in 2000, and the organization has continued to grow. Its 2003 budget was close to $9 million, $7 million of which was earned income. The model envisioned by Hirsch is built around classes and concerts, as it continues to be as of this writing. These efforts remain highly successful in covering organizational and instructional overhead, thus leaving the organization to use foundation support as "venture capital" for new efforts.

The classes were really the big revenue drivers at Old Town, because, you know, you had people that were coming every week; and they were giving you money every week. With concerts, even [with] a frequent attendee, you'd see him six, eight, ten times a year. With classes, we'd see people for classes every week for weeks [and] months on end. . . . And Old Town was lucky in that we had a lot of opportunities, good earned-income opportunities that other organizations don't have. So we were able to create a number of different profit centers within the organization that basically paid most of the overhead, which allowed us to go to the foundation community to seek what in the for-profit world would be considered venture capital. It allowed us to do the more risky things and go after audiences where the payoff wouldn't necessarily be within a short time period. (Hirsch interview 2004)

The success of the Old Town School's market-based approach has substantially changed its orientation from the particular cultural niche once so closely associated with folk music. This change demonstrates the capacity of a broader group of middle-class cultural consumers to support the operations of a nonprofit arts organization. Moreover, it is capitalizing on the broad musical tastes referred to by Peterson and Rossman (2005) as the "omnivore tastes" of contemporary cultural consumers, while enabling multiple opportunities for hands-on participation in music making. The case of the Old Town School provides an interesting front story of organizational transformation that changed from one serving a narrow and diminishing market to one that remained connected to its core purpose by enabling a significantly wider array of return and loyal customers. The transformation was carried out through marketing research, product development, and attention to the desires and needs of a new generation of customer-participants. It illustrates how transaction-based arts participation—one that builds a consumer habit of hands-on participation in a wide variety of musical traditions—is a strategy that can fund an organization's operating budget. It also hints at the kind of internal organizational coordination needed to manage and sustain such efforts.

Two organizations—the Smithsonian Institution and the Old Town School of Music, representing a national museum and an arts learning center—illustrate two different aspects of wider, more varied kinds of arts participation enabled through a transaction-based model. The Smithsonian has seen success in consumer add-ons, primarily in the form of cafés and gift shops. The Old Town School shows how arts lessons can possibly offer organizations a stable and lucrative form of support through consumer transactions because of the built-in potential for the return and

loyal customer. But what happens when the whole process is scaled up from what is essentially a community-based arts organization to an organization with a budget five, ten, or a hundred times its size? A third case, presented later in this chapter—the San Francisco Symphony—will address this.

UNPACKING THE MEANING OF RELATIONAL PRACTICES: FINDING RELEVANT HUMAN INTERACTION

In addition to the kinds of transactions that cultural organizations have been developing to attract newcomers, we identified a fairly broad range of ways in which arts organizations are focusing on relationship building in their efforts to bring in and engage members of their local communities, particularly those people who have little or no previous experience with the organization. Relationship building is described by arts leaders in humanistic rather than economic terms:

➤ Having an understanding of the wants and needs of the community, the desires of the community and balancing that knowledge against the essentially artistic mission of the organization. (Susan Talbott, former director, Des Moines Art Center)

➤ Forming authentic, rich, and varied connections between artists and audiences. (Will K. Wilkins, executive director, Real Art Ways, Hartford, Connecticut)

➤ Building trust within the community. (Victoria Moreland, director of community affairs, Seattle Art Museum)

➤ Questioning what might we learn from the audience as opposed to how big is our audience going to be. (Ann Barber [pseudonym], advisory committee member)

➤ Seeing the organization as integral to the daily lives of the citizenry as opposed to a separate entity that is occasionally engaged and occasionally not. (Ken Foster, executive director, Yerba Buena Art Center, San Francisco)

➤ Developing our models by working with the community in its own space. (Kumani Gantt, executive director, Village of Arts and Humanities, North Philadelphia)

➤ Going into the community and having a presence there. (Wei Zhou, marketing manager, Newark Museum)

➤ Opening yourself up to different constituencies, different groups, different markets. That's the only way to do it. (Jeffrey Hermann, producing director at Perseverance Theater, near Juneau, Alaska)

➤ Inviting new audiences in but also turning some degree of control over to those audiences. (Michael Warr, founder and former executive director, Guild Complex, Chicago)

These ideas suggest the importance of knowing, understanding, and sharing resources with a community as a prerequisite to the community valuing the work of the organization. A consistent theme in relational practices is the importance of the organization acting in ways that are relevant to the communities it has identified in its locale.

Three aspects of relationship building are redefining interactions between organizations and their communities.

First is the notion of reciprocity. Through relationship building, organizations are engaged in the kind of give-and-take that sets the tone for an organization to be viewed as a community participant, or, as Andrea Allen, Education Director of Seattle Repertory Theatre, puts it, a good neighbor. Being a good neighbor means developing and maintaining relationships outside the arts organization's daily art-producing environment. This might mean attending community meetings, sitting on boards of local social service agencies, or exchanging services, favors, and sometimes money, all in support of shared local efforts. Such community-involved relationships seek to move beyond building specific bridges to local venues. The good-neighbor relationship sets out to establish an image of the organization that permeates the community beyond specific events or direct contact with individuals. Through such reciprocal exchanges, arts organizations are seeking ways to incorporate new groups as part of their core constituency. They are also becoming part of these very communities.

Second is the notion of representation. Many different types of organizations founded in the late twentieth century describe their work as community-based, and they locate themselves within a particular community with the purpose of representing the art and issues of that community to outsiders. Examples include the Mexican Fine Arts Center Museum in Chicago, Wing Luke Asian Museum in Seattle, and Appalshop in Whitesburg, Kentucky.

Third is the notion of transformation. Long-established canon institutions, such as the Museum of Fine Arts Houston, the Walker Art Center, and the Chicago Symphony Orchestra, as well as organizations founded in the mid-century era, such as the University Musical Society, the Seattle Repertory Theatre, and the Des Moines Art Center, have undertaken relational activities to transform some of their outmoded institutional practices into those more relevant to their changing local communities.

Together, these community-based, community-involved, and community-relevant relationship-building activities add up to a new role, that of

cultural intermediary, where the arts organization functions between and among diverse communities, as demonstrated through the work of Intermedia Arts of Minneapolis.

Cultural Intermediary: The Case of Intermedia Arts

A midsize community-based arts organization founded in 1972 with an annual budget of $1.3 million in 2004, Intermedia Arts attracts people to programs at its Minneapolis location and carries out a range of programs in communities throughout the metropolitan area. The organization's hybrid nature is reflected in exhibitions, performances, presentations at the building it owns, off-site conferences, school and community-based workshops, and other events, even including a parade. Its fluid organizational boundaries extend through the typical nonprofit organization of board, staff, contracted artists, and volunteers but also include the fiscal support of artists' entrepreneurial efforts and groups undertaking community service activities. With many of its programs offered for free or paid for and conducted through contractual relationships with artists, schools, or community groups, annual participation is at best estimated in the range of thirty thousand to forty thousand people. One indicator of how it has fared is seen in the growth of its budget over five years (1999–2004), with contributions showing an average annual increase of 13 percent.

Sandra Agustín, artistic director, attributes Intermedia's ability to sustain and expand its programming to "doing programs that are relevant to our community."

> We're not serving *a* community, or serving *the* community, we are the community.
>
> SANDRA AGUSTÍN

We think of ourselves as part of this community; we listen, invite, and go to places outside of our building. We go to visual habitats. We're not serving *a* community, or serving *the* community, we are the community. So our responsibility, I think, shifts. We have to look like where we are. We have to behave like where we are; . . . we're really . . . trying to engage everyone around us that we're interacting with. (Agustín interview 2005)

Intermedia views itself as an integral part of the local community and builds interpersonal relationships among organizational staff, artists, and residents through its web of community-based workshops and programs. Its program focus has always been *inter*media: that is, involving a variety of media, artistic traditions, and technology. And its core program has always engaged local artists and nonartists in cross-media art exhibitions, performances, and workshops taking place at its organizational site as well as throughout the community in other public and private facilities.

Among some of its largest events are the B-Girl-Be conference of women and girls in hip-hop culture and the annual Art Car Parade. Its recent efforts to build participation—initiated as the program series *Immigrant Status* and focused specifically on the growing immigrant populations in Minneapolis—have enhanced its core mission and transformed its organizational role to one of broker or intermediary between diverse cultural groups within the Minneapolis–St. Paul area. Because of Intermedia's efforts, immigrant cultures have now joined the fusion created by the work of local adult and teen artists, urban street culture, and other forms of contemporary art.

Through a three-year strategy to build new relationships with the full variety of area immigrant populations, including African, Hispanic, pan-Asian, and eastern European groups, Intermedia now regularly links people and organizations, making possible new kinds of interaction across cultural boundaries. The need for the program was identified through Intermedia's analysis of local demographic change. Organizational documents highlight the Census 2000 figures which revealed that communities of color in Minneapolis neighborhoods surrounding Intermedia Arts comprised 38 percent of the total population, compared to 23.6 percent in 1990. Through its organizational relationships, it identified substantial populations of African, Russian, and Latino immigrants among the racial and ethnic diversity of its surrounding communities. Immigrant Status was designed as a program series but expanded the participatory environment of the organization overall, according to Intermedia's executive director, Daniel Gumnit: "It has resulted in a broader audience and specifically increased the range of kinds of people who participate." It is not unusual for programs to develop as a result of the logic and practices of the people that the organization assembles as participants.

> Our job is different than, say, a history museum because, [for us,] art is to connect living stories and experiences in hopes that we will ignite other conversations, and perhaps even action. Our hope with *this* program is to shine the light on immigrant artists living in this community, immigrant artists as leaders . . . When we say "we are a catalyst that builds understanding among people through art," it is not necessarily to win you over to my side, but it is to provide you with more information and [a] context so that you can [understand it and] relate it to your own story. It is about perpetuating culture not just archiving it. We want to break down the "us versus them" and see the commonalities. (Agustín interview 2005)

Examples of how the programming is worked out are seen in Intermedia's exhibitions on themes relevant to immigrant experience. Its first Immigrant Status exhibition, Ndimgbe (December 2003–March 2004),

featured the work of seventeen African artists from countries such as Chad, Ghana, Cameroon, Somalia, Ethiopia, Democratic Republic of Congo, and Nigeria. All the featured artists were recognized artists in their homelands, and they pointed out that the inclusion of artists from different African nations as a curatorial practice was not typically done in the artists' homelands or in exhibitions in which they had participated in the United States. More often, a homeland or U.S. exhibition would explore how an artist's work contributes to or represents its national culture. By contrast, this exhibition series focused on the intermediary culture of immigrant status, a third and often transitory culture produced by the juxtaposition of homeland and U.S. traditions and values. It showed at times traditional techniques, a blending of stylistic approaches, and the struggles these artists face finding people who might recognize the cultural foundations of their work. Moreover, artists featured in the exhibition became the basis for Intermedia's Moving Lives speakers' bureau, a service in which Intermedia sponsors artists as speakers or as workshop leaders with schools and community groups. In several cases, these experiences through Intermedia have launched artists into further entrepreneurial efforts.

Another exhibition in the Immigrant Status series, Faith in Women (November 2005–January 2006), brought together seven local women artists through the presentation of their artwork, including painting, pottery, soap carving, textile weaving, and drawing. The women's countries of origin included Mexico, Laos, Ukraine, Egypt, and Iran—several groups that had been settling in the Minneapolis area over the last twenty-five years. The exhibition of these artists' works, plus the exhibition's events and supporting texts, were designed to present women as leaders and, more broadly, to "honor the immigrant women who create and nurture new communities while preserving and passing on their indigenous practices" (Intermedia exhibition pamphlet 2005). Just as in the exhibition of African artists, this range of artistic practices and cultural backgrounds would not likely have come together in any other outside context focusing on contemporary immigration issues. The added feature in this case was gender, and the exhibition showed the ways that women's art both fit into and emerged from immigrant life (figure 1.2).

By incorporating into their programming a wide variety of issues and concerns facing newer immigrant groups, Intermedia instilled elements of its Immigrant Status series as permanent enhancements of the organization's core program. The programming series served as a vehicle to build participation in the arts by removing customary barriers among people from diverse backgrounds. Intermedia's workshops, exhibitions, and performances constituted opportunities to share and celebrate the new expe-

1.2 Installation by Patricia Mendoza for Faith in Women exhibition at Intermedia Arts in Minneapolis, September 29, 2005–January 7, 2006. Photograph by Timothy D. Lace © 2005.

rience found when diverse people and cultures converge. This was a new experience for many who had never been to an arts organization of this kind, or who in the past had seen the work of Intermedia to be interdisciplinary but not necessarily intercultural. Some past supporters have interpreted the program series as a social service activity for immigrants. However, through smart public relations and the use of art by diverse local groups, Intermedia highlighted how the artists in the series were connected with the larger, majority community—noting that all Americans have the immigrant experience in their own history. Intermedia's new role as an intermediary between cultures and cultural groups thus weaves the work of local groups and organizations into the artistic mix. This set of relational practices is distinct from conventional practice in that it seeks to create a direct link between art and the local communities as a strategy to build participation in the arts.

Intermedia's role as an intermediary between cultures is further exemplified in one of the workshops first held as part of this series. Talking Suitcases was conceived around storytelling and memoir conventions transformed into sculptural constructions inside suitcases. The first workshops sought to shed light on the plight of new immigrant groups who come to the United States as refugees. It was begun as an entrepreneurial effort by artist Susan Armington, who hosts workshops now sponsored by

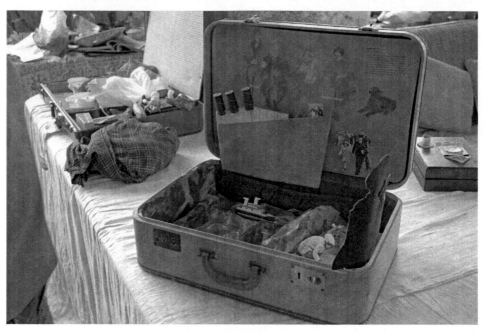

1.3 Talking Suitcase. *Saying Goodbye,* by Marie Simcox.
Photograph by Timothy D. Lace © 2005.

Intermedia; participants were asked, "If you had to leave your home on a moment's notice and you had only one suitcase, what would you take with you and what would you leave behind?" The resulting personal vignettes were displayed within an open suitcase (figure 1.3). Such objects became more than containers of personal and family history:

> This suitcase is like a journal in three dimensions, something very personal, very handmade, like a journal that is handwritten. It's your deepest thoughts. These suitcases hold people's deepest personal experiences and stories in a way that other people can read them just like in a journal. But instead of being a journal, it comes to life in three dimensions. (Armington interview 2005)

Made predominantly by nonartists, the suitcases were presented in an Intermedia exhibition. They represented a new relationship between people and objects, as well as between local people and the arts organization. Through relationship-building activities of this kind, Intermedia engaged people who had not previously participated in any activities at the organization. The objects they created—suitcases representing what was taken and what was left behind—redefined art, the experience of viewing art, and the role of the organization. According to Armington, defining the

activity as "art" allowed interaction that would not have occurred in the normal course of everyday life. "It's different than ordinary life. Frankly what happens is we can engage in incredibly deep conversations that in normal life there is hardly a place for" (Armington interview 2005). Making a "talking suitcase" in a workshop provided both artists and nonartists with opportunities to test and expand artistic skills, as well as to learn about themselves and others in a nonthreatening environment.

> In the workshops, a group of people come together and make suitcases. While the [process of construction] is pretty separate, they share them at the end of the workshop. It is powerful because people really hear other people's stories. Sometimes they hear parts of their own story in someone else's suitcase; sometimes they get an insider's view of someone else's life. The word "moved" is too trite a word to describe the feelings I have had. Rather, some stories completely changed my view about people from certain parts of the world. For example, I did not know what was happening in Somalia in the personal way it was happening. One man's story, he's about twenty-six now, but the story is about when he came home one day from school as a young man and his family was just gone. He came home and a neighbor told him his family was gone. This neighbor sort of adopted him until he ultimately came here. In his suitcase, he had a box. The box represented his home. When he was telling the story he opened it and it was empty; it represented his family that was gone. And not only do you feel it, you can conceptualize it when it is this object. As I said, these are not things to buy or to decorate your homes; they are things that carry powerful personal stories that are also universal in terms of the feelings that we share. (Armington interview 2005)

Workshops such as these led to a new cultural lens through which to view art based not on an abstract notion of "quality" but on the diversity of perspectives and depth of experience. The Talking Suitcases exhibition provided an opportunity for others to see and understand the intimate details of peoples' lives and struggles. For some participants, the talking suitcase was a self-portrait, a portrait of a loved one, or an important capsule of family history. For others, the content in the art objects provided the catalyst to talk about their own lives and issues they face:

> We [had] an exhibition of Talking Suitcases at Intermedia. A lot of people came through and looked at these suitcases. . . . The suitcases often reminded people of their own story and they would start to tell it to us right there. I remember there were some suitcases from girls whose story told of their crossing the border from Mexico to the U.S. [At the exhibition] some other high school girls visited who had done the same thing. They were in a class with people from all over. They just began telling their story. It was

more dramatic than what was in the suitcase because no one in the class had ever heard [their story] before. It started a discussion right then and there about whether it was fair for people to be treated so badly. Another girl said her father had almost died. It was all right there in the gallery that this discussion started. (Armington interview 2005)

This account shows how such relationship-building practices extend into the art-making process, exhibition development, and the visitor experience. The art not only helps make connections among people but also locates an organization in a different place than does an institutional environment centered around the conventional practices of showing only the "best" art. Furthermore, such organizational practices as Intermedia's are not designed simply to serve as a pipeline for art school–trained artists who might send work around to galleries in hopes of getting shows. Rather, exhibition practices are the result of locally embedded relationships. They are intended to stimulate greater understanding among traditionally segregated groups and to share the lives of individuals in the community. In the larger social context, these exhibitions and programs seek to challenge the beliefs and stereotypes that feed ethnocentricity and racism while offering the alternative of understanding through shared experiences.

Intermedia's efforts to build relevant human interaction among participants in its organizational activities have been particularly effective in diminishing the cultural obstacles experienced among those having immigrant status. Through making and displaying the art, hosting workshops, and producing written materials, the cultural context such activities create are defined by the commonalities rather than the differences among groups. Their organizational practices build bridges among new immigrant groups and among new immigrants and those long-term citizens who often view themselves as the entitled owners of a national or local culture. Intermedia's relational practices provide a good example of the kind of bridge building between cultures that many arts organizations are using to build participation in the arts.

THE DNA OF PARTICIPATION BUILDING: BUILDING TRANSACTIONS AND RELATIONSHIPS AT THE SAME TIME

Transaction building and relationship building have been introduced as separate analytic concepts in order to demonstrate the kinds of distinct organizational practices often involved in building earned-income streams or engaging people who have had little or no experience with a particular art organization. But there is an additional model that combines these two practices—when an organization gracefully blends its skill at building re-

lationships with its expertise in documenting, managing, and scaling up the economic value of transactions. The next example considered here is of a large-scale, complex organization that has streamlined its multiple departments involved in revenue generation and has invested in technology to improve transaction management at the same time that it has sought to build new and improved relationships with a greatly expanded roster of patrons.

The San Francisco Symphony, founded in 1911, had annual total revenues topping $56 million in 2004. Like the Old Town School, more than 50 percent of its budget is earned from programs. The Symphony has been able to show increases in contributions averaging 8 percent annually, totaling just over $20 million in 2004. Its program revenues of nearly $23 million have shown a 4 percent average annual increase over the five-year period 1999–2004. The story of this organizational transformation exemplifies the struggles and opportunities of arts organizations whose core program is built around live performances involving ticket sales.

One challenge faced by the San Francisco Symphony was to find a way to sustain income in the face of declining subscription sales—a trend that many performing arts organizations we interviewed have witnessed over the past fifteen years. According to ticketing services staff at the San Francisco Symphony, subscriptions for its twenty-four-concert series were very popular through the late 1980s. Although the Symphony has a strong base of more than thirty thousand subscribers annually, today most subscribers limit their commitment to a six-concert series. This change is significant. If the same subscribers are now going to one-quarter of the productions, this translates into as much as 75 percent fewer people in seats during a season. From the subscriber side, this trend of committing to a shorter subscription series is associated with both social and technological changes that have resulted in new ticket-buying patterns. Specifically, double-paycheck, baby-boomer families are no longer involved in just one type of social activity. Power and social commitments are shared between partners, and time for socializing is more limited. With audiences less willing to make a full-season commitment, performing arts organizations began to offer a wider range of subscription choices. The San Francisco Symphony went one step further by seeking to make it easier for patrons to participate in Symphony programs. This was the essence of its patron-relations strategy, and it stopped short of nothing to achieve this goal.

At the heart of the strategy was a shift from an inventory-based transaction model to a service-based model. This meant that, rather than the transaction being a record of reduction of inventory, it was a record of contact with a person—that is, a relationship. Every person was considered to be a patron—the highest place on the transaction scale. According

to Afshin Afshar, chief information officer at the Symphony, "Our goal is to build everything around the patron, [and we] make this our motto: the 'patron-sensory system' meaning that the patron would be where you start. If you go look at a patron's record, everything about the patron that you need to know will be within a click or two away from your reach. For us, this translates into better service" (Afshar interview 2005).

The patron-sensory system focused staff efforts on providing service to patrons rather than a yield-management approach that would focus daily decisions around moving ticket inventory. Rather than offering daily ticket specials or price adjustments based upon inventory and demand, the Symphony shifted its practices to encourage customers to want to attend more and to encourage donors to want to give more, based primarily on their experiences of positive contact with staff and the organization. However, the organizational changes required for making such contact easier and more pleasant were not simple in the context of such a large, complex organization. Providing this kind of customer service required improved staff training, better organizational coordination, and improved technology.

Web-based ticketing made it easier and more convenient for ticket buyers and subscribers to purchase tickets. The comprehensive Web site offered detailed information about performances, a wide range of subscription packages from six to eighteen performances, a great array of mix-and-match options, and seat selection that included previews of the vantage point offered by available seats. The Symphony also invested in other forms of technology, including interactive educational Web sites and Web-based merchandise sales. These investments meant that the Symphony had the kind of technically efficient environment necessary to manage the self-service transactions that are increasingly popular with a middle-income, educated population. Technology provided for better market penetration and increased access to ticketing services for these Web-savvy consumers. Web-based ticketing also freed Symphony staff to build relationships—the kind of personal interaction and service that only people can provide.

With this goal of improved customer service, then, the San Francisco Symphony invested in new technology that stimulated a reordering of the organizational practices involved in generating revenue. Like many large and complex organizations, the Symphony had numerous specialized departments involved in generating revenue—fund-raising, marketing, and ticketing—and, within those departments, even more specialized functions such as corporate giving, foundation and individual giving, tele-fundraising, corporate sales, groups sales, telemarketing, subscriptions, and single-ticket sales, to name a few. One can begin to imagine

the duplication of records possible for a single patron. It was not until the year 2000, after years of development by the Metropolitan Opera in New York, that an integrated database was available that had been designed for nearly all the records generated and managed by nonprofit performing arts organizations.

> In the past we didn't have any way of tracking [what each independent department was doing]—for example, our marketing department was sending their mailings and so was the development or fundraising department, plus other departments sent their own communication packages. We had no idea that we were sending so many pieces of mail to our patrons. Once [the data integration was complete] all that information was stored in one database. So with one small report, we found out—we were terrified to find out—that there were patrons [who had] received more than twenty mailings from the Symphony in less than two weeks. So we realized we had to change our business processes and have all these different departments work together to make sure we are not flooding our patrons with information, making them numb to our appeals. (Afshar interview 2005)

The Symphony was among the first nonprofit organizations to buy into a software package developed by the Met that integrates discrete departmental databases into a single application. The software was made available to the field through a new nonprofit organization, the Tessitura Network. By integrating all its databases, the Symphony was able to see the problem of interdepartmental competition in its own efforts to build relationships and scale up transactions with customers.

> With a new integrated database [Tessitura], we developed a matrix system where we actually share or manage the contacts so we are not hitting the same patrons with mail too often. Same thing goes with our telemarketing and tele-fundraising. Now we can track all that information so our fundraisers, tele-fundraisers don't call our patrons right after telemarketing has called them. And I think patrons appreciate that too. They don't want to be bothered day after day with calls from the Symphony if they can do everything in one phone call . . . Because of this application, we can now have all the information we need to provide customer service in one place. When a patron comes to the window or calls, the call center people and ticket services people don't have to scramble going from system to system or from file cabinet to file cabinet to get their information to give them what they need. Everything is there. With a few clicks they can provide them the information they need or the services they need. So for us . . . this technology has translated into better servicing, better services for our customers, better and faster services. (Afshar interview 2005)

The reordering of its revenue-generating efforts meant that sales efforts were concentrated in a ticketing service, which was considered to be the key point of contact for 95 percent of the Symphony's patrons. They improved interdepartmental coordination by establishing weekly meetings between the ticket services director, the box office manager, and the marketing manager. These meetings resulted in brainstorming about how to interact with callers, strategies that were all documented through the database. Furthermore, the frontline workers no longer simply took ticket orders from customer-initiated phone calls. With all the patron's records at their fingertips, the staff had a wealth of information available that allowed them to engage in a conversation with the patron. They asked return ticket buyers how they liked the last show, how their seats were, if they had problems coming to the theater. In short, they sought to provide more personalized service beyond simply selling tickets. In addition, ticketing agents worked to scale up single-ticket purchases to subscriptions early in the season. They invited every ticket buyer to make a donation, rather than limiting requests for giving to a single time of year or to a special activity by the tele-fund-raising department. The result has been impressive: through customer-initiated calls alone, ticket services brought in $1.3 million dollars in contributions in 2004.

The point of the improved interaction is clearly twofold: to build relationships with patrons and to increase the value of the transactions. The services provided in any moment of contact are geared toward customer satisfaction. The integration of technology with skilled customer-service staff allows for a more efficient operation overall. Computer-based ticketing can accommodate last-minute cancellations, easier ticket exchanges, and even the resale of a subscriber's unused ticket—making it rare that there are empty seats in the most prized sections. Further, by tracking barcoded tickets, staff can determine when valued patrons arrive. Web and e-mail technology allow the organization to notify patrons of parking and construction problems. Through the use of sophisticated technology, interdepartmental coordination, and a highly trained customer service staff, small transactions are more easily cultivated into relationships that can lead to transactions of ever-increasing financial value. The patron-sensory approach allows the San Francisco Symphony to deliver highly customized services once reserved for only the most privileged and prized patrons.

CONCLUSION

As this chapter shows, organizations have many untapped resources at their disposal. Their own databases, reintegrated in a new way, can provide new forms of access to community supporters, partners, visitors,

single-ticket buyers, members, subscribers, and patrons. Just as a database of well-documented and managed transactions is a resource that can be mined for new customers, well-documented and nurtured relationships with residents and organizations in their local communities provide organizations with opportunities to mine the cultural, human, and financial resources found within the networks of their interactions.

To build relationships with new or underserved audiences involves relevant programming, reciprocal exchanges, and representation of the people and organizations found within one's community. By preserving the direct link between art and local communities as a strategy to build participation in the arts, there is a new role for the arts organization as an intermediary between local artists, diverse cultures, and cultural groups. The results of such practices are new community ties, new participants in the arts, and a transformed organizational culture, all of which are built on the value of shared human interactions.

By conceptualizing arts participation as transactional or relational, organizations have a number of obvious ways to gauge change. Transactions can be monitored to build return and loyal customers and increased voluntary giving; relationships can be monitored for changes in the number of interactions, in the variety and range of reciprocal exchanges that occur. This variety of participation does not add up to a single arts audience; it reflects the variety of participation that can occur even within a single organization. Rather than being viewed as a single ascending scale, the variety of arts participation found within each organization is best monitored individually, allowing each type of participation to be like the points on a star that may grow longer or recede but will each contribute to the star's brightness.

2 Changing Culture and Practices Inside Organizations

BETTY FARRELL

All organizations that are launching efforts to develop new customer/audience relationships and new levels of participation—whether by deepening the experience of current audiences or by expanding the organization's reach to newcomers—will face the need to change at least some aspects of the way they operate. At the very least, they will need to reexamine their practices of doing business as usual. Despite organizational differences in artistic genre, size, age, depth of staff, or mission, cultural organizations such as museums, dance companies, theaters, literary arts groups, musical groups, presenters, arts learning centers, and community cultural centers share some common challenges in identifying what kinds of organizational change are necessary in the project of building greater public participation. They need to draw from a range of strategies to create the infrastructure that will allow them to implement and support the activities that will sustain the most successful practices over time.

Organizational change is not easy. Referring to the museum world specifically, but with an insight applicable to many organizations, one cultural critic has argued that "organizational inertia is spontaneous, profound change is not. Truly far-reaching change requires the kind of sustained and steadfast leadership that can endure periodic setbacks and survive inevitable spells of unpopularity, both within and outside the organization" (Weil 1997, ix–x).

Strong leadership and the institutional alignment of goals can produce organizational adaptation or change that is relatively smooth and proceeds by widespread internal consensus. But most efforts are more halting and fraught with ambivalence—developing out of necessity, proceeding by trial and error, and sometimes met with resistance and structural barriers. This

chapter will explore the multiple ways in which cultural organizations are working on internal sources of change—revising the images they project to the public, the meaning and uses of their physical space, their organizational dynamics, and their projects and programs—and the successes and challenges they have faced in the process.

CRAFTING A NEW PUBLIC IMAGE

Many canon arts organizations—typically characterized by municipal/universal collection museums, symphony orchestras, and opera and ballet companies, with their origins in the late nineteenth and early twentieth centuries during a period of intense cultural institution building in major U.S. cities—appear daunting to newcomers to the arts. They are housed in formidable, imposing buildings. They may not be easily accessible by public transportation from all residential parts of the city and suburbs, and they are often located in urban downtowns where parking is expensive. They tend to have a high admission price, except on the free days or evenings when they may seem overly crowded. The uniformed guards at their doors and throughout their buildings seem most closely to resemble police officers or terrorist-screening airport security personnel. And these are just the most immediately visible, physical barriers that a new visitor to a museum, symphony hall, or well-established performance space would have to overcome in order to enter. There are also the perceptual barriers—what to wear, how to speak and act, what not to touch or do, and whether that person at the front desk will look at you as though you don't belong—that might prevent someone from crossing the threshold of this foreign and somewhat exotic cultural space.

That there are real and perceived barriers that restrict the access of newcomers and make the art world seem impenetrable is not news to cultural organizations of all kinds, especially the canon institutions. The San Francisco Symphony has addressed this issue on its Web site, where a "How to Prepare" button on the home page leads directly to a "First-timer's Guide."

The top five misconceptions about going to the Symphony:
1. Everyone wears tuxedos or evening gowns.
2. You should clap after every movement of a piece, even that one piece they always play at the beginning where a violinist stands up and everyone plays the same note.
3. Classical music isn't meant to be enjoyed—it's meant to be appreciated.

4. It's good to leave your cell phone or your pager on during a performance—especially if you answer the phone and carry on a complete conversation.

5. Coughing adds to the music—it's like a new percussion instrument.

Allow us to clear some things up. We want your first experience with the San Francisco Symphony to be faux pas–free. So, we've put together some tips for the first-time concertgoer. (http://www.sfsymphony.org/templates/basic.asp?nodeid=123, accessed December 24, 2005)

The most frequently asked questions that follow this introduction include: What is classical music? Will I enjoy the concert? (Answer: "Absolutely!") Will I recognize any music? What exactly are seasons and series? What's the difference between a concert and a recital? What should I wear to a San Francisco Symphony concert? When should I clap? Can I bring the kids?

By no means exclusive to symphony orchestras, these questions reflect real concerns and fears on the part of many potential visitors and participants that arts organizations cannot afford to ignore. Do such Web sites reach first-timers and make a difference in their initial encounter with a new cultural experience? No follow-up research has been done to confirm this. But what the proliferation of this type of Web site can tell us is about the perception on the part of cultural practitioners that they need to address the issue of the audience's familiarity and level of comfort with their product.

Many cultural organizations believe that their first order of business is to dispel the notion that they are elitist institutions—or, in the words of Lonnie Bunch, former president of the Chicago Historical Society, "a venerable institution that few people actually want to visit" (Bunch interview 2004). A large building with an imposing architectural style conveys the image of a rich institution with unending resources at its disposal. The Alabama Shakespeare Festival has to work hard to attract diverse audiences because its beautiful new facility—the result of a twenty-two-million dollar gift from a single donor—"looks like a cross between an upscale church and a country club to some people." In the words of its former artistic director Kent Thompson, "The downside of our building . . . [is that] some people think, 'Oh well, that's a white or an upper-class institution'" (Kent Thompson interview 2005). The Isabella Stewart Gardner Museum in Boston instituted its neighborhood-focused, free summer Neighborhood Nights program—featuring a silent-film festival or music under garden tents—by creating an alternative entrance into the stately museum's grounds "so that it doesn't feel like coming into a rich lady's house" (Anderson interview 2005).

The relative inaccessibility of the art form itself and the cost of admission can also convey the impression that an organization is out of popular reach. Susan Talbott, former executive director of the Des Moines Art Center, joined that organization at a time when the staff had already identified greater community engagement as the primary institutional goal. The admission fee to the museum had been removed, so it was now free to the public. The art center launched a major outreach effort to various organizations and communities in their area that led to a strategic plan for broadening their reach to new participants:

> Internally, we made a list of the different communities who we were interested in reaching and talking to, and we worked with the . . . leadership of the United Way when we put together our human service group. We worked with many of the schools and universities in the area when we put together our education group. We . . . worked with the Iowa Arts Council and wrote to, maybe, 500 Iowa artists, inviting them to come to this meeting. And that was the one that was the most well attended—the one where I thought there would be a lot of bitterness, because, . . . at that time, we really didn't do very much with Iowa artists. So I thought there would be a lot of bitterness, and in fact it was just the opposite. They were so thrilled to be included and to be asked their opinion and to be able to make suggestions, many of which we acted on. . . . We took very, very careful notes. We read the notes, we processed them, we discussed them . . . we really developed, without meaning to develop, a strategic plan for how we were going to proceed with opening up the organization to the community. And really building trust. Interestingly, it took a very, very short time to do. I thought it would take years. It didn't. (Talbott interview 2005)

The Des Moines Art Center also curated a cutting-edge contemporary art show early in Susan Talbott's tenure that was participatory, user friendly, and geared especially to teens and families. It provides a striking example of how "difficult art" can be made accessible, even within the confines of the same physical space that had previously been interpreted as elitist:

> That show turned the community around because people loved it. It was participatory, with some of the work. It was mostly cutting-edge contemporary art, which is part of our mission. And it was carefully chosen and presented in a way that was completely user-friendly. It also traveled [around] the country and abroad. . . . And so, the combination of all of the buy-in from our various community partners and this incredibly popular show turned things around. By the end of the year people were [saying] "Oh, isn't it amazing how the Arts Center has changed!" And I was actually credited for doing things that I had nothing to do with. (Talbott interview 2005)

Even community arts centers can convey a message of exclusivity. Evelyn Craft, executive director of the Arts Center in St. Petersburg, Florida, described the change of cultural climate that it was necessary to implement with the front office staff, made up of older volunteers, when she first assumed her position:

> If someone came in to buy a membership for twenty-five dollars, [the front office staff] would say, "We'll take your application and let you know if you qualify." Rather than, you know, "Please join us, and here are the benefits," it was "Well, we'll see if we'll let you in." Or, "Are you an artist? I'm not sure that you want to join otherwise." . . . I think they were just older volunteers, and they just didn't get it. . . . Instead of understanding that your members are your loyal core supporters who help you grow, they saw them as being more work, one more name to add to the mailing list, god forbid, or one more newsletter to mail out. (Craft interview 2004)

This was the case of an organization that had not yet developed a firm commitment to inclusivity and expanded participation.

> There had been a split among the board and volunteers, . . . and the staff had basically been demoralized from all of the turnover. So, we started again and were able to encourage the people who were really enthusiastic about the organization and [about] opening it up to the community—[staff] who believed in the mission to have more contact with people when they came in. (Craft interview 2004)

With candor and the willingness to share the mistakes, as well as successes, that contribute to useful lessons for all types of organizations, Craft noted:

> We did a series of focus groups . . . and tried to find out what was important to [newcomers] about membership, and what wasn't, and how we could enhance that. And then, based on that, we attempted to train our staff to be more proactive about selling membership with scripts of names. Well, that was a disaster. The staff was uncomfortable doing it, and when they were pressured into doing it, they scared the people half to death. [Visitors] were physically backing out of the building to get away from this intense sales effort. So that was not working. . . . so we developed the guest membership. Essentially it's free for ninety days. So you get to try out a membership, and then, if you want to, you can convert to a full membership. We do regular mailings to [these guest members]; they get a phone call from a volunteer if they express an interest in a particular area. . . . So that was a lot more palatable for the staff and it was obviously more

> Look at your organization as an outsider would and . . . get a fresh eye . . .
>
> EVELYN CRAFT

palatable to the people coming in the door. We did learn, too, . . . that many of our visitors were either seasonal residents or tourists. So we've been able to target a different market with some of our programs and advertising. . . . And now we're going to try and do some master class weeks to have a beach package—beach and arts package.

In the end, I think you have to look at your organization as an outsider would and you have to try to get a fresh eye on what your programs are and then how you present yourself to the community, whether it's in your printed pieces or [in] radio advertising . . . In the end it comes back to mission, and how you communicate your mission to your community. (Craft interview 2004)

Efforts to create a more welcoming environment have led many cultural organizations to revise their front-staff training programs—such as the Seattle Art Museum's charge to its staff that they are all responsible for creating "excellent visitor experiences" (Moreland interview 2005-1). The Speed Art Museum in Louisville saw this as an education effort as well as a training program in public relations:

What we've got to do first is educate our board, and our staff, about what public value is and about why it's important to build participation. And then we've got to train our staff . . . how to make a welcoming environment for families. It's OK for kids to talk loud; they're going to occasionally run, you know. . . . Let's give our staff what they need to address those kinds of things. We [are] just emerging as this place where it's cool for families to go. . . . The museum was founded in 1927; it's always been a place where there was a black art exhibition; but somehow it does have this . . . reputation that, you know, only white people were welcome. That's never really been the case; people were not turned away in the early days when there was segregation. But, largely it was a place that was supported by the upper crust, and so we're still getting over some of that, even though it really hasn't been that way for a number of years. . . . The other big "ah-ha" [we learned from our research] is that people really want to be invited, and sometimes we just have to send out communications to say "we invite you." In some instances, that may be all it takes. Some people felt that, even though it's a public place, they had not been invited. (Peavler interview 2005)

Other organizational strategies to become more welcoming and inviting include efforts to diversify the pool of volunteers, to think about strategies to make admission more affordable, and to rewrite communication materials with greater attention to using more accessible language. Some of these efforts can meet with internal resistance—from museum curators, for example, whose extensive training and expertise in art history may lead them

initially to resist what they see as the encroachment on their turf or a diluting of their expertise, when a participation-building tactic that encourages visitors to write their own wall labels is introduced; or from traditional subscribers or donors who wonder why all these new people are present, many of whom may not know or follow the conventional rules of etiquette.

Crafting a new public image means becoming more accessible, open, and inviting through a variety of strategies that break down the real and perceived barriers to cultural participation. Welcoming newcomers into the physical settings of cultural organizations—some of which have been preserved and are experienced as sacred spaces, closer to a religious setting or to school than to a place for spending leisure time—is the first, very important step in the project of building broader and deeper kinds of participation.

REINVENTING THE USE OF SPACE

Getting newcomers in the door is the first challenge for cultural organizations. What they encounter when they get there is a complicated interplay of a physical space, a social environment, and programmatic opportunities. When visitors come to a concert, opera, ballet, or play, they are coming to attend a particular performance; it's the quality of that performance and the visual and auditory experience they have, in addition to the social experience, that will determine whether they will be encouraged to make a repeat visit. If you don't like the performance, you can always leave, but by then you may already have made a sizable investment of time and money, including the cost of the ticket(s), the parking, the babysitter. Other types of cultural organizations—museums, arts-learning centers, community cultural centers, literary arts programs—have the advantage of offering a range of programs, activities, or exhibits from which visitors can pick and choose. If you're not interested in one exhibit in the museum or one kind of arts class in the community center, there's always another that might capture your attention. What goes on in the cultural setting—its meanings and uses—presents different kinds of challenges, then, for engaging the new or the sporadic participant.

How can arts organizations make best use of their settings and physical spaces to enhance the encounters of new participants? Deborah Clearwaters, manager of public programs at the Asian Art Museum/Chong-Moon Lee Center for Asian Art and Culture in San Francisco, has given extensive thought to this issue, because since 2003 the Asian Art Museum has been housed in one of San Francisco's historic buildings—the former main library, a 1917 Beaux-Arts–style structure. Following an extensive rehabilitation that preserved the historic exterior and many internal archi-

tectural details, the museum now has "an entrance with a grand staircase, loggia and great hall, vaulted ceilings, skylights, inscriptions, molded plasters, . . . stone floors," as well as twenty-nine thousand square feet of gallery space, three multipurpose classrooms, an Education Resource Center, and Samsung Hall, in the center of the building, used for live arts projects and hands-on learning experiences (http://www.asianart.org/building. htm). At the American Association of Museums Conference in May 2005, Clearwaters and colleagues presented a panel entitled "The Architecture of Education: Designing Spaces to Fit Programs and Programs to Fit Spaces" to discuss some of the challenges of creating engaging, participatory exhibits and a sense of connection and immediacy for a primarily novice audience in the face of such imposing spaces and architectural grandeur. The museum's AsiaAlive program was designed to be an "accessible, entry point for people of all ages, learning styles, and knowledge levels—and a program to entice people into the museum for the first time." Clearwaters noted, "We've grappled with [space issues] a lot for AsiaAlive because it's in this huge hall that's very grand and beautiful but it can dwarf the artist sometimes. . . . [There are] very high ceilings and this big, marble, cold space. The importance of design on programming is one of the things that we've learned from doing AsiaAlive. It's more important than we ever imagined" (Clearwaters interview 2005).

The Asian Art Museum's Samsung Hall was considered too cavernous for art displays, and it needed focal points, intimacy, and "activity to enliven the space." The staff's solution was to use the space for demonstrations by living artists and for a variety of hands-on, creative activities that change monthly—to provide "a dynamic sense of change that would [offset] the perception of a static museum." They achieved this with the help of "temporary walls to define space and display artist work; storage carts for walls and activities that could double as bars for events; and lightweight, easy-to-store furniture—all of which [needed to] be quick and easy to set up, break down, and store in a small space" (Clearwaters 2005, 22–26). These solutions were created within the constraints of a tight budget, ongoing programs in the space during the planning process, and a trial-and-error approach. The AsiaAlive program has had many indicators of success—high levels of participation and satisfaction among its visitors and greatly increased visibility of its programs. Yet, ultimately, Clearwaters argues, in a significant lesson that may be more widely applicable to many other organizational contexts, "the original architecture wins out and we must adapt programs to it" (ibid.) (figure 2.1).

Other organizations have also tried innovative approaches to reinvent the uses and meanings of their physical space. Orchestras have experimented with a thrust stage that extends out into the audience and creates,

2.1 AsiaAlive program at the Asian Art Museum, July 2003.
Photograph by Kaz Tsuruta. Copyright Asian Art Museum of San Francisco.
Used by permission.

to the accolades of critics and audiences, a more intimate experience, much
the way that a theater-in-the-round brings an audience closer to the ac-
tors and stage (Pogrebin 2004; Tommasini 2005). The Chicago Symphony
Orchestra (CSO) provides a free Day of Music once a year that features
a continuous program of simultaneous music and dance performances,
including concerts by the full orchestra, occurring in multiple spaces in
the orchestra's Symphony Center. The response has been overwhelmingly
positive, often with lines of visitors, who represent greater age and racial/
ethnic diversity than a traditional symphony crowd, stretching around the
block as they wait for a seat to open up in one of the many reconfigured
performance spaces. The CSO staff estimates that several thousand visi-
tors have turned out for this annual Day of Music event. This is a striking
example of how a "venerable institution" can be transformed into a wel-
coming and popular place with a combination of more informality, free
access, and an expanded repertoire of diverse programming.

The question of what gives a new visitor a sense of ownership of a space
remains challenging. But programs for young people have often been con-
cerned with finding ways to make the physical space feel like their own.
Julie Parson-Nesbitt, former executive director of the Guild Complex in

Chicago, a literary arts organization, reports on a collaborative effort with a teen program that made their own space more familiar and accessible to a new group of young participants:

> [W]e had a very successful partnership with another community based organization called Young Chicago Authors. They are focused on teenagers, [and] we collaborated with them to do one event a week at the Chopin Theater. So we had a youth event on Tuesday night, and then we had an adult event on Wednesday night. And what happened was that all these teenagers came on Tuesday night, and they really claimed the space. They would read their own work, and they would organize events there on Tuesday nights; and then, because they were so familiar with the space and literary activities, they would come again on Wednesday nights [when] they would hear the adult authors. And a lot of times they'd read on open mics and they'd be really active at the Wednesday night events. So that builds our youth audience tremendously; I mean we just had a huge expansion of our youth audience. (Parson-Nesbitt interview 2004)

The meaning of a theater space may also change when the audience gets to experience closer encounters with artists. The Pittsburgh Ballet sponsors Afterthoughts following its Friday night performances, when audience members can choose to stay around after the show, "come down to the front of the theater and talk with our artistic director and some of the dancers who just got off stage, maybe took their costume off, threw on a bathrobe, and they're still in their makeup" (Miller interview 2004).

The first fifty people to answer an invitation were also given an "insiders' tour" by the Ballet—invited into the costume shop to hear costumers discuss their craft and view a fitting for *The Nutcracker,* watch the design and building of a stage set, and even participate in a beginning ballet class designed to give audience members and trustees a tangible and close-up taste of the rigorous training that dancers complete.

Cultural organizations have used strategies such as these to make their spaces feel inviting and accessible to groups of newcomers to the arts, but unconventional juxtapositions of art and physical settings are also a way of shaking up the status quo and challenging the venerability of venerable spaces. Kickin' It with the Old Masters, the Baltimore Museum of Art's exhibition of artist Joyce J. Scott's work, did this when it placed the artist's rendition of the lynched body of a black man, made from glass beads and covered in racial epithets and titled *Somebody's Baby,* directly over the head of Rodin's bronze sculpture *The Thinker,* in the museum's entrance court. Director Doreen Bolger said about this powerful exhibition, which included a variety of activities and outreach events related to the social and political themes of the show: "Basically, the museum is a

different place because we did the exhibition. It's changed how people think; it's changed how people work. It's changed how we present ourselves to the public. I think it's changed how the public perceives the museum. That's really a long-term legacy" (http://www.wallacefoundation.org/WF/KnowledgeCenter/KnowledgeTopics/ArtsParticipation/Baltimore Museum.htm, accessed June 27, 2005).

Alternatively, organizations have experimented with taking their art out into nontraditional settings—as the Loft Literary Center in Minneapolis does with its once-a-month, happy-hour book club at a downtown pub (Caflisch interview 2005), or the Louisiana Philharmonic does with its innovative, rotating-venue, Find the Phil program, in which the orchestra performs one-hour nonstandard classical concerts in rock clubs, garden nurseries, underground theaters, a glass-blowing factory, a Vespa showroom, and a Brazilian tango club:

> In the music club, which is called Café Brazil, the musicians put together a program of classical tangos, and they started it by doing a Ginastera string quartet, which is really heavy going. Not only is it tough on the musicians, but it's really [challenging to the listener]. . . . In that particular one, which was held . . . in the sort of downscale part of the French Quarter, there were 250 people [who] wedged their way into that club. . . . They were out on the sidewalk. . . . [The musicians] talk to the audience, and . . . explain why they're doing what they're doing. If anyone has a question, they'll answer it. They stay afterwards and have a drink with the crowd. But they play one hour of real, not dumbed-down music. The one in the garden nursery . . . had a completely different crowd. It was a suburban area, with a lot of older people with grandchildren, and there was humor in the music. The musicians got together and figured out what pieces would [work], and then they had [a] stand-up routine that they did; it was hysterical. (Litwin interview 2005)

Arts practitioners are paying greater attention to the constraints and opportunities of the physical spaces in which they present their art, since those spaces are weighted with meaning for participants and potential participants. At the same time that efforts are being made to challenge the traditional meanings of venerable spaces, adapt them to new uses, and take art outside to new kinds of venues, there has been a flourishing of new building and renovation projects in cultural organizations around the country. It might be argued that the expansion and reconceptualization of physical space by cultural organizations in the contemporary era match the intensity of the original cultural institution–building period of the late nineteenth and early twentieth centuries. Museums are adding

new wings or new buildings, theaters are expanding the number of stages and creating more flexible performance spaces, and many cultural organizations have reconfigured areas in their buildings to be used as education resource centers or for interactive activities and exhibits. And the motivation driving this construction boom in new buildings and new spaces is, in many cases, to present an airier and more inviting kind of physical presence that is linked to new kinds of experiences in those spaces.

The Walker Art Center's expansion and renovation of its building was described by the architectural reviewer in the *New York Times* as

> an exhilarating place to view art, one that packs in 11,000 square feet of additional gallery space, a 385-seat theater, a hip new restaurant and an expanded bookstore while upholding art's place as the center of the museum experience. Anchored by an aluminum-clad tower, the addition is a masterly example of how exhausted motifs can acquire new meaning when reworked in a fresh setting. . . . The lightness of the aluminum tower functions as a visual counterpoint to the forbidding Barnes building, infusing it with a new dignity. The contrast between the two forms also echoes the stone towers of two churches across the street and the cluster of skyscrapers in the distance. Viewed as part of this panoply, the Walker evokes the tangled relationship between culture, commerce and religion at the beginning of a new century. And it hints at the museum's aggressive public mission, its belief in art's power "to redeem our isolation," as the critic Dave Hickey once put it. (Ouroussoff 2005, 31)

Sarah Schultz, the Walker's director of education and community programs, sees a strong link between the opening of the new building and the new Civic Engagement Initiative that is planned. The Walker has begun a project of mapping out

> how a contemporary arts institution could actually be a public space for civic dialogue and engagement . . . how we can take the art that we show, the programs we [do], and the artists we bring in and really start to bring out the threads of this work that connect to people's lives and to some of the issues that we face in the Twin Cities community. . . . As we like to say, we're not programming *for* the community, but programming *with* the community. . . . when you start to think about your audiences and the kinds of experiences we want to create in the new building. It's really [about] trying to create interpretive projects and experiences where people can also find their own way into the art. (Schultz interview 2005)

We're not programming *for* the community, but programming *with* the community.

SARAH SCHULTZ

As the Art Institute of Chicago also completes its new wing, "trying to give a venerable institution a contemporary identity . . . with lightness and airiness" (Pogrebin 2005), there are echoes among other cultural building projects that have been driven by organizations' need to be attractive and accessible to a new public. Thus, the Asia Society in New York renovated its building to be "more light, open, and inviting" (Cooper interview 2005). The Seattle Art Museum has been expanding its downtown building at the same time that it is opening the Olympic Sculpture Park on the waterfront in order to be more in the public eye. Even an institution such as the Isabella Stewart Gardner Museum in Boston, constrained from changing anything in its original 1930 museum according to the dictates of the will of the founder, has been considering a separate, physical expansion effort:

> [W]e're so constrained for space, just for the kind of staffing needs that a twenty-first-century museum has and visitor services needs, plus wanting to have an area that is more transparent where residents could come together and work or where the public could come and explore the archives or chat with an artist in residence. We're looking at the back footprint of our property and already worked with a master plan[ner] from . . . three years ago to help us figure out mapping on campus; and we have just hir[ed] Renzo Piano to do the next phase of pre-design work with us so that we can understand the scale and scope and what's possible on the back of the campus. . . . We'll be looking at things again—orientation, visitor amenities, customer service. You know, being a more welcoming place for visitors. (Anderson interview 2005)

Not everyone in the art world is so sanguine about the power of new or renovated buildings to inspire new levels of participation. Ella Baff, executive director of the Jacob's Pillow Dance Festival in western Massachusetts, argues that people are drawn to the arts because of personal relationships, not physical structures:

> Everyone's been building these huge facilities for the past fifty years, and now there's so much . . . pressure to fill them. Building all these big buildings—and it continues to happen, and it just makes me rant and rave because most of the time they have no idea what to put in them; they have no money to support them; and they have no money to develop audiences of any measure that are really going to make any difference. . . . [How do people come to the arts?] Someone took them. It might have been a teacher on a field trip; it was an auntie who sang at the piano; it was a father who loved opera. Somebody took them there. And this we must remember. (Baff interview 2005)

Ultimately, it's about creating an arsenal of strategies, in which airy, inviting buildings and reinterpreted physical spaces are only one possi-

bility. How cultural practitioners work inside those physical settings may be even more important to the task of participation building—and also particularly intriguing, since most of these strategies and practices are not visible to the visiting public.

RESTRUCTURING THE ORGANIZATION

What happens to cultural organizations when they begin to rethink their ways of doing business as usual? Many start with changes in the staff, encouraging the hiring and retention of those who will be "drum majors for change" (Bunch interview 2004), as well as those who will be adept at working outside of highly specialized departments or narrowly defined areas of professional expertise. Organizational change is not only driven by incorporating different types of people, however, but by adopting interdisciplinary projects in which staff expertise can be juxtaposed and remixed in new ways that produce some fundamental changes in organizational culture. Lisa Roberts (1997) wrote a detailed account of one such project at the Chicago Botanic Garden that brought museum educators fully into the curatorial process for Linnaeus: Lessons and Legacy, an exhibit on the naturalist Carolus Linnaeus. By asking questions about the exhibit from the perspective of the visitor—"How are [collections] displayed, what is said about them, and who does the saying?"—education staff members were instrumental in helping shift the museum's project from one of transmitting "objective knowledge" to one of "deciphering [multiple] interpretations—anticipating and negotiating between the meanings [of an exhibit] constructed by visitors and the meanings constructed by museums" (Roberts 1997, 3). As in this case, where the goals of visitor education and experience were brought into the curatorial process of constructing an exhibition, many cultural organizations find that the process of change happening inside their own walls is not something that they set out to effect consciously as large-scale transformation. Rather, it is the unintended consequence or the byproduct of smaller kinds of adaptations that are taking place through more collaborative strategies and through new forms of communication and decision making inside cultural organizations.

Breaking Down the Silos

Breaking down silos within the organization by creating more channels of cross-departmental communication and collaboration has been one primary strategy by which organizations have restructured how they operate. Sarah Schultz at the Walker Art Center notes the strong internal collaborative system of work groups the museum has developed—an

artist-in-residence work group, a civic engagement work group, and an interpretive materials work group, among others. She sees the change toward a more collaborative working environment as requiring "the balance of a lot of different agendas. . . . [But] we've embedded all of these different agendas in our work. [And] that balancing act for me has always offered a very potent kind of creative tension" (Schultz interview 2005). Victoria Moreland, director of community affairs at the Seattle Art Museum, described that museum's complex network of committees that ensure project coordination and the sharing of ideas: a "directors' advisory"— a committee of all the departmental directors who meet together weekly along with the director of the museum; a "dialogues task team"—representatives from all departments and divisions who meet regularly to discuss particular projects, review research, and come up with strategies to be implemented in their various departments; and "all-staff retreats" that allow members of the staff at all levels to get involved in the museum's initiatives (Moreland interview 2005–1). Work groups, cross-divisional teams, meetings, and retreats are not simply tactics to involve more staff members in institution-wide projects; they are also longer-term strategies for changing the dynamic process through which an organization works. They are processes that, directly or indirectly, can reshape an organization's internal culture.

Realigning Decision Making, Responsibility, and Power Sharing

For Peter Marzio, director of the Museum of Fine Arts, Houston (MFAH), the committee process is the means by which new ideas get tried out and, eventually, become more widely accepted, including at the board level. Changes in the way decisions are made and power is allocated can help spread the commitment to change more widely throughout a complex organization. In the process, new ways of working collaboratively across departments may be created, although not without presenting some new challenges. Staff who work in an organization that has had a traditional, top-down power structure may find it difficult to adjust to a new executive director who believes in less hierarchy and more shared decision making— but also more responsibility. At the MFAH, for example, all senior staff members are charged with fundraising responsibilities. This responsibility, according to Peter Marzio, "is much more of a threat to a lot of the more traditional types than are the broad participation issues" (Marzio interview 2004). But, as more staff members, including museum curators, are charged with development responsibilities, a fuller understanding of what broadened participation means has become an institutionalized feature of the way the MFAH works. In traditional organizational contexts, this mandate might serve simply to reinforce the old patterns of ca-

52

tering to the wealthiest donors. In a restructured organizational environment, such as the Museum of Fine Arts, Houston has developed, it means the shared responsibility of reaching a wider group of donors and more widespread staff participation in articulating the institutional values.

New forms of staff interactions, including cross-departmental patterns of communication and shared processes of decision making, are not the only elements that go into changing the internal structure and culture of an arts organization. The support of the board is crucially important. Penny Peavler at the Speed Art Museum notes how lack of commitment at the board level can stymie efforts to create change:

> [T]o be completely frank, we have had board members in the past who have not cared if anyone walked in the door, because we were supposed to just protect the art and keep it nice and [not] let anything happen to it. This is a real sea change for us in terms of where we're headed, and so this training is going to be about creating public value—how to talk about what we're doing and why it's important to that one third of the community that's only somewhat . . . interested in what we're doing; and also how to recontextualize what we're doing for the one third who is very interested. There are ninety-two cultural organizations all competing for that one third of the Louisville market. You know, three hundred thousand people—a very small number overall. I mean, if you figure there are a million people in the Louisville area, [that means that] one-third are pretty interested—three hundred thousand . [Another three hundred thousand] are lukewarm. And then there's roughly [another] three hundred thousand who are uninterested. So what we've got to do first is to educate our board and our staff about what public value is and about why it's important to build participation. (Peavler interview 2005)

Including the board and the staff in discussions of institutional goals and values to support more and broader community engagement is the first lesson from organizations that have successfully incorporated their community-building and participation-building efforts into their core mission. Developing an inclusive, institution-wide planning process, which includes cross-departmental task teams and work groups that meet and talk about issues frequently, helps to open the organization's channels of communication and builds greater understanding of the institutional mission among staff at all levels, from front-desk personnel and guards to those in senior staff positions. The Museum of Fine Arts, Houston has also experimented with "internal sabbaticals" for its senior staff—opportunities to try out work in different departments, with the goal of creating fresh perspectives and renewing work opportunities for individuals, but also with the consequence of strengthening the networks through

which collaborative efforts can grow. In their efforts to bring in the widest possible range of new perspectives, many organizations have also added key community members and outside groups as advisory committees, beginning to build an expanded network of community contacts and potential partners that will be based on relations of trust. The process is one of relationship building, inside the organization itself and outside among multiple communities. As many organizations have discovered, however, opening these channels of communication requires careful listening and institutional willingness and capacity to act on some of the ideas and requests. How and where organizational decisions are made may also undergo change in this process, since institutional flexibility and nimbleness will be prerequisites for responding to communities and social conditions in a perpetual state of flux.

Internal Resistance to Change

There are many reasons for the staff of cultural organizations to resist change. Sometimes long-term staff members do not share the new institutional mission or set of goals. Lonnie Bunch faced this at the Chicago Historical Society (renamed Chicago History Museum in 2006) when he assumed the position of president there in 2001:

> Some of the resistance is that you've got [staff] people who have been here twenty years. And [they] basically say "we're a good, solid 'B' institution; what's wrong with that?" And I came in saying "if you're not an 'A' institution, then you're going to die." So there was some of that. And there was some resistance to the fact that I was an outsider. I wasn't from Chicago. I mean, they knew me; most of the people in this place knew me from my days at the Smithsonian. But, you know, I was just this Smithsonian guy coming in, and I used to get a lot of "well, this isn't the Smithsonian." And I said "so, is there something wrong in aspiring to be the Smithsonian?" (Bunch interview 2004)

In other instances, there may not be resistance as much as a lack of familiarity with the different cultural traditions of new participants, or the challenge of having to learn a new language that was not part of a traditional art school education. In the face of the staff's active resistance or simply its difficulty in adapting to new demands and approaches, many arts directors have responded by slowly instituting relatively nonthreatening changes to the standard organizational practices and traditional programming. They actively try to learn from experience—assessing special programs, getting participant feedback, and learning from failure, as well as success. A flattened organizational structure and lots of opportunities for cross-departmental brainstorming sessions and conversations

open up the organization's internal communication channels and help build a culture of respect for different kinds of expertise. As staff members come to understand that building participation and establishing ongoing relationships with newcomers to the art world is not a superficial effort, but one that is central to the institutional mission, the whole process of change may become more acceptable.

In the words of Peter Marzio,

> I think the key is that, in my experience, most of the people who work in art museums are good people . . . who were [originally] attracted to beauty. And the one quality about beauty is that you always want to share it. This is what I tell the staff. . . . It is fundamental—the minute you see a sunset or anything beautiful, the first human reaction . . . is that you want to share it with somebody, if for no [other reason] than to verify what you're feeling. . . . Too often these outreach programs are seen as threats to the more standard professional profile when, in fact, it's the final step in that job . . . The problem in the art museum is that there's no one speaking for the audience . . . It's the director's job to represent that broad cluster of communities out there, however you want to define them. And [to remind everyone] that they are not a threat. They are, in many ways, the justification for everything else. But, when a new director comes in, I wouldn't necessarily . . . lead with that. What you want to do is embrace what the people are doing, and then what you tell them is "I just want more people to see this. You've done such a great job." And that way it's not a threat. And then, if they say "I don't know how to do it," I'll just say, "Well, you just keep doing what you're doing; let's see if we can't work together to figure this thing out." I've just always found this notion of sharing beauty to be the one constant in the human equation. (Marzio interview 2004)

These are some of the lessons learned from cultural organizations that have planned and implemented incremental changes in their organizational strategies and practices—changes that have steadily infiltrated all corners of the organization and have infused the organization's working culture. Even taking the first steps toward incremental change in the organization requires the considerable institutional commitment of time, energy, and imagination to keep the increased-participation and relationship-building goals at the forefront of the organization's agenda and to keep the commitment to them fresh.

NEW APPROACHES, NEW PROGRAMS

Opening the doors to new audiences and finding new ways of doing business inside organizations do not inevitably result in new kinds of

programs. But that is often the outcome when organizations actively begin to seek out new perspectives and new voices in the process of planning their creative endeavors. Program changes come in many shapes and stripes, and they may be developed to fulfill a particular goal aligned with the organizational culture. Hybrid organizations, such as community cultural centers and arts learning centers, often have participation-building goals in their core programs; others, such as museums, theaters, and performing arts organizations—especially those that are canon institutions founded before the 1930s—need to develop auxiliary or expanded programs to supplement or stretch the projects that define their core. Examples of some of these new program approaches suggest the wide range of ways that different cultural organizations have been creating programmatic change.

Core Programs for Building Participation

Walter Dallas, the producing artistic director of the New Freedom Theatre in Philadelphia, described the theater's strategy of engaging preview audiences in postperformance talk-backs as a way to bring people traditionally relegated to the passive role of "receiving" culture in the theater into the production process:

> What I would do after the show was to say, "Did that particular magic trick work?" or "Did you believe that the table lifted up by itself?" And then someone from the audience might say, "Well, I could see her hands lifting the table, but if the tablecloth were moved this way, it would hide it from the audience." And [at] that moment we would go back to that scene in the play, bring the actors out, go through the lights cue, move the tablecloth as suggested and try that scene again. And then, if it works, it's in the show. And so that person now owns that part of the show. Or, there were other suggestions where we talked about the dialogue: "Did you believe that she would really say that?" or "Do you think that was a true line?" And someone might say, "It seemed that this line worked except for those last two things at the end"; so, we would go back and adjust the dialogue, and we would run the scene with the audience suggestion and incorporate it into the show if it really worked. . . . It wasn't just, "Let's get the audience involved!" These were really issues that we needed help with, and we got the answers from the audience. And what we found was that they knew we were going to use it because we did it right there in front of everyone. Everyone would always stay for these sessions—I mean, the entire audience. No one would leave. And then what would happen is [that] these people would come back and bring their friends [and] say, "This is when it comes to my part." There was a real sense of ownership, literally, that we built with the audience. . . . There are now some people who will only come to the previews so they can be part of that experience. (Dallas interview 2005)

56

In this case, the staff at the New Freedom Theatre developed a new way to work with their audience—involving them as participants in the core activity of producing theater. Performances are staged now as a collaborative effort between the professional staff and a more engaged group of audience members.

Auxiliary Programs for Identifying and Reaching New Participants

The Seattle Art Museum conducts extensive research, including surveys and focus groups, on the needs of the African American and Asian American communities that it has targeted as the new participants it would like to engage. Then, it follows up on that research with the creation of cross-departmental teams who discuss possible program responses. The museum's emphasis has been on slowly and steadily developing relationships that are focused, consistent, and built on trust; and the staff understands that providing relevant programming is part of that relationship-building process (Moreland interview 2005–1). The process of engaging new audiences begins, then, as an auxiliary program at the Seattle Art Museum, led by the community affairs department that itself is an auxiliary component of the traditional organizational structure.

In addition to identifying one or two specific targeted communities, many cultural organizations are also seeking ways to develop crossover programs and audiences. Faced with multiple communities in their local vicinity with many different interests and needs, cultural organizations have recognized that one important new public service they can provide is to build bridges that will encourage connections among these different communities. The Asia Society in New York City created a series of very successful exhibitions geared specifically to the Iranian community, the Taiwanese community, and the South Asian Indian community. But it also planned a memorial service for the 2004 tsunami victims that would address the multiple communities and societies impacted by that disaster, and it produced another program called The Voice is a Sacred Instrument, with four singers from different national traditions. The Asia Society's goal has been to create "organic"—not forced—kinds of crossover experiences (Cooper interview 2005). The staff of the Chicago Historical Society has expressed a similar commitment in developing exhibitions on Catholic Chicago or on the history of teenagers in Chicago since 1900. This latter project was designed

> to take a story of adolescence, and to begin to bring in teenagers to think about history and [to] craft a new generation of audience; but, even more importantly than that, it allowed us to tell stories of race, of gender, of ethnicity in ways that are seen not as "oh, this is a black story, or a Latino

story, or a white story." Rather, this is a story about Chicago, which means that I am suddenly learning that there was a difference between being a black teenager in the '40s and being a white teenager in the '40s. (Bunch interview 2004)

Expanding Programs for Greater Inclusivity

Continuing to "shake things up programmatically," as Arena Stage in Washington, D.C., has tried to do, is not just a commercial, market-driven strategy to be new, different, and entertaining, but a way to respond to the interests of new audiences (Boland interview 2004). There are inevitable tensions as cultural organizations struggle to find a balance between preserving the old and introducing the new—especially in terms of balancing the traditional programming that may be demanded by long-term subscribers and major donors with new programming that expands the artistic repertoire beyond the traditional canon. A feature article in the *New York Times,* "New Overtures at the Symphony," described the variety of ways that orchestras around the country are hoping to appeal to "the neophytes, the dabblers, and mainly the ungray," including preconcert cocktail parties with salsa dance lessons, free dinners, video screenings of classic movies as backdrops to the orchestra performance, and hand-held electronic devices that provide a running commentary on the musical program (Wakin 2005, 1, 24). Such a smorgasbord approach can be gimmicky and distracting, undercutting the core artistic product and experience. But Don Roth, president and CEO of the Aspen Music Festival, who was able to create new programs under the Knight Foundation's Magic of Music grant initiative, argues that this is not necessarily true of all new programs and approaches:

I think I was a more conservative presenter before [the Magic of Music opportunity]. I really became converted to the fact that you could do these innovative things in a way that didn't dumb down the music, but really [allowed you to] present edgier music than the traditional concerts were doing. . . . And the more I studied the history of presentation, . . . how music's been presented, the traditions of when you applaud . . . all of that is all over the map. None of it is the core; the core is presenting music with integrity. . . . Just [as], if you look at a Shakespearian play, you wonder why in the middle of a serious play you have the interjection of this broad comedy? . . . In that historical setting . . . there were people who were not literate, who needed that from Shakespeare. . . . To us, today, it's sometimes a little jarring, and it also makes the plays very long; but that's the context. [Similarly], Beethoven . . . didn't think it was so horrible for people to applaud; [he] would even repeat things in the middle of a concert presentation,

or play single movements. In our society, we've created a sense of high art and low art . . . that didn't necessarily exist [in the past]. . . . The things that Handel was writing were public art. Verdi's operas were popular art and, if you listen . . . to *Rigoletto* . . . and you allow yourself to pull back from the sense that this is grand opera, you can hear how this was . . . written for a public in a way that was meant to be dramatically and musically accessible. It's great music, but it wasn't meant to be worshipped. . . . The Metropolitan Opera in New York was for many, many years supported by working class Italian immigrants who brought the love of opera with them—not well educated, not rich people. . . . We've created a sense that certain kinds of art belong to rich people. And [given] the structure of [cultural] non-profits in the U.S. . . . of course we're highly reliant on the generosity of affluent people, . . . and the economic structure of [many cultural] institutions, such as orchestra and opera companies, requires the price of admission to be very high, [which] is a real disincentive [for participation]. (Roth interview 2005)

The Aspen Music Festival has therefore pursued a strategy of expanding the repertoire and expanding the nature of the concert experience as another means of reaching out to a broader public.

Creating art that engages, enriches, transports, enlightens, provokes, or challenges a wide range of viewers, audiences, and participants is of course at the heart of what cultural organizations seek to do. It makes sense that the programs they offer should be as broadly gauged, flexible, and dynamic as the organizational structures and practices that support them. As the many examples of creative programs and approaches cited here suggest, the range of cultural strategies has never been fuller—and the stakes for cultural organizations to make use of them have never been higher.

CONCLUSION

Some cultural organizations are on the forefront of change; others are taking steps but not yet there; still others are holding fast onto old models and traditions. It is important to recognize that the latter are also firmly rooted in a set of values, and that there are many social and cultural forces at work that make individuals and organizations resistant to change. It often requires powerful external events to push heavily bureaucratized, complex organizations to restructure—an economic downturn that threatens the organization's survival, the arrival of a new director with a mandate for change, or a sudden opportunity created by an external funding initiative. Even faced with these pressures or opportunities, not all cultural

organizations have the capacity or the commitment to undertake the difficult process of change.

The cultural organizations and their staff members who have embraced the multifaceted kinds of organizational change discussed in this chapter as part of the larger project of opening their doors, breaking down barriers, building different kinds of working relationships inside and outside, and reinventing their role as public institutions are not working with a set of clear blueprints. They recognize the need to get more new visitors to cross their thresholds and the need to build the kind of ongoing relationships that will make them want to return; they also share the institutional values that underscore and support this effort. But, as in artistic work itself, they have to engage in creative processes to begin and sustain organizational change—imagining, translating, articulating, and transforming the ideas for change without blueprints or any prescribed models.

Most cultural organizations, including many of those cited in this chapter, begin this process, whether unintentionally or by design, in incremental ways. But organizational change is not always slow, careful, and the result of a fully rationalized planning process. A more dramatic case of radical change in the structure and culture of an arts organization can be seen in the case of the Glenbow Museum in Calgary (Alberta), Canada, which, when faced with severe financial cuts to its budget, a top-heavy management structure, and general organizational drift, underwent a radical transformation in the early 1990s. A full account of this experiment in radical organizational change in an established, canon institution is provided in Robert Janes's 1997 book, *Museums and the Paradox of Change: A Case Study in Urgent Adaptation*. Radical, transformative change, in this case, was led by a visionary director and a staff willing to take risks, beginning with the premise that the organizational traditions upon which museums were founded are increasingly unable to address contemporary social issues and community concerns.

In contrast to their traditional role as stewards of culture, the Glenbow staff engaged in "upside-down thinking—or thinking the unthinkable" (Janes 1997, 115–116) to shake up the status quo, encourage a new sense of public responsibility and ownership, and, in the process, to unleash the creative potential of the organization, its staff, and its community participants. They reenvisioned the museum as a "learning organization" with a formal commitment to cross-functional, project-based teamwork. They developed a "museum school" in which teachers moved their classrooms to Glenbow for a minimum of a week to engage students in learning critical interpretive skills and engaging in exploratory, hands-on projects with the collections. They developed community-inspired exhibitions, such as Healing Legacies: Art and Writing by Women with Breast Cancer,

which was curated in close collaboration with nine community agencies and drew an audience of sixteen hundred on its opening day (Janes 1997, 243–249). By 1995, in the midst of its transformation from a traditional canon museum to a more interactive museum/community center, 52 percent of Glenbow's operating budget was based on earned income, higher than any of the top ten museums in Canada (Janes 1997, 211). The Glenbow staff committed themselves to new commercial activities, such as facility rental, that could produce more revenue and move the museum closer to the long-term goal of sustainability. They have continued to experiment, to work collaboratively with their own staff and with multiple external communities, and to experience successes and failures in their programs, which they see as an important part of their learning environment. In these ongoing efforts, the museum offers a potent example of what's possible when complex cultural organizations take the risky and difficult steps of creative rethinking and reinvention of their core goals, purposes, and practices.

Among the many insights gleaned from the wide range of cultural organizations and their staffs that have guided our research, the perspectives of three directors serve as appropriate summary comments on the challenges and the opportunities of organizational change. Robert Janes, the president and CEO of Glenbow, who oversaw the museum's comprehensive organizational change project from the beginning, argues that "[organizational] adaptation requires at least two related types of behavior—freeing one's self from tradition and redistributing power and privilege" (Janes 1997, 221). Freedom from "the tyranny of tradition" does not mean jettisoning all professional standards and practices. Rather, it means the willingness to rethink everything—even, for example, questioning such "sacred" elements as the museum's permanent collection, to ask if it is still a viable and effective means of providing meaning and enjoyment for visitors. A redistribution of power would also change the nature of the cultural organization by "mak[ing] each staff member responsible for the organization's culture, responsible for delivering meaning and value to our customers and supporters, and responsible for the quality of their own experiences. . . . Ultimately, the redistribution of power and privilege must be seen far beyond the organization—in the communities where we work. . . . Simply put, patriarchy and control foster isolation; while individual responsibility and stewardship nurture the web of community relationships" (Janes 1997, 226).

Janes's analysis of the change process at Glenbow includes the devolution of power that accompanied this major effort in organizational restructuring. The challenge to traditional organizations with power invested in their boards and managerial hierarchies is a profound one, particularly as

other voices within the organization and in the communities they serve seek to be heard.

Kathy Halbreich, former director of the Walker Art Center, argues that the ideas and momentum for change often come from young people who "are not beholden to the truths that precede them." She sees innovative institutional change as the natural complement of the global influences that have opened up the art world to a broad and diverse set of perspectives and that call for a fundamental change in the role that a cultural organization can play:

> I think, in a certain sense, we can be a platform for learning about and engaging in different values. And there are not that many institutions in our communities where that is possible and actually central [to the organization's mission]. . . . Our role [unlike other civic institutions that speak about one thing] is to speak about multiple things. And that, for me, is what [defines] the gigantic challenge and the gigantic pleasure of . . . all cultural institutions. (Halbreich interview 2005)

And, from the perspective of Umberto Crenca, artistic director of AS220, the artist-run live/work/exhibition/performance space in Providence, Rhode Island, there is the reminder that cultural organizations are ultimately about human relationships:

> Every single person who has participated here for any extended period of time has defined a piece of AS220 in some way. That's what it's about. That's the building process. That's what sustains the organization. It ain't the four walls; it's not a building. You know, it's about the individuals and the people who we are challenged, always, to figure out how to accommodate. And once they're accommodated and they grow within this institution, they inevitably have some defining role in the future. And . . . that's the only way we're going to stay current and vital, you know. That's the magic . . . that's the formula. So I could name, literally, . . . probably a hundred people off the top of my head who were significant [to the building of this institution]—and some of them have been my biggest critics and the organization's biggest critics, the most difficult, crazy people on the planet who have had an enormous influence and impact on defining this organization. (Crenca interview 2005)

These are only a few examples of the new ways of thinking, practical approaches, and painstaking processes that are driving change inside many cultural organizations today. Cultural leaders and their staff and community collaborators in the change process recognize that change is now the norm—that cultural organizations and the whole cultural field cannot remain static in the face of broader patterns of social change. They will need

to work creatively to build organizations that are institutionally flexible and agile if these organizations are to remain robust and relevant. In an era in which many individuals are now actively engaged in creating their own culture through appropriation, remixing, and "mash-ups" that combine existing things to create something new, organizations are also in the process of re-creating their own cultures through a creative remixing of new practices and programs. The project of crafting a new kind of organizational culture and new ways of doing business is still very much a work in progress, which is hardly surprising given the range and complexity of cultural organizations and the issues they face as they seek ways to build participation.

This chapter has explored many of the structural changes going on inside cultural organizations as a result of their multiple efforts to reach new participants and their continued efforts to engage previous patrons. Such changes are most likely to become institutionalized—that is, embedded within the organization and capable of being sustained—when they are intentional and deliberate. In the next chapter we turn to the question of the leadership that makes change possible—where it is located in the cases of several exemplary cultural organizations and how such leadership has worked to help build greater participation.

3　Leaders Bridging the Culture Gap

D. CARROLL JOYNES AND DIANE GRAMS

As arts organizations large and small seek to increase the size and diversity of their audiences, they discover not only gaps in their rosters of enlisted supporters but something much more substantial: a culture gap. This is the difference between what the institution has traditionally done to engage audiences and what it needs to do to attract new kinds of participation from its community. Leaders are challenged with identifying ways to bridge this culture gap. Who in fact are these leaders, and what role do they play in the process of building, sustaining, and institutionalizing relationships with underserved communities? In this chapter we focus on the successes and challenges of such relationship-building efforts; we also see how these relationships can turn into transaction-building memberships and ticket sales. We examine how leaders at four canon institutions bridged the culture gap as they worked to build new and expanded relationships with their local communities, and how executive leadership, middle management, board members, and advisory board members each played different and important roles in the effort. Although some organizations may encounter external resistance to their revised organizational missions, the accounts in this chapter alert us to the kinds of entrenched resistance from within the institution that leadership may also face in the process of change.

Although often located in the executive suite, leadership to build audiences might also be found within the board of trustees, in the ranks of senior and middle management, among program staff, or with community advisory boards. In the cases we present here, change is not the result of a single leader working alone; it is a process that is directed by more broadly distributed leadership within the ranks of the organization. Whether the job is done by a "change agent" who introduces new steps, or a "continuity agent" who affirms past commitments with updated strategies, such leaders distribute both the necessary vision and the authority among their

colleagues and support staff, who in turn, integrate new practices and new audiences with the old ones. Over time, distributed leadership helps to institutionalize the practices of participation building. In the most successful cases, these values and practices come to be shared by all staff and volunteers, and the interactions that develop with a broad range of local constituencies become part of the sustainable fabric of the institution.

Four canon institutions—the Museum of Fine Arts, Houston (est. 1900), the Art Institute of Chicago (est. 1879), the Newark Museum (est. 1909), and the New Jersey Performing Arts Center (est. 1988)—provide the case studies for consideration in this chapter of how relationships are built with new or formerly excluded groups. Canon institutions, as referred to here, were historically established according to the conventions of European "high culture." However, these four institutions have since come to consider the broadest spectrum of their racially, ethnically, and economically diverse local populations as among their core constituents. They are each found in urban centers having 50 to 80 percent of their total city populations comprised of traditional minorities—that is, African Americans or Latinos (see figure A.1). Juxtaposing the efforts underway in these institutions provides insight into how leaders respond to diverse groups in their local contexts and how they distribute leadership within their own ranks and through their communities.

THE MUSEUM OF FINE ARTS, HOUSTON
When a Chief Executive Officer Guides Change

Leadership to build new audiences can come from the office of the chief executive, as Peter Marzio demonstrates at the Museum of Fine Arts, Houston (MFAH). His commitment to building a more diverse body of participants was carried out through a twenty-five-year expansion project that began with the notion that the museum could and should be relevant to the daily lives of the people of Houston. What distinguishes this expansion project is that it was designed to include all of Houston, not just its elite communities. When he came to Houston in 1982, Marzio brought a vision that would redefine the institution and its relationship to its community:

> Having watched [token efforts to engage diverse audiences in the arts] throughout the late '60s and early '70s in Washington, D.C., and elsewhere, I just decided that, if I ever had the influence, what I would try to do is deal with the nature of art itself and what institutions were promising to deliver. That was the only way I could imagine there being true participation— meaning long-term—and making it a habit of people's lifestyles to include the art museum as part of their . . . overview of things that are desirable

in their communities. When I started here in 1982, Houston was kind of the ideal place for it. . . . The institution was having financial difficulties and relatively low attendance. About three hundred thousand people were coming [annually] and, when we did the first attendance profiles, it was like what you see in most art museums: [the audience was] older, white, upper-middle class, and more women than men. I think it's a pretty standard portrait, and we were no different than anyone else. And we just decided that we were going to change that, and we were going to try to do it from the ground up—meaning the art collections themselves, the boards of trustees themselves—and begin to define the institution in a broader way so that it would have a future. [We wanted to be different from] a lot of museums in the Northeast and in the Midwest where you had these great museums, which were sort of dying because they were dealing exclusively with certain kinds of art, or their boards were one color and the city was another color. And, you know, the institutions weren't relevant to the communities that made up their area. What you wound up with were these white institutions in a colored sea, and it just [didn't] work. (Marzio interview 2004)

In his view, leaders have to approach change by addressing the actual and potential resistance from within and from outside the institution:

The key was to [initiate change] in such a way [that] it wasn't threatening to the people who were already here at the museum, letting them see that broadening the institution wasn't taking anything away; it was adding to the institution and making it richer and more fun. There were a lot of skeptics. The notion that almost any art form can include all races is not an easy lesson to learn. You're not taught that way in school. Art history tends to be pretty clear cut in its exclusions. So, even among learned people, you really had a lot of built-in prejudices to fight. (Marzio interview 2004)

Marzio is one of the few leaders we interviewed who has been in place long enough to see the full-scale transformation of a canon institution. The MFAH had once existed as an essentially segregated entity that allowed minority communities only limited hours of access; today it is a museum that values and represents the full range of racial and ethnic diversity found within the geographic area it considers to be its community. This core value of inclusivity permeates its administrative leadership at all levels and in every department from curatorial to security. But how was this accomplished?

Distributing Leadership through Engaged Staff and Volunteers

Beth Schneider, former director of education at MFAH, has worked closely with Marzio, and she pointed to his leadership as the main reason

she stayed at the museum for more twenty-three years: "Peter is . . . the brains, the ingenuity, the creativity behind all this; he's the one who sets the tone." Few museum directors have been involved in nearly every hiring decision at the institution. According to Schneider, "Peter is a great populist in the best sense of the word, and he sets very high standards for quality, everything from the art to the work that people do" (Schneider interview 2004). Although Marzio provided the core commitment to building participation, his approach has been to distribute leadership, letting others like Schneider and even the youth docents be exemplars. According to Marzio, a classic example of youth leadership was seen in one of the museum's teenage docents.

[This young man] volunteered on Thursday night when we have high school students give tours to young students. They think it's cool when they see a high school kid taking them around. It turns out he's one of the really bright kids in the school. We were so taken by him and his attitude that when we broke ground for our new building in '98 or '99, we asked him to give a short speech about his experience at the museum and what the new building would mean. And he gave this incredible talk [in which he described one of his tours]. I mean he talked about how he got off on our collections from the nation of India. And he was talking about these various figures, you know the ones with multiple arms, and . . . when he does his tour, [he noted how] everyone's very polite until we get to this figure. "It's a big bronze figure," and he said, "I'm trying to explain to the kids that [the sculpture is showing] movement by having lots of arms, that it's almost like stop action photography." And then he said, "What we then do is we all stand on one foot with the other foot folded and we wave our arms up and down like the sculpture." I mean [he] just turned the art into really meaningful stuff. [He shared] thoughts that were actually so sophisticated that most of those people sitting in the audience hadn't thought about it. So, in an odd way, he was teaching them at the same time. (Marzio interview 2004)

From the beginning, Marzio had a very clear idea of what he wanted and what he needed in order to transform this cultural institution. Unlike some directors who have to struggle with entrenched municipal forces and institutional structures, Marzio had no such constraints in Houston. The "small government" approach of Houston's politics, coupled with the lack of entrenched interests from strong labor unions or academic traditions that might have resisted increased participation from Houston's extensive middle-class African American and Latino populations, combined to make the realization of Marzio's vision possible.

Tapping into Diverse Tastes

The innovative organizational practices designed to reach new audiences have spurred the museum to reinvent itself. Yet Marzio and his staff have deftly linked the new practices to the museum's past. As Marzio points out:

> Let's face it—more than half of what we do is very traditional. I mean you know, we have one of the best curators of European art in the world, and we have easily the best photography curator. So, . . . it's not that it's all this new [way to do business], but I'd say about half of [it] kind of rattles people that way. (Marzio interview 2004)

An example of this is the theme that guides the MFAH's diversification efforts—A Place for All People. The motto is said to be etched on the original building cornerstone and was the product of efforts by the founding society women who were more interested in cultural education programs than in amassing collections. Marzio has used these founding principles of the museum to reinvigorate the museum's core educational mission, and he then recruited Schneider in 1984 to lead the education department. These efforts were consistent with the work we observed of other directors nationally, as exemplified in the national task force involved in drafting the report "Excellence and Equity: Education and the Public Dimension of Museums," first released in 1992 by the American Association of Museums. This report emphasized the "expanded definition of the museum's educational role that involves the entire museum" and is based upon the principles of public service, inclusivity, and leadership from both inside and outside the museum. The motto "A Place for All People" was spotlighted in MFAH public programming in the early 1990s, and the motto has since been embraced as an enhancement of the museum's core mission.

Rather than leading the museum toward having a single specialty and identity, Marzio wanted the MFAH to offer a rich array of experiences that would attract new, more diverse audiences and tap into the increasingly diverse tastes of traditional audiences. These new "omnivore" tastes are increasingly characteristic of contemporary fine arts audiences. Marzio envisioned a museum that could attract and represent just such diverse tastes.

> I get excited by the mix. That's what drives me.
>
> PETER MARZIO

> The standard theory is that, if you specialize, you can become known for being really great at one thing, and the world will beat a path to your door. . . . And I respect that. But . . . I want [our museum] to be an institution that has a lot of great things, [so] that, at different times, you might have different reasons for coming or there might be different people here at different times. . . . I get excited by the mix. That's what drives me. It's that you

never quite know. Even in our exhibition scheduling, we use a magazine format, so that . . . there might be one article in the magazine [that is] the reason you bought it, but then you're going to go through other articles simply because they're there. And that's the same approach that we use in the museum. . . . You almost have to trip over [the exhibits when] you're going to the original reason why you came. (Marzio interview 2004)

The clarity of Marzio's vision has transformed the museum into a place for diversity not only in terms of its visitors but also in the way the collections are interpreted. As a leader with a vision, he brought in some unconventional ideas that helped transform traditional curatorial practices. For example, in one exhibition, he asked that local residents work with curators to write wall labels for the art. The museum invited community leaders, politicians, physicians, bankers, clergy, and educators to study their favorite works in the collection and share their ideas by creating the wall labels. This project is exemplified in the wall label for Mary Cassatt's painting *Susan Comforting the Baby* (c.1881), with text written by Booker T. Wright Jr., M.D. In this case, Dr. Wright foregrounded the issues of race and class—evident to him as a viewer, but rarely mentioned by art historians in critical analyses of the painting (figure 3.1).

3.1 Mary Cassatt, *Susan Comforting the Baby,* c. 1881, oil on canvas.
Museum of Fine Arts, Houston. Gift of Audrey Jones Beck.
Used by permission.

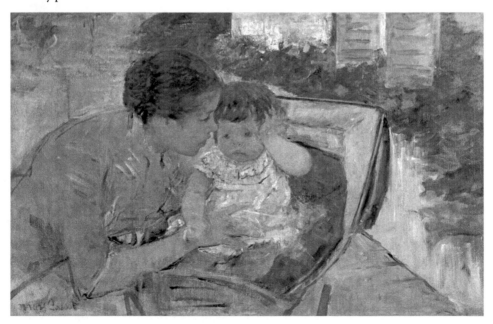

Mary Cassatt was born just about one hundred years before I was, and this painting is more than one hundred and ten years old. To me however, the painting is both timely and sensitive. The subjects are Susan, a woman who babysits an infant, and the baby itself, most likely belonging to an upper-class family. The scene is probably in Paris since the artist lived there during the years that the painting was completed.

Personally, I have known many women who have worked in similar fashion as Susan, and, therefore, there is nothing of majesty or singularity about the painting. It is of note, however, because it depicts people in an everyday setting, one which would be quite common today.

My eye is drawn to the baby, centrally placed in a light-colored dress. She has undoubtedly just awakened from a nap in the garden of the home. I identify, however, with Susan, even though she is apparently of less importance to the artist, evidenced by the drab-colored and ill-defined clothing and her face turned away from the viewer towards the unnamed child.

I am taken with the artist's use of definition in the faces and the lack of definition almost everywhere else. As an amateur artist, I note the contrast in the definition of line along Susan's face with the lack of line and lost borders between Susan's thumb, hand, and the baby's hand.

To me, this painting is about the elite and the working class, about the very young and the young, about a mother and child, about a woman and an infant. Even though a hundred years have passed since this scene occurred, it would not be unusual in Hermann Park.

I imagine how surprised Ms. Cassatt would be to know that women have orbited the earth in spacecrafts and have been elected leaders of some of the most popular and most powerful nations on earth.

By Booker T. Wright, Jr., M.D., orthopedic surgeon. From the exhibition Call and Response 2: The Artist and the Museum, essay published in the catalog *A Place for All People,* 1998, Museum of Fine Arts, Houston (Schneider 1998).

This exercise helped to rebalance traditional aesthetic standards of excellence with ongoing sensitivity to the staff and the target audience, both of which struggled to learn new language and social skills that would enable them to navigate the museum together. With a doctorate from the University of Chicago in art history and American history, Marzio had the credentials and authority to guide curators through the process of learning new skills to produce exhibitions and interpretative materials that were relevant and understandable to the new audiences he hoped the museum would engage. What made the task easier was that Marzio ensured it was a project (and sometimes a struggle) that the entire museum staff

and board shared. The activity of having community members become involved in exhibition production, through focus-group research and as guest "curators," has proven fruitful. Since cultural canons are the product of academic traditions, which by their very nature are meant to transcend local community concerns, what Marzio accomplished by involving local communities and local people at the level of producing knowledge seems particularly noteworthy.

Serving Diverse Tastes

The MFAH also implemented a number of interesting strategies to engage the Hispanic and African American populations in Houston. Although the museum carries out a wide range of daily programs, according to Schneider, the core program has always been assessed by what is actually up on the walls:

> People see the main business of an art museum as putting art on the walls, putting up exhibitions. . . . You can have the best family programs, the best school tours, the best lecture series, and that's important; but people see putting art on the walls as the core mission of art museums. And when you put on the wall art by people that they know or that they care about, you are bringing them in to that core activity in a way that little else does. It's also not quite as temporal. That is, a program lasts an hour, two hours a day and then it's gone; an exhibition may come and go but it's going to be up there for two to three months or maybe longer. And anybody that comes in, at any time, can participate in it. (Schneider interview 2004)

The staff's investigation of community preferences for types of exhibitions led to some surprising results:

> We learned that when people say they want to see art from their culture in the museum, museums don't often know what that means until they talk to the audiences. So, for the African American community, they didn't want to see African art specifically, they wanted to see African American art; and often they wanted to see things that were very specific—things created by African American artists living in Houston whom they might know. With the Latino community, we found that there wasn't an interest in pre-Colombian art, but there was a big interest in Renaissance and Baroque art with a religious theme because that was a part of [their] day-to-day culture. We learned that exhibiting art by students and by local artists is one of the best ways to make communities understand that we really care about them. (Schneider interview 2004)

Such knowledge has informed the museum's acquisitions, exhibitions, and programming. Each of these areas is planned in direct response to

71

an understanding of local demographics and of preferences identified in focus groups with members of the museum's target groups. Through such practices, the "culture gap" that was once evident at MFAH has begun to be bridged. One major initiative has involved the museum setting its sights on becoming the premier institution nationally for contemporary Hispanic art. Under Marzio's leadership, the MFAH created an entirely new curatorial department that was designed to collect and interpret Latin American art. The department became the International Center for the Arts of the Americas in 2001. Mari Carmen Ramirez was hired as the Wortham Curator of Latin American Art and the director of the center. To establish such a permanent position required no small commitment. At a minimum, an organization must guarantee a permanent salary for a curator, as well as providing the support staff, space, and acquisition resources, all of which can require the income generated by a five- to ten-million-dollar endowment. Moreover, the institutional commitment must cross all departments, including building, storing, and conserving collections, mounting exhibitions, and publishing research, because all of these activities are called upon by the curators. Along with these commitments, the MFAH was also committed to producing extensive bilingual programming, including establishing a bilingual Web site and hiring bilingual guides and teaching staff. By emphasizing continuity in its traditional practices along with innovation, Marzio created stability for the institution with enough change to make the museum "a habit" in the lives of Houston's citizens. Such a policy has gone a long way toward redressing the cultural organization's history of exclusionary practices with its very diverse community.

Gaining without Losing

Marzio distributed the leadership for this major institutional shift by introducing new daily routines and creating space for new activities. Equally importantly, he encouraged involvement by members of the board and its many different committees. According to Marzio, "as [an idea] goes through the different committee structures, what you're doing is . . . getting people to embrace this idea; and if it's really going well, it becomes their idea. So, by the time it gets to the final step, maybe half of your fundraising is done and you haven't mentioned a word yet about fundraising." The result is gaining something without losing anything.

> When we say "a place for all people," which is our marketing theme, it's real! And the real test was at the board level and the museum has just handled it really, really well in terms of going from a segregated city where there were separate visiting hours for black people in the '40s (and earlier)

here in the museum. . . . Now, we have board meetings [involving] a really mixed group of people racially [who] . . . all tend either to have access to money or have money. (Marzio interview 2004)

Marzio emphasizes the essential role board members have played in planning and fund-raising efforts for this private cultural institution. Diversification of its board has not meant loss of revenue or donors: "If you lay our numbers out and look at them, there aren't too many institutions that have grown the way we have, both physically and financially" (Marzio interview 2004).

Indeed, the figures are a testament to the museum's success. Since the beginning of Marzio's tenure at MFAH in 1982, the museum's operating budget has increased more than tenfold, from $4 million to $40 million in 2004, with total contributions topping $262 million in 2004. Contributions increased an average of 16 percent a year between 1999 and 2004, even before a major bequest, which subsequently raised this average figure to 84 percent. The museum showed similar sustained growth from program and membership revenues, with a 14 percent average annual gain. It has doubled its space from 227,000 square feet to 532,550 square feet by adding five new buildings. Participation has grown from roughly 300,000 in 1982 to an estimated 1.8 million participants in its combined museums, sculpture park, and art school facilities by 2005. An additional 700,000 people participated in its off-site programs in libraries, hospitals, public schools, public parks, and other community venues.

THE ART INSTITUTE OF CHICAGO

When Middle-Management Employees Guide Change

At the Art Institute of Chicago (AIC), the effort to broaden and diversify participation was carried out through short-term, auxiliary programs initiated by the education department. Leadership came from a team of middle managers but was implemented with the political and financial support of the museum director, board leadership, and an advisory committee comprised of some of Chicago's wealthiest and most successful African American leaders. The strategy to engage more African Americans began in the early 1990s with a rethinking of the ways that the Museum's collections were and were not being used, and how exhibitions were selected and planned.

The Art Institute of Chicago is the oldest among the institutions examined in this chapter; it also has the largest budget. Its overall revenue in 2004 was reported at $197 million, which encompasses the $77 million budget of the School of the Art Institute, the museum's $38-million operating budget, and a number of smaller programs. Its total contributions

73

have seen only a small average annual increase (1 percent) over the five-year period from 1999 to 2004; yet its program services and membership combined have increased on average by 10 percent annually during the same period. With tuition revenues from its renowned art school included in its reported program revenues, the percentage of its earned income (46 percent in 2004) typically surpasses contributed revenues (31 percent in 2004). The Art Institute of Chicago ranks in status among the top canon institutions in the country. As a survey museum, its collections and disciplinary breadth cover nearly every significant phase of art history. It currently has more than one hundred disciplinary, collecting, and special interest committees and support groups.

Examination of the Art Institute's efforts to increase the participation of African Americans in Chicago from an estimated 2 percent of its total audience to 10 percent demonstrates how a complex canon institution can build participation primarily through its auxiliary programs. These programs were developed through the museum's education department rather than through a strategy embraced across departmental boundaries and throughout the organization's core programs. It also illustrates the pivotal role that middle management and support staff can play as change agents in firmly established and well-endowed institutions. The middle manager's role, which often entails "managing up while managing down," requires skillful and sometimes politically difficult interactions with the executive director, board of trustees, and other senior staff and as support personnel.

Experience Meets Academic Credentials

The managerial team was led by Ronne Hartfield, executive director of museum education. Hartfield served in this position from 1991 to 1999 after a noteworthy career that included earning academic degrees in history, theology, and literature; an appointment as professor of comparative literature and dean of students at the School of the Art Institute of Chicago (1974–1981); and founding and serving as the executive director of Urban Gateways (1981–1991), an award-winning Chicago-based arts education program. Like Schneider at MFAH, Hartfield's position at AIC was based in the already well established education department, which had expanded by the early 1990s to carry out a wide range of community-engagement goals, including more involvement by teachers, local artists, and surrounding ethnic communities. Among these goals was a major effort to increase African American participation at the museum. Despite her academic credentials and arts administration experience, Hartfield recalled that, among the some of the staff at the AIC, her background had "no currency."

I don't have a degree in art history. That is a big negative. . . . However, it was a challenge that I had to overcome. The museum likely couldn't have hired somebody [having my community skills] with a graduate degree in art history because black people don't go into art history in general. . . . If [institutions] want to change, they're going to have to take somebody who's somewhat nontraditional. (Hartfield interview 2004)

Ronne Hartfield's role before and during her tenure at the Art Institute was as a national figure who focused on bringing more African Americans into the field of art, as well as facilitating the expansion and dissemination of historical knowledge about the artwork of African Americans. This was an area in which there was growing interest, but still limited knowledge. Although she did not have conventional credentials in art history that usually conferred authority at the AIC, she was authorized to initiate and carry out some new initiatives. The authority to do so was granted by the museum's director, James Wood, and key members of the board of trustees, including the board's chairman Marshall Field IV. Hartfield was also given legitimacy as a change agent when the AIC Women's Board permanently endowed her position. Her position grew stronger as she brought in substantial foundation support for the new initiatives. According to Eileen Johnson, a member of the newly established African American Leadership Committee, there was also substantial support from the African American community for the change project that Hartfield was preparing to lead.

This was really important in a large urban center. . . . Most [other institutions receiving grants to diversify their audiences] were small, [but] this was an old and wise institution. . . . It was so natural for [the AIC] to address the inclusion of this minority group for all kinds of different reasons: from good public relations to political reasons, to tax reasons, to half a dozen others. And [getting a grant] was kind of a goad to do it now. I think that, in terms of the volunteers on the [Leadership Committee], their general reaction was that they were doing something to actually make this a reality—that is, greater inclusion of their community, our community, which was the black community, into the activities of the Art Institute, [a place] from which we derived so much pleasure. They represented, I think without exaggeration, symbols of the leadership in [Chicago's] African American community. They were very, very interested in advancing education and advancing involvement of our community in its primary cultural institution, the Art Institute. (Johnson interview 2004)

Even with such broad political, financial, and community support, there were still practical and strategic decisions made by Hartfield that could not please everyone. According to the strategic plan *ReFocus/ReSources*

Initiative, drafted in 1990, AIC sought "to increase the number of middle-class African American visitors and members to the museum" and "to engage and involve African Americans in the life of the museum"—a plan that meant establishing both new relationships and new financial transactions. The decision to focus on the middle class rather than the poor was challenged by some members of the African American community, but it was encouraged by others as a strategy to reach both transactional and relational goals:

> I thought we should start with the more privileged African Americans, that is, the community which would be most likely to become members. That got us a whole lot of flak, just saying that. Some people asked "What about the poor?" You know, and I said, we've got five years here. . . . We can work marginally with the poor, but our major efforts have to be [aimed] at people most likely to join. In other words, you have to be realistic and very clear about who your target audience is and how you are going to attract them. You can't do everything, and you can't do everything at once. (Hartfield interview 2005)

> You have to be realistic and very clear . . . You can't do everything, and you can't do everything at once.
>
> RONNE HARTFIELD

Hartfield's approach was smart, practical, and successful, but not easy. African Americans made up a large group in Chicago and possessed a significant portion of the city's wealth, but, until this effort, AIC had not aggressively sought their sustained involvement. Research conducted by an African American communications group as part of the museum's ongoing planning and assessment efforts showed increasing awareness and visits among the African American audiences that the Art Institute sought to engage. It showed that 80 percent of those surveyed intended to visit the AIC in the coming year, and it revealed "no strong barriers to visitation"—just that they "needed to be motivated to visit." The Leadership Committee played a critical role in identifying how the African American community could best be reached. According to Johnson,

> "How" [to market to the African American community] was certainly influenced by the Leadership [Committee]. In other words, the [Committee] was being responsive to questions of "how do we reach your community?" And some of the answers definitely had to do with our churches. Some definitely had to do with organizations within the community which would not be as well known in general. I think that this query and this dialogue, which was ongoing with this committee all along, was extremely important in advancing the agenda [of the museum]. (Johnson interview 2004)

The research also pointed to a range of exhibition and program offerings that would be relevant to that segment of the African American population the organization was most interested in reaching. Yet pursuit of these exhibitions and programs involved collaboration and consensus with the curatorial and membership departments, both of which were outside Hartfield's authority, and this limited what could actually be accomplished.

Through the process of initiating this change effort, Hartfield discovered a cultural gap between the AIC's program offerings and the abilities and interests of many of her colleagues, particularly in terms of the knowledge of African American contemporary art that existed in the institutional field. This culture gap was one of the dilemmas that Hartfield and other change agents in canon institutions have continued to face. Does the institution seek to make its existing collection or repertoire relevant to different audiences, and, if so, how? Does it, for instance, begin where the MFAH did by using nonacademic language on wall labels in order to make the knowledge it has more accessible and relevant to its audiences? Or should it fundamentally alter, at least in some ways, what it does in order to reach these new audiences, as MFAH did in building its collections of Latino art and hiring a curator with expertise in the academic canon where Latino art is found—in the "Art of the Americas"? There is, it appears, no single correct path to follow. It is clear from Hartfield's account, however, that the tack taken at AIC was not one of an institution-wide reenvisioning of how it would henceforth do business. Rather, this team of mid-level staff members undertook a series of short-term projects to test the extent of involvement possible.

One such project involved using the museum's collections to develop curriculum for social studies and visual arts teachers in inner-city schools.

> I got a grant . . . to bring in all these teachers from inner-city schools [but] my staff said, "I can't do it. It's too much work, I'm already snowed under, I can't do it." So I hired a woman from outside to do it. She was an incredible teacher, and she loved the idea of this project. My staff gave her such a hard time. They put up such a [fuss]; they would not help her for one second. She used to come to my office in tears over the simplest things like letting her use phones, things like that. It was just subversive resistance. But, halfway through, we're close to the end of the [first] year, two of my staff said "We want to do this project now; you can fire her now. We want to do it, we've got time now. . . . [and] you know, she's taking up space we need for other things; she's taking up funds." I said, "I'm sorry—she's hired for two years." And that was that. (Hartfield interview 2005)

Because the change project was located in the education department and led by mid-level staff, this kind of resistance persisted relatively

unchecked as the team introduced new programs and projects. Repeatedly, Hartfield heard from curators that the requisite "knowledge" apparently did not exist to bridge the culture gap. This was particularly evident when Hartfield undertook efforts to bring an exhibition to Chicago of work by Horace Pippin, a self-taught African American folk artist:

> It was a borrowed exhibition, so all that needed to happen is to have the director of the museum give the OK—and all we have to do is buy it—a curator doesn't have to work for three years to [actually] make it. . . . So, in the end, the director [Wood] decided we are going to move forward with this. Now the head curator for twentieth-century art did not see this as a priority for his attention. Who is Horace Pippin? [he asked]. No one on the education staff had ever studied African American art. Not one of my lecturing staff, my teaching staff, nobody had ever heard of Horace Pippin. So the issue was [why is] all this space is being given to somebody that nobody's heard of? (Hartfield interview 2005)

Hartfield was able to push ahead because she had the grant money and support of the AIC's top leaders to do so. What renders this story even more complex is the issue of the kind of exhibit that was being proposed. In this case, it was African American folk art—a genre of art more likely to be collected by white art collectors than black art collectors (Fine 2004)—resulting in a situation in which there was not a readily available cohort of black art collectors who could be involved in supporting the exhibition.

This example speaks to the larger dilemma, as expressed by Julia Perkins, then the director of community programs: Was it her job to focus solely on targeting the African American community? Or could exhibitions of particular interest to African Americans also be of interest to others? As a member of the education department staff she asked, "How can we programmatically insert a 'voice of color' into the discussion from the outset? Or do you just have exhibitions about [and for] that community?" (Perkins interview 2004).

One of the real hurdles in any change effort can be seen when an underrepresented art form—in this case, African American art—is inserted into the traditional canonical framework where, if it had previously appeared at all, it was in a subordinate status to European art traditions. According to Hartfield, addressing this issue posed an even greater challenge than segregating the work in separate exhibitions. The staff faced a conundrum: "What were we to do? Have smaller exhibits for African Americans on the margins of the museums, or bring them into the major exhibitions in a creative way?" (Hartfield interview 2005). The dilemma is exacerbated when artistic reputations are based solely upon race. Leadership Commit-

tee volunteer Johnson pointed out that many African American artists want recognition as artists without reference to race or ethnicity:

> An artist is an artist of certain proficiency, whether he's black or white. And I think that many of the outstanding black artists would prefer not to be known just as a black artist, but as an artist, as a very fine artist, and an achieving artist. . . . It's great to be heralded in your community, and I don't think that any artist disdains that. But I do feel that artists want to be known, not just with the signature of their kind. . . . I think that to be an artist is what we're trying to achieve. . . . Inclusion of black art in exhibits is one step toward that goal. (Johnson interview 2004)

As Johnson's comments suggest, cultural organizations face a challenging task when they set out to incorporate an ethos of equity and inclusion into institutions with well-established traditions around the canons of artistic "excellence," and to find a reasonable path between marginalization and recognition.

Seeing Results

Despite the challenges involved in launching this change project at the Art Institute of Chicago, we found substantial evidence of increased participation among African Americans and a sustained commitment by the AIC. Over the decade from 1990 to 2000, African American attendance at the museum rose from 2–3 percent to 6 percent of the total annual admissions. Seventeen black-themed exhibitions were mounted; three of those attracted a total of 150,000 visitors, 48,000 of whom were reportedly African American. Targeted programs and special events included up to four educational programs annually and up to five performances held in conjunction with exhibitions that attracted an estimated 17,000 African Americans. The AIC enhanced its African American collection by acquiring a total of fifty-one objects, including a much-publicized daguerreotype by Samuel Miller of abolitionist Frederick Douglass. Among its other acquisitions were works by a number of both self-taught and institutionally trained, African American artists, including Kerry James Marshall, Marion Perkins, Archibald Motley, Kara Walker, Carrie May Weems, Roy DeCarava, Jacob Lawrence, Martin Puryear, Dawoud Bey, Rashid Johnson, and Charles White.

Hartfield raised the funds to cover costs for several two-year curatorial positions designed to mentor African American curators, all of whom subsequently landed significant positions at other institutions. Museum memberships of African Americans more than tripled, from an estimated 2,000 in 1990 to 6,100 out of an estimated 100,000 members in 1999.

Although Hartfield and other key staff have now retired or moved to new positions, the efforts to build participation at the museum have continued. Most notably, the African American Leadership Committee continues and has been a model for similar committees in twenty-eight cities, including New Orleans, Baltimore, Norfolk (Virginia), Milwaukee, Detroit, and Houston. This has also led to the establishment of the National Alliance of African and African American Art Support Groups, formed in 1998.

The examination of the Museum of Fine Arts Houston and the Art Institute of Chicago shows how such institutions have carried out change projects that are responsive to the interests of the diverse audiences they seek to serve. Whether led by middle managers or chief executives, these efforts have had to account for the breadth of the culture gap that exists not only in their own institution but also in the field. Leaders may face many instances of organizational resistance if they try to distribute leadership for change more broadly throughout the institution. But what happens when such institution-wide change is *not* necessary? In the study of two cultural organizations in Newark, New Jersey, we see how founding missions that were focused from the beginning on serving the

3.2 New Jersey Performing Arts Center (NJPAC).
Photograph by Timothy D. Lace © 2005.

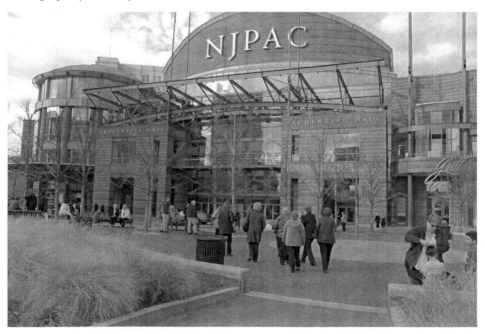

diverse populations within their local communities have engaged a wide array of community volunteers in both traditional and non-traditional roles.

NEWARK, NEW JERSEY

Continuity through Long-Term Community Leadership

Perhaps more than any American city that I've studied, Newark suffered from the ill-perception of New York, and from a lot of people who used to live here and used to believe that this was their town, and whose departure was hastened by about a half a century of urban decline. Cities rise or fall, depending on, in large part, the image of the city—for people living inside it, and especially for people living outside it. And that's very important in New Jersey, . . . a state that . . . in a period of about thirty years became the most suburban state in the union. And with that transformation of urban to suburban, you get these very negative perceptions. . . . So, in answer to your question, the presence of the museum, and more recently, NJPAC, it is a good thing. . . . It's a good thing for people who live in the city, who, for all sorts of reasons that I don't need to introduce to you, thought that their city had all but fallen into the Passaic River. (Price interview 2005)

As Rutgers University urban historian Clement Price pointed out, Newark, perhaps more than any other city in the United States, had had to find a way to thrive in the shadows of the country's major urban cultural and economic center. The cultural dominance of Manhattan leaves cities like Newark to struggle on its margins. Newark's two major cultural institutions, the Newark Museum and the New Jersey Center Performing Arts Center (NJPAC), have, as part of their daily organizational practices, focused on sustaining the engagement of diverse populations (figure 3.2). Located two blocks from each other in the heart of Newark, these two large institutions are playing an important role in the revitalization of an urban core that still bears scars of the riots of 1967. Both cultural organizations have operated from original charters that included serving the full range of ethnic and working-class citizens living in and around Newark. Effective leadership has meant working with a wide array of community leaders to sustain and expand the original visions of their founders. Both institutions have operated within a richly diverse environment by structuring ongoing serial activities with the extended community leadership at the core of everything they do. As a result, both provide their own significant contributions to the story of how leadership operates through traditional organizational structures to enable cooperation and to address and redress the gaps in cultural representation and engagement that can so easily separate organizations from their local communities.

81

A Century Apart, but Similar Founding Principles

The Newark Museum was founded in 1909 by librarian and populist John Cotton Dana who, in the nineteenth century, envisioned the museum as a center of support for a broad network of community-based efforts. Today it embodies many of its founder's progressive ideas about education for children, immigrants, and working-class families. Dana believed that.

> [i]t was pointless to devote a museum entirely to the display of objects that had no connection to the lives of most of its potential visitors. To display only such works to the exclusion of everything else was actually pernicious. It must inevitably suggest to the public that only things that were old, rare, costly, and mostly of foreign origin, were capable of providing visual delight. (Weil 1999, 15)

In Dana's view, the true work of the museum as a service institution "was in enriching the quality of its visitors' lives, not in accumulating masterpieces for its own greater glory, . . . [and recognizing] that the museum has both the capacity and the obligation to be a life-enhancing institution" (Weil 1999, 15). The businessmen, civic leaders, and collectors he assembled to help build the museum were committed to acquiring outstanding collections and presenting innovative exhibitions, all in the service of the entire community.

Today, the Newark Museum is referred to by its director, Mary Sue Sweeney Price, as a "mini-Smithsonian, caring as it does about both art and science," with a tagline of "eighty galleries of inspiration and exploration." With an annual budget of twenty million dollars, it is the largest museum complex in New Jersey. It has shown consistent growth, with an 8 percent average annual increase in contributions and an exemplary 40 percent annual growth in both program and membership revenues between 1999 and 2004. Its success at increasing participation is, in part, evidenced by that consistent growth.

Like the Museum of Fine Arts, Houston, the Newark Museum has benefited from the long-term tenure of its director, who has worked there since the mid-1970s. Sweeney Price has balanced community-engagement practices with conventional museum practice by intentionally championing a philosophy of "balancing excellence and equity." She has "drummed this into [her staff]" and has made it a core value upon which daily activity is structured. "My feeling is that they are really just flip sides of the same coin—that, without excellence of scholarship and the collections, the equity that one fosters may not be as meaningful. And, without the equity, we might as well not be in public institutions like museums" (Sweeney Price interview 2005).

The structure of the eighty-gallery facility enables topical exhibitions, such as Power Dressing: Men's Fashion and Prestige in Africa, an exhibition linking a conventional museum display of African ceremonial garments to other historic and contemporary forms of dress; America's Pastime: Portrait of the Dominican Dream—Works by Freddy Rodriguez, an exhibition of contemporary artworks with Dominican baseball legends as its central theme; and The Bride Wore Red: Chinese Wedding Traditions, an exhibition of historic and contemporary marriage traditions in China that led to comparative investigations of ceremonial wedding garments among other nations and ethnic traditions. The museum's Black Film Festival, begun in 1975, is now the longest-running festival of its kind. It also provided the model for Cinema Latino, a festival begun at the museum in 2004.

Such programming is the way the Newark Museum quite possibly serves the most diverse audience of any museum. Although some museums may still consider their audience "a single audience," Sweeney Price described the Newark Museum's audience as one composed of "subgroups of between ten and twenty separate audiences." This segmentation of audience has meant that the museum and its director are involved in serial activities, going from one group to the next:

> We are beginning to prepare for an Asian Indian and South Indian photography exhibit, which will be a very exciting show. And we are getting to work with that community. Tonight we are having a farewell party, summing up some of the work we've done on this Chinese American programming [with the exhibition The Bride Wore Red]. Next week I have a black film festival meeting. We haven't engaged [the festival committee] recently as much as we should. We've had a number of meetings now with the new Portuguese council, so we're kind of getting back into that. We look forward to working again with our Japanese American friends and the Korean community in New Jersey on some other upcoming events. There is always something new to do. There is always a new community to reach out to, always new immigrant groups. The most recent group that we had the wonderful opportunity to work with [in conjunction with Power Dressing] was the new African expatriate community, all of the African immigrants who will soon outnumber African Americans in New Jersey; [we wanted to] bring them into the fold. (Sweeney Price interview 2005)

A similar founding strategy coupled with "serial programming" is also evident at the New Jersey Performing Arts Center, which was founded as an educational organization in 1988; in 2004 it had an annual budget of nearly twenty-six million dollars. It, too, has seen consistent growth, with a 7 percent average annual increase in contributions over the five-year

period from 1999 to 2004. Since the opening of its state-of-the-art performing arts facility in 1998, it has been able to achieve and sustain program revenues of more than ten million dollars annually.

Trained as an urban planner, NJPAC's founding director, Lawrence Goldman, assembled a wide range of business and political support to establish the performing arts center, with urban revitalization defined as part of its core purpose. He recognized the inherent problem in efforts to diversify a cultural audience after the fact. So, from the outset, NJPAC was conceived as an institution whose mission was to respond to the needs, expectations, and preferences of a wide spectrum of the city's and state's population. Unlike an older canon institution struggling to modify its mission and to retrofit itself, NJPAC did not have to reorient its programs or persuade staff or board members to change emphasis and direction in an effort to attract a different audience.

Engaging Community Leaders through a Conventional Board of Trustees

Both the Newark Museum and NJPAC operate within a richly diverse environment in which volunteer community leadership is at the core of everything they do. The older of the two, the Newark Museum, has relied heavily on the hands-on involvement of a large and active board of trustees, who in turn lead the advisory committees. The more recent arrival, NJPAC, has a traditional fund-raising board. But it also relies on a staff working closely with a wide constellation of constituency-focused advisory councils who help to build relationships and sell tickets to customers located all over the state.

At the Newark Museum, the task of representing and involving a diverse range of communities and subcommunities has been woven into the daily activities of an extended board of trustees, totaling nearly eighty members. They work as fundraisers and hands-on representatives of the museum. The two board members we interviewed, Gloria Buck and Grizel Ubarry, have, like Sweeney Price, been involved with the museum for more than two decades. Buck, an African American professional, became involved with the museum in 1975 through an advisory committee for the Black Film Festival, in the first year of what is now the oldest festival of its kind. Ubarry came to the board in the mid-1980s to work extensively with the Latino community.

As a Latina professional, Ubarry fills a very traditional role of trustee, from budget oversight and fund-raising to organizational policy making. This was evident as she and E. Carmen Ramos, the museum's assistant curator for community engagement, recounted the internal discussion over how much of the museum's interpretative materials should be bilingual.

Ubarry's position was that the vast majority of Latino museum and movie-goers in New Jersey speak English, thus making the expenditure unnecessary for what she considered to be "two sets" of the same wall labels, publicity, and program materials. Ramos, on the other hand, emphasized the symbolic impact that bilingual materials have and the role they can play in inviting diverse participation. The resolution for the Freddy Rodriguez exhibition, which Ramos curated, was to do the "two sets" only for the major wall labels, with the rest in English and with a translated version in a paper hand-out available to visitors on request. As this example shows, in communities dominated by groups once relegated to "minority" status, there are many new challenges to be considered around diversity issues.

The central task facing the cultural organization has not been attracting new minorities or immigrants to participate in cultural activities. Rather, it has been to recognize and represent the diversity already prevalent in the local community. Among the groups that Ubarry and Ramos have focused on are Puerto Ricans, the largest local group, as well as Dominicans, Cubans, and other South and Central Americans—all of whom include different ages and immigrant statuses. As Ramos, points out, "Through Cinema Latino, we're really trying to reach a young demographic that may be more inclined to go to a film festival rather than seeing an exhibition. But [after] getting them in the door—maybe they could be interested in what else is going on here" (Ramos interview 2005).

The collegial relationship that exists between Ubarry and Ramos has been replicated many times over at the Newark Museum, since both trustees and administrative staff are equally involved in nearly every program activity, in addition to policy making, fund-raising, and long-term planning. Trustees connect the museum to community leadership and community networks. Many of the current board members have been involved with the museum for decades, continuing family involvement that extended back for generations. According to Gloria Buck, many of its trustees are those who have traditionally been drawn to cultural boards—people who are committed to community service and who have the means to make substantial contributions. But, according to Buck, "it goes so much deeper than that. They have a real dedication to serve, and they do" (Buck interview 2005). There are also board members who are new to this kind of community service, many of whom represent the diverse communities that the museum has identified as its newest constituency.

Now we have Asian and Portuguese board members. These new members understand what the board does, its level of required commitment, and the amount of work it involves. And this level of engagement among the board members is replicated among the city's political elite. The

current mayor [Sharpe James] [is] very, very supportive; in fact all the mayors and county executives have been supportive of the museum. (Buck interview 2005)

The structure of staff–trustee interaction at the Newark Museum may appear conventional at first glance. What is distinctive about this board, however, is the way it has been cultivated over many decades to be truly representative of its diverse community. The committee structure within the board of trustees is a powerful and well-established leadership platform that has supported and enabled board members to work effectively at the task of developing and sustaining its deep connections with the community (figure 3.3).

Engaging Community Leaders through Constituent-Focused Advisory Councils

In contrast to the Newark Museum's traditional board structure, advisory council members at the New Jersey Performing Arts Center have played the key role in linking that organization to the community. According to Bishop Andre Jackson, chair of the Ministers' Advisory Council at NJPAC, this volunteering has not only helped NJPAC, it has helped him to serve his own community better.

The Ministers' Advisory Council is a group of ministers and pastors of various churches and denominations and religions throughout New Jersey. We meet quarterly to discuss different programs and events that are taking place here at the New Jersey Performing Arts Center. Our primary concern is that it allows our parishioners, who are constituents of the state of New Jersey, to be participants in the events that take place here at New Jersey PAC. [The advisory council] was initiated early on, when NJPAC was first built, to give people we pastor a sense of ownership and involvement with the center. In many instances, we introduced NJPAC to some people who would never have had the opportunity otherwise to experience the array of programs and events that take place here. So, for us, as pastors, it has been a good cultural influx into our ministry, as well as allowing our people to have a sense of ownership and participation. (Jackson interview 2005)

Advisory council members are linked to NJPAC through professional staff members in the marketing department. The committee members are then the conduit to broader statewide constituencies, and it is through these councils that the relatively young performing arts center has engaged in relationships that extend far into the state of New Jersey. Among its many advisory councils are the Corporate Advisory Council, which engages human resources directors of local corporations; the Ministers' Ad-

3.3 Attracting diverse audiences to the arts is the primary goal of New Jersey Performing Arts Center.
Photograph by Timothy D. Lace © 2005.

visory Council, which is the link to countless congregations throughout the state; the Latino Council, which is the link to Newark's Latino Chamber of Commerce and its wide array of Latino businesses and community members; and the Student Advisory Council, which involves students of local universities and representatives of Resident Housing and Student Activities divisions on local campuses.

It is this extensive network of advisory councils that distinguishes NJPAC from the other organizations discussed in this chapter. These advisory councils perform the two-way function of advising the organization and promoting it to their constituency. According to Catrina Boisson, director of marketing at NJPAC, "The basic premise is, if you want to engage people and find out how to engage a community, then the best person to ask is a member of that community." Although the goal is, in part, "to sell tickets and to increase the audience . . . there is an awful lot of listening that goes on," she said. "We want to know what they're feeling, what they're hearing, and how *they* can best advise *us*" (Boisson interview 2005). The fact that most of these advisory councils are connected in one way or another to NJPAC's ongoing marketing efforts helps to explain its success in reaching and sustaining ten million dollars in annual

program revenues since the first year of operations. Advisory councils have been part of the organization since the very beginning, for good reason: "Without them, we could never afford the media it would require to have a presence in many, many diverse communities. . . . And, as a side note, I don't think that [would be] the most effective or tactical way to really engage communities. We go the relationship route. And the advisory councils are at the center of that effort" (Boisson interview 2005).

The quarterly meetings of each of the advisory councils require an enormous organizational effort. For the staff, this has meant scheduling these meetings, attending them, listening carefully, and regularly following up. Sustaining these relationships is really the challenge. Yet given what a key component for success the councils have become for NJPAC, sustaining these relationships has been a top priority. One way they have reinforced the importance of the councils has been through public recognition at performances. NJPAC staff representatives wander through the gathering crowds and seated audiences to greet and talk to guests. From the stage, they formally recognize and thank groups for coming, and they acknowledge the groups in program books. Since advisory councils represent a voting constituency in the state of New Jersey, they have also served an important fund-raising function—in particular, by helping to save NJPAC during a recent financial crisis that threatened its public funding.

As this account suggests, locating leadership within the advisory councils has helped to ensure that no culture gap emerged between this young organization and its statewide constituency. Through these volunteer leaders, NJPAC has maintained a direct link to specific constituencies whose collective voice is even greater than that of individual or groups ticket buyers. Like traditional donors, these constituencies have played an important role in the funding of this public institution. The relationship established between the organization and its constituent network is clearly a reciprocal one.

CONCLUSION

One characteristic that has distinguished the expansion project carried out over twenty-five years by the Museum of Fine Arts, Houston from that of other institutions is the consistent and widespread commitment it has demonstrated to include a growing number of the city's residents on its roster of participants. Development of its core program has been responsive to and inclusive of the cultural diversity that exists both in the local vicinity of the museum and in metropolitan Houston. The policies guiding the MFAH's acquisitions and exhibition schedules have been designed to build the diversity of its general museum audience; at the same time,

its educational and community-based programs have targeted social and geographic groups more specifically. Most importantly, there is, according to staff, "an ethos of inclusiveness and an understanding that to have a diverse and inclusive audience you have to work at it all the time" (Schneider interview 2005).

Comparisons of the MFAH and AIC highlight the tensions that can emerge when established canon cultural organizations embrace change and uncover, in the process, the institutional gaps in knowledge and practice that extend far beyond their own walls. Indeed, as sociologist Charles Simpson has pointed out, a museum's "first interest is in maintaining the value of the collections and building upon the aesthetic commitments which their curators have made to already established artistic directions" (Simpson 1981). Although Chicago's relatively large number of African American art collectors and artists are an apparent testament to a substantial "art world" both locally and nationally, there are a limited number of market-based intermediaries, such as commercial galleries, artist representatives, or critics, who are knowledgeable about the work of African American or Latino artists in either mainstream or segregated markets operating in ethnic communities. It is the traditional role of these intermediaries or gatekeepers to promote reputations by "discovering" new artists and to help attract audiences—including museum curators— to this work. It was therefore a difficult task for staff at the Art Institute of Chicago to undertake a change project without the intermediaries in place who could help provide the bridge between the organization and this new community of potential participants. Under such circumstances, it is not surprising that what some observers interpreted as "institutionalized resistance" at the AIC was viewed by others as "upholding rigorous standards." Participation-building efforts will often involve such tensions and contradictions as canon institutions rethink their missions and goals in their efforts to reach new audiences and find multiple ways to promote inclusivity. As these organizational stories illustrate, there are many issues to be resolved when an organizational culture focused on maintaining and elevating its international institutional legitimacy takes on the new project of building participation, particularly among groups that were once ignored or excluded from its fold.

The case study of two major institutions in Newark, New Jersey, highlights how sustaining core institutional commitments to serve and involve diverse constituencies can be effectively carried out in a variety of ways—through the traditional role of trustee or through the leadership of an advisory council or committee. The work of relationship building that continues to go on at both the Newark Museum and NJPAC has been less about any one individual leader's strength or consolidation of power than

about the distribution of leadership that draws on the creative interaction among talented and dedicated executives, middle management, support staff, and a wide array of volunteers. Such distribution of leadership is an effective answer to the gaps in access and service that once prevailed in the cultural organizations in these communities.

Through these case studies, we can draw some conclusions about the role of leadership in building participation in the arts. First, it is the job of change leaders at various levels of the organization to identify gaps in their cultural services and in their participant rosters. It is also the job of leaders to support efforts that will help bridge these culture gaps. Effective leadership is not about the consolidation of power, but about the distribution of authority. Although we have cited indicators of the organization's growth as one measure of success, another gauge might be the extent to which leadership is distributed throughout the organization and the community. One indication of widely distributed leadership is when the organizational goals and values, as expressed by the top leaders, are also seen in statements and actions of the middle management, support staff, volunteers, and community members that the organization purports to reach and involve. The specific cases cited here highlight how particularly successful chief executives, middle managers, and community leaders have engaged in a variety of efforts to build and sustain relationships with diverse local communities. The Museum of Fine Arts, Houston, the Art Institute of Chicago, the Newark Museum, and the New Jersey Performing Arts Center demonstrate how the distribution of leadership works and how organizations both old and new have institutionalized and sustained successful transactional and relational efforts at participation building.

The kinds of efforts described here are at work in many different types of organizations mentioned throughout this book. Clearly, the age and size of a cultural organization will structure the nature of the participation-building efforts undertaken and the leadership challenges they present. Many relatively young organizations established since 1965 were founded with similar inclusive and community-service missions and have employed organizational practices to draw in diverse local communities from their very inception. The change project for large canon institutions founded before 1935 is profoundly different. Whether retrofitting, renewing, or starting anew, these organizations face the challenge of building widespread institutional commitment to the process of change, and this process requires the political and personal skills of leaders positioned throughout the organization. Leadership is necessary not only to launch the process of participation building but also to distribute and institutionalize the large and small tasks necessary to sustain the effort.

4 Partnering with Purpose

DAVID KARRAKER AND DIANE GRAMS

Like most businesses large and small operating in today's global economy, arts organizations are increasingly seeking to engage in arrangements that include alliances and joint ventures, formal partnerships, and informal collaborations. This chapter focuses specifically on relationship building among organizations—in particular, investigating how organizations share resources or engage the resources of others in efforts to build arts participation. External relationships among organizations provide a range of direct benefits in the process of building participation, including increasing organizational capacity, increasing the credibility and legitimacy of participating organizations, and providing access to skills, technology, space, or other desirable goods. Organizational collaboration may also be a good in itself—that is, it is one way to achieve a broader distribution of public goods, a task that is fundamental to the nonprofit, tax-exempt status of all cultural organizations.

We found that the most important structural aspects of working partnerships were those rooted in an ethos of equivalency: partnerships that involved trust, sustained give-and-take, shared purposes, and lots of communication geared toward the mutual benefit of those involved. Such relationships are distinct from those in which one organization seeks opportunistically to acquire and dominate interorganizational arrangements and/or resources. In an overview of lessons learned, we present a range of organizational examples to show that the process of maintaining strong working relationships with partners in order to achieve a participation building goal is no easy task.

This section is followed by four more detailed case studies of partnership arrangements: Guild Complex and Young Chicago Authors, two Chicago-based cultural organizations that work together to leverage their resources and build a larger pool of participants; the Louisiana Philharmonic Orchestra, which has developed both local and statewide partnerships with cultural and social service agencies; the Arab Community Center for Economic and Social Services and the University Musical Society, which

have worked together in the Detroit area to create new audiences for Arab American art and new avenues for understanding Arab culture in a time of little tolerance; and, finally, a partnership between the city of Pasadena and the Armory Center for the Arts, a collaboration between a municipality and an art organization, which has been an incubator for developing a network of smaller arts organizations in this Los Angeles suburb.

As we will show, the objectives of these arrangements are primarily relational—that is, they involve organizations seeking to build interactions among their organizations and with individuals from target communities or groups. The specific goals of their activities vary widely, in some cases focusing on the expansion of audiences in general, in others targeting specific groups, such as young people, members of underserved ethnic or racial groups, and residents of neighboring communities.

LESSONS LEARNED

An Ethos of Equivalency

As Francie Ostrower (2004) highlights in her study of partnerships between large and small cultural organizations, many such arrangements don't work because the disparity of money and size often leads to a disparity in the exchange. The organizational staff we interviewed seemed to have learned how to negotiate such differences. Among the variety of program aims expressed by our interviewees, several key features distinguished interorganizational relationships that worked well:

- Authority is not located within a single organization, but rather is located externally among organizations. No one organization held decision-making authority over the group. Rather, the relationship brought together two or more organizations in an exchange relationship, each with a shared and enduring expectation that other participants will advance their shared interests of the whole in building participation more forcefully and successfully in concert than it would be able to do on its own.
- They negotiate the terms of their interactions as equals, however disparate the ultimate scope of their contributions may be once the partnership gets underway.
- The lasting orientation toward equivalency and renegotiation between organizational participants is what sets working relationships apart from those that did not work. This commitment to sustained give-and-take, or reciprocity, is key.

Achieving and maintaining an ethos of equivalency is not an easy task. However, equivalency does not suggest that each organization must mir-

ror the other's functions. Inevitably, organizations that choose to partner have disparate strengths that make the partnering arrangement desirable. The sense of equivalency that emerges in the most successful partnerships is not always possible to achieve among two or more organizations. One reason a partnership might fail is because the wrong organizations come together. Linda Myers, executive director of the Loft Literary Center, recounted how she and her administrative partner, Nancy Gaschott, held meetings for nearly a year before they found the right partners to be involved in a permanent partnership that would produce a home for each of the organizations. The partnership was established first through finding organizations that complemented, rather than competed with, the mission of the Loft. Their partnership with Milkweed Editions and the Minnesota Center for Book Arts resulted in a collaborative fund-raising effort to plan, purchase, and rehab a loft building to house the three partners. The partnership then established a separate nonprofit organization to manage the facility. The harmony that developed among the partners was in part the result of each being the "right" partner whose circumstances enabled it to share in the united goal of having a permanent home for the group.

Trust, a Level Playing Field, and Open Communication

Rachel Cooper, director of cultural programs and performing arts for the Asia Society in Manhattan, cited The Floating Box, a project the society undertook in its partnership with the Museum of Chinese in the Americas.

> It could never have happened if [either of us] had not been there. . . . There was a kind of generosity and spirit, and I felt like part of it was that we met either physically or by phone fairly frequently, just to try to make sure that we knew what we were all talking about. . . . We had real respect for each other; enough so that someone can say, "Well, we're worried that you're the big institution and we're going to get swallowed up and disappear"— and then say: "Okay, what are we going to do about that?" (Cooper interview 2005)

In addition to fostering respect and openness, a successful partnership recognizes that each partner is autonomous, but occupies a niche in the relationship. The fact that the Asia Society has a larger budget did not prevent the Museum of Chinese in the Americas from engaging the society on equal footing. In such a nonhierarchical arrangement, sustaining working alliances of this sort depends on a "spirit of goodwill" (Dore 1983), together with what Powell (1990) terms a "norm of reciprocity," within which each member proceeds from a high sense of obligation and trust.

Baraka Sele, assistant director of programming at New Jersey Performing Arts Center (NJPAC), created a program called Global Exchange to

facilitate innovative international collaborations between American and African organizations and artists. Similar to Cooper, Sele has invested resources of time and money to create a level playing field so that an equal exchange can take place:

> [L]et me just say, I feel that it's my job, as much as possible, to level the playing field between those two groups so that a real [give and take] can take place. I think we don't do enough of that. I think we kind of [accept the disparities presented]: "Okay, these are those poor Africans"; "Oh okay, these are the rich Americans; this is just the way it is." No! This isn't just the way it is! How do we use our own resources to remedy that? I think that's the piece [often] missing. (Sele interview 2005)

Characteristic of both Cooper's and Sele's accounts is the importance of open communication. Cooper notes that equivalency involves articulating what you agree upon and what resources each can bring to the table, and also understanding where you don't agree.

> [There are] certain things that we're able to do because we have resources that may be different from what another organization has—maybe certain expectations about timing—and you really need to sit down and try to be as specific as possible and also to be realistic. So that, in a sense, you're trying to create parity that isn't based on necessarily money alone. (Cooper interview 2005)

Similarly, Sele regularly fills the job of negotiator in the beginning of a partnership to make sure each side's needs are met from the start. As she spoke, she illustrated this: [Reaches to one side]: "What do you all need to make this collaboration work? Okay, got that." [Reaches to the other side]: "What do you all need to make this collaboration work? Okay, I think I can work that out." (Sele interview 2005) The partnerships in which Cooper and Sele were engaged were both relatively short-term and involved implicit agreements as to how they would be carried out. In long-term partnerships, such as that created by the Loft Literary Center, agreements are likely to be explicit by necessity.

> You're trying to create parity that isn't based on necessarily money alone.
>
> RACHEL COOPER

A commitment of equivalency is critical to an effective partnership because it unites different organizations under the aegis of a shared interest while maintaining the organizational autonomy of each partner. As these examples show, partnership involves not only assertive choices for partners but assertive action to create and maintain a sense of equivalency. In the following section, we explore through detailed case studies what work-

94

ing-partner relationships might look like, how individuals and goals are balanced through the trust, reciprocity, and communication that characterizes the partnership, and the enhanced or expanded arts participation that results.

GUILD COMPLEX AND YOUNG CHICAGO AUTHORS

Exchanging Main-Stage Legitimacy for a Youth Audience

This case study shows how, through reciprocal exchanges and pooling of resources, a partnership increased the capacity of two small literary organizations to provide programs to youth. Located just eight blocks apart in Chicago's Wicker Park neighborhood, these two literary organizations enhanced and expanded both of their programs by cooperating to establish a network of forty Chicago public high schools and twenty-nine youth service organizations, for which they became a literary resource and the hub of literary programs for urban youth. The two core organizations, Guild Complex (GC), a Chicago-based cross-cultural (adult-focused) literary organization established in 1989, and Young Chicago Authors (YCA), an after-school program involving teen authors founded in 1991, increased the number of youth participants in their after-school literary programs from fewer than five hundred to well over four thousand annually in just four years. Moreover, while the partnership helped Guild Complex build a youth audience, it helped YCA increase the legitimacy of its teen program.

With Michael Warr, an African American poet, and Luis Rodriguez, a Mexican American poet and writer, as two central figures in the founding of Guild Complex, the organization's core program was built around a cadre of adult writers representing both the artistry and the ethnic diversity of contemporary literature. Guild Complex's youth programming was established as an auxiliary program designed to provide a supportive and nurturing environment in which inner-city youth were encouraged to find their poetic voice. It developed from an eight-week summer workshop series, "Writing through the Prism of the Self and Community," begun in 1997 and hosted by Rodriguez, who by then was nationally known for the publication of his 1993 memoir of gang life, *Always Running: La Vida Loca, Gang Days in L.A.* The eight-week workshop featured Tuesday-night youth poetry events in which participants read their own work and listened to their peers. Wednesday Talk Backs provided youth with access to Guild Complex–featured authors who engaged the youth informally in discussions about poetry and the profession of writing.

As it sought to build its youth audience, GC invited youth service organizations, such as Young Chicago Authors, Street Level Youth Media, and specific schools, to cosponsor youth events. Typically the exchange

amounted to a joint marketing effort in which GC promoted the event in its own monthly calendar, which included naming cosponsors, who in turn brought their youth participants and also helped to publicize the event. This programming was stabilized and expanded through a formal partnership with Young Chicago Authors.

YCA was founded by Dr. Robert S. Boone, an author and educator with an extensive background in teaching urban youth. YCA's core program involved twenty sophomores from several inner-city high schools who became engaged in an intensive Saturday writing program. One of the tactics Boone used early on to attract and retain youth participants was to offer college scholarships of up to two thousand dollars a year to every student who continued to participate in the program through graduation, a practice that had to be discontinued when the popularity of the program made it financially impossible to sustain. Since 1991, YCA has graduated nearly two thousand teens from its core writing program held on Saturdays. By 1997, the organization was an established literary resource for community service agencies and area public schools.

Both GC's and YCA's programming were enhanced and expanded through their partnership. They cooperated in efforts to build and maintain connections to teens and their adult mentors through the network of schools and socials service agencies they established. The focal point of their effort centered on engaging youth in spoken-word poetry events every Tuesday night at the Guild Complex. The exchange between the two organizations allowed GC to make a weekly commitment of space to youth on Tuesday nights. It allowed YCA the opportunity to offer additional programming options for youth not accepted to its intensive Saturday writing program.

> The Tuesday program began for kids who couldn't come on a particular Saturday, so they would make up the class on Tuesday. Then Tuesday became . . . more for performance; you know, there'd be an open mic, there would be pizza, and occasionally guest writers. One thing it [did was to] grab some of the kids who might have missed out on the scholarship program the first time around. Because now they're juniors or seniors, we could not really let them into the Saturday program; but . . . they could be involved with our program in other ways. At any one time we probably had ninety to one hundred kids involved in our Tuesday program. And now we've expanded even more by sponsoring events like the [citywide teen] Poetry Slam. (Boone interview 2004)

Julie Parson-Nesbitt, former Guild Complex executive director, characterized her organization's commitment to young people as a way to expand organizational participation over the long term: "For the Complex, the

youth audience in one sense was our most important audience because kids in high school become an adult audience, and by cultivating them as teenagers and by familiarizing them with the space and the authors—and just the idea of going to a poetry reading—we are building an adult audience [for] poetry and literature for the long term" (Parson-Nesbitt interview 2004).

Unlike some organizations that must undergo extensive program development in order to attract and engage youth, according to Parson-Nesbitt, Guild Complex's adult-centered core programming appealed to youth without any additional program development effort:

> [Youth] came and they loved these events, they just loved them. They thought it was just the coolest thing in the world. . . . We would present writers like Willy Perdomo, who's a . . . Puerto Rican poet who grew up in the Bronx. . . . Uher Hamad, who's an Asian American poet who talks a lot about growing up with prejudice and racism and oppression. . . . Poets like Amiri Baraka and Naomi Shihapnigh are people whose experiences reflect the experiences of these kids. And these kids had never imagined that a famous writer could be talking about them. (Parson-Nesbitt interview 2004)

The mechanics of the exchange between Guild Complex and Young Chicago Authors included an exchange of money along with program coordination that maximized each of their own resources. GC's core programming featured urban spoken-word poetry that was naturally enticing and relevant to teen culture. GC arranged its agreements with its featured adult authors to include time with youth in the teen program. YCA maintained its Saturday writing program, often encouraging youth to perform their works in the Tuesday open-mic sessions at Guild Complex. GC and YCA agreed to advertise their events cooperatively in *New Expression,* a citywide Chicago monthly for teenagers with a circulation of seventy thousand, distributed through public high schools in Chicago. The additional programming costs were minimal, amounting to an estimated ten thousand dollars annually. GC paid for staff costs amounting to fifty dollars a night. Young Chicago Authors paid the eighty dollars per night rent for Tuesday night performances, organized youth to attend Tuesday night, and covered the ticket cost for Wednesday programs if the youth went on their own. According to Boone, YCA more than tripled the weekly teen involvement in their programming, adding eighty to one hundred teens weekly, through the Tuesday night spoken-word events on GC's calendar. Most importantly, YCA's program gained legitimacy not only with educators as a writing program but with youth who had access to the noted writers booked at Guild Complex. According to Boone, "We certainly gained a type of credibility. We had access to some of their guest writers . . . I could tell my kids: 'Well you know if you want to go Wednesday to hear a great

poet, here are the people over at the Guild.' . . . If they wanted to go to hear one of these people they can and we'll pay their fee to get in" (Boone interview 2004).

According to Parson-Nesbitt, teens not only became involved in youth-targeted programming with the YCA group, they came on their own and brought their friends to other programs as well. In this way, the Guild Complex was also able to mentor teens into young adults who became GC staff members and who subsequently took the program back into Chicago public schools.

As a result of the partnership, both Parson-Nesbitt and Boone saw growth in the youth audiences at their respective organizations and in their funding for youth programs between 1997 and 2002. Guild Complex's teen program expanded from a small summer workshop to a weekly event. In addition, GC developed and expanded a school-based residency program through which it placed young writers in schools to carry out workshops. Some of these were the young writers who began in the YCA program. In terms of numbers, teen audiences for its events grew nearly tenfold in just four years; its budget for teen programs quadrupled to more than seventy-five thousand dollars annually by 2001. Teens attended events and also performed spoken-word poetry on the Guild Complex's main stage. The program of Young Chicago Authors grew in stature and in numbers of participants. In addition to its core Saturday program and its weekly spoken-word poetry events, YCA now hosts a local teen poetry slam involving youth from thirty-five to forty schools annually.

One lesson that becomes apparent from this case, however, is that, in spite of the measurable success seen in increased youth participation and expansion of the organizational networks committed to the program, such partnership-based programs do not automatically become self-sustaining. Youth programming at both Guild Complex and Young Chicago Authors was largely dependent upon foundation grants. Moreover, the partnership was largely sustained through the commitments made between the two directors. Even though the program was successful in terms of the numbers of youth participants it attracted, it was still one of the first to be discontinued when Guild Complex was forced to retrench its efforts after a change in its leadership and after multiyear commitments by funders ended.

THE LOUISIANA PHILHARMONIC ORCHESTRA

A Phoenix Twice Arising from the Rubble

In this case study we explore how a large organization became involved in numerous partnerships with organizations large and small with the goal of bringing its program directly to local communities and in engag-

ing those communities in the production of the program. Since its inception, the Louisiana Philharmonic Orchestra (LPO) has been distinguished from more conventional orchestras in that it was founded as a cooperative, artist-run organization. We spotlight here two of its partnership efforts that resulted in the broader distribution of a public good—its statewide community-engagement tour and its unique partnership with a public health school and the library system. These efforts are distinguished first by their geographic scope and second by the nature of the public good distributed.

LPO was founded as a musician-owned and -operated orchestra following the financial collapse of the sixty-year-old New Orleans Symphony Orchestra in 1991. From the beginning, the seventy-member LPO presented a full symphonic repertory and established itself as the major presenter of symphonic music in the region. In the years both preceding and following Hurricane Katrina, it has been the most active orchestra in the Gulf South, performing more than 125 performances each season.

As it continued to grow, the orchestra sought to broaden its base of support and cultivate participation among nontraditional, nonsubscriber audiences from a wider geographic base. The effort combined what the LPO termed "high-quality performances and audience education in creative formats" with performing in underserved urban and suburban areas throughout New Orleans and in rural areas throughout the state of Louisiana. The guiding assumption behind the LPO's approach to participation building has been that finding new audiences means performing in venues where people live and work and fostering collaborations with key entities in those locations.

Bringing the Program to the People

No one articulated the challenge of undertaking a statewide participation-building effort better than did LPO's senior vice president of external affairs, Sharon Litwin, referring to her organization's decision in 2003 to conduct a nine-city community-engagement tour involving the collaborative performance of a work it had commissioned for the bicentennial of the Louisiana Purchase:

> [The tour] was fantastic, because it certainly exposed areas of the state to this orchestra that had not really known [us]; . . . [however] we all learned a lot of things from it: one is just [the challenge of] transporting a full orchestra, their instruments, and making motel reservations in communities that are not tourism communities. . . . The other aspect [was that the music] was a "cold instrumental work." So we worked with choruses around the state who could obviously not come to New Orleans to rehearse. Just working with them long distance, getting the music to them,

trying to work with the composer [who was] working with them, doing a little tape recording so he could hear and comment—[this] was all incredibly involved. So, one could almost see that a project like that would be all-consuming for one full-time person. Well, when you're at an organization like ours, which has ten full-time people doing *everything,* that's where the labor intensity comes in. [It was] well worth it. We'd do it again. But I would warn everybody up front: it is a lot of work. (Litwin interview 2005)

Creating partnerships with local governments, businesses, schools, churches, and universities throughout the state was necessary not just to enable the mechanics of the statewide tour but also to carry out the collaborative vision of the composer who planned performances with local choruses. Local partnerships were therefore necessary for finding performance venues, as well as enabling the travel and lodging of all of the seventy orchestra members and their instruments. The partnerships with local choruses were also essential to the artistic content of the work, which had been created to link people of historic and present Louisiana.

[Community engagement] was the whole purpose. We [did not] want to just drop in on other people's turf and drop out. . . . Many of these communities have some kind of musical ensemble that they call their orchestra. We wanted to avoid [generating] north versus south, or big city versus little town [animosity]. . . . I'll use the southern phrase, [we wanted to avoid being viewed as a] carpetbagger. It was really important . . . that we engage the community, so not only did we work with their choruses, but we worked with the schools and with the children. . . . The composer Rob Kapilow was very concerned about community ownership of the works that he does of this type, so we made two or three visits around the state with him [in 2002], the year before this was to happen, to get input from the community. We had little town-hall meetings; we had meetings with students; we had meetings with different ethnic groups—Native Americans, African Americans—so he could have input from all of them about what they really thought . . . that the Louisiana Purchase meant to this state. And it was very revealing, so we tried very hard for there to be more input than just a) the music and b) music with their participation. From that point of view, it was exceedingly successful. (Litwin interview 2005)

Among the LPO's partners were Hibernia National Bank, a statewide financial business, and all the local schools, churches, community centers, and colleges found in the region in which the orchestra was scheduled to perform. By tapping local governments and businesses, it sought to ensure that the broadest cross-section of the entire state, beyond the city of New Orleans and its immediate metropolitan area, could be involved. The goal was to generate the active participation of local communities in producing

an original orchestral concert with the only full-time professional orchestra in the Gulf Region.

According to Litwin, partnerships with local organizations helped the LPO negotiate its way through numerous barriers. As Litwin points out, several of the cities on the tour were not tourist destinations, and many had only one or two motels, which were often not sufficient to house an influx of nearly one hundred people. Performance space was also limited. In one city, fifteen LPO musicians presented a customized work in a local bank lobby, the largest local space in which to gather for a performance. Locally-based partnering organizations also helped maneuver through the series of obstacles inherent when groups work at long distance to create a musical performance. Since local choruses were scheduled to sing with the orchestra without much face-to-face practice time, the rehearsals took place through exchanges of music and recordings; communication was maintained through an Internet message board. Both were important ways to create and maintain interaction with the composer/conductor.

As Litwin attested, this project involved coordination far beyond anything she or other LPO staff had expected. But the outcome was an enormously successful tour in terms of the relationships that were built and the satisfaction that was generated through the collaborative concerts. She emphasized that such efforts are time-consuming and do not lead to increases in ticket sales or program income. They were never intended to do so. Rather, this was a project rooted in an ethos of relationship building— finding ways to enable people from throughout the state to participate in the creation of an artistic work with a professional orchestra, something few nonprofessionals have ever done.

Recasting the Purpose of Public Concerts: Music and Public Health Literacy

In 2004, the LPO initiated a program called Orchestrating Your Health, involving a partnership between the orchestra, the Louisiana State University Health Sciences Center (LSUHSC) School of Public Health, the New Orleans library system, the city health clinics, and the Parkway Park Commission. This community-based program series featured orchestra members playing outdoor concerts in parks with medical students on hand to do medical screening, pass out information, and provide referrals to local clinics.

The partnership developed as a result of a single performance in one of New Orleans's African American neighborhoods. A community visit led to an event in which LPO members performed in a park near one of the city's health clinics to a crowd of seventy-five people. With clinic staff among the crowd, the idea of a partnership between art and health practitioners

took hold. The idea and the subsequent partnerships would ultimately recast the purpose of such community-based performances. The partnership put the complementary resources of the orchestra and public health professionals to work. Through the partnership, they found a way to distribute more broadly the public good each had to offer.

At a typical park concert produced by the partnership, orchestra members played music that resonated outdoors, while LSU public health students displayed exhibits with general information about such topics as diabetes prevention, obesity, and smoking cessation. The students offered simple medical tests, such as blood pressure screening, and discussed preventive health services, using the General Prevention Guidelines for All Average Risk Adults designed by the American Cancer Society, the American Diabetes Association, and the American Heart Association. Using the guide, students filled out a form as they queried participants on a range of subjects—age, gender, ethnicity, status of their health insurance, the last time they visited a primary care physician, and the last time they had specific tests. Those interviewees who had never or rarely been screened before were referred to the area community health clinic. The leveraging capacity of this program was enhanced when the public library system was brought into the partnership, allowing participants to utilize the libraries' existing access to the Internet and to MedlinePlus, a program of the National Library of Medicine and the National Institutes of Health, which maintains a Web site, http://medlineplus.gov, designed for consumer use. The partnership thus provided people with access to multiple kinds of resources. The LPO's purpose was to enhance and build participation in its own organization but also to distribute more widely the dual public goods of arts and health services. The partners each made valued contributions based on their own resources and expertise. Litwin explains:

> [T]he School of Public Health provided graduate students who would refer people to the city health clinics for follow-up. This is really quite new and uncharted territory, really. . . . The School of Public Health [is better able to assess what] are the areas of public health that they need to address in this community. . . . [Our job is] the performances. . . . The musicians [interact], explaining and talking to the audience. For the audience, there is lots of information available on everything you can think of, from abuse of any kind . . . to diabetes to heart disease to mammograms. . . . The libraries are the direct link to Medline. Anyone can get on Medline [in any library] and get any kind of information they need. [Library trainers were on hand] helping people to do that. (Litwin interview 2005)

The partnership transformed the purpose of a community-based concert from one that was simply a strategy for broader distribution of art

to underserved communities into one in which a classical music concert was linked to the dual public services of medical screening and improving health literacy. According to Litwin:

> Just the fact that we go play in underserved communities in itself is beautiful enough—and I believe that's our obligation. But it seems to me that, if you are to couple that with a really socially responsible project, then that needs to be able to show [measured] outcomes. And the medical school is deciding if they want to focus on a particular disease . . . or series of diseases, or what? It makes sense to them to focus [on an area they have expertise in] and get into the community in ways that they wouldn't be able to do in any other way. [Without our partnership], I mean, they simply can't. So we're really sort of trying to play to everybody's strengths and get a really good and measured outcome here. (Litwin interview 2005)

The first program series linking art to public health produced through the partnership began in the 2004–2005 season and featured performances in six different communities. The partners had planned, for the 2005–2006 season, to target one community and do multiple concerts there in order to build a stronger presence. They also hoped to build a greater sense of trust between the medical students and professionals, the musicians, and the local community. With a more formal partnership between the LPO, LSUHSC School of Public Health, and the New Orleans Public Library that had the potential to further research and tracking of health outcomes related to the public concerts, they anticipated that a greater public health impact could be achieved and measured through return visits. These three partners then collectively developed a proposal seeking $31,615 to support a pilot program called Orchestrating Better Health, geared to producing measurable health improvements in New Orleans's poorest, least-educated communities. This case study demonstrates how individual organizational resources leveraged through partnerships enabled three groups more effectively to distribute the public good embodied in live music concerts while building participation in the arts. Through this project, they also began to fulfill concrete social needs connected to both health and computer literacy.

Hurricane Katrina's devastation of New Orleans and the greater Gulf region had an enormous impact on the LPO, just as it did on almost every other organization in the area. In the month after Katrina, the 2005–2006 season was cancelled, but the orchestra carried out several performances at St. Louis Cathedral, on the campus of Loyola University of New Orleans, and at sites throughout Louisiana from its temporary headquarters in Baton Rouge—all directly a result of relationships built from earlier partnership activities. With the support of American Airlines and a number of

nonprofits and businesses in Nashville, Tennessee, the orchestra members were reunited for the first time after Katrina, in Nashville, on October 4, 2005, when they played a benefit concert in support of the orchestra and its members. Along with the rest of New Orleans, the LPO is still in the process of recovering and reconnecting to its supporters and partners. A full thirty-six-week season for 2006–2007 was in full swing at the time of this writing. Needless to say, many of the poorer communities targeted by the Orchestrating Your Health partnership no longer exist. But once the infrastructure for health services is rebuilt in the communities that remain, LPO hopes to reinvigorate the promising partnership that created this innovative program.

THE ARAB AMERICAN NATIONAL MUSEUM AND UNIVERSITY MUSICAL SOCIETY

Organizational transformation of both partners can be seen through the case study of the Arab Community Center for Economic and Social Services (ACCESS) during its development of the Arab American National Museum (AANM) in the Detroit area and its partnership with the University Musical Society (UMS), an independent nonprofit organization affiliated with the University of Michigan in Ann Arbor. How they came together and established an enduring and reciprocal relationship is a story based upon having the right partners, reciprocal sharing of resources, and open communication, punctuated by occasional shrewd negotiations.

It was a good match when the University Musical Society (est. 1944), a mid-century era performing arts organization, and ACCESS (est. 1971), a social service agency, turned to each other at a time when both were ready to invest in a partnership. Each needed the resources the other possessed. UMS had been rethinking how it defined its audience and community, and it found in ACCESS an organization that had a long extended reach into the Arab community and in a wide range of other ethnic communities in the Detroit area. Since 1987, ACCESS had increasingly invested in cultural arts programming specifically for the Arab American community. As it prepared to open its museum in 2005, it turned to forming a partnership with the long-standing UMS for expert assistance in implementing a wide range of fine arts programming.

Two Ships Meeting in the Night

The University Musical Society had previously followed a rather conventional approach to presenting, with a mix of artistic genres and disciplines. Annually, it presented seventy to eighty dance, theater, and musical performances; its Choral Union Series was in its 127th season in 2005, and the

chamber music series had a history stretching back more than thirty years. Over the years, the UMS has brought jazz, world music, mime, and African American storytelling to its performance space in Burton Memorial Hall on the University of Michigan campus. During the five-year period from 1999 to 2004, it showed marked success, with substantial increases in its contributions (19 percent average annual increase) and small growth in its program income (3 percent average annual increase). Its strategy for nearly two decades had been to engage in both national and local partnerships, which included seeking and enabling involvement by the diverse communities found in the Detroit region.

This community-involved approach began in 1987, when the newly appointed president and chief operating officer of University Musical Society, Kenneth Fischer, began to think differently about audience and community as a result of interactions with some of the top leaders in the performing arts field. What he found through an informal survey of these leaders made him rethink the meaning of audience and community relationships:

> First of all, [these leaders] understood that this is a business that's very local; you know, each of our communities is different. So when I sat down with, let's say, Ruth Felt of San Francisco [Performances] and said, "Ruth, tell me how you do it," she'd laugh and say, "Well you know Ken, San Francisco is probably very different from Ann Arbor, so I don't know that what I do here would necessarily work there; but might I suggest some questions you ought to ask yourself?" And what really stimulated me was the consistency of the questions that these great presenters were suggesting I ask myself; and these questions were: How do you define your community? How well are you serving your community? What are you doing to advance the art form? How are you engaging your audience with the art? What are you doing for young people in the community? Well, I got to tell you, I wasn't thinking about any of those kinds of questions. I thought my job was to make sure that I kept bringing Jessye Norman and the Berlin Philharmonic into town, and everybody would be happy. (Fischer interview 2005)

This questioning began a process that led to a transformation of the University Musical Society and to an expansion of its view of community beyond just "people who attended concerts":

> These questions then led to discussions among our board of directors about growing, diversifying, becoming a more interesting organization and one that would "be serving the community" in a different way. So, I mean that just led to then asking a whole set of different kinds of questions. We came to realize there were communities in our midst with a rich cultural heritage who not only didn't feel welcomed at the Musical Society because of the narrowness of our point of view about

music or dance, but actually some felt discriminated against—you know, that [the] Musical Society really didn't want them around. And it took a little while to come to understand that's the way people felt, and we undertook actions and strategies to change that. (Fischer interview 2005)

Through the partnership and a lot of hard work, UMS redefined its interaction with the local community and established more direct contact with the communities found in and around Ann Arbor. It began to focus on building relationships with the people living and working in geographic proximity to the organization and on presenting art from their cultures.

Around the same time, the Arab Community Center for Economic and Social Services (ACCESS), whose core purpose was rooted in the field of health and human services, began to invest in cultural arts programming. ACCESS was founded in 1971 as a community-based health and human services organization, addressing the needs and aspirations of Arab immigrants and native-born Arab Americans. Its programs have expanded over the years to the extent that, today, ACCESS is the premier Arab human services organization in the United States. Its Cultural Arts Program was established in 1987 to provide the Arab American community with "culturally relevant programming and exhibitions." The focus has been on the celebration and presentation of the arts and culture of the Arab and Arab American world. The East Dearborn Arab International Festival, Concert of Colors, World Music Festival, Cinco de Mayo/Umsiyyah Fanniyah (a celebration of Arab and Latino music, poetry, and art), and educational workshops and presentations about the Arab world, Arab Americans, and Islam have been among the programs and projects developed by the Cultural Arts Program since its inception. The Cultural Arts Program director, Anan Ameri, describes how the program originated:

When I came in 1997 the program was . . . two people. Cultural Arts had a couple of rooms in the administrative building of ACCESS, and out of these two rooms . . . we organized exhibits, we organized concerts, we organized touring—but we were limited because we didn't have a facility. So we became art presenters more than an art organization, because we didn't have a facility. If we wanted to do a concert, we had to go to another facility. . . . If we wanted to have a library, [to] start collecting archives about Arab Americans, we had no place to store it. (Ameri interview 2005)

Through its Cultural Arts Program, ACCESS optimized its existing partnership with the multiorganizational consortium known as New Detroit, founded in the wake of racial disturbances in 1967. New Detroit is a multicultural network of "about seventy organizations of every ethnic

group that you can think of in Detroit," according to Ameri. ACCESS's involvement in the network brought a citywide participation in its cultural arts programs.

> New Detroit was created by businesses concerned about the well-being of Detroit. . . . [T]hey've tried to attract business back to the city. The director of ACCESS connected with these people [in 1994]. He sat on their board and they came up with two programs together. One of them is the Concert of Color and [the other] Cultural Immersion Program. The Cultural Immersion Program is purely educational, where people sign up for it from the different corporations, and they spend a whole day in each community where they learn about the culture: one day with Arab Americans, one day with Latin Americans, one day with Native Americans, African Americans, etc. And then we came up with Concert of Colors. Concert of Colors was a one-day program of five performances of [each of] the major ethnic groups in the city. Then, when Detroit celebrated its three-hundred-year [anniversary in 2001], we decided to go back and be part of that celebration and do a three-day festival. It was so well-received we decided to keep it. And I say for us [such] things work as a process. When we said we want to be part of the multicultural Detroit celebration and we can put on a three-day music festival, you know, I don't think we had in mind that we would do it every single year, [but indeed have done so]. (Ameri interview 2005)

Because ACCESS found new resonance for its cultural arts programming in both the Arab community and the larger multicultural network of groups in the Detroit area, it undertook a plan to build its own facility. It was this plan that originally drew ACCESS to UMS, and it was the three-day festival that put ACCESS on UMS's radar screen. The seed of partnership took root at a time when UMS was deeply involved in efforts to diversify its music repertoire in order to attract new audiences to its events and to involve community leaders in its organization.

Anatomy of the Partnership

Ameri and Fisher each echo the key points of choosing the right partner discussed earlier in this chapter: reciprocal exchange and open communication. Their accounts show how two organizations with different but complementary aims can work effectively together. According to Ameri, the first element of forming a participation-building partnership is that it "has to be win-win situation. . . . If both parties are not going to gain something out of it, then forget it. . . . Number two is that the mission[s] of the two parties should somehow meet." A third point is that the terms of the agreement between the parties should be clear—reduced to a

written agreement if at all possible. "People don't like about to talk about money, and they don't like to talk about who's going to do what. [But], if these terms are not clear, then I don't think people can have a . . . successful partnership." It was this forthright approach that Ameri brought to UMS.

The University Musical Society did not have any history of work with Detroit's Arab community. Moreover, until 2003 and its partnership with ACCESS, it had never presented music of the Arab world. When Ameri pointed this out to Fischer at UMS, the two leaders agreed to work together to craft such a program. They jointly developed a grant proposal that resulted in full funding to implement the project, and ultimately they were able to bring the world-renowned pan-Arab musician Simon Shaheen to the university for a three-week residency under the collaborative canopy of ACCESS and the Musical Society. Project funding also enabled ACCESS and UMS to commission a new work by Shaheen that was performed in Burton Hall by Shaheen's ensemble, complemented by the performances of three Arab American musicians from the Detroit area. Fischer describes how the emerging process of partnership was built around trust, respect, and communication:

> We've worked with a lot of other partners, but ACCESS has always impressed us as really knowing about what makes for a successful partnership. You've really got to know each other; you will have had other experiences with each other on one another's turf; you will have built a sufficient level of trust and respect; and then you're going to know if you want to go the next step. So it's like . . . dating—moving to more serious dating, and then an engagement and then marriage. . . . One of the things I've always liked about working with ACCESS is that we ask each other the good questions—What do we want out of this? What do you want? What do I want? What do we want together? And how do we make it happen? (Fischer interview 2005)

The relationship that developed during the Shaheen residency led the two organizations to raise funds together, as well as to exchange two other, possibly more valued, resources—leadership and expertise—at the same time that they were implementing the Arab music series and opening the first-ever Arab American National Museum. According to Fischer:

> As we were implementing the Simon Shaheen residency, we were also planning for the Arab World Music Festival, which took place [in 2004–2005]. So we were executing one project while we were planning another. . . . We saw the Simon Shaheen project as the first step in deepening the relationship and . . . the Musical Society continuing to educate itself about Arab music and the Arab countries with ACCESS's help. [However,

ACCESS was deeply involved in its own efforts to build the museum.] So what ACCESS made clear was: "We want to help you here, but we're going to be opening the first Arab American national museum in May of '05 and we're going to have to be focusing most of our attention on that. So we can help you, but we need to get you involved with others." And one of the outcomes of that was the creation of an honorary committee, probably sixty or seventy people, eighty percent of them from the Arab community—[this was expertise and] people we didn't know before [and] ACCESS introduced us to them. . . . What was clear was that the Musical Society wanted to learn much more about the Arab world, about Islam, about Arabic music. We had a lot to learn, and ACCESS could be a good teacher for us. And . . . ACCESS wanted to learn how to put on better shows . . . better technical shows, and they said: "You know, you guys have been in the business a long time. Maybe you can help us learn how to do this." (Fischer interview 2005)

> We ask each other the good questions—What do we want out of this? What do you want? What do I want? What do we want together? And how do we make it happen?
>
> KENNETH FISCHER

The spirit of reciprocity, evident through the exchange of leadership and expertise between the young museum and the established musical society, helped each partner transform its own organization. With the help of the museum, UMS was able to carry out a program series of Arab music. Even more importantly, it was able to bring an array of Arab American community leaders into its fold to perpetuate its commitment to the music of the Arab world. At the same time, UMS was able to help the newly established museum to professionalize its own efforts.

ACCESS's newfound capacity to mount programs from its own facility has not kept the Cultural Arts Program from engaging in partnerships. The Arab American National Museum (AANM), located the Detroit suburb of Dearborn, opened its doors in May 2005, attracting 30,000 visitors during its first year of operation and 47,000 the second year. It houses permanent historical exhibits, an auditorium and gallery space for temporary exhibits, classrooms, conference rooms, a library and resource center, a community courtyard, and a gift shop. The stated mission of the Arab American National Museum is to "document, preserve, and educate the public on the life, history, culture and contributions of Arab Americans" and to "serve as a resource to enhance the knowledge and understanding about Arab Americans and their presence in the United States." Its exhibition schedule of contemporary art premiered with In/Visible, an exhibition of art by first- and second-generation Arab Americans. A public symposium, entitled "Exploring New Forms and Meanings: The Intersec-

tion of Audience, Ideas, and Art," accompanied the exhibit opening and offered presentations, lectures, and open discussions by participating artists. AANM continues to rely on partnerships as one means of maintaining diverse audiences.

THE CITY OF PASADENA AND ARMORY CENTER FOR THE ARTS

Partnership as an Incubator for Citywide Arts

The final case considered in this chapter exemplifies organizational transformation through establishing and maintaining a network of partnerships among arts, social service, and education groups, each of which shares space in a municipal facility managed by the Armory Center for the Arts. The organization, known today as the Armory, began in 1947 as the education department of what was then the Pasadena Art Museum. It underwent several iterations until it became independent of the museum in the early 1970s. According to its executive director, Scott Ward, success is something that you let happen: "There's a kind of beauty to the chaos of how a dream takes you, however corny or organic it sounds. I think one of the routes to success is to allow the opportunity just to come along; [allow it] the time and the space to see if it will come to fruition" (Ward interview 2005). This philosophy guides how Ward and the Armory staff work with their city and a number of organizations in a network of partners.

The city of Pasadena helped create such an opportunity. The city offered the organization a thirty-year lease on a fifty-six-thousand-square foot city-owned building that had once housed the National Guard Armory. The agreement began as an exchange with the city—cultural programming in trade for use of the building. This opportunity led to a transformation of this arts education organization into the Armory Center for the Arts. The expanse of space allowed the organization to recast its mission of community service through arts education to include creating and sustaining an elaborate network of interorganizational partnerships in pursuit of expanded participation. California's fiscal crisis meant an abrupt decrease in support by the California Arts Council. In the wake of the crisis, the Armory Center saw the opportunity to expand its support of other organizations. Such interorganizational partnerships have now become a participation-building project in their own right.

The new mission recast the way in which the center has used its facility in service of the arts in Pasadena and surrounding communities. Rather than focusing on income-producing efforts such as space rentals,

they chose to serve as an "arts incubator" that lends support to struggling groups. As Ward notes,

> [I] became aware that, . . . by simply inviting organizations into our building, we could (help) make those organizations stable. . . . It allowed the Armory to expand the number of people we were reaching, expand the breadth of who we were reaching in terms of the diversity of those folks, and for virtually no cost at all. . . . So we were able to add a theater component, [a] filmmaking component, artist studios; [we were also able] to work with dance and music organizations, to work with AIDS service organizations. And again, through that "gesture of space" we were able, in a stable fashion, to provide services to the community. (Ward interview 2005)

One of the Armory Center's enduring partners is Side Street Projects, originally founded in Santa Monica to help talented emerging artists generate income. Side Street Projects codirectors Jon Lapointe and Otoño Luján described their organization as experimental. According to Lapointe,

> We really believe in lighting the fuse, in a sense, to try out new models. . . . The projector rental program is an example of that. We identified a need in early 2000 for video art; a lot of projection-based stuff was becoming increasingly popular with young artists, and I am speaking of [those young artists less than] ten years out of school. And video projectors are expensive to buy and to rent. So we worked with Epson to get a slew of projectors donated that we loan to artists, depending on their need. (Lapointe interview 2005)

Side Street also coaches emerging artists in such nuts-and-bolts activities as how to write a compelling proposal, prepare an effective résumé, and make professional presentations. The organization also acts as the fiscal agent for individuals whose lack of nonprofit status would otherwise render them ineligible for philanthropic support.

Speaking of the work of Side Street Projects and a number of other organizations that relocated and now occupy rent-free space in the building, Ward notes:

> There's a kind of synergy that begins to occur when a variety of activities are all under a single roof. So . . . there's more opportunity for collaboration, there's more opportunity for a kind of cross-pollination, there's more opportunity for cost efficiencies. Part of what we get out of it frankly comes from an expanded sense of mission. . . . So what we really started to take on as part of our mission was the general community arts health of our city; and we continue to be both a catalyst and convener in that sense. (Ward interview 2005)

This arrangement with arts organizations is a win-win situation. The synergy feeds back into the Armory Center's core education programs, which have traditionally taken place in neighborhood-based sites. The success of housing several organizations that nurture each other and generate a broader collective audience has come from its relationship with the city of Pasadena. The Armory Center has since embarked on an expansion program to underserved communities in Pasadena—leading community development efforts by taking over other abandoned or underutilized facilities identified by the city and renovating them for small, neighborhood-based arts groups free of charge. Ward explains that the expanded mission of the Armory Center for the Arts is to "plant programming inside underserved neighborhoods, [and] to use those organizations to more profoundly serve those neighborhoods." (Ward interview 2005)

CONCLUSION

Although partnership is a term with broad application, the successful partnerships discussed in this chapter are the result of very specific choices. First comes choosing the right partners, followed by an assertive choice to be involved in a reciprocal relationship that is characterized by a sense of equivalency, trust, and open communication. Reciprocity is a state of sustained give-and-take. Organizations identify the resources they have and the resources they need in order to make a partnership work. Partners have to share a sense of trust and believe that the common good will be the primary criterion in all individual and collective decisions. To facilitate partnership, an ongoing vehicle must be in place to stimulate and encourage open communication so that each of the partner organizations can be assured that their needs will be met and that obstacles will be addressed. It is worth repeating that different organizations participating in a partnership need not seek the same outcome, but the aims each pursues must be complementary, clearly stated, and directed toward a collective end.

Each of the partnerships described in this chapter involved organizations cooperating to build participation in the arts without cost to the individual participants, as a service distributed for the larger public good. Yet even successful partnerships do not always become self-sustaining. They require patronage from individual donors, foundations, corporations, or government sources. Moreover, these partnerships were often dependent upon strong and persistent leadership. No matter what degree of inter-organizational equivalency was established at the start, once the partnership was underway, these leaders had to be able to communicate the im-

portance of a shared future in order to persuade other members of their organization that partnering is better than going it alone.

Successful partnerships can lead to more effective program delivery, enhancement of a core or auxiliary artistic program, program expansion, increased organizational capacity, or even the transformation of an organization. The bigger story of the relational strategy of building partnerships is found in the partners' increased ability to distribute more broadly the public goods associated with their specific artistic purpose. The story is also in the potential for the partnership to stimulate and enhance other public services, including reaching youth, promoting adult health care screening and health literacy, building tolerance of cultural difference, and supporting neighborhood-based community development efforts.

5 Building Youth Participation

BETTY FARRELL

I enjoyed working with artists in residence; I hadn't had that opportunity before. We got to work with two artists from Puerto Rico to create a public art project. They came in and we helped them come up with the idea and worked with them over time. As corny as it sounds, it makes you feel important as a teenager to work with a major institution's public project. I had been to the Walker before—seen 'Cherry Spoon.' But, yeah; that's about it. [Working with the Teen Arts Council] gave you a sense of responsibility at a time when you were starting to want that and you were not necessarily given that. A rewarding responsibility, rather than a dead-end job.

—MIKE, A VETERAN WALKER ART CENTER TEEN ARTS
 COUNCIL MEMBER (2005)

Mosaic [Youth Theatre of Detroit] has taught me how to be me. Before Mosaic, I wouldn't talk to many people and couldn't sing in front of people without being nervous. *Now That I Can Dance* gave me a sense of confidence and a more positive attitude about what I can do in life. Another great thing about Mosaic is that we have so much fun and still get our work accomplished. It teaches us young artists how to manage our time, something we'll definitely have to do when we reach college.

—TANGELA, ENSEMBLE MEMBER OF THE MOSAIC SINGERS,
 PART OF THE MOSAIC YOUTH THEATRE OF DETROIT, QUOTED
 IN "MOSAIC"

One thing about teenagers is that this is a stage when we're just realizing who we are and what our talents are. We will be realizing that for the rest of our lives—but you just want to be really

creative and get out there and do what you want to do. A lot of places are looking for teens. And one thing that any class or workshop that is working with teens [has to do] is to be able to respect our creativity, like ISH did. . . . They'd say, 'OK, here's the move; go ahead and try it.' And we just got out there and eventually we got comfortable. They just pushed us through their energy. . . . We learned the steps by watching and practicing and being supportive and using our creativity.

—TEGAN, A TEEN PARTICIPANT IN THE ISH INSTITUTE, A BREAK
DANCING/BEAT-BOXING/SPOKEN-WORD WORKSHOP LED BY A
GROUP OF AMSTERDAM ARTISTS, CHILDREN'S THEATRE
COMPANY (2005)

"It's modern, unpredictable, fun, eclectic." If this describes your cultural organization, you may already have a sizable audience of youthful participants. For many, however, attracting teenagers or families with young children or even young adults in their twenties and early thirties presents a daunting challenge. Despite the fact that all adults once passed through these life stages themselves, the pace of social change in the early twenty-first century makes the world of contemporary youth feel like a foreign country.

We live in an era and a culture in which youth is a potent economic and social force, in terms of young people's capacity both to define fashion and to set the standards of taste culture. Marketers have identified preteens (ages nine to twelve) and teens (ages thirteen to seventeen) as a primary, trendsetting consumer group, and marketing to young people is now big business, as the many current books trumpeting this fact would suggest (see, for example, Siegel, Coffey, and Livingston 2004). Economist Juliet Schor argues that "kids and teens are now the epicenter of American consumer culture. They command the attention, creativity, and dollars of advertisers. Their tastes drive market trends. Their opinions shape brand strategies" (Schor 2004, 9). Although middle-aged baby boomers continue to dominate the consumer market through their sheer demographic size, as they have done since they gave definition to "youth culture" in the 1960s and 1970s, it's not surprising that today's youth should be another targeted audience of marketers. Since the early twentieth century, the prevailing ethos of commercial culture has been entertainment and spectacle, and the young are the most attentive audience for what's new, entertaining, and stimulating. It is against this backdrop of the social, economic, and cultural power of young people that cultural organizations have also set their sights on increasing their numbers of youthful participants,

including children, teens, and young adults. Why, how, and with what consequences is the subject of this chapter.

WHY YOUTH?

The rapid aging of the audience for the arts has been the subject of journalism articles and social science research for over a decade. The research division of the National Endowment for the Arts has tracked this phenomenon in its surveys of public participation in seven benchmark art forms—classical music, opera, theater, ballet, museum-based visual art, jazz, and Broadway musical theater—in 1982, 1992, 1997, and 2002. The general trends point to arts audiences who are aging faster than the population as a whole. Although education remains the best predictor of participation in any of these art forms, age also matters—with older people attending all of the art forms (except jazz) more often than younger people of the same education, income, gender, and marital status levels (Peterson, Hull, and Kern 2000, 2–9). Fewer of those who attend the performing arts buy subscription season tickets, one of the standard means by which symphony orchestras, theaters, and ballet companies have traditionally met their operating and production costs. Younger audience members have tended to be more sporadic in their attendance patterns and less willing to commit their financial resources to full subscription programs. They are also much more likely to have cultural tastes for a wider range of cultural genres and experiences (Peterson and Rossman 2005).

Nevertheless, the young remain an important target audience for cultural practitioners from all fields. They represent the audience for now and in the future. They often have the leisure time and disposable income that older adults—with jobs, mortgages, and family responsibilities—lack. They are also at a stage of life when they have and are receptive to creativity and fresh perspectives. Their energy and inquisitiveness and willingness to take risks are the same qualities that many artists share. They are therefore a particularly appealing group for arts organizations to tap as their newest audiences and participants. This chapter begins with a focus on relationship building among teenage participants in arts programs and cultural organizations. It will also address the special challenges of engaging young children and families, as well as young adults. Each of these life stages involves different developmental and social issues, and each is a different niche market that organizations must address independently as they seek ways to attract a wide age-range of young people in the present and to sustain their participation for the future.

TEENAGE ARTS PARTICIPANTS

Teens, Consumer Culture, and Social Change

Teenagers represent both the greatest challenge and the greatest promise for arts organizations seeking to expand their reach to young participants. Although reaching families of parents and young children and groups of young adults is also a goal of many arts organizations that will be discussed later in this chapter, teenagers—poised between childhood and young adulthood—occupy a special space of paradox. They are already powerful consumers and cultural tastemakers, yet they are also psychologically and socially malleable—in the process of forming identities and in need of both structure and freedom. According to a report from the Surdna Foundation,

> Teenagers live in an environment filled with extraordinary pressures to conform. At a stage in life typically filled with uncertainty, bravado, disillusion and passionate discovery, the dominant culture—and especially the mass media—exert a homogenizing impact on the formation of identity. A recent study of 27,600 teenagers in 45 countries found "the single most significant factor contributing to the shared tastes of teens surveyed was TV—in particular MTV—which 85 percent watched every day" and which the study called "a public address system to a generation." (Levine 2002, 12–13)

But contemporary teens are not simply the passive recipients of mass media products. They are also actively engaged in the creative and interactive opportunities afforded by the Internet and digital technology. Some twenty-seven million people—most of them under the age of thirty—are reportedly members of the online social networking site MySpace, where they maintain home pages filled with blogs, personalized artwork, and links to other users (Williams 2005, 1, 10). According to a recent study by the Pew Internet and American Life Project, teenagers are some of the most prolific creators of new online content: "57 percent of all teenagers between 12 and 17 who are active online—about 12 million—create digital content, from building Web pages to sharing original artwork, photos and stories to remixing content found elsewhere on the Web" (Zeller 2005, 1, 18). This is a generation that has come of age with digital technology and with that technology's creative and interactive potential. One of the challenges to art organizations, then, is to tap this dynamic youthful audience, recognizing its desires for active participation and creative stimulation while at the same time providing an alternative and potentially more critical outlet for engagement and creativity than that offered by the market forces of consumer culture.

The Challenges of Art Programs for Teens

There is a high degree of consistency in the findings of a number of reports on building successful arts programs with meaningful art exposure for youth. All stress that these programs need to be specifically youth focused and involve projects that are process oriented rather than simply product oriented. They need an emphasis on high artistic standards, but with flexibility about what constitutes accepted artistic genres and practices. They need to be responsive and relevant to teens and to the issues that they, rather than even the most well-meaning and concerned adults, define as most important to their lives. And they need to promote an environment conducive to respect, tolerance for difference, active engagement, and personal growth.

Art educator Philip Yenawine (2004, 9–17) has identified twelve qualities of successful teen arts programs that relate to the structure and goals of the program, the tone it sets in working with teens, and the interactive style that is created among staff and participants. In terms of structure and goals, he notes that clear criteria for teachers and teaching must be established, especially in terms of choosing staff who "love working with teenagers"; that programs must combine guidance and independence for young people; that there needs to be a strategy in place for assessing the individual, which also involves self-evaluation; that programs need to include diversity of students and staff if the social goal of learning to participate in multicultural communities is to be realized, and if young people are to be recognized and cultivated as future workers and leaders. Such programs need to be housed in inviting buildings and classrooms—settings that promote learning and morale. In terms of the tone of programs for youth, Yenawine stresses the importance of providing a welcoming environment, policies that are transparently open and fair, and a culture of confidence building. And in terms of the style of interaction that programs promote, the most successful establish an ethos of respect throughout the organization, as well as opportunities for individual growth and for teamwork and shared responsibility.

The Surdna Foundation's *Powerful Voices: Developing High-Impact Arts Programs for Teens* concurs with many of these findings. This report observes that young people seek out art programs that provide for their artistic, personal, and social development. Programs that support them must be accessible, adhere to rigorous standards, provide opportunities for sustained contact and peer interactions, set goals, and build a sense of ownership among youth participants (Levine 2002, 7–9). Among the many organizations that have established successful youth programs that closely adhere to these guidelines, the Walker Art Center in Minneapolis

stands out for the scope and longevity of its work with teenagers. It serves as a model of an arts organization not initially set up to meet the needs of teens, which nevertheless has allowed an ethos of "youth directedness" to infiltrate its institutional mission and core programs.

WACTAC (Walker Art Center Teen Arts Council): A Case Study

Around 4 p.m., kids slowly begin filtering into the meeting room, which is lined with art books and magazines, wall art, computers, a video monitor and equipment, comfortable couches. There are snacks placed out around the room; there's some background music playing; the kids mill around, chatting with each other and with the two staff members who are present. The meeting gets started, but in a casual and fairly free-form way, led by one of the teens who has been designated as the moderator of the week. A few adult visitors are present and introduce themselves and their programs. Ideas for WACTAC programs for the 2005–06 year are tossed around. A museum curator arrives and makes a lengthy visual presentation about an upcoming exhibition, encouraging the teens to think about ways that they might participate. He's inviting and solicitous of their ideas because he knows that they have had significant success in the past in helping to create the buzz and spread the word that will draw youthful audiences. And they also have a substantial budget at their disposal, some twenty-five thousand dollars for programming and ten thousand dollars for marketing budgeted in 2005–06—not an insignificant factor for the curator who could use some extra funding to support his exhibition and its related programs.

These notes from the site visit on November 3, 2005, to the Walker Art Center Teen Arts Council (WACTAC) testify to the event's low-key, fluid organizational style, the easy camaraderie and sense of trust evident among the kids, and the clear but nondirective guidance provided by the two full-time staff members mentoring the group. All of these elements are features of a unique program that the Walker has developed and refined over the past decade. It is now an established program, but one that is constantly renewed by the periodic turnover of the young people whose ideas and energy are its driving force.

In the early 1990s, under the leadership of its director, Kathy Halbreich, who believed from her own experience that art could speak in especially meaningful, critical, and liberating ways to young people, the Walker Art Center launched a program to reach out to teenagers in the Minneapolis metropolitan area. The number of teens included among all visitors to this premier contemporary art museum in the Upper Midwest was negligible in the early 1990s, and Halbreich believed that this could be changed. Contemporary art, after all, with its emphasis on cutting-edge ideas and

images, experimental forms, and challenges to the status quo should hold an innate appeal to youth, who are champions at questioning established conventions and traditional hierarchies. The mission statement of the museum and for the new program reflected this potential symmetry:

Organization Mission Statement:
Walker Art Center, formally established in 1927 as the first public art gallery in the Upper Midwest, is a catalyst for the creative expression of artists and the active engagement of audiences. Focusing on the visual, performing, and media arts of our time, the Walker takes a global, multidisciplinary, and diverse approach to the creation, presentation, interpretation, collection, and preservation of art. Walker programs examine the questions that shape and inspire us as individuals, cultures, and communities.

Teen Programs:
Teen programs create and support the interactions with and connections to contemporary art, young people, and artists of our time. Teen programs seek to provide vehicles and resources for young people ages 14–18 to safely ask complex questions, voice their own ideas and opinions, and explore their critical and creative potential. (Walker Art Center 1999, 1)

The Walker staff first began a year-long study group with representatives from social service agencies and organizations dealing with adolescents. According to Kathy Halbreich, planning for and generating ideas about teen programs required her to set aside several hours every week for nearly a year so that she could build relationships with and gather information from the community-wide working group she had assembled:

There were people from the park board; there were people from an education organization that served gang members; there was a local public television station. We met every Monday for three hours. And people kind of filtered in and out . . . [as] we met for a year. For a year, we actually studied together from various points of view. We had a psychologist come in who studied what attracted teens' attention; we had someone who studied suburbs and what life was like for kids there. We did this all together. Robin Hickman went on to do a program with the local television station called "Don't Believe the Hype," which was made by kids—City, Inc., . . . an organization that served and helped transform the lives of kids who were involved in gangs. (Kathy Halbreich interview 2005)

This kind of local interaction was built around organizations and leaders who shared common concerns about youth and who were willing to dedicate time and energy to build alliances with like-minded leaders. As this account suggests, both formal and informal interaction across organizations and with experts who have studied their local communities

helped to give shape to a program designed to attract a new audience to the Walker.

Such long-term commitment with local organizational leaders has not traditionally been part of the job of a director of a cultural organization. Indeed, several board members questioned why Halbreich felt this was important. From her perspective, however, "this is really the foundation for our work with teens in the community. And I hoped that we will go on and reinvent the world together" (Halbreich interview 2005).

In addition to working closely with the community organizations serving youth, the Walker staff also recognized early on that they could not create a program for teens without the active engagement of teenagers themselves. They did not know at the beginning, but learned by trial and error, two crucial lessons: "Teens want, need, and may demand input in the process, not just the product. Allow them to participate in shaping and running the project." And "the social aspects of a program are a critical part of the process. Often the most exciting thing the kids get out of a project is meeting other teens with different backgrounds and interests" (Walker Art Center 1999, 3).

The program that evolved in 1996 after two years of study and experimentation was the Teen Arts Council, popularly known as WACTAC—a group of twelve teenagers from diverse backgrounds, with interest but not necessarily experience in art, and representing a range of high schools across the Minneapolis metropolitan area. Their primary task was defined as marketing the Walker to their peers and encouraging more participation by youth in the museum. To this end, they planned their own programs, including a biennial WACTAC-curated teen visual art exhibition and performance (Hot Art Injection); they invited artists to talk, perform, and conduct workshops; they participated in projects with resident artists; they published their own arts zine, called *Fig. 12*; and, in general, they provided a teen voice and presence to the work-in-progress at the Walker.

One of the important institutional commitments to the success and longevity of the teen programming at the Walker Art Center was the decision to support full-time staff for the youth program. There was strong top leadership commitment from the outset, yet the kind of widespread and deeply rooted commitment throughout the institution that has come to epitomize the Walker's work with teens was only built over time. Christi Atkinson, the associate director of education and community programs who has worked with the Teen Arts Council since its inception, described the evolution of this institutional conversion as a product of WACTAC's successes in consistently selling out their events and generating good attendance at any exhibit they helped promote. In planning the 1997–1998 activities, for example, Atkinson notes,

[T]he teens said they wanted to bring in the [artists/activists] Guerrilla Girls, and I remember the curators all rolling their eyes—"Oh my god, they're so '80s!" But they decided to stay out of it and, you know, it sold out. . . . Now the curators actually approach the kids and say, "Do you want to be involved with my exhibition? Will you curate the opening night party events? Create the soundtracks for the exhibition?" . . . The teens have got an incredible amount of freedom now because they have such a good track record. . . . Since the Teen Arts Council has been working, teen attendance is now about 10 percent of our total audience—that is, seventy thousand teens, not including school groups, who now come to the Walker annually. (Atkinson interview 2005)

Despite the track record and the successes, despite the high level of institutional commitment to see programs for young people succeed, despite the work to create the substantial investment in an infrastructure needed to support them, teen programs housed within a large arts organization always present challenges. The Walker's "Teen Programs How-To Kit" provides useful cautionary advice for organizations who are just setting out to develop or expand their youth programs:

> Your success will depend on having the following elements in place:
> - *Awareness* (Develop support within your organization. Chances are good that your work with teens will have a ripple (or tsunami) effect throughout the institution—from security staff who want to know why teens are wandering the halls to your director who may start getting unsolicited letters about how to improve things.)
> - *Experienced Staff* (Engage people who can work well with teenagers and have good negotiating and organizational skills. Know how to identify such people.)
> - *Time* (Expect that working with teens will be labor-intensive and will always take double the number of hours you think it will.)
> - *Willingness to Learn* (Learn from the teens and be sure to acknowledge your own mistakes.)
> - *Funding* (Get some! Think about what it will take to support the scope of your program.)
> - *Know Your Teens* (Begin by asking the big questions. Who will your program target? All teens? Some? "At-risk" youth, HIV-positive teens, pregnant teens? How old? What geographic parameters? Become involved with your targeted group by reading their high school newspapers, spending some time with them, watching MTV. Find out how you can connect with them. Ask them what juvenile programs, schools, or community centers they're involved with.)

- *Know What You Can Do* (Stick to your limits. It took the Walker three years of research and experimentation before hitting on its most successful program to date—we created a teen advisory body, the Walker Art Center Teen Arts Council, affectionately known as WACTAC.) (Walker Art Center 1999, 2)

WACTAC staff members have learned from experience that there are institutional parameters that need to be respected, and that no teen program can be structured without some limits. When a teen-inspired marketing brochure for the first Hot Art Injection exhibition in 1996–1997, featuring Michelangelo's *David* holding a syringe, was institutionally rejected as inappropriate, the teens, not surprisingly, experienced this as an act of censorship. They responded by making buttons that read "Boring and Not Offensive," which, according to one veteran WACTAC member, nine years later have been turned into a T-shirt logo sold in the museum gift shop (Emmett interview 2005). Staff also learned that dealing with teens involves the unpredictable. Although a Walker-sponsored public art graffiti project called for graffiti competitions (Below the Belt: Battle of the Underage) and graffiti were prominently featured on the Walker Art Center Teen Programs brochure, no one at the Walker anticipated finding impromptu graffiti added to the museum's bathroom walls. Even a staff experienced in working with young people overlooked the fact that a WACTAC-sponsored event with the renowned skateboarder Ed Templeton would bring in many teens with their own skateboards—and an aggressive response by the museum guards who didn't want to let them in.

> We forgot to sit down with [the new batch of guards] and say, "We've asked all these kids to come; they're all going to be skateboarders; and they've never been in a museum before, so they won't know what the rules are. So we need to be gentle with them and be ready to send a lot of them back to check in their stuff at the lockers." This kind of thing is constant, but you kind of forget. (Atkinson interview 2005)

Many of the same themes sounded by the Yenawine (2004) and Surdna Foundation (Levine 2002) reports about the necessary ingredients for successful youth arts programs were reflected in our interviews with and in writings by the Walker staff, best summarized by their emphasis on empowering teens (with the proviso that this will inevitably mean negotiation, dialogue, and sometimes compromise), trusting them with money and real responsibilities, and allowing them—with guidance—to make the kinds of decisions that they define as most relevant to their lives. The outcome at the Walker Art Center has been a teen program that has been

transformative—to the institution, which has incorporated the WACTAC teens as full-fledged staff members and is now a more welcoming environment for teen visitors; to the curators, who like the energy that the teens bring to the Walker and the way their presence keeps things new and a little different; to the artists in residence, who rate the experience of working with teens as the best part of their residency; and to the teen participants themselves who have made full use of their "freedom within a structure" to explore their creative capabilities, to tackle important and controversial issues that are often off-limits in school, and, in the process, to help shake things up.

> *Thrill Ride!* Hey kid, tired of sitting at home watching the same Puff Daddy video on VH1? Do you find yourself wishing that you could experience the Easy Rider, free love, and rock-and-roll days your parents once did? Well, cheer up, all you little vatos and chivatas! Free *Jimi Hendrix* and *Charlie Parker* music is just around the corner! With large bean-bag chairs to lounge in, you can check out music as well as hip 1960s videos and magazines. While relaxing you can also check out the old school Pop Art of *Roy Lichtenstein* and *Andy Warhol*. With so much cool '60s stuff you might just have a natural trip . . . Maybe. So stumble down to the *Walker Art Center*, and show that I.D., so you and a pal can get in *free*. We've got the lounge space you're looking for, and remember we accept ugly kids, too! ****Free with High School I.D.****(WACTAC zine, *Fig. 12*, issue 5 [1998], 9)

Other Teen-Oriented Arts Programs

Arts organizations of all kinds—large or small, downtown-and-established or community-based, and spread across all genres of the visual arts, literary arts, theater, dance, and music—have taken seriously the challenge of attracting more teenagers to their exhibitions and programs. Not all share the Walker Art Center's qualities of deep commitment on the part of top leadership and widespread staff commitment, or have its level of committed infrastructural resources, or offer the kind of cutting-edge contemporary art and programs that have an inherent appeal to young people. For some, teen programs are at the core of their organization. For many others, these programs are new and relatively tentative additions to an ongoing organization that must adapt in a variety of ways to become more teen friendly and accessible. Some cultural organizations have been led to establish teen programs not because of their original institutional mission but because of the powerful lure of foundation-grant initiatives or by the same recognition of the financial potential of the burgeoning youth market that has caught the eye of commercial marketing researchers. Each organization has it own set of issues relating to its particular history and mission that make the project of attracting, retaining, and incorpo-

rating teenaged participants—who are often noisy, demanding, and prone to asking difficult, critical questions—especially challenging. Nevertheless, there are many creative efforts and experimental programs across all types of arts organizations that are attempting to meet these challenges. The following examples are offered as a small sample of the many varied efforts being made to engage teens in the arts.

Teen Programs in the Visual and Media Arts

AS220 (Alternative Space 220) is an artist-run organization in Providence, Rhode Island, that, for more than twenty years, has provided an open, nonjuried forum for exhibitions and performances, a residency program, youth programs, a café, and a live/work studio space for artists. Founded by artists Umberto Crenca and Susan Clausen in 1985, its premise was to provide a creative environment where, literally, "anything goes." Its facilities and services are made available to all artists who need a place to exhibit, perform, or create their original artwork, especially those who cannot obtain space to exhibit or perform from traditional sources because of financial constraints or lack of previous experience. Its inviting openness, where people are encouraged to participate experimentally and at all levels of sophistication is, according to Crenca, part of AS220's appeal, especially to young people venturing into new forms of artistic expression:

> The mission of AS220 is to be open and un-curated and essentially accommodating. The real challenge of our organization and our staff is to be accommodating as opposed to judgmental. As a result . . . there are very few people who have requested an opportunity to do something at AS220 that have not gotten it, at least [if they're] from the state of Rhode Island, which is our primary focus. Everyone who needs an opportunity to do something gets an opportunity to do it; so you essentially continue to build your base, never reduce your base. Therefore, you're constantly growing in terms of the [number] of people who are participating and getting involved. (Crenca interview 2005)

AS220's accommodating approach is rooted in a belief in equality that permeates the organization, including the fact that everyone, from the director to the newest staff member, gets paid the same hourly wage. Few cultural organizations can claim to have sustained this kind of accommodating and egalitarian program for twenty years. Thus, part of AS220's appeal is that it is the institutional embodiment of an accessible, experimental, and creative environment rarely found by young people or adults in the bureaucratized worlds of school or work.

> AS220 is about community building. Art is the vehicle. Self-expression and supporting the individual voice and individual perception and individual

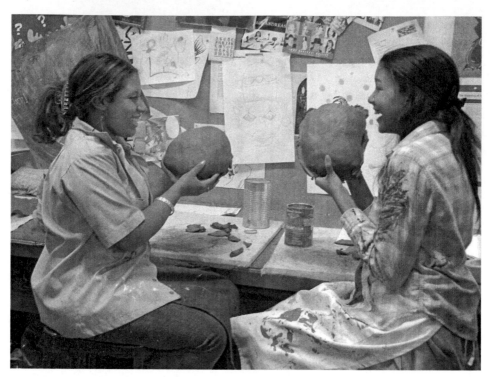

5.1 Kiara Taveras and Christel Rosario learn to work with clay through AS220's Broad Street program.
Photograph by Merrari Mckinney. Courtesy of AS220. Used by permission.

expression is the way we build community; by providing opportunity for that, by recognizing the individual, it goes a long way in terms of building community. So that's sort of underlying everything that we do. (Crenca interview 2005)

One of the community-based programs that AS220 runs is called the Broad Street Studio, which engages young people from the community, a significant percentage of whom have already become acquainted with the organization through its services to incarcerated youngsters (figure 5.1). The bond established in that setting draws kids to reconnect with the group once they've been released. The Broad Street Studio has built its program with support from other youth stakeholders: the Department of Children, Youth, and Families, parents, the public school system, and the city health department.

Well, we're working with young people. . . . So I think in every situation and every time we put our foot forward, there's a real kind of natural instinct to look at what are the relationships we need to be building? We can't

do this alone. It's not going to sustain itself, and it's not going to define it-self in the most useful way if we don't have the stakeholders involved. As a result, we end up building all these partnerships and relationships, like with the Corporation of National Service, or the Health Department, or the Department of Children, Youth, and Families, Department of Educa-tion. We have partnerships and relationships with all these people. As I'm saying it I'm impressed, but [laughs] it surprises me, because it happens in such a natural, organic way. It's the way we think. It's the way we build programs here. (Crenca interview 2005)

The focus and orientation of AS220 is on community building through a process of engagement. It's about validating creativity at every level. It's about accessibility and the cross-pollination of ideas. As such, it is a natu-ral home to young people, as well as adults, who are seeking the freedom to experiment with different forms of expression.

What people come to the table with is their life experiences—how they perceive the world through their senses and their eyes, and then what they [produce] in the form of some sort of art. How can that [life experience] be judged? Now, some people may have more technical skill than others . . . , but is my story any more valuable or better or profound than the person sitting next to me? I don't believe that, and I think that's part of the ba-sis of some of the values that we operate under, and boy it just keeps get-ting proven true over and over again because we're always constantly be-ing surprised by new ideas, new talent, new young people—and old—who come here and get an opportunity [to] tell their story in some form or an-other through their art; and you sit back, and you get blown away. (Crenca interview 2005)

If openness and lack of juried evaluation are two of the most appeal-ing characteristics of the AS220 model of an arts organization, its seem-ing opposite—an environment focused around structured training, disciplined work, and rigorous high stan-dards—can also attract youth participants to the visual and performing arts. Marwen is a free arts education program, offering studio classes in painting, sculpture, clay, photography, design, and animation for Chicago youth in grades six through twelve. Marwen's mission, according to its execu-tive director, Antonia Contro, is "to provide the highest-quality visual arts and career and college planning programs to under-served youth in Chicago after school and on weekends. . . . Our arts-based model har-nesses the natural inclination of adolescents to focus and learn, act with

> We're always constantly being surprised by new ideas, new talent, new young people . . . and you get blown away.
>
> UMBERTO CRENCA

127

creativity and conviction, and relate in socially productive ways" (Contro 2004, ix).

Marwen provides the kind of structured environment that many adolescents need for the related developmental tasks of "building identity and self-esteem, fostering positive relationships, developing the desire to learn, enhancing cognitive ability, and defining values" (Kaufman 2004, 21–23). According to Kelly Bollinger, assistant director of development,

Marwen was actually founded on the principle that communication [and] technical life skills really can be taught very effectively through the arts. So we began this after-school arts program, and basically we offer very high quality visual arts programs. We have six specialized studios, and that means that we can offer everything from . . . classic painting and drawing, photography, ceramics, sculpture, to . . . videography and animation. [There's a] huge, wide range of classes. All of our courses are taught by professional artist teachers who are working in the Chicago community—as fine artists, at architecture firms, as graphic designers, whatever. And [they] teach at Marwen on a part-time contract basis. They're paid pretty well actually. So that means that students are actually learning from people who are practicing art all day long in their [work] lives. And we're very much about long-term relationship building with students, in that our terms are each 8 weeks. Students come here for two and a half hours a week typically to participate in a course. We have a pretty rigorous attendance policy. If you miss more than two classes, you're dropped from the course. So you're welcome to come back the next time—no problems, no holds barred. You can sign right back up. But we try to instill in our students a sense of responsibility. And pretty much from the moment that students walk into Marwen, they know that they are somewhere a little different from, maybe, their schools, or other community organizations that they are affiliated with. Marwen is—our space is—absolutely beautiful. You walk into a huge student gallery that has all the work from the previous term displayed in it. Each student who has taken a class that term has at least one piece from that course on the wall. And it's installed beautifully; these are great exhibitions. And then they go upstairs or downstairs to one of our six specialized studios where they engage in real, intensive arts learning with professional artists. . . . Our college and career components evolved only a few years after our free art classes started. You know, we started seeing that the students who were coming in here . . . wanted more information about, "well, what can we do with this once we leave high school?" So we developed, slowly over the years, our college planning and career development programs, which offer a range of courses, workshops, intensive programs. We have an annual Artward Bound study trip where students go around the Midwest and visit different colleges. It's all about . . . teaching them art; but we're teaching

them life skills through art, and how then to take these skills and make them into really successful college [experiences] or careers. (Bollinger interview 2005)

With an active alumni advisory board of fourteen members (two of whom are voting members on Marwen's board of trustees) and a current student advisory board of six that work with the staff on ideas and projects, it is clear that students who do not always have the inclination or the opportunity to participate with such rigor and intensity in their schools connect to Marwen in a deep and serious way. The advisory board members have planned exhibitions together and have strategized about future projects. They also created a mural for the Marwen building as a response to being the target of graffiti, arguing that "if anybody was going to make art and put it on the walls of Marwen, then we should be doing it." The Marwen philosophy is to treat teens as individuals who are deserving of respect and professional attention. Kids are greeted with a handshake and a welcome as they come in the door. Although their parents are invited to visit Marwen, they cannot attend classes, since this is defined as the teens' space. Marwen staff members are intent on providing a different kind of experience for teens, "a really professional quality, high-level-of-responsibility kind of program" (Bollinger interview 2005). Marwen's is a different model of engaging youth in the visual arts than that promoted by AS220. But both share an emphasis on respecting young people as individuals and on providing an environment—whether highly structured or open-ended—that nurtures their creative potential and their cognitive and emotional development.

Teens and the Performing Arts

Theater and performance art have long been recognized as effective learning sites for young people outside of school. Research by anthropologist Shirley Brice Heath has established that out-of-school arts-based programs for youth provide the "roles, rules, and risks" that young people need to thrive (Heath with Roach 1999, 22). Young people who work in the arts "for at least three hours on three days of each week throughout at least one full year . . . show heightened academic standing, a strong capacity for self-assessment, and a secure sense of their own ability to plan and work for a positive future for themselves and their communities" (Heath, Soep, and Roach 1998, 2).

It's not only that they develop good communication and organizational skills, along with discipline and self-confidence. Arts programs also push young people to use their imaginations, to think abstractly, to become

real-life problem solvers, and to learn to work in collaborative environments. The programs promote ways of thinking critically and of communicating that are enormously valuable tools for life.

Two theater projects working with teens serve as vivid examples of programs that illustrate these research findings. The Mosaic Youth Theatre of Detroit, founded by Rick Sperling in 1992, provides free training for youth ages twelve through eighteen in theater, vocal music, and technical stagecraft. "Mosaic" refers to the diversity of the kids in its programs, who are drawn from all over the metropolitan Detroit region and from different socioeconomic and racial-ethnic backgrounds. The Mosaic Youth Ensemble members—thirty of whom are currently in the Mosaic Acting Company, fifty-five to sixty in Mosaic Singers, and another ten to fifteen in the Mosaic Technical Crew—are primarily African American, although the theater company recently expanded its programs and outreach efforts to Latino youngsters in the southwestern area of Detroit and to young people in Detroit's Arab American community. Mosaic's 2005 production, *Now That I Can Dance: Motown, 1962*, was an original play about Motown's early years, based on oral history interviews. As Sperling noted in an interview on

5.2 The Mosaic Youth Ensemble from its 2005 production *Now That I Can Dance: Motown, 1962*.
Copyright Mosaic Youth Theatre of Detroit. Used by permission.

National Public Radio, "[A]ll of Motown's major stars—Stevie Wonder, the Supremes, Martha and the Vandellas, Marvin Gaye, Smokey Robinson— began their careers between the ages of twelve and twenty-two. . . . I think a lot of people don't realize that these were teenagers that changed the world" (Headlee 2005).

In Minneapolis, the forty-year-old Children's Theatre Company (CTC), which has a well-established reputation of producing high-quality theater performances for a core audience of children ages four through thirteen and their families and teachers, has more recently expanded its programs specifically to address a teenage audience. In addition to the annual main-stage productions that cast teen actors as well as adult professionals, the CTC has developed a new series of performances geared for teenagers and adults. Their first production, *Antigone*, was performed promenade style—no seats, with the performers pushing through the audience to get to their performance spaces—a style that managing director Teresa Eyring described as "just a thrilling, unexpected experience for the teens who came" (Eyring interview 2005). To complement the performances, CTC also created the STAND Festival, with a series of events that included playwriting workshops and play readings by teens, spoken-word performances, multicultural music and dance presentations, and issues forums. The festival's name reflects the audience experience of standing during *Antigone* but also signifies "standing up for what you believe in— because Antigone was a teenage girl who stands up to authority, stands up for what she believes when her brother is killed and left unburied" (Eyring interview 2005).

Since that first teen-oriented program in 2003, CTC has produced plays in this series on the themes of environmental racism and environmental justice; the relationship between an African American and a Somali girl in Minneapolis; World War II and the Holocaust from the perspective of a Polish children's advocate and founder of an orphanage in the Warsaw ghetto; and—in an adaptation of *The Odyssey*—the anonymous border-crossing experience of a contemporary Southeast Asian refugee. Concurrent with each of these plays are programs oriented to teens that are intended to contextualize the plays' themes, highlight their contemporary relevance, and encourage critical dialogue.

Both theater programs share a commitment to creating high standards and expectations for the teen participants and to producing professional-quality shows. Sperling talks about being "overwhelmed by the hunger and excitement of the kids to get involved in something positive and artistic" when he and four fellow actors first began to do theater outreach programs in the Detroit public schools, 90 percent of which had no theater

arts programs of their own. Their first major play, *Runaways*—an all-teen multicultural musical—drew three hundred kids to the audition. The performance that resulted

> ended up being far better than any of us—the professional actors who were in this group—imagined it would be. . . . When the show started to get close to completion, we started to say, kind of sheepishly, "This is better than what I'm doing in my [professional work]." And it absolutely was. It was more dynamic. The talent level was equal to or better than in the professional scenes we'd been in . . . I mean, the kids were not as trained, so we had a three-month rehearsal process instead of a six-week rehearsal process. But the product we ended up with was so [great]; it just blew us away. (Sperling interview 2005)

Sperling's experience with *Runaways* acted as the catalyst for the staff of the Mosaic Youth Theatre to set the highest expectations for its youth ensemble members. The staff members believe that young people thrive when given the challenge of achieving professional theatrical standards, and that such expectations also help foster the social and emotional skills of developing disciplined work habits, effective problem-solving skills, and respect for differences among it youth participants. Teen performers interviewed during a rehearsal break for a main-stage production at the Children's Theatre Company also recognized the social and academic benefits that they had gained from their involvement in the theater:

> What's fun is that these people [the other cast members] become your best friends. . . . Other teen performers share a love for the arts and the passion to be here; most kids [at school] don't understand the stress level of performing [and of] practicing when there's lots of homework. But people here get it. (Rachel interview 2005)
>
> One of the most important things I've learned here is how to organize my time effectively. It's helped me build such a high threshold for stress. When you have ten hour rehearsals, I'm going to sit down and plan out my time efficiently, and know exactly when to do my homework, when to go to rehearsal. That makes life so much easier. (Conor interview 2005)
>
> It's funny. There have been times when I've been, like, an A/B student, and then I get in a show. And after the show is over I've got all As, because you know that you've got this show—you've got this at stake. Your parents could so easily be, like, "You're not auditioning for the next show because you didn't get the grades that we want you to get." [But] I want to be here; I want to be doing this. So, I know that I have to work that much harder to make sure that I'm not letting my teachers down, I'm not letting myself down, [and] so I can keep everything in balance. (Alison interview 2005)

132

Both theater programs involve teens working in collaboration with adult professionals. Both subject teens to intense competition in the audition process and to a rigorous rehearsal schedule that demands commitment, self-discipline, and a capacity for teamwork. Few of these young people will go on to a career in the performing arts, but all of them will have "experienced a love for the arts and a true understanding of the art—of what goes into a production, of how hard it is" (Sperling interview 2005). Gregory Smith, director of education at the Children's Theatre Company, echoed this in his review of the impact on teen participants in the ISH Institute, a summer workshop led by a group of young artists from Amsterdam who perform using spoken word, martial arts, hip-hop, break dancing, beat boxing, and a DJ-style narrative:

> [The participating] kids got to see that the arts are a discipline—that you have to work at it, that you really invest your time and your energy and your sweat and blood into creating your artwork. It was funny because, after the second day of [the ISH] dance class, I was in the elevator with the kids and they were, like, "Oh, my back is sore! I'm hurting in places I never knew I had!" And so, they were starting to get that picture of this [being] hard work. You know, a lot of time we just think about the end product and never think about the journey that you have to go on to get to that end product. And, to me, and I think to this institution, it really is about that journey. (Gregory Smith interview 2005)

Both programs have received extensive testimonials from teens about the personal impact that their participation has had, yet both organizations also understand the need to develop rigorous ways to measure and evaluate that short-term and longitudinal impact. For all of the opportunities provided by these programs, there are still inevitably many challenges, both external and internal—transportation for kids too young to drive or in cities or communities where public transportation is limited; recruitment of the very kids for whom these programs would make the most difference; and even the challenge of increased demand for such engagement by young people when the supply of programs is limited. As Sperling notes, "We can't be outreaching and turning kids away at the same time" (Sperling interview 2005).

Arts practitioners who have created high-quality programs for teens know that there is always a social services component to their work. They meet this need in a variety of ways—through strategic partnerships with social services agencies, schools, and libraries that can provide support, and through a designated staff member who is always available to talk to teens and their parents about everyday problems and who can make referrals to social services. But there will always be competing pressures on young

people that limit access or their committed participation—from the lack of family support and the disruption caused by transitory lives, to time pressures from school and work, to transportation and safety issues, to the powerful competing lures of popular culture and the consumer marketplace.

In the end, these teen-based arts programs are about creating a new kind of space—one that is nimble yet authentic, monitored yet liberating, and challenging yet responsive to the social and developmental needs of young people, while it offers stimulation, a diversity of opportunities, and challenges: "You give kids skills, but then you challenge them to take those skills and utilize their own imagination, their energy and drive and creativity, and make it what they want it to be. They get to drive the car; we just put the gas in it for them" (Gregory Smith interview 2005).

The programs also offer a kind of critical space that is rarely available to young people in other parts of their lives. Kathy Halbreich, former director of the Walker Art Center, notes:

> One kid said to me, "You keep asking us to ask questions, but nobody has ever taught us how to do that before." And I think these kids bond to this institution because we give them permission to ask questions—and we are actually quite insistent in trying to teach them how to frame their questions; not the *right* questions, but *good* questions. . . . And it is a bit of a cliché, but I really hope we can teach them to be really good questioners and consequently really good citizens. And feel like they can make a difference. Because I think what has happened in our country, particularly among the disenfranchised, is the loss of hope. . . . And a tiny little program like this can really have a profound impact on twelve or fourteen kids' lives . . . and they, then, are the ones who go out in the community and seduce their brethren. And I like the fact that it is about relationships. (Halbreich interview 2005)

> You give kids skills, but then you challenge them to take those skills and utilize their own imagination, their energy and drive and creativity, and make it what they want it to be.
>
> GREGORY SMITH

ENGAGING FAMILIES WITH YOUNG CHILDREN

Attracting more teenage participants to the visual and performing arts and engaging them deeply in positive creative experiences are not the only challenges that arts organizations face. Indeed, many have recognized that the task of building future participants and audiences for the arts needs to start at much earlier ages. The 2004 RAND study *Gifts of the Muse: Reframing the Debate about the Benefits of the Arts* makes a strong case for recognizing the intrinsic, as well as the instrumental, benefits of the arts—the former including the experience of captivation and pleasure, the increased

capacity for empathy on the part of the viewer, the creation of social bonds and the expression of cultural meanings that art can confer (McCarthy et al. 2004). Intrinsic benefits are what actually draw people to the arts and encourage their sustained participation. The authors of *Gifts of the Muse* therefore conclude by calling for strategies to support lifelong involvement in the arts. Starting early with programs for preschoolers and young children—and simultaneously engaging their families and teachers who will support and sustain these efforts—is a crucial first step in that process.

Researchers and arts practitioners agree that, just as with teenagers, young children need access to high-quality art that is not dumbed down. The Children's Theatre Company in Minneapolis, which has a long track record of creating quality programs for children ages four through thirteen and their families, believes that children deserve the very best art—even better than what adults might get, given adults' more developed capacity for aesthetic judgment and making critical distinctions. Managing director Teresa Eyring argues that

> theater for [young] children [can] in some ways [be] more imaginative—there are more risks you can take artistically because children are less conservative than adults and children are willing to take certain leaps of faith in storytelling that adults sometimes are not. But, that said, I also think that if you are going to try to attract families [and older children], then it's really important to try to do good work and do work that isn't just storybook titles, but also plays that have to do with current themes and current stories that aren't being told. (Eyring interview 2005)

CTC has recently launched a program for preschoolers, introducing the Dockteatern Tittut company from Sweden, who began their forty-five-minute puppet show, *The Cat's Journey*, to a spellbound audience of two-to five-year-olds and adults by greeting the kids and parents in the lobby, having them take off their shoes, and then ushering them into a tent set up inside the theater to create a more intimate performance space. Eyring notes that there has been more creative emphasis in Europe than in the United States on sponsoring innovative arts programming for young children; this is also reflected in CTC's school partnership program, Neighborhood Bridges, which uses the Reggio Emilia teaching method (Cadwell 2003, 4–6) for its program of teaching critical literacy through storytelling to third- and fourth-graders in Minneapolis and other schools. In other strategies to attract families as participants to theater shows and programs, CTC sponsors Grandparent and Me days, when grandparents and grandchildren are invited to a breakfast and morning performance, and—recognizing the time pressures on working parents—Tuesday Pizza Nights, when parents and children share a dinner of pizza on picnic blankets in

the lobby before attending a show. Focus groups with parents suggest that what they value most about these programs is the way that shared theatrical experiences generate ongoing family conversations and can inspire even their youngest children's curiosity.

The valued opportunity for parents and children to spend time together in family-based arts programs was a recurring theme in our interviews with arts practitioners across all artistic genres and organizations. Museums, in particular, have pushed to develop programs that combine visual stimulation and interactive participation for children and parents. The Asian Art Museum in San Francisco succeeds in getting families to visit its AsiaAlive exhibit because there are fun, hands-on things to do for kids. The Newark Museum sponsors a half-day family festival celebrating Chinese culture as a way to draw new Chinese immigrant families in the area to the museum. The Seattle Art Museum hosts a family-oriented hands-on activity that is coordinated in partnership with the Seattle Center's series of monthly ethnic festivals. Education director Victoria Moreland notes that, for the Day of the Dead Festival, "We had fifteen hundred kids stop by and make sugar skulls. So, we premade fifteen hundred sugar skulls; a school actually [had a project] and helped us make a thousand of those. The kids painted the skulls—put icing on and painted and decorated those skulls however they wanted. So that was one of the children's hands-on activities" (Moreland interview 2005).

In all of these programs, economic accessibility also makes a difference. The Walker Art Center's Free First Saturday program, which is geared to families with young children and offers a series of very user-friendly activities in the galleries, draws large crowds. Walker staff report attendance on these free family days to be between two thousand and three thousand visitors (figure 5.3).

The Speed Art Museum in Louisville, Kentucky, has been focusing on families and young children in its Art Sparks program. In part, the Speed's building renovation in 1996, which included a forty-six-hundred-square-foot interactive art gallery, has made family programs more attractive and viable. Director of special projects Penny Peavler notes the new range of activities that the space now allows:

We began to have something going on all the time in the Art Learning Center. There are twenty different multisensory, interdisciplinary activities within the Arts Sparks Interactive Gallery; plus, there's a hands-on workshop space which we can use to train teachers or to teach children about painting—you know, "This is what egg tempera feels like." And then we have a Planet Preschool area, which is for children under five; and we have an electronic art room where we do things with new media . . .

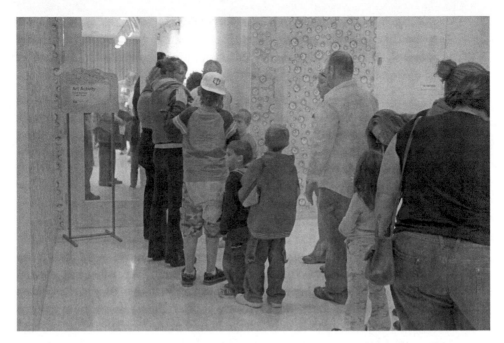

5.3 Families wait in line to participate in hands-on art activities during the Walker Art Center's Free First Saturday program, November 2005. Photograph by Timothy D. Lace © 2005.

The new plan is to [continue to have] Art Sparks, but to take the activities out into the galleries . . . on a more regular basis, more frequently, but with more breadth of assortment . . . [so that, for] people who come back a few months later, there [won't be] the same hands-on [activities]; it will be something new out there. (Peavler interview 2005)

The Speed Art Museum's new emphasis on drawing family participants comes out of citywide research in cultural planning. With schools less able to sponsor the kinds of cultural field trips that, in the past, introduced many children to the arts, family visits are now much more important in providing that gateway experience. These experiences across arts organizations are richly varied and structured to be accessible and inviting—from a family-friendly, kid-friendly ballet, such as Agnes de Mille's *Rodeo* performed by the American Ballet Theatre; to free summer evening dance performances geared to families at Jacob's Pillow; to short Shakespeare adaptations, such as *The Romeo and Juliet Musical* for five-to twelve-years-olds and their parents, performed by the Chicago Shakespeare Company; to family-oriented holiday celebrations, with food, brass bands in the courtyard, and a marionette troupe in the Tapestry Room of the Isabella Stewart Gardner Museum.

The goal of these programs is to provide the opportunity for families to spend time together, as they also engage in hands-on, interactive, creative activities that are both fun and educational. Melanie Smith, director of education for San Francisco Performances, notes:

> I think the thing that we're noticing about the family audiences is that it's not just the kids who are learning. . . . The parents really want [to learn too] because they often have had no art education, at this point. There [have been] changes in education that took place in California beginning in the late '70s that have been taking place nationwide since then. [Parents] don't really know what this stuff is about; they're not really familiar with classical music or jazz or contemporary dance. So, they're learning right along with the kids. A philosophy in our family programming is not to do kiddy shows. I don't mean that to be such a pejorative, but . . . we give family audiences exactly the same fare that you'd get on a Saturday night main stage Herbst [Theater] concert, only it's shorter, it's more accessible, and the artists talk a lot more. They talk about what they're doing. They invite kids on stage to try things out. The pieces are shorter; there's much more interaction; the whole program only lasts an hour. But we don't have giant Snoopys or any of that . . . That's not for us. (Melanie Smith interview 2005)

The challenge is to provide educational opportunities in the arts in ways that are developmentally appropriate for children yet will appeal to a multigenerational, more sophisticated audience as well. The full impact that such early arts participation has over the life course deserves much broader longitudinal study. But the smaller-scale research to date holds out some positive findings—that childhood participation in the arts is a greater indicator of continued adult participation than is mere exposure to the arts; and that nonschool participation by children also tends to promote greater adult participation than does school-related exposure (Dabson and West 1990).

TRANSITION TO ADULTHOOD THROUGH THE ARTS

If children and teenagers can be categorized by chronological age and developmental stages, the transition period of postadolescent young adults into adulthood is far murkier. It's a life stage that is historically, sociocultrually, legally, and experientially defined, often in very different ways depending on the analytic lens being used. Social scientists argue that, in the contemporary era, childhood seems foreshortened, while the full transition to adulthood now appears to take much longer than it did in the past. Arts organizations that have turned their attention to the cohort of young people in their twenties and early thirties have learned that their cultural tastes tend to be more eclectic and spread across a broader spectrum of

art forms, and that their cultural consumption patterns are more fluid. These appear to be new cultural tastes stretching into adulthood that are characteristic of the baby boomers born after World War II and of newer cohorts of young adults born since 1970. Sociologist Richard Peterson and colleagues, who have been following these trends in cultural consumption patterns, identify the newer pattern of cultural tastes as "cultural omnivorousness"—a tendency for young and middle-aged adults to participate in a mix of the fine arts and popular culture, with the result being more competition for their leisure time and their consumption and donation dollars (Peterson and Rossman 2005). White middle-class Americans born in the decades before World War II were much more likely to shift their tastes to the fine arts and high culture as they entered adulthood and to become subscribers and donors to the arts. Younger adults are far less likely to do so.

The obvious challenge for arts organizations is to have to work harder and do better at competing for the time and attention of these culturally omnivorous young adults. Marketing strategies that make full use of the new technologies to reach young adults and to track their cultural visits, levels of participation, and consumption patterns have become a top priority in many cultural organizations. The New York City Opera, for example, advertises on its Web site a Big Deal! membership package to anyone between the ages of twenty-one and thirty-five as

> an affordable way to experience the original multimedia artform. Members receive the best seats available to each of New York City Opera's 16 productions with savings of up to $80 a ticket! No other arts organization in the city offers young people this kind of accessibility or convenience. . . . Share the City Opera experience with a friend and go for free! Tell your friends about Big Deal!, and when they sign up, you get one free ticket for every member that joins. (Encourage two friends to join with a Duet membership and you receive two free tickets.) (http://www.nycopera.com/productions/big/index.aspx; accessed December 1, 2005)

The online blurbs for the operas, written in a catchy "personal ads" style, were what first caught the attention of a young friend in her twenties who brought the Web site to my attention for this project:

- → *LA BOHÈME*: Young starving artists and die-hard romantics looking for their muses. Particularly attracted to flirts and girls with terminal diseases.
- → *LYSISTRATA*: Feisty Greek woman leading wives in a sex strike as an anti-war protest. Looking for participants who won't crack under the pressure.
- → *DON GIOVANNI*: Don Juan looking to add names to his catalogue of international one-night-stands. No over-protective dads.

➤ *CARMEN*: Hot gypsy girl, very independent, loves smoking,
 drinking, and stealing. But if we hook up, two words: watch out.

Julie Peeler, director of the National Arts Marketing Project (NAMP)
for the Arts and Business Council, cautions that there are important dif-
ferences between age cohorts that arts marketers need to be aware of:

> So, if you're targeting an older generation, they really understand the
> concept of art for art's sake. But if you are targeting baby boomers—baby
> boomers are all about utility. "What is this arts experience going to do
> for me?'" You have to be a little bit more factual when you talk [to] them.
> Generation X is all about new and different, new and different, new and
> different. This is why you can't sell them season tickets. Because, unless you
> are a multiarts presenter, [can you] guarantee them that everything they're
> getting, even though they're coming to the same location, is new and dif-
> ferent every time? This Generation Y is a lot more like their grandparents.
> They've been referred to as "Eisenhower with a pierced nose ring." . . .
> They like traditional things. . . . Consequently, because [each cohort]
> comes from a different framework, you have to speak [to] each one
> differently. There are ways to do multigenerational marketing. If you've
> ever seen Blue Man Group, you realize that [they're] targeting Gen Xers
> and Baby Boomers. Very clear, definitive targeting. It's kind of interesting
> to look at—a great, great [example] to study. (Peeler interview 2004)

In addition to marketing savvy, arts organizations hoping to attract
young adults have identified a number of strategies as the key draws to
cultural organizations for this age group. These include reduced ticket
prices—ten-dollar tickets for young people under age twenty-five at the
Seattle Repertory Theatre that have had the effect of "sending their youth
numbers through the roof" (Allen interview 2004); interactive opportuni-
ties, such as competitive scavenger hunts through museums modeled after
reality television (Salamon 2004); enhanced educational opportunities that
involve meeting the artists before or after a performance; and social net-
working opportunities with other young adults. The Isabella Stewart Gard-
ner Museum in Boston has organized structured opportunities for young
professionals in the community to have personal interactions with artists:

> The other way to connect this younger professional group that isn't with
> family is to do something on a small scale—highly engaging—where they
> have access to some bright thinker or conservator; for example, we were
> working with this charming gentleman over the last year, who is an Ital-
> ian furniture expert, to help catalogue our collection and to do some con-
> servation treatments with the staff because we have the finest and largest
> Italian furniture collection in the U.S. And so we used him as a way to
> connect to people. We had a few walkabouts . . . in the mornings where

they [could] come and have some coffee and, for just a short amount of time—forty-five minutes to an hour, they had a chance to walk around with this person. Not only did they learn about the collection and Italian furniture, but they got to ask questions, maybe about some pieces that they owned, or things they were thinking about purchasing, or questions about silk that they were exploring. There's a hunger for education, I think, but also a heavy social component. (Anderson interview 2005)

The appeal of the social component for this age group should not be underestimated. Andrea Allen, director of education at the Seattle Repertory Theatre, described the theater's new subscriber program for young professionals:

The Holy Grail are these thirty-somethings who are entrepreneurs . . . [with] money—disposable income and lots of it; but they don't seem to be showing up on philanthropy lists. They don't seem to be showing up as patrons [of the arts]. So we ended up having a couple of these entrepreneurial types on our board and they got really riled up about starting up The Crew [Seattle Rep's new subscriber program], in which they subscribe to four or five plays in the season, and there are parties associated with three of them. There's something like three hundred people who come; they try to do thematically linked parties to the plays. And frankly they're a huge networking opportunity. And part of the way we got as many people [joining] is because the people on our board are these high-up entrepreneurs that everybody wants access to. So, . . . people start to see theater not just as a place [where] I come to see a play, but a place where I come and see people that I like and have an enjoyable time. . . . We have a concierge staff, so that when you come in there is someone there. [It's not just someone] to ask "where's the bathroom?" but someone you can ask a question. We have a lot more presence in the lobby of folks who can answer your questions, talk to you at the intermission. And I think that has a huge amount to do with [our appeal to young professionals]; so even if you found that you didn't like the play, [the social interaction] is a part of the experience. (Allen interview 2004)

CONCLUSION

Opening a variety of arts experiences to incorporate young people at all stages of life requires institutional commitment and great intentionality on the part of dedicated staff. There are as many kinds of programs as there are arts organizations and creative staff members who run them. The examples cited here are only a small sample of the ideas and strategies that have been tried—sometimes unsuccessfully, sometimes with necessary changes and refinements that must be learned by trial and error—by

arts practitioners who are looking for ways to include youth among their participants. It is neither an easy institutional commitment to make nor a short-term project with an end point. In the words of Sarah Schultz, director of education and community programs at the Walker Art Center, "If you invite people in, you have to really invite them in, and mean it. You really have to be able to have the capacity, on some level, to act on their advice—or to hear it—and then really have them feel as if [that advice] had an impact, in some form or another" (Schultz interview 2005).

The multiple projects involved in attracting and incorporating children, teens, and young adults as new cultural participants are models of the relational strategy that we have defined as focused on relationship building in the present and for the future. This strategy does not necessarily result in immediately measurable results, such as a large increase in the number of youth participants, especially for events that are not specifically geared to attract them or on days when admission is not free or substantially reduced. Even the Walker Art Center, with its extensive and committed program to attract teens, has found in its survey research that visiting patterns among this youth demographic have essentially remained stable since the mid-1990s. These statistics may not reflect the numbers of young people who attend WACTAC-sponsored off-site events, and they certainly do not measure the much more ephemeral, but equally important, qualities of an institution's cachet among the young as a place that is modern, unpredictable, fun, and eclectic. Yet it is just such ephemeral factors that produce a buzz, define a "scene," and perhaps even create the familiarity with cultural experiences that produce a lifelong attachment to the arts.

Measuring this impact on individual participants over the life course will require longitudinal studies that are the stuff of social science research, rather than the more traditional audience surveys or focus group analyses that most cultural organizations now undertake only sporadically. Yet, until we know more about how early arts exposure among children, teens, and young adults conditions lifelong patterns of cultural participation, the impact of the kinds of youth programs described in this chapter will not be fully captured in conventional quantitative measures. What we do have evidence of, however, is that opening the doors in authentic, committed, and sustained ways to children, teens, and young adults can produce some unanticipated changes in the organization itself, from the addition of auxiliary and expanded programs to more fundamental transformation of mission and programs at the organization's core. Young people who have had their first taste of high-quality, stimulating arts experiences and highly participatory forms of engagement will most likely want to find and experience these throughout their lives. This is both the challenge and the promise of engaging a new generation of youthful participants.

6 Diversifying the Arts
Bringing in Race and Ethnic Perspectives

MORRIS FRED AND BETTY FARRELL

It is not only the young who are the new audience members for the future, but a more racially and ethnically diverse range of adults who have not been significantly visible in the audiences for mainstream arts. For most of U.S. history, the "fine arts" have been dominated by European artistic traditions and cultural values and consumed by a culturally specific audience that was predominantly white, Anglo-European, highly educated, and upper- to middle-class in background. Many cultural organizations with this audience profile have understood themselves as representing "Culture," rather than "a culture." The awareness that there are other traditions, values, and interests in the arts with appeal to a more diverse range of arts audiences has been slow to take hold or to challenge the status quo in the mainstream cultural sphere. But the notion of equity is now being added to the long-held tradition of excellence in the arts, and the ethos of exclusivity has begun to give way to a commitment to inclusivity.

The current project of diversifying participation in the arts is built, then, on a relatively new moral impulse for inclusiveness in the cultural sector that is driven in part by the changing demographic landscape of the United States. Arts organizations are responding to these new patterns of racial and ethnic diversity by establishing different organizational goals and different conceptions of what it means to diversify. On the one hand, organizations that have long been defined by an Anglo-European perspective are now attempting to change their practices to supplement or stretch their repertoire to become more diverse by adding auxiliary and expanded programs to their core in order to draw a multicultural audience. On the other hand, ethnic organizations are also diversifying the cultural field by providing core programs that represent their own traditions and artistic products. A recent study of ethnic museums in Los Angeles noted that

[A]lthough many museums retain their status as prestigious Temples of art or science, many also aspire to serve as forums for the representation of diverse identities and points of view. Thus, they address issues, exhibit collections, and provide for communities once considered peripheral to the mainstream museum. Such museums have become vehicles to affirm and articulate new forms of identity and community, but also sites of conflict and contest, where different groups battle over appropriate definitions and representations. (Loukaitaou-Sideris et al. 2004, 53)

As this statement suggests, ethnic organizations add diversity in terms of museums' organizational mission and intended audience, but their impact on changing the cultural landscape is neither simple nor straightforward. As these institutions seek cultural parity with the more established institutions, and as their concerns are embraced by the institutional core on the National Mall in Washington, D.C., they share many of the same challenges facing all institutions that seek to expand both customer and donor bases. Yet their presence opens up many questions that mainstream cultural organizations have only recently begun to ask: Who and what is represented in most genres of art, and why? Who decides? What is missing from those representations? What should new representations include? How will institutions build their own capacity and the capacity of the field to serve this variety of audiences?

These provocative questions can challenge the status quo and unsettle deeply held values and beliefs, as numerous recent examples of art controversies over issues of representation have attested. But the process of unsettling the status quo creates not only controversy but the space for arts organizations to think more responsively about the needs, interests, and tastes of new audiences and participants. When they do so, they discover several things:

- ➤ Ethnic audiences want to see representatives of their communities as performers and artists, along with deeper representations of their cultural traditions.
- ➤ Ethnic audiences want exhibitions and programs that are relevant to issues in their own lives.
- ➤ Ethnic audiences are attracted to art reflecting values that resonate with their communities and to organizations working purposefully to build long-term, sustained relationships with them.

Not surprisingly, ethnic cultural organizations seek to control their own cultural representations. They want to present what they consider to be truly authentic interpretations of their history and traditions and, in the process, to contest stereotypical or simplistic views of those traditions. Occasionally, as we will see, they begin to challenge the notion that

144

a racial or ethnic group has a single identity or mode of representation. In this, they have been joined by a range of new hybrid cultural organizations whose mission is to represent diversity through their structures, operations, and repertoires. This chapter will explore the variety of ways that the interrelated imperatives of diversifying art forms, diversifying cultural organizations, and diversifying cultural audiences have been unsettling, reshaping, and challenging the cultural landscape.

EXPANDING THE CANON WITH DIVERSE STAFF AND REPERTOIRE

What does it mean to diversify a cultural organization? One meaning is to change the complexion of the organization by adding more people of color to the board, the staff, and the artists, while simultaneously pushing the artistic repertoire to expand beyond the traditional canon in which it operates. The Chicago Sinfonietta is one cultural organization that was founded upon this principle and has been doing just that since 1987. Among all the arts, it is perhaps most surprising to find a dynamic of innovation and change at work in a symphony orchestra, where the artistic product has traditionally been rooted in a Western European classical repertoire from the nineteenth century and in a particularly rule-bound performance style. Like many of the performing arts organizations in our study, the Chicago Sinfonietta earned nearly 50 percent of its $1.7 million annual revenue in 2004 from its programming revenues, which included ticket sales and contracts for its performances. Its subscriber base of eleven hundred has been augmented by five thousand to ten thousand single-ticket sales annually, a number that is likely to increase dramatically as the organization expands its repertoire to reach a broader audience.

Describing itself as "the nation's most diverse symphony orchestra [that] shatters traditional boundaries through its collaborations, creating synergies between classical, dance, theater and other musical styles including jazz, rock, and world music," this professional orchestra, founded in 1987 by African American music director Paul Freeman, embodies diversity among the musicians on the stage, in its repertoire, and on its board of directors. In 2006, it had twenty-one African Americans, four Latinos, three Asians, and one Native American making up the musicians on stage; an African American musical director at its helm; African Americans making up 50 percent of its board; and four to five works per year written by composers of color and performed by guest artists of color. Thus, the Chicago Sinfonietta represents an unusual level of racial diversity for any cultural organization, much less one in the world of symphonic orches-

tras. This is undoubtedly a key factor in explaining why its audiences are currently composed of 55 percent people of color. Its stated mission of musical excellence through diversity (www.chicagosinfonietta.org) is thus represented throughout the organization, as well as in its innovative approach to programming.

According to its executive director, Jim Hirsch, who brought to the Chicago Sinfonietta some of the marketing strategies and organizational changes that he spearheaded so successfully as director of the Old Town School of Music, the strategy that any cultural organization trying to involve a more diverse set of participants must pursue is "making the tent as large as possible." To this end, the Sinfonietta's programs include the traditional classical repertoire, the orchestra's signature performance, the Martin Luther King Tribute Concert, and innovative collaborations with jazz and rock musicians, dance companies, theater performances, and video projections, which, in Hirsch's words, intentionally "mess with the orchestra model." Their goal has been

> [We want] to stretch how people perceive orchestral [music] . . . to open some doors so it becomes relevant for a broader range of people.
>
> JIM HIRSCH

to stretch how people perceive orchestral [music]: what orchestral music is and [what it] can be, and trying, hopefully, to open some doors so it becomes relevant for a broader range of people. . . . We have one foot in the traditional orchestral world—we did Tchaikovsky's *Fifth,* [but we had] the first half of the concert with [Chicago's Mexican folk band] Sones de Mexico and this young, African American cellist, Patrice Jackson, who kind of blew the doors off the place. . . . We just want to explore [new musical combinations]. (Hirsch interview 2005)

The Sinfonietta works at creating new "point-of-entry" opportunities—such as the concert collaboration with the Chicago-based rock group Poi Dog Pondering in the 2005 original and remixed performances of Dvorak's *New World* Symphony, which attracted a younger audience of rock fans, or the collaboration with the virtuoso guitarist Fareed Haque and renowned tabla player Zakir Hussain, which melded jazz, classical Indian music, and orchestral music and brought in a new audience of South Asian Indians, "99 percent [of whom] had never been to a Sinfonietta concert before" (Hirsch interview 2005). Hirsch calls "diversity and daring" the two concepts that the orchestra sells—with its staff, composers, and performers more closely modeling the racial and ethnic diversity of the city in which it is located, and with its "unstuffy," relevant, and innovative programming. As one Chicago music critic noted:

[A]ny orchestra that dares to put a Mozart piano concerto at one end of a program and a concerto for steel drums and orchestra at the other had better have the artistic wherewithal to justify its chutzpah. Fortunately, Chicago Sinfonietta has been shaped into a buff and vigorous chamber orchestra in its 19 seasons under founder and Music Director Paul Freeman. [This] concert was another example of how the nation's most racially diverse professional orchestra is also among the most musically diverse (von Rhein, 2006)

Even so, attracting equally diverse audiences cannot be left to chance. Diversifying arts participation is at the very core of the orchestra's ongoing project. The Sinfonietta actively markets its programs—through its media partners, through churches and organizations such as African American sororities and fraternities, through partnerships with groups such as the Puerto Rican Arts Alliance, and in Chicago's most racially diverse communities. It offers board members free tickets to invite people from their social networks to sample Sinfonietta concerts via a "birds of a feather" marketing strategy—and, in a more specific instance of audience targeting for the Martin Luther King Tribute concert, it tried sending its staff members out to the Marshall Field and Nordstrom department stores to hand out free ticket vouchers to African American women professionals, or "Mrs. Huxtables"—a group it targeted as family cultural decision makers who should receive a direct invitation to the concert. This is one example of the kind of direct approach that Sinfonietta staff have been willing to try in their attempt to keep their audiences as diverse as possible as they expand their reach. Through such efforts, the Sinfonietta's subscriber base grew 24 percent from 2004 to 2006, and the goal is to keep that base growing by 8 to 12 percent per year.

As the Chicago Sinfonietta seeks to build upon its diverse audience, its efforts cannot rest on a single point-of-entry experience. To date, the orchestra has had greater success in attracting African Americans than Latinos—37 percent versus 5 percent respectively. But, in its mission and strategies, in its relentless quest to learn more about the tastes and interests of its targeted and potential audiences, and in the way it has managed to break out of old traditions—even while retaining a mix of the old and the new, the playful and the serious—the Sinfonietta represents a model of a cultural organization that is elastic and expansive in its participation-building efforts. Few symphony orchestras, surely, can claim to have commissioned a Concertino for Cell Phone and Orchestra—with audience cell phone participation (Pasles 2006)—for the 2007 season. Because its multiple efforts to live out its motto of diversity have so visibly created "a large tent" for an organization that is rooted in a classical tradition, the

Chicago Sinfonietta is particularly well positioned to build and expand its multicultural audience.

ADDING AUXILIARY PROGRAMS TO SUPPLEMENT (AND CHALLENGE) THE CORE

Most cultural organizations find themselves in a very different situation than the Chicago Sinfonietta, which has built diversity into its entire organizational structure and into its expanded programming efforts. More typical are the organizations that are now facing the task of diversifying by adding auxiliary programs that will help attract a broader racial and ethnic mix of participants, while still maintaining their core programs and audience base. Short-term strategies or limited efforts—such as a museum exhibit featuring black artists during February, the month officially dedicated to celebrating African-American culture and heritage, or Latino-themed events scheduled to coincide with Cinco de Mayo—are destined for, at best, limited, short-term success. Any effort to build a multicultural audience that does not institutionalize the project of engaging diverse participants in a long-term, sustained effort cannot hope to succeed.

This is the message of Donna Walker Kuhne, president of Walker International Communications Group, who identifies five crucial goals for mainstream organizations intent on building and sustaining a multicultural audience:

- Listening to the needs of the target community, then institutionalizing the idea of engaging diverse participation as part of the organizational mission, through the involvement and empowerment of staff, and through programs that reflect an interest in creating new audiences.
- Creating a presence that helps broaden the organization's reach into a targeted community, and cultivating the audience as a long-term strategy.
- Reaching new communities through personal relationships, rather than necessarily through the content of the art, since it is personal relationships that build trust and bring in new audiences.
- Choosing new marketing strategies, such as selling blocks of tickets to groups, offering ways that new audience members can sample the cultural offerings before committing to a ticket sale, and developing a task force of community volunteers to help with the marketing effort.
- Building bridges to audiences through forums of dialogue about arts and culture that allow new participants to explore how the art relates to their own life. (Kuhne interview 2004)

As Kuhne's list and other evidence collected over the course of this study suggest, the types of relational strategies and transactional strategies for building a more diverse group of cultural participants are closely interwoven. Building relationships with diverse audiences is the precursor to engaging them in more sustained transactions with the organization. Greater institutionalization of the processes designed to build transactions will help build organizational capacity to serve these groups over the long term.

The Seattle Art Museum

Among established cultural organizations that have sought to become more visible to local African American, Latino, and Asian communities, the Seattle Art Museum (SAM) stands out for its multifaceted approach. In the midst of an expansion project to triple the size of its downtown museum site, to renovate its sister facility, the Seattle Asian Art Museum, and to develop the eight-and-a-half-acre Olympic Sculpture Park, the museum has also been investing considerable effort in expanding its reach and making its presence more visible to local communities of color. With a new mission statement—"SAM connects art to life"—the museum signaled its intention of becoming a more accessible organization. Most significantly, it began a research effort in 2001 to put the visitor at the center of all its programs and activities by conducting extensive surveys of visitors' interests, expectations, and experiences at the museum; conducting focus groups with diverse community members before all major exhibitions; doing a follow-up "How Are We Doing?" survey to assess their ongoing efforts; and working with cross-divisional task teams within the museum to prioritize, implement, and evaluate a full range of audience engagement efforts. A 2005 report, "Measurements of Success: Outreach and Diversity Efforts," highlights some of the outcomes of those efforts inside the museum, among visitors, members, and staff, and in Seattle's communities:

- From 1999 to 2001, the ethnic diversity of SAM's visitors varied from 8 percent to 10 percent of total visitors; from 2002 to 2004, an increase of diversity in 14 percent to 34 percent of total visitors was achieved.
- Comparing two exhibitions with similar art content and overall visitation revealed nearly a 100 percent increase in ethnic diversity of SAM's visitors. During the Impressionism: Paintings Collected by European Museums exhibition in 1999, 316,000 visitors and 8.1 percent visitor ethnic/cultural diversity was noted; in 2004, for Van Gogh to Mondrian: Modern Art from the Kroller-Muller

149

Museum, 288,228 visitors and 15.5 percent visitor ethnic/cultural diversity was tallied.

- Based on 2004 membership data, 21 percent of SAM members were people of color, compared to 27 percent of its total county population (King County) according to the 2000 U.S. Census.
- Ethnic/cultural diversity—among staff, board, and volunteers combined—reflected an increase from 12.3 percent to 15.5 percent over the past four years. However, the ethnic/cultural diversity of staff declined slightly.
- Among the museum's community engagement results, the report also cites its extensive community partners and programs, a high level of involvement of children and families in the monthly ethnic festivals cosponsored with the Seattle Center, the distribution of free and reduced admission passes (8.4 percent of which were redeemed, a proportion about twice as high as usual); and diverse audience participation in a series of community dialogues, including three Forums on Race programs. (Seattle Art Museum 2005)

Such audience research is high on the Seattle Art Museum's priority list of strategies to engage audiences and participants. It speaks to the kind of institutional commitment that Donna Walker Kuhne identifies earlier in this chapter as central to any long-term effort to build diverse participation. It suggests the museum's recognition of the need to collect reliable baseline information and to track changes over time, as well as to evaluate ongoing participation-building strategies both inside and outside the organization. The Seattle Art Museum's priority on audience research has allowed it to become a more responsive organization. When it conducted its "How Are We Doing?" community survey in July 2003 among a diverse audience, it learned that "61 percent of the respondents . . . had visited the museum more in the past two years than in previous years due to more engaging exhibitions, special invites received from SAM, and more engaging programs and events." They learned that respondents perceived the museum as having greatly improved in "diversity of exhibitions, community outreach efforts, and marketing efforts to diverse communities" (Seattle Art Museum 2003).

How has this research effort played out in the kinds of exhibits that SAM presents? An example is reflected in the narrative account by Victoria Moreland, SAM's director of community affairs, of the 2004 exhibit Only Skin Deep (see text box on Only Skin Deep).

Many organizations have launched similar kinds of relevant and compelling auxiliary exhibitions or programs, beyond their permanent collections or core programs, which are intended to reach a broader audience and help in the process of diversifying participation. The Seattle Art

A great example of how SAM involved all ethnic/cultural groups in this process can be seen in a 2004 exhibit, Only Skin Deep: Changing Visions of the American Self, organized by the International Center of Photography in New York. The exhibition led viewers on a provocative journey through the history of American photography, while critically considering its role as a medium that shapes how we understand race and national identity, provoking us to rethink our ideas of what an American looks like, of what makes anyone more or less an American. The exhibition featured over three hundred historic and contemporary works dating from 1840 to the present, contrasting a diverse range of genres and movements.

Because the exhibition dealt with potentially controversial images, SAM felt it important to understand how community members/visitors might respond, and [to] enlist their assistance in presenting this exhibition. In the months prior to the opening, we had dialogues with our Community Advisory Committee and community partners; focus groups gathered input from the community at large. We invited individual feedback through our community network Listserv of over four thousand diverse contacts and through postings on various e-news/event sites catering to diverse audiences. In these feedback sessions, the curators presented a wide range of images, some of which were difficult to view, such as those of the Ku Klux Klan in action or of ethnic group stereotypes. Our purpose in showing these stark images was to learn about which concerns we should be particularly sensitive.

Focus group participants were very candid in providing feedback on everything from exhibition titles, themes, and marketing strategies to the importance of incorporating multiple community voices in the exhibition, and providing space for reflection and response within the galleries. In response to these suggestions, a small library of resource materials and online access to related materials was developed so visitors could respond to and further explore the many questions posed throughout the exhibition. . . .

We had sensitivity training for our frontline staff and volunteers regarding diversity and customer service. The goal of the training was to prepare staff and volunteers to adequately deal with audience members affected by the subject matter and images. During the time of the exhibition, front-line staff only reported a few emotional incidents, such as visitors crying. Staff offered visitors [tissues] or directed them to an area where they could sit alone for awhile.

We wanted the exhibit environment to be conducive to people sharing their ideas. Multiple response areas were created in the galleries by providing visitor response cards and hand-held gallery guides, prompting visitors with questions about the exhibition. Docents were introduced to a new method of working with audiences—visual thinking strategies (VTS)—which gave them a method of making their tours more conversational and less docent-directed. The docents' learning objective

(continued)

was to engage visitors in a discussion in which they would explore how historical and contemporary photographs used the conventions of photography (composition, lighting, pose, costume, and setting) to create works in which stereotypes are suggested, reinforced, and/or challenged. Docents encouraged people to speak from a personal point of view about images in the exhibition. For example, one image, by the artist Roger Shimomura, "24 People for Whom I have been Mistaken," included photographs of twenty-four people, thirteen of whom wore glasses, most [of whom] appeared to be of Asian descent, with two appearing to be white, and one [of whom] appeared to be a woman. A simple starting question, "What do you see?" brought on a lively discussion from the group about personal experiences of being stereotyped.

By the conclusion of the show, over three hundred handwritten cards were posted on a bulletin board at the end of the gallery for all to read, reflecting the heartfelt impact the exhibition had on viewers' understanding of race and racism. The response cards also provided visitor demographics showing that more than 35 percent of visitors to the show were people of color. The success of the program in meeting our goals to expand participation was recognized at the end of the exhibit with a letter from Seattle's Mayor Greg Nickels praising the exhibition and SAM's efforts to stimulate public dialogue around race and identity.

—Moreland interview 2005–2

Museum has given recognition to the diverse groups that make up the city's communities by including them in the process of representing their culture and by creating programs that are relevant to the interests and needs of their multiple publics. The museum has made a serious effort to build trust in Seattle's diverse communities by explicitly acting on the motto "SAM connects art to life," while understanding that lives are complex and varied and that needs and interests are ever changing.

The project is long-term, demanding, and expensive, and it involves institutional vision, commitment, and sustained resources. So far, at SAM, these efforts and programs have been sustained by foundation grants, although the museum has made a commitment to continuing the department of community affairs beyond the initial grant period. Whether most organizations are up to the labor-intensive and long-term challenge of creating and sustaining the strategies and programs that will draw a more diverse audience is an open question. As this case study suggests, there are multiple factors at work—from committed leadership, to changes in the organizational culture, to the institution-wide willingness to make diversity a top priority. The pressures within most mainstream cultural organizations to revert to a supposedly universal model of "Culture" are therefore great. Many efforts falter when special funding initiatives end,

when the leadership that has driven the effort changes, or when diversity efforts are given lower priority than other organizational goals. This is one of the reasons that ethnically specific or pan-ethnic cultural organizations also play an important role in the process of diversification in the cultural sector, for—by their very nature and purpose—ethnic cultural organizations can make diversity their core priority.

ETHNIC CULTURAL ORGANIZATIONS: PROMOTING DIVERSITY AS THE CORE

In part as a response to exclusion from the mainstream cultural landscape and in part driven by the surge in the ethnic cultural politics that characterized the 1980s and 1990s in the United States, a new set of culturally specific and ethnically defined institutions has now firmly taken root in the cultural field. Several ethnic cultural organizations in this study serve as examples of the ways in which cultural spaces have been used to define and explore ethnic identity issues and cultural representation. In this way, they offer another model of diversification of cultural organizations—one that identifies diversity as the core of the organization's mission, structure, and programs. The Mexican Fine Arts Center Museum in Chicago and the Wing Luke Asian Museum in Seattle are two examples of representative organizations that will be considered in this context.

The Mexican Fine Arts Center Museum

Located in the Mexican American neighborhood of Pilsen in Chicago, the Mexican Fine Arts Center Museum (MFACM), as it is referred to in this study (renamed the National Museum of Mexican Art in December 2006), is viewed by many as the premier institution for Mexican art in the nation; it represents the cultural roots of Chicago's substantial Mexican American community of 1.3 million people, a concentration second only to Los Angeles among U.S. cities. Its mission is to provide opportunities for individuals to develop bonds within the Mexican American community, to explore their connections to other cultural groups in the Chicago area, and to integrate themselves into American cultural, economic, and social life. It is simultaneously a museum and, as its name suggests, a center for community activities. This expanded notion of what a cultural organization can and should be is a feature common to many other ethnic organizations.

The MFACM was founded by a group of educators under the team leadership of Carlos Tortolero and Helen Valdez. Since opening its doors in 1987 it has grown enormously in terms of facility, budget, the size and prominence of its collection, and its reputation as the only accredited

Mexican American museum in the United States. But its purpose remains most deeply rooted in the idea of giving a sense of identity and pride to the Mexican American community. Carlos Tortolero, founder and president of the museum, states it most clearly: "We are here for the Mexican community, first and foremost. By presenting the art and artists that should be presented, we are part of setting the cultural agenda for this country. When we talk about the importance of "first voice" we mean [that] no one is more expert about our culture than we are" (Tortolero interview 2006). According to the MFACM's director of development, Randy Adamsick, "Even as the museum has grown financially from basically zero to five million dollars in twenty years, we still want to have exhibitions that serve the people in our neighborhood. So, we are dedicated to keeping admission free and our education programs affordable; . . . we want to do all we can to remain the hub of the community" (Adamsick interview 2005).

The museum was founded by Carlos Tortolero and Helen Valdez, educators with a commitment to using the arts to stimulate and preserve knowledge and appreciation of Mexican culture, with particular emphasis on a commitment to youth. The MFACM runs the Yollocalli Youth Museum, which each year provides two hundred young people with career training in the arts; and it sponsors Radio Arte, a seventy-three-watt radio station run by 120 youth staff members. Both are located in the Pilsen neighborhood. Radio Arte broadcasts to approximately five hundred thousand people on Chicago's South Side, but it focuses primarily on local neighborhood and youth issues. The MFACM's exhibitions are attended by more than fifty thousand school-age children and teens each year, filling an important gap in art education in the public schools. Through its specific youth programs, through the mentoring of young staff members, and through the program with the Chicago school district, the museum has made significant strides in living up to its founding educational mission.

In addition to using the arts to enhance the Mexican American community's sense of shared tradition and identity, the MFACM sponsors other programs and exhibits attracting two hundred thousand people annually. Its programs are intended to provide a means of strength and renewal among individuals in the community. The Dia del Niño (Day of the Child) Family Festival, for example, draws its cultural resonance from a tradition celebrated yearly in Mexico on April 30. But the family- and arts-oriented program that has been developed, to great success, by the Mexican Fine Arts Center Museum involves hands-on activities, music, and food, along with partnerships with social service and government agencies, corporations, and the school district to promote nutrition and good health. In 2004, with the support of such organizations as the Department of Public

Health, Human Services, and Children and Family Services, the program produced a record attendance rate of ten thousand participants—a 100 percent increase in a two-year period. According to Nancy Villafranca, director of education,

> Interestingly, while the focus was still on families and art, we also partnered that year with the Consortium to Lower Obesity in Chicago Children [CLOCC]. So now we have added a health aspect too. Confronting this issue is especially important because of the high obesity rate among children in Chicago, particularly Latino youth. The program was meant to educate about the value of eating healthy [foods], exercising, and lowering obesity or hypertension. We had a climbing wall, a presentation by the Chicago Bicycle Federation, cooking demonstrations, and other types of health-related activities, computer games. . . . The event has become a huge annual success. (Villafranca interview 2005)

The theme of spiritual healing is also built into the traditional activities that the MFACM sponsors every autumn in its Day of the Dead exhibit. The 2006 exhibition marked its twentieth year. According to Tortolero, the exhibition always includes three sections—one with traditional

6.1 Dia de los Muertos/Day of the Dead installation by Roberto Valadez at the Mexican Fine Arts Center Museum, Chicago, November 2006.
Used by permission. Photograph by Timothy D. Lace © 2006.

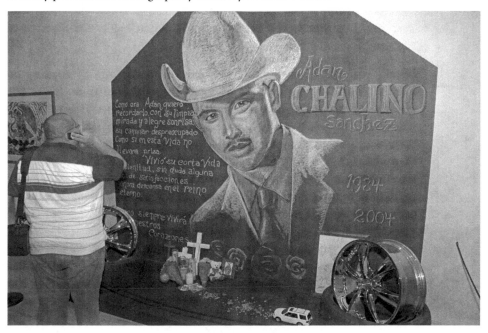

ofrendas [altars] from Mexico, a second with *ofrendas* by Mexican Americans, and a third with contemporary expressions of the Day of the Dead theme. The common link across these galleries is in promoting awareness of the deeply rooted traditions and cultural heritage shared by Mexicans and Mexican Americans. The exhibition also provides an opportunity to deal with grief (figure 6.1).

> One of my favorite stories is about a teacher's aide who came with a school group. The following Saturday, when I stopped by the gallery, she was there. I saw her, she saw me. We smiled at each other. She came up to me and said, "You know, grandma passed away so I thought I'd bring my daughter to talk about it." That's what it's supposed to be. That's what you try to do. It's [a way to] deal with grief. [From creating *ofrendas* to visiting the show, it helps] to talk about it, to talk about whether or not there is something after life. Life is valuable, and we should appreciate it. (Tortolero interview 2006)

The goal is also to make these traditions meaningful and relevant in a contemporary sense to both insiders and outsiders. To this end, the museum has developed different tours of the exhibits—one designed to provide the necessary social and historical context for an understanding of the holiday by outsiders, another to deepen the experience of this cultural tradition for the core Mexican American audience. Thus, promoting a sense of cultural identity, strengthening the bonds within the community, and focusing on spiritual healing are three interrelated goals of the Day of the Dead exhibit at the Mexican Fine Arts Center Museum. There is an educational function to the exhibit as well, according to the director of education:

> [E]very year a different school is selected to participate by creating an *ofrenda*. One or more classrooms work in collaboration to create one *ofrenda* for the entire school. We always try to connect the exhibit to something that has happened in the school—for example, a school where there was a shooting and a student was killed. So the exhibit is more than about the healing. In such cases, we would learn about the life of the student and how his classroom came together to create the *ofrenda*. I recall that, in 2001, one school changed plans immediately after 9/11, dedicating their *ofrenda* to those who had lost their lives. For that particular school, the exhibit helped with the healing process. Coming to the museum and talking about the tragedy in the atmosphere of the Day of the Dead exhibit does seem to make people feel better. We always have a community *ofrenda* where we just have these little pieces of paper, and we say, "Now you write a little something to someone you lost this past year or

[to someone] in your life." In that sense, we try to make [the exhibit] more interactive. (Villafranca interview 2005)

As these examples suggest, this cultural organization and others like it are particularly well positioned to encourage ethnic audiences and participants to explore their cultural roots, to pass on traditions and a sense of heritage to younger generations, and to address social issues and problems that are especially salient in their local community. In the process, they can act as powerful institutional forces that help give definition to an ethnic identity and give shape to an ethnic community defined socially and culturally, rather than geographically. But identity, however bounded and defined it may appear or feel to people, is rarely a fixed category. From the perspectives of contemporary scholars and artists, it is the fluid and arbitrary quality of identity—the fact that it is subject to constant revision and reinterpretation—that makes it so interesting and potentially controversial. Even while serving as the glue that bonds people together, identity can therefore be a highly contentious and volatile characteristic of groups. Challenges to a group's sense of identity have fueled some of the sharpest and most prolonged battles in the arena of cultural politics. A final example, drawn from the MFACM's special exhibition The African Presence in Mexico: From Yanga to the Present, which ran from February 11, 2006, through September 3, 2006, serves as a reminder of the special challenges that an ethnic organization faces when it sets out to challenge the construction of the very ethnic identity it had originally helped to define and shape.

Randy Adamsick describes the process that went into developing the exhibition, along with the challenges and opportunities it offered to use the arts in a collaborative effort between the Mexican American and African American communities in Chicago. Speaking before the exhibit opened, he noted:

The idea for the exhibit has two separate roots: the first is that we were concerned [about] the fact that, in Mexico, like many other countries, race is seldom spoken about openly. The dominant assumption throughout Mexican history is that you are either Spanish or indigenous, and there are no other racial or ethnic categories. And Mexico is really far more diverse than that. For example, Mexico City has a huge Jewish population. In the state of Guerrero, the majority is of African descent, a fact recently verified by a sickle-cell study. So there has been a great desire to tell that history [of] Mexico. . . . Our main gallery will have the four hundred years of history and paintings, objects, and photographs. From the seventeenth century we are going to have these wonderful panels that depict the sixteen levels of race as it related to being white, being African, being

indigenous, Mestizo, etc. Initially, I sensed much hesitation in dealing with the issues of this race-loaded show, particularly since there is often a denial of an African presence in Mexico. The center gallery will focus on U.S./Mexican relations in the twentieth century. Additionally, we plan on having . . . about a dozen public programs mixing locations throughout the city. (Adamsick interview 2005)

Using art exhibitions to address group differences does not imply that the process will be easy or harmonious. Two months prior to the opening of The African Presence in Mexico exhibit, a commentator close to the planning process for the exhibit observed that, from the outset, the MFACM had planned to put together a steering committee for the exhibitions that included roughly half MFACM key staff and half African American leaders in Chicago. This proved an invaluable source of ideas, differing points of view, and, ultimately, a buy-in from their communities. The dynamic of the early meetings was collegial, but also somewhat cautious. Both groups seemed concerned with guarding their territory.

Only two funding organizations out of the fifteen that had initially been approached ultimately denied funding for the exhibition. In both cases, it was reported that representatives from the predominantly African American funding institutions had objected to a Mexican museum depicting what they considered to be African history. Tortolero admitted fearing that some people might think "we were trying to steal their thunder." In addition, many MFACM staff heard dismay from their own friends and families when they described the theme of this impending exhibition. The most typical reactions were: "What are you doing that for?" and "There are no Africans in Mexico!" According to Tortolero,

[W]e recognized early that this was not going to be a popular show to some people. "Shade-ism" is an issue we don't talk about. If you want to get people in the Latino community nervous, talk about skin color. You can talk about God, politics, but walk into a Mexican family's home and talk about skin color [and] they get very nervous. They do not like talking about it. It really makes people uncomfortable because it becomes racism in our own community. You know, I attack the mainstream a lot because of its racism. But there is racism in Mexico. So we would be hypocritical if we did not talk about it. But a lot of Mexicanos, Puerto Ricans, Cubans don't like talking about that, because it makes us the bad guy. Well, we are the bad guy too, sometimes. Racism is racism. Mexico is a country that has never dealt in the proper way with its indigenous past. So, if being dark is bad, being African is worse, obviously. Mexico has not dealt with its indigenous past, [and] here we are throwing in the African now. Oh my God, too much information—overload, overload. A lot of people were uncomfortable

with that in the Mexican community. In fact, some people called me up and told me so. (Tortolero interview 2006)

These initial responses point to the different perceptions and cultural stakes that African Americans and Latinos have in relation to such issues as language, culture, and skin color; the historical experiences of slavery, colonization, or immigration; and continuing patterns of exclusion/inclusion vis-à-vis mainstream American society.

Revising historical interpretations of identity, culture, and tradition can be a potent source of contention, as well as a bond of commonality. The early concerns voiced about the nature of this exhibit raise more general questions about the willingness of ethnic cultural organizations to challenge or transcend the very boundaries of group identity that they have helped forge. Despite the initial concerns expressed about the MFACM's exhibit, The African Presence in Mexico was a great success. The committee work paid off, and the buzz generated by the exhibition in both the Mexican and African American community got louder as the exhibition went on.

> People would come to me and hug me and kiss me and say, "Thank you. I'm African American, Mexican. It's about me. And it's about time somebody did something with this issue." It's one of the nicest things that happened with this whole show. In the arts world you never hear the word[s] "Thank you." I mean, people say, "The show's great," "The show looks good," [or] "It sucks"—whatever. But they hardly ever say thank you. (Tortolero interview 2006)

By the time the Chicago exhibition closed, an estimated seventy-two thousand people had attended. The MFACM estimated that 58 percent of the audience had been African American, many of whom came to Pilsen and to the museum for the first time. The diverse audience-building potential of this show will be further tested as it travels to at least ten other institutions through 2010. Tortolero reports, "It's the first show ever to travel to an African American museum, a Latino Museum, a major museum in the United States, and to go Mexico. A smaller panel show is being constructed to travel to libraries and schools." An extensive bilingual catalog that includes an in-depth history of Africans in Mexico and reproductions of featured works was published by MFACM to accompany the exhibition. The launching of this exhibit provides a glimpse of the courage and mutual respect such projects must engender if they are to succeed. It also shows one particular dilemma faced by ethnic cultural organizations that have defined part of their mission around the promotion of a singular ethnic identity. There is a clear value in giving voice to a group that

has been ignored by mainstream cultural organizations. There is value in creating programs that expand understanding by outsiders of a group's identity, cultural traditions, and experiences. But there is also a delicate balance to be maintained between the projects of strengthening internal social bonds and of giving recognition to complex, internal differences within an ethnic or pan-ethnic community. This is a challenge that is particularly characteristic of ethnic organizations as they seek to set the record of cultural representation straight, and it is the subject of the next organization to be discussed, which has its focus on inter-group relations within the multiple Asian communities of Seattle.

The Wing Luke Asian Museum

Since its founding in 1967, the Wing Luke Asian Museum has operated as a small, neighborhood-based, Asian American museum (as distinct from the Seattle Asian Art Museum, which is part of the SAM complex and houses its Asian art collection). It sees its mission as addressing the needs and interests of Seattle's Asian–Pacific American community. Its executive director, Ron Chew, describes the museum, when he took over in 1991, as "a $130,000, two-person, small historical society." Over the next fifteen years, it became "a million dollar operation that's . . . in the midst of a capital campaign to transform the institution from a seventy-two-hundred-square foot facility to a thirty-five- to forty-thousand-square foot 'community heritage center' that will house both a library resource center and the museum collection" (Chew interview 2005). Like the Mexican Fine Arts Center Museum in Chicago, the Wing Luke Asian Museum sees itself as being more of a community center than a traditional museum. According to Ron Chew,

> Institutions that are all people imported from the outside have difficulty understanding the local culture and developing the kind of relationships that make for a strong foundation.
>
> RON CHEW

The challenge for me, when I came in 1991, was to look at how to transform the museum into a different kind of institution, [so that] it truly [could] become more of a community center, rather than a cultural institution that was . . . built on objects. . . . The initial strategy was looking at who [to] hire, as staff . . . So, rather than looking at people with necessary subject expertise and education, [we looked] at people who were community organizers—people who had relationship-building skills, . . . who had community contacts and relationships, who could work in a collaborative style, who embodied the kind of staffing that could then make the institution a different kind of institution. . . . I came to the museum as a former community jour-

nalist [who had] worked in that arena for about fifteen years. I'm actually a local person, and . . . another ingredient that I think is important is having [some] of your staff be local folks—[people] who are brought in who have relationships with the local community. . . . I find [that] institutions that are [made up of] all people imported from the outside have difficulty understanding the local culture and developing the kind of relationships that make for a strong foundation. (Chew interview 2005)

Given this recruiting strategy, many of the Wing Luke staff members, unlike those at many mainstream organizations, are young people in their teens and twenties. Many have accrued six to ten years of experience with the museum by moving up through the ranks; they represent an emerging core of young people of color who have been mentored in community-based museum work and are poised to assume the next generation of practitioner and leadership positions in the cultural sphere. The board includes members from the Chinese, Japanese, Filipino, South Asian, Korean, and Southeast Asian communities, as well as white Americans. In its structure and orientation, then, the Wing Luke Asian Museum represents an ethnically based cultural institution with a high degree of institutional diversity. What makes the organization particularly interesting is that it also represents multiple Asian American communities, each of which has a different set of complex needs and interests. Its focus is therefore not on forging a single sense of ethnic identity but in giving voice to the rich multiplicity of traditions and issues that are often hidden behind the common label of "Asian American."

The diversity of this potential audience presents special challenges to this cultural organization. In the words of Ron Chew,

The Asian–Pacific American community is a very diverse community comprised of . . . over forty different ethnic, linguistic, religious subgroups; in order to be effective in gaining increased audience participation [among these diverse groups] there needs to be understanding of the fact that you don't have one formula, one approach, or one method of success. It's [a matter of] understanding each of the subgroups, being respectful of those groups, and organizing strategies that both target particular groups . . . and bring [groups] together . . . through theme-based exhibitions and programs that resonate across . . . ethnic groups. So, it's about understanding diversity and then incorporating strategies that acknowledge that. (Chew interview 2005)

The Wing Luke Asian Museum has identified a variety of internal interest groups within the broader Asian American community of Seattle who

make up the museum's primary constituencies, each of whom require different strategies and approaches. These include:

- ➤ Asian American communities with different histories of immigration to and length of residence in the United States: Chinese, Japanese, and Filipino Americans who came to the United States before World War II, in contrast to the more recent arrival of Koreans and Southeast Asians since the 1960s.
- ➤ Different generations within these Asian American communities— seniors, as well as youth. Ron Chew notes, "We found an important ingredient to increasing participation: ensuring that the approach is intergenerational, . . . having a base of activities that draws both younger . . . and older people into the mix. That creates a longer-term, [more] sustainable relationship. . . . Within the Asian community, there has always been a strong emphasis on the role of the elders as important bearers of wisdom and a connection to the past. There's always been an investment in the young people as the hope of the future, and a desire to support their activities. So, using some of that cultural background, knowing that that was an important part of our work, . . . we came to the conclusion [of developing intergenerational programs] pretty organically" (Chew interview 2005).
- ➤ The community of Asian (primarily Chinese and Japanese) adoptees and their white parents, who also represent a growing segment of the Asian American community.

How can a single relatively small cultural museum and community center provide services and programs that recognize and address the diversity of this range of groups? The Wing Luke Asian Museum develops programs in dialogue with the various groups in the Asian American community through a process called "community response" in which the museum staff invites local community members who are neither curators nor museum specialists to share ideas and participate in program planning. The result is a fairly quick turnaround time in developing "community response exhibitions." Cassie Chinn, program director at Wing Luke, describes the process through which one such exhibition—Sikh Community: Over 100 Years in the Pacific Northwest—originated, developed, and ran between October 2005 and April 2006 (See text box on Community Engaged Planning).

Coming to know a complex and diverse audience and what its many interests are has become the hallmark of this refashioned museum/community center. The approach of the Wing Luke Asian Museum makes clear how building relationships is an integral part of the participation-building

The Wing Luke Asian Museum has been a meeting place for the different ethnic groups to come and find strength in their connections and commonalities, but also to be able to celebrate differences. One good example of this is our developing relationship with the Sikh community, which today is faced with the issue of mistaken identity. This became especially true after September 11, when the turbans worn by the men connected the Sikhs in many people's minds with Osama bin Laden and Islam. Many in the Sikh community felt an even greater need to show who they were and to present all the contributions that Sikhs have made to the Pacific Northwest and the United States. For example, most people don't know that a Sikh operates the largest private security firm that's been hired by the government, that the largest peach-grower in the nation is a Sikh American farmer, [or] that the father of fiber optics is a Sikh American.

People were excited about having the Sikh community exhibition here at the museum because it forms an interesting complement to our permanent exhibit that includes a display on Japanese American internment. Thus, with the Sikh exhibit, the visitor can make those connections and see parallels and differences between the post–World War II Japanese-American experience, and the post–9/11 Sikh experience.

Our strategy with the Sikh project was to bring together members of the Sikh community to work with the staff in deciding what this exhibit was going to be about, what it was going to look like, and what was going to be in the exhibit. We wanted to enable them to make those decisions and move us along to a final product. We served as the fiscal agent for a grant that members of the Sikh community needed to show a film. From there, our relationship with them started to build; we began thinking that the general public really needed to be more educated about the Sikh community.

We had done about three months of outreach . . . to see what their participation might be, . . . [and] to get a group together to start planning for this big exhibit. We wanted to develop a core group, which then led to hiring an intern from the Sikh community, and now a member of the Sikh community joined our board as well. For the goal of the exhibit, the group decided to investigate and discuss different forms of discrimination and perceptions that people have about the Sikh community. We began with . . . a context [about culture, history, and religion] for people who might not know anything about Sikhs. The museum's philosophy is that our job is to find out what the vision of the community is and to carry it out. Sometimes, we might have an idea, such as a vision for the upcoming exhibit; but, if the community doesn't see it that way, we have to step aside (figure 6.2).

—Chinn interview 2005

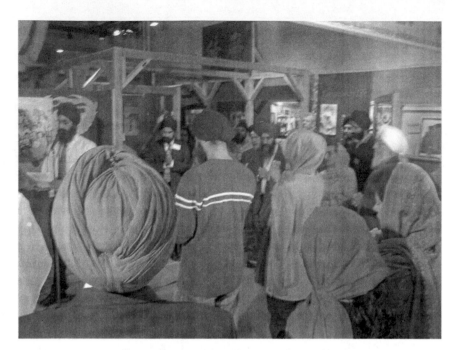

6.2 Pan-Asian Pacific American exhibition and programming at Wing Luke
Asian Museum involved the Sikh community.
Courtesy of Wing Luke Asian Museum. Used by permission.

and future transaction-building process. Its permanent exhibitions include
depictions of the two-hundred-year history of immigration and settlement
of Asians and Pacific Islanders in the state of Washington and a replica of
Camp Harmony D-4-44, a Japanese American internment camp in Puy-
allup, Washington, during World War II. This exhibit's capacity to pre-
serve memory and educate a new generation about the internment experi-
ence is one of the reasons that two thousand senior citizens in the Asian
Pacific community converged on the state legislature in Olympia during
Asian–Pacific American legislative day in 2004 to lobby—successfully—
for funds for the new Wing Luke Asian Museum.

Past exhibitions at the museum have included such projects as Tunnel
Visions on graffiti art; It's Like That: APAs and the Seattle Hip-Hop
Scene; and Case #082A: Violence through the Eyes of the Youth, which
may account for why a recent visitor survey revealed that 49 percent of
the museum's visitors are between eighteen and twenty-nine years of age.
The museum aimed at drawing an even broader multiracial and multieth-
nic set of participants to its 2004 project Beyond Talk: Redrawing Race,

which used painting, photography, video, and conversations over a series of potluck dinners to address issues of racism, discrimination, and stereotypes. In these programs and others, the Wing Luke Asian Museum has used its broadly defined focus on diversity and its community-response orientation not only to address the multiplicity of complex issues within the Asian–Pacific American community, but also to begin to build bridges to other groups and communities in Seattle through programs that address urgent social needs and common concerns. As an organization that has made the many facets and meanings of diversity its core concern, the Wing Luke Asian Museum offers a compelling institutional model of how to reach and engage audiences' interests and concerns through a variety of cultural expressions that give voice to a pan-ethnic community's internal diversity.

MOVING DIVERSITY TO THE CULTURAL CENTER: THE CULTURAL EXPRESSION OF RACE AND ETHNICITY ON THE NATIONAL MALL

The diversity projects considered so far in this chapter play an increasingly important, but often circumscribed, role in the larger project of diversifying and changing the cultural field. Such independent organizational projects to expand the traditional canon as that of the Chicago Sinfonietta are still rare. The longevity of the many auxiliary projects that take place within mainstream organizations is often curtailed by lack of institutional resources once special funding initiatives run out, as well as by changing priorities and other competing goals of these organizations. And ethnically or pan-ethnically specific cultural organizations, although certainly occupying a central place in local communities, tend to be small, underfunded, and residing on the periphery of the institutional cultural sphere. This is why the opening of the National Museum of the American Indian (NMAI) and the planned opening of the National Museum of African American History and Culture (NMAAHC) have been so closely watched and eagerly anticipated as additions to the Smithsonian Institution, the nation's premier cultural complex. Both new museums—positioned as they are at the political and symbolic center of the nation's capital on the National Mall and conferred with legitimacy as national museums—have brought the project of diversifying culture to new prominence. The placement of these new museums on the nation's front lawn signals a new centrality for the expression of cultural diversity and a more open recognition that race and ethnicity are significant parts of the story of the American experience that deserve a more public presence and hearing.

The National Museum of the American Indian

The opening of the National Museum of the American Indian (NMAI) in Washington, D.C., took place in 2004. Its significance, first, has been in transforming the historic meaning of museums in Native American experience. For Native Americans and other colonized peoples, museums have often been viewed as "instruments of dispossession" (Cobb 2005, 486). A scholarly discussion of the new museum describes how the director of the National Museum of the American Indian had

> a very clear sense of how to turn an instrument of dispossession into one of self-definition, thus truly making the National Museum *of* American Indians . . . [a place to] celebrate, protect, and support the living Native cultures of the Americas, not study, classify, or objectify them. . . . [E]very aspect of the museum including its very purpose and function, had to be filtered through Native core cultural values and adapted accordingly, [recognizing] the proposition that a museum-as-gathering-place or a museum-as-cultural-center must consist of more than exhibitions. (Cobb 2005, 488–489, 493)

This focus is immediately apparent upon entering the museum's space, which was carefully designed to assert the physical and spiritual presence of Native Americans in the nation's capital. To draw attention to the fact that American Indians have vibrant living cultures, a large open space at the entry was provided for musical performances, dances, and storytelling. Even in designing the grounds of the museum—referred to as "the Native landscape"—attention was given to all aspects of the physical environment, such as the waterfall and stream that runs alongside the museum, created to be part of the experience and to "pay homage to the site by revealing the way it was before Europeans arrived . . . even attempting to reclaim some of the original wetlands to attract migratory birds back to the Mall area" (James Pepper Henry interview 2006). Moving about the museum floors, a visitor is immediately struck by the collaborative principles that guided the construction of the permanent exhibitions; representatives from twenty-four Native communities were invited to curate different themes as represented in their tribal cultures, thus allowing these communities to have a major voice in the interpretation and presentation of their respective groups (West 2004).

From the outset, the NMAI's approach was to make it clear that the museum sees itself as a steward, rather than owner, of the collections housed there. Staff members charged with responsibility for community and constituent services ensure that programs are taken on the road so that they

continually reconnect with Native American communities throughout the country. They also provide technical assistance programs at cultural centers and tribal museums, training individuals in all aspects of collections' management and exhibition development. In this way, the museum has reinforced its role of stewardship.

Functioning as a combined museum and cultural center, the NMAI has also been envisioned as a place for performances, demonstrations, and conferences—in short, a setting for ongoing discourse on traditional and modern Indian identities, including a planned exhibition on black Indians, which will further serve to expand ideas about American Indian identities. There is clearly a balancing act at work in this museum: the commitment to recognizing and representing the uniqueness of each tribal culture, while at the same time constructing, through its exhibitions, a more complex historical account of collective Native American experience(s) for other visitors (Nagel 1994, 162). In celebrating varieties of Native American cultural diversity and unity and in ceding significant control to Native American groups to represent their own cultures, the National Museum of the American Indian has created a new kind of ethnic museum—one that is at once at the center of institutionalized museum culture in the United States, but that also operates with a different set of priorities, goals, and values.

The National Museum of African American History and Culture

The mission statement of the National Museum of African American History and Culture (NMAAHC), scheduled to open in 2015, states that this new cultural organization will "give voice to the centrality of the African American experience and will make it possible for all people to understand the depth, complexity, and promise of the American experience. The Museum will serve as a national forum for collaboration with education and cultural institutions in the continuing quest for freedom, truth, and human dignity" (Presidential Commission 2003, 1). Although the NMAAHC is still in the early stages of development and planning, its founding director, Lonnie Bunch, a former curator at the California African American Museum, the Smithsonian Institution, and the president of the Chicago Historical Society, brings a wealth of experience to the role. Many of the same issues faced by the NMAI and by other culturally specific organizations throughout the United States are at play in the construction of the NMAAHC. There are expectations that the new museum will also serve as a cultural and community center, providing facilities for public gatherings that include lectures, screenings, performances, and town meetings—"a place [for the African American community] to

come together . . . [and] for visitors to confront the emotional nature of race in America and explore ways to come to grips with personal, community-wide, and national issues regarding race" (Presidential Commission 2003, 29).

In articulating the core goals of the NMAAHC, Bunch has argued that the museum has a unique opportunity to challenge the idea that racial/ethnic and mainstream cultural organizations are fundamentally different. His vision for the museum is to show how African American experience is central to what it means to be an American:

> As America continues its internal debates about who we are as a nation and what our core values are, where better to look than through the lens of African American history and culture? If one wants to understand the notion of American resilience, optimism, or spirituality, where better than the black experience? If one wants to explore the limits of the American Dream, where better than by examining the Gordian knot of race relations? If one wants to understand the impact and tensions that accompany the changing demographics of our cities, where better than the literature and music of the African American community? (Bunch 2005, 52)

Coming from the museum's founding director, this statement expresses the vision that the NMAAHC, in its collaborative programs and exhibitions, will provide a forum for exploring the tension between presenting a complex, painful, and often tragic history and celebrating the richness and resilience of African American culture. This is the fundamental challenge of a museum whose project is bringing diversity into the center of national cultural consciousness and debate.

The recent decision to locate the NMAAHC on the National Mall in Washington has also solidified its national meaning and central cultural legitimacy. The NMAAHC staff has noted that one of its challenges is to ensure that mainstream cultural institutions, including other Smithsonian Institution museums, will continue to do serious work on African American culture. The unique position of the NMAAHC, as the only Smithsonian museum that does not begin with a collection, may actually advance this aim, since maintaining a close relationship with collectors and other cultural organizations for exhibition materials will be a central means by which the museum will be able to engage in a collaborative effort to achieve its objective of "becoming an African American museum with relevance to all Americans, in reminding us of what we were, what challenges still remain, and . . . what we can become" (Bunch 2005, 53).

The Smithsonian Institution derives its cultural power not only from its imposing presence on the National Mall and the enormity of its collec-

tions but also from the symbolism it shares with the many political memorials, cultural institutions, and social agencies located in the nation's capital. Although it is too soon to evaluate the full cultural impact of the new NMAI, and the NMAAHC is still many years from completion, the high visibility of both museums points to the challenges and promises of other cultural-diversity projects that are having an impact on changing the cultural landscape throughout the country. As a number of the people we interviewed during this project pointed out, the very concept of the cultural "mainstream" needs to be reassessed, since what was once considered the norm of universal culture can now be seen as specific to a particular cultural tradition. Cultural-diversity initiatives have brought new interests and perspectives to the cultural sphere, but they have also begun to raise new questions about what can and should constitute the "core" of a cultural experience. The "mainstream" might better be understood as a dynamic metaphor for the ongoing stream of established cultural programs that are now continually being fed by the tributaries of diverse perspectives, projects, and initiatives.

CONCLUSION

This chapter has focused on a range of cultural organizations that have been attempting to diversify the arts—from expanding the traditional artistic canon to bringing in new voices, perspectives, art forms, and organizational practices that will attract and engage new participants. The realization that there is no single strategy or one-time effort that will help build a more diverse group of cultural participants became clear in the course of our research as we investigated a variety of organizations and cultural forms. If there are general lessons to be learned from the wide range of practitioners we interviewed and organizations we studied, including those highlighted in this chapter, they include some of the following insights:

➤ There must be an understanding that an institutionalized diversity project is a multifaceted, never-ending process that needs to permeate all aspects of an organization's culture and practices. It needs to be renewed and refreshed in order to stay alive and dynamic, and it can disappear if it is not given priority and nurtured.

➤ There must be recognition that diverse audiences are, in fact, diverse in their interests and tastes. There is no one-size-fits-all formula that will attract them. Reaching different audiences that are characterized not only by race and ethnicity but by social class, age,

nationality, longevity of residence in the United States, language, and different histories of cultural participation will require different kinds of programming and niche marketing.

→ There must be a willingness on the part of cultural organizations to cede some of their control and expertise by giving people real opportunities to take ownership in the production of culture—in other words, making it possible for people to become more engaged in the processes of cultural planning, presentation, and promotion of activities, performances, and exhibitions from the beginning. Participation—especially sustained participation—is built on deeper kinds of engagement than simply being the recipient of cultural products.

→ There must be a willingness to take risks by producing exhibits, performances, and programs that have meaning and relevance to participants, even if these are emotionally challenging and potentially controversial. Although there is little general proclivity in American society to address such difficult social issues as racism and inequality, many cultural organizations have drawn participants to provocative programs on these topics because they allow for new modes of understanding and new possibilities for dialogue and communication. Newcomers to the arts want relevance and meaningful connections to their lives; this is one of the most powerful incentives to cultural participation.

Diversifying the arts is therefore much more than the recognition that there is cultural richness in plural perspectives and representations. It is more than a targeted strategy to bring in new participants for a blockbuster program or event. It is a long-term project that holds out the promise of transforming the meaning and relevance of cultural organizations in the lives of Americans of all backgrounds and in making culture a more central component in public discourse and civic participation.

7 High-Tech Transactions and Cyber-Communities

WENDY LEIGH NORRIS AND DIANE GRAMS

Many nonprofit arts organizations have entered the information age by doing what they do best: experimenting. However, they may not anticipate that their efforts to use new technology as tools to build participation have the potential to lead them either into a technological black hole that requires ever greater input of resources and expertise or into new, higher-quality program delivery and expanded opportunities for participation building. When talking about technology and art, the focus of conversation often moves to the most recent buzz—in 2006, it was podcasting, a topic we discuss in this chapter. We also take a broader look at the role of technology in building arts participation. We examine the use of technology as a tool in streamlining transactional forms of participation by improving data management and providing new methods of making the transaction through e-commerce. We also look at the most recent wave of new uses of communications technology for building relationships over large geographic distances. Web sites and a range of e-marketing tools can help organizations to target their marketing efforts more precisely and efficiently. Technology is also democratizing participation by enabling a wider array of voices to be heard, beyond the authoritative voice of established experts.

Our review of cultural organizations and their uses of technology suggest that some organizations struggle with the most basic control of technologies necessary to reach new audiences. Although many different applications carry promise of more efficient use of organizational resources, technology is typically only one aspect of the solution. Also necessary are improved staff communication skills and improved organizational coordination. Other applications promise the possibility of providing more direct contact between their organizations and their constituents, even to the point of building new types of cyber-communities. Although technology can build new relationships among people who are spread across large

geographic expanses, the relationship-building activity must be intrinsic to the organizational mission and of interest to the people who have access to the technology. As this chapter shows, building participation using high-tech tools of the information age often requires that arts organizations do better research and spend more of their resources on technology if they hope to move their technology-based efforts beyond short-lived, underutilized experiments.

FROM DULL TO CUTTING EDGE COOL
Improving the Front Page

Although nonprofit arts organizations often project an attitude of technological daring and innovativeness, the majority of Web sites we reviewed were simplistic and seemingly ineffective. By reviewing and analyzing the Web sites of nearly one hundred arts organizations to assess their use of common Web page attributes, we found:

➤ Most Web sites were primarily informational with few attempts at simple interactive integration. Although the majority of sites allowed simple navigation through news and reports of organizational activities and products, only 20 percent had integrated interactive elements such as streaming audio, video, flash media, slideshows, virtual tours, and interactive games. Fewer than 10 percent had additional educational components such as supplemental classroom guides and/or lesson plans or activities, program notes on upcoming performances, or other background information about the arts.

➤ Most Web sites attempted to make transactions easier; however, few provided for online ticketing or other features to encourage direct user interaction. Most sites allowed the user to purchase membership packages or make online donations through a combination of email and snail mail, yet fewer than half offered direct online purchasing of individual tickets or other merchandise. Fewer than 10 percent included Web-log (blog) links, either for organization staff or for members of the community. Most of these blogs were not frequently updated providing little incentive for people to revisit Web pages or post a comment.

➤ Most organizations made some attempt at representing ethnic diversity by including images of diverse audience or staff members on their Web sites or offering bilingual access, yet only 20 percent actively encouraged youth or school-age users.

A number of nonprofit organization (NPO) Web sites exemplify successful efforts to address one or more of these points and are discussed

throughout the chapter. However, one organization that has tackled each of these issues is San Francisco Symphony (SFS). Its Web site incorporated interactive elements and dynamic site design. At this writing, the home page (www.sfsymphony.org) opens with a flash advertisement about subscribing. Pictures of musicians fall into place, transitioning into a shot of SFS music director Michael Tilson Thomas. The layout of the page is streamlined and dynamic, allowing multiple options for the user to click on links to text and images. Rolling the cursor over the menu bar on top provides additional options (for example, "Explore the Music" pulled down a menu for "Meet the Composers, Styles of Music" and "Special Feature Articles"). The calendar on the right-hand side of the page allows users to see the dates of upcoming performances and to purchase tickets directly and easily. The SFS Web site also offers a variety of audio clips featuring symphony performances and excerpts from documentaries. From the home page, a user can enter its online store to purchase DVDs, books, posters, bags, and other items. There is also a button to enter SFS Kids, a Web site designed specifically for children (www.sfskids.org) that has integrated interactive games with arts education targeted at kids. Children are able to learn about music fundamentals, such as tempo, rhythm, and pitch. Additionally, children visiting this Web site can learn how to identify musical instruments by sight and sound and can experiment with orchestration and composition.

Blogs: A Daily Cause or Personal Accounts of Work

Several Web sites for the nonprofit arts organizations have experimented with blogs, yet few have been able to generate the kind of enthusiasm seen with political news blogs. Although the impact of the daily chats distributed through political blogs, such as the Daily Kos (www.dailykos.com), have been felt in national politics and by national media because of the competition they provide to their editorial departments, blogs have yet to find such a central place in nonprofit arts organizations. Blogs first emerged in the mid-1990s, and the number of political blogs skyrocketed during the 2004 presidential campaign as a form of grassroots journalism and punditry. By March 2005, one source documented 34.5 million blogs on record (Riley 2005). None of the blogs created by arts organizations examined for this study had anything near the activity of the Daily Kos. In fact, most arts blogs had trouble generating any response whatsoever to an initial posting. It could be because they lack the immediacy of "a daily cause" that has stimulated the high levels of participation in their political counterparts. Arts organizations' uses of blogs tend to be offered as a humdrum glimpse into how staff members view their work and the world—how they prepare for exhibitions, shows, and events; what it's like to deliver and install large-

scale works of art and stage sets; and how they feel about art and its impact on their community. As such, they endeavor to personalize the work of their organizations, but they do not have the momentum generated by issues or controversies linked to the outside world.

Independent blogs on arts and culture themes are more successful than blogs offered by nonprofit organizations. Entrepreneurial Web sites such as ARTSjournal.com and the informative Cultural Policy Listserv (http://www.culturalpolicy.org/listserv) now distributed by Americans for the Arts have developed an accessible form of arts journalism and criticism that is independent of a specific art provider or a mainstream media producer. These sites add a new information source to the limited coverage of the arts offered in major daily newspapers. By independently distributing culture news summaries via e-mail and linking these to their Web sites and original news sources, these publishers have attracted national audiences for their e-publications and independent blogs. This innovation in the cultural sector by independent authors and critics has contributed to the success of another new media form and has changed visitor experiences to museums.

Podcasts and the Next Big Thing

Electronic arts journalism and a second kind of innovation—proliferation of off-site and unauthorized audio tours—accelerated the adoption of podcasting as a practice by independent critics and curators, and also by arts organizations. Ever since a professor and his undergraduate communications class at Marymount Manhattan College produced the first unauthorized audio tour of the Museum of Modern Art (MoMA) in the spring of 2005, podcasts freed the traditional audio tour from the control of the production houses hired by museums.

Named for the iPod, Apple's successful portable digital music player, podcasting is revolutionizing audio broadcasting and penetrating the nonprofit arts sector. Armed with a digital recorder available for less than one hundred dollars, or just with a higher-end cell phone, anyone can produce a digital audio file and make it available to millions of people for download via the Internet from iTunes or other MP3 sites. Once downloaded, these can be accessed through a computer and transferred to a portable MP3 player or an MP3-enabled cell phone. Podcasting provides art organizations and artists with a new communications vehicle, similar to an independent low-budget radio station.

By the summer of 2005, the Museum of Modern Art, which was the subject of the first unauthorized audio tour via podcast, began appropriating this once-subversive technology by offering its own programs available for free via its Web site, according to Allegra Burnette, creative director of

digital media at MoMA (Kennedy 2006). Many museums now use podcasts to complement the recorded audio tours that have become popular with museumgoers since the 1980s. Since MoMA began podcasting, more than twelve thousand audio pieces have been downloaded from the museum's Web site per year, including two thousand downloads in May 2006 alone. Now, a visit to MoMA on Free Friday nights reveals just how popular this event has become with young, technology-equipped museum visitors. Everywhere one looks, visitors have cell phones up to their ears or are posing in front of artworks and using cell phones to take digital videos and photographs of themselves and the art.

As technologies become more integrated, and cell phone, digital audio and video players, and Internet access become increasingly bundled together in handheld portable devices, these high-tech toys may transform how arts participants experience museum visits and arts performances. And, as museums and their visitors move toward using MP3 technology, more visitors may begin bringing their portable players with them, allowing museums to spend less on buying, upgrading, and maintaining equipment, and to spend more on the audio content itself.

For now, however, museums are still wrestling with how to manage this transition and its logistical problems. At this time, there are still few museums that enable visitors to dock their own MP3 players and download content from the museum on-site. For this reason, the Walker Art Center in Minneapolis launched a cell phone–based audio tour system in April 2005. Art on Call constituted an important middle ground between a rental audio tour and true podcasting, allowing for more spontaneity than podcasting, more cost-effectiveness for both the Walker and its visitors, and convenience for visitors wishing to access audio information on objects in the Minneapolis Sculpture Garden without having to stand in line at the Walker Center. For Robin Dowden, the Walker's director of new media initiatives, it made a great deal of sense to work with the kind of technology that people were already familiar with. By building on visitors' widespread access to cell phones, the Walker has avoided many of the generational and financial barriers still associated with MP3 technology. By early 2006, the Walker's tech staff had begun developing parallel programs to allow the same content to be accessed by both telephone-based and Web-based technology.

Providing a range of voices via free Web-based access that supplements or replaces those of the experts, podcasts have freed the audio tour from the confines of the museum and have added more alternatives to the costly printing and distribution of catalogs. Podcasts and cell phone access are not only changing audio tours, they also allow for off-site touring and conversational narratives with both experts and nonexperts. Whereas

traditional audio tours were scripted and recorded by high-cost producers, podcasting and cell phone–based audio tours run off an institution's own servers, and maintenance, upgrading, and updating are done regularly on centralized equipment. By finding technology that many people are now comfortable using, arts organizations have knocked down some of the generational barriers in technological modes of delivering information.

In addition to audio tours, digital audio has promoted innovation among independent art journalists and critics. *Bad at Sports,* a weekly podcast begun in 2005 by two Chicago-artists-turned-critics, Duncan MacKenzie and Richard Holland, offers discussion and dialogue about the local art scene following a radio talk show format (http://www.badatsports .libsyn.com; other information is found on their Web page, http://www .badatsports.com). The proprietors boast that downloads of their weekly program have grown to five hundred. The 20 MB files require high-speed Internet hookups; once downloaded on a computer or MP3 player, one can listen to the radio-style talk show anytime.

Some of the most innovative podcasts document art-triggered conversations among museum visitors, occasionally taking the form of impromptu journalism or just casual conversation among friends. Some advocates of the new audio tours believe that the democracy inherent in this new broadcast medium will have the power to liven up the museum-going experience. Rather than requiring silent meditation or listening to a lecture by an expert, these museum visits, now led by digitized and occasionally irreverent docents, might invite strangers to question what they see and converse about what they are experiencing.

THE PROMISES AND PROBLEMS OF CYBER-COMMUNITIES IN THE ARTS

Although most nonprofit arts organizations still use their Web site largely for one-way distribution of information about their organization, a few have assertively sought to build cyber-communities by linking arts producers and audiences through their Web site. The Western Folklife Center (WFC, est. 1980), a Nevada-based organization whose goal is to preserve, encourage, and educate about the cultural heritage of the American West, was one of the few we investigated that did. With a budget of $2.5 million (2004), the WFC provides a vital link between several partners, including the Smithsonian Institution and a number of universities and national organizations interested in preserving folk traditions.

The center's Web site is a virtual mirror of its core programming: a blend of campfire storytelling mixed with the contemporary genre of performance poetry and ethnographies of folk traditions. The Web site

links its annual National Cowboy Poetry Gathering, held each January in rural Elko, Nevada, to its monthly radio show, *What's in a Song,* and to regular cultural exchanges among local areas and nations. The site incorporates storytelling, postcard writing, streaming audio and video, and provides access to detailed archives. Through its Web site, the center has the potential to connect people who are spread across a broad geographic area of the western United States, and, increasingly, around the world. Just as Chicago's Old Town School of Music has broadened its folk music genre by embracing world music as well as American folk music, the Western Folklife Center uses stories, Web links, and images to relate the American cowboy experience to the broader range of "international herding cultures." Staff members and affiliated ethnographers have created a series of "Postcards from the WFC," evoking the lure of being on the road and relating travel tales through the postcard-writing tradition. One "postcard" from Kyrgyzstan describes a series of popular sporting events laced with local ritual; another documents a trip taken to interview a South Dakota ranch woman about her work and the early days of the National Cowboy Poetry Gathering. It features photographs of the poet and her husband as a young couple, images of the red rock roads that divide their property, and a quilt she received on her ninetieth birthday.

Research behind Web Site Development

The Western Folklife Center invested in market research prior to redesigning and launching a new Web site in late 2005. Based on the results of a survey done at the January 2005 Gathering, WFC found that high-tech tools have a place in the future of the organization because they enable supporters to stay connected to the organization. Yet, the WFC also found that many of its core participants had limited access to the Internet. Moreover, those who did have access were not much interested in interactive conversations. Rather, the survey revealed that its current supporters valued the quality and the authenticity of the material that the Western Folklife Center presented and that it is devoted to preserving. Director Charlie Seeman attributed this "need to connect" with awareness that the lifestyle and culture of ranching are threatened. While the center's national event provides an important sense of intimacy and opportunity to share and strengthen social networks, the Web site functions to distribute the cultural traditions to a broader audience beyond its most avid supporters.

The WFC initially thought that technology would be the key to connecting its supporters between annual gatherings. However, it found out there was less knowledge of and experience in using the Internet than staff thought. The average age of respondents was fifty-one, and many key supporters—ranchers and cowboys—were representatives of the classic

graying audience found in other arts disciplines. For many of these supporters, even basic computer jargon was a barrier. As Darcy Minter, WFC's director of external communications, notes, "[W]hat we found out from the survey was a little bit disheartening" (Minter interview 2005). Having collected 680 completed surveys from its core audience at the annual National Cowboy Poetry Gathering, WFC found that only 17 percent of respondents were interested in an interactive Web site. However, many more people were interested in a Web site offering access to music, photography, and video, which was exactly the sort of material that WFC was ready to offer.

For the Western Folklife Center, access to technology was a barrier closer to home than it expected. Because its headquarters in Elko, Nevada, is more than three hundred miles from a major city, the WFC turned to the Web as a way of maintaining contact with participants. However, many live in more remote rural areas that are not serviced by wireless, DSL, or broadband providers and therefore must rely on slow dial-up service or traveling to public access sites, such as local schools or libraries. In building its Web site, the WFC sought to achieve a balance between attractive design and content that would not require visitors to use the most cutting-edge media software. When the interactive component of the Deep West blog did not generate widespread interest, as the survey had predicted, it was abandoned.

Western Folk Life's Web site shares similarities with the trendier Web sites developed by urban artists and art critics, but the staff is careful to make sure that bells and whistles don't become barriers to participation for the less tech-savvy among its audience. Whereas some arts organizations can assume that visitors to their Web sites will know how to download music or join online forums or Listservs, the Western Folklife Center now knows that it must educate and instruct many of its audience members in order to use technology as a tool for strengthening relationships with them. Moreover, the use of technology, in this case, allows uninitiated urbanites an opportunity to savor cowboy culture and provides a means to connect to a community of rural supporters.

THE OTHER SIDE OF THE TECHNOLOGY COIN: DATA MANAGEMENT

Beyond communications software, new data management technology has the potential to help organizations turn a single consumer transaction into involvement by a long-term, loyal patron. However, simply investing in new software or hardware is not a silver bullet for all problems associated with data management. Arts organizations face a range of challenges that

include the staff's lack of technical skill and lack of organizational coordination, as well as lack of appropriate technology. Indeed, arts organizations seeking to build participation have found that their traditional way of operating within information silos is a barrier to efforts to increase participation. By maintaining silos of information in isolated departments, each of which may use different software packages, organizations limit their ability to share information internally even as they are trying to establish consistent organizational relationships with participants. Part of the solution is found with new high-tech tools. Such tools are improving organizational outcomes by improving their capacity to manage and mine the data found inside their own walls.

Small arts organizations are often limited by the cost of data management technology as much as by staff skill. Julie Parson-Nesbitt, former executive director of Guild Complex, a small literary center in Chicago with an annual budget under two hundred thousand dollars, describes the organization's basic struggle to manipulate data in its own mailing list and in the audience surveys it collected without having anyone on staff who knew how to operate such databases.

> We really had to work on our database, you know, because we were building audience and building our database and our membership; that was kind of an ongoing struggle. . . . [In retrospect] I think it might have been helpful to have more technology assistance [early on.] [It] was really hard for us because [we were trying] to create data from the surveys . . . We should have built that component into a long term goal . . . What we ended up doing was joining an organization called the . . . Technology Resource Center. They helped us put the database together and get the surveys together. (Parson-Nesbitt interview 2004)

Through membership in a service organization designed to provide technical assistance to such small organizations, Guild Complex was able to address its own limitations in the short term.

Educationally based organizations, such as the Center of Creative Arts (COCA, est. 1986) in St. Louis, face other problems. COCA, with an annual budget of $6.3 million in 2004, had seen exponential growth in widely divergent program areas that included classes, workshops, performances, and exhibitions. According to Kelly Lamb Pollock, director of corporate and foundation relations, until recently COCA did not have an information technology person on staff. Although its size allowed it to spread the cost of one expert across numerous departments, it faced other problems. Organizations have often created parallel internal systems because of operating with different computer database systems. A single participant might have multiple histories within an organization

because the departments used different tools to contact and track those relationships. A newly hired staff member then faced the daunting task of developing a software application that could link its various departments:

> Education is really our foundation here. It's what we do the most of. And, so, our registrar's database is the core of . . . our software, and we also need a box office ticket sales component [that] then ties them into the donor; and there are very few [databases] that have these features. Some [other organizations] have customized their box office to do the little education programming that they do, or they customize their education software to do the little bit of box office sales; but we have pretty extensive programs in all of those areas so there's really no software out there that exists for a community arts center such as ours. In the development offices, we are using [fund-raising software] Raiser's Edge . . . our box office has just been using a [customized version of Microsoft] Access. We're still working on an application that will talk [to each department] and also interact with our Web site and be able to do online registration and ticket sales. (Pollock interview 2005)

The problem was an inefficient use of its own organizational data because the organization could not effectively integrate data from one department to the next.

Ticketing presents an additional problem for nonprofit arts organizations. Consumers have been increasingly using the Web to make ticket purchases. Because Web-linked databases can be costly and the interface with other data sources difficult, some of the larger organizations still use outside commercial service bureaus, such as Ticketron or Ticketmaster, for single-ticket event sales. Although using such services makes ticket purchasing easier for consumers, it can also mean lost revenue and lost data for organizations. Both may be reasons to invest in an internal system, according to Jack Rubin, president and CEO of Tessitura Network, Inc, a nonprofit network that has developed software for the specific needs of arts organizations:

> [Ticketron and Ticketmaster] really were more interested in making a profit than they were in servicing all aspects of the constituents. So their main goal is to sell a ticket or do a transaction [and] earn a service fee on that transaction. The ticket gets sold and there's all this data that may or may not be collected . . . most of these [service bureaus] were venture capital backed or had shareholders or investors that were out to make as much money as possible. That's fine; that's the American way, and it's capitalism. But the [nonprofit] arts have some very unique needs. . . . Many of the nonprofits that we deal with rely upon unearned revenue—that is, contributions,

donations, et cetera, for anywhere from 20 to 80 percent of their funding. So they have to be really good at these relationships; knowing your customers and your donors and your patrons and treating them well [is key]. And systems that are primarily set up just to sell a ticket that are not tied to a fundraising system are not necessarily optimal for serving the customer. (Rubin interview 2005)

Improved Customer Service

As they look to new uses of technology to build participation, then, small organizations often face the problems of cost and staff expertise, and larger organizations face the problem of organizational coordination. Consider an arts center that has multiple kinds of relationships. It might simultaneously:

- ➤ Enroll students in classes.
- ➤ Sell tickets.
- ➤ Offer memberships.
- ➤ Provide subscriptions or packages.
- ➤ Book group visits.
- ➤ Raise money for different purposes (capital campaigns, annual funds, outreach programs).
- ➤ Offer educational programming.
- ➤ Sell other kinds of merchandise.

The implications of these multiple tasks are significant. Many arts organizations seeking to build participation are recognizing that compartmentalizing information within departments makes it nearly impossible to track multiple mailings and multiple transactions by the same customer. In such cases, lack of internal coordination turns the marketing staff, the box office staff, and the fund-raising or development staff into competitive units who can become nuisances to the very people whose support matters most to the organization as a whole. As Rubin pointed out, e-commerce platforms developed by the for-profit world were not designed to build long-term relationships with the customers, particularly the kind of relationship that would lead to increased voluntary giving. Improved data management technology for use by nonprofit organizations interested in building participation also had to improve the organization's capacity to manage and cultivate long-term histories with people. Moreover, they had to create a sense of a personalized relationship with the organization as a whole, not just to a specific product, performer, or event. This is especially important in cultivating the organized voluntary giving so crucial to non-profit organizations.

The Tessitura system was developed by the Metropolitan Opera in New

York to address just this problem. Alerted by its board to the issue of nuisance communication, the Met began exploring options with a number of software companies in 1995 but ultimately decided to start from scratch instead.

> [Simply building] an interface between two different products . . . is a never-ending technology project, because [as] one product changes . . . you're never really passing all the data through. . . . [Instead the Met] just decided to [build the ideal system]. . . . They organized projects, hundreds of pages of specs and [identified how] the ideal system would [work]. And they bid that out in '95, got various bids to program their ideal system; and one of the bids was five million dollars and [would take approximately three years to develop.] And they took that to the board and the board said, "Just fix this." (Rubin interview 2005)

The result was Impresario, a user-friendly, Windows-based customer-relationship management (CRM) program that appealed to other arts groups, who were soon asking whether they could purchase it as well. Rather than form a for-profit company, the Met decided to form a separate nonprofit organization to license and maintain the program in perpetuity. By 2006, Tessitura: Arts Enterprise Software, licensed through the Tessitura Network, Inc., a nonprofit organization, had nearly two hundred licensees throughout the world. Among these currently is nearly every major opera, symphony, performing arts center, and theater company, including the Metropolitan Opera, the Lyric Opera of Chicago, the Santa Fe Opera, San Francisco Symphony, the Chicago Symphony Orchestra, the Kennedy Center, the Royal Albert Hall (London), Yerba Buena Center for the Arts, New York City Ballet, Alabama Shakespeare Festival, Goodman Theatre, the Stratford Festival (Canada), and a number of smaller groups who share the software through collaborative agreements, such as the Kentucky Center for the Arts, Milwaukee Arts Partners, and the Seattle Theatre Collaboration. Only five museums had bought into the network as of August 2006 (www.tessiturasoftware.com). Tessitura solved the problem highlighted by Rubin: it is geared to the cultivation of arts patrons, and it has an exclusive focus on nonprofit arts organizations. Because it can manage a broad range of transaction and relationship data, it enables an organization to create a more direct and personalized relationship with a patron.

> And I think that's the key: any system can do transactions, print a ticket, process a donation, whatever. . . . But along the way we realized that this customer relationship stuff really works, and if we can deal with our customers in a more professional, more caring manner, so that we have more

opportunities to please them as opposed to irritate them, and [if] we can record all their preferences, we can then act on their preferences. If we can record information about them, again in a sensitive, confidential way where needed, we're going to do a better job of communicating within organizations.... Tessitura has enabled them to transform the organization, and thus be able to better deal with their clientele. As I'm sure you've heard from a number of organizations, it's [about] the long-term customer relationships—keeping those donors, keeping those members, moving them up in the membership grade or however an organization scales it—that's [what is] going to cement long-term relationships. (Rubin interview 2005)

> It's [about] the long-term customer relationships—keeping those donors, keeping those members, moving them up in the membership grade or however an organization scales it—that's [what is] going to cement long-term relationships.
>
> JACK RUBIN

Tessitura's standardized reports allow multiple people within the organization to draw on pooled information about constituents and to avoid the problem of contacting people multiple times. Simple reports on ticketing statistics for a given event, which was once a highly departmentalized task, can now be done by almost any staff member, and the organization can now generate up-to-date information that allows it to sell last-minute tickets. Even though much information is easily accessible, the most sensitive financial and personal data about an organization's patrons can be protected by multiple layers of access security.

Once software is in place for documenting transactions with participants—ticket purchases, preferences, donation patterns, and involvement of all sorts—what are some of the ways arts organizations have used this information to build participation? Improved data management allows for improved communication with customers. E-mail technology, which can "narrowcast" messages honed to the preferences and age of list members or subscribers, has forced arts organizations to become savvier about the tone and content of the material they send out. Having a database that can regroup people according to geographic locations or aesthetic preferences allows arts organizations to reach subgroups within their constituency more effectively. They can identify the organization's overreliance on an aging demographic or, conversely, an influx of new supporters that may grow with the organization. Web-based ticket sales, along with the ability to narrowcast with e-mail Listservs and targeted e-mailing, have allowed organizations to be more effective in reaching constituencies who are spread over a wide geographic area. This is evident with the Alabama Shakespeare Festival, an $8.5 million operation (2004) serving a region well beyond its five-county core. The festival is a midsize

theater, but it is the largest in the region. According to Kent Thompson, former artistic director of the festival,

> Web sales of tickets have been a huge boon to us, because that's an increasingly larger portion of our audience. . . . Technology has also allowed us to track where our ticket sales come from. We have ticket buyers from nineteen states, and about 45 percent of our audience drives from outside the five-county region surrounding Montgomery. That's at least an eighty-mile drive. The Web and e-mail [have] been very important to us in building audiences because traditional media—newspapers, even television, particularly local television—are not necessarily very effective tools for us [to reach our audiences]. . . .What has meant a lot has been our ability to stay in contact with them over e-mail and with our new [Tessitura] ticketing system, which is about two years old [and] is linked with our new telephone system. . . . When somebody calls us, and it's a subscriber or a frequent attender, a screen will pop up that has all [the caller's] information [readily available] for the [ticketing] person [to see]. . . . So technology has really improved our customer service. But [it has also improved] our ability to reach out to those audiences and keep them informed in ways that were either cost-prohibitive to us, because we couldn't advertise in [all of] the six largest cities in a three-hundred-mile radius, or just timeliness. The fact that we can send them a newsletter electronically once a month, that's really improved our ability to reach out to that traveling audience. And that's realistically our growth audience, because the five-county region only has 340,000 people. (Kent Thompson interview 2005)

Cost versus Benefit

Every Tessitura-user organization we interviewed hesitated to share specific details about the cost of this system. It is clearly an expensive proposition, even though there is a sliding scale for nonprofit arts organizations interested in buying into the system. The initial investment is estimated to range from fifty thousand to five hundred thousand dollars, representing an estimated 3 to 5 percent of the operating budget of the licensee. Some organizations have pooled their resources and formed consortia or collaborations in order to justify the investment necessary to buy into the network. The fee includes an organizational commitment to the necessary software, hardware, staff salaries, and training. Three key features of the agreement distinguish it from other similar software companies: it grants a perpetual license; it doesn't charge a fee per seat or per user; it doesn't charge transaction fees for Web sales or Web donations. Given such distinctions, its users have expressed satisfaction with their investment in the long run. "With the percentage of sales on the Web these days being anywhere from 20 to 70 percent, it doesn't take too many transac-

tions with two or three or four or five dollar fees to bring in a lot of money to pay for either a license or ongoing operations" (Rubin interview 2005). Indeed, a quick calculation shows that a midsize to large organization currently selling fifty thousand to one hundred thousand single tickets annually through Ticketmaster would likely earn back a five-hundred-thousand-dollar investment in two to three years by using such software.

In addition to these unique licensing terms, using the software allows an organization to connect to a network of like-minded individuals working in the nonprofit cultural sector. The network convenes annually to discuss problems and needs and to share in the process of building technological solutions. With high-tech tools, staff skills, and cross-departmental coordination in place, arts organizations can provide the same friendly, personalized service offered by some of the most competitive for-profit businesses in the leisure and travel industry.

Tessitura seems to be a model technological tool for twenty-first-century nonprofit arts organizations interested in building the kind of relationships that can lead to increased transactional values. Although high-tech programs such as Tessitura allow arts organizations to provide high-quality customer service, they offer little help in documenting the broader, relational forms of participation building where no consumer transaction is involved or intended. There is not, as yet, an answer for the problems of education-based organizations, such as COCA, that need to link a registrar's platform with fund-raising, or to solve the problem of how to capture group-visit data.

USING TECHNOLOGY AS PART OF INNOVATIVE PROGRAMMING

Many organizations are learning to integrate data management, communications tools, and innovative programming to build participation in their organization, even without a high-tech data-management tool such as Tessitura or sophisticated Web design. They are still seeing the cost-effectiveness of e-mail marketing—especially sending postcards and newsletters via the Internet, rather than through the postal service—and they have begun to use some innovative programming ideas to reach audiences. For example, the Louisiana Philharmonic Orchestra (LPO) used a fairly limited Web site and e-mail system to carry out a program called Find the Phil. In this program, a group of LPO musicians chose a theme for their concert and a location in New Orleans in which to perform. The orchestra then posted thematic and photographic clues on its Web site that progressively revealed the location, along with e-mail notifications that urged interested audiences to join in deciphering the puzzle to discover where the

musicians would play next. Modeling its Find the Phil program on the underground approach of rave concert presenters, the Louisiana Philharmonic Orchestra succeeded in drawing young adult audiences who were willing to track down the musicians in local bars, parks, or other sites. It succeeded in doing so without any highly sophisticated or expensive technological resources, but, rather, through an innovative use of basic Internet communication tools.

Technology and Family-Focused Programming

Technology has the potential to play an important role in initiatives that appeal to untapped portions of a broad geographic community. Effective use of technology can assist an organization in building new relationships by providing a link that blends marketing with traditional programming. One such effort is underway through the Hancher Auditorium's SPOT program, an auxiliary program targeting families with young children who live in rural and urban Iowa. The Hancher Auditorium (est. 1972) is a university-based performing arts organization located in Iowa City, a midsize university town (population 62,220 in 2000). With the SPOT program, the Hancher linked its statewide traveling arts residency program with kid-friendly technology to deliver high-quality, family-oriented talent to rural, suburban, and urban Iowans.

The program idea took shape when one of the Hancher's experiments with children's programming sold out without any dedicated advertising expense. Witnessing the success of Iowa Children's Museum, the Hancher's artistic director, Judy Hurtig, recalls, "[B]oth my codirector and I realized that there was a really sizable, affluent group of [young families] in this community that was not coming to Hancher, people who had the financial means to come" (Hurtig interview 2005). The Hancher had the artistic and educational resources to develop this new constituency. For decades, it has hosted renowned artists, some of whom have expressed their desire to experiment with more direct contact with audiences. A number of these artists have conducted workshops that the Hancher broadcast statewide through the Iowa Communications Network—a fiber-optic distance-learning venture paid for by the state of Iowa.

After considering a range of options, the Hancher decided to pair Web technology with local programming as a way to meet many Iowan families where they live, both literally and virtually. The Hancher found that most parents of young children were more likely to go to family-oriented arts events than to adult-oriented arts events. When they attended, they wanted value for their money. The Hancher staff realized that parents might readily choose to attend performances that offered quality time with their children, if these were scheduled to fit conveniently into fam-

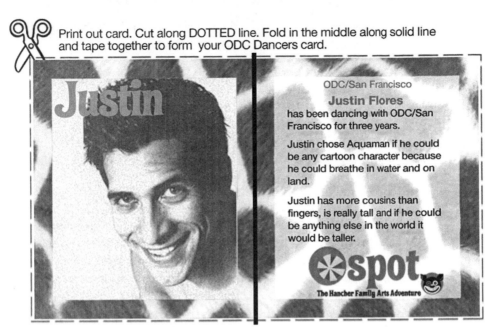

Print out card. Cut along DOTTED line. Fold in the middle along solid line and tape together to form your ODC Dancers card.

Justin

ODC/San Francisco
Justin Flores
has been dancing with ODC/San Francisco for three years.

Justin chose Aquaman if he could be any cartoon character because he could breathe in water and on land.

Justin has more cousins than fingers, is really tall and if he could be anything else in the world it would be taller.

❋spot
The Hancher Family Arts Adventure

7.1 Children's trading card for Justin Flores, a dancer with ODC/San Francisco performing in the 2005 SPOT program with Hancher Auditorium at the University of Iowa in Iowa City.
Copyright Hancher Auditorium. Used by permission.

ily schedules. By offering locally based performances, coupled with educational technology that families could enjoy access to before and after events, this new program addressed the challenges and needs of families with young children. It also had the potential to extend the impact of a given participatory event and to multiply the number of places in which participation could occur, such as home, school, or library.

Engaging Young Audiences through Technology

The SPOT program Web site has functioned as a point of contact as well as a provider of information about the programming activities surrounding the artist residencies. For one program, it offered online crossword and jigsaw puzzles, word searches featuring elements from the artists' performances and bios, and downloadable coloring pages with characters from *The Velveteen Rabbit,* a danced adaptation of which was subsequently performed by the Oberlin Dance Collective (ODC). One of the most interesting elements of the Web site from SPOT's first season was a set of dancers' biographies in a trading-card format designed for young people, as opposed to the traditional playbill format to which many adults are accustomed.

187

These trading cards—written by the dancers themselves—had fun, playfulness, and a kid's-eye view of the world in mind (figure 7.1):

- ➤ Justin Flores has been dancing with ODC/San Francisco for three years.
- ➤ Justin chose Aquaman if he could be any cartoon character because he could breathe in water and on land.
- ➤ Justin has more cousins than fingers, is really tall, and if he could be anything else in the world it would be taller. (www.hancher.uiowa.edu/spot05/cards/justin-card.jpg)

These cards can be seen as marketing tools and souvenirs for children, many of whom asked the dancers to autograph their cards on performance days. The trading cards were also a direct tie-in with the organization-wide commitment to making contact with art and artists more personal and immediate for the participants. The more real and approachable the artists are, Hancher speculated, the more fun, freeing, and inviting art would be for new, young audiences. Even Hurtig was surprised by how well the experiment turned out:

> I knew that . . . this was going to be a terrific company for this project, but these dancers were like camp counselors; you know, they just loved kids. And you would see the kids . . . just hanging all over them. . . . Part of the reason I think this happened [was] that the kids knew the dancers when the dancers arrived in each town. We would have a big welcome reception for both ODC and Dan Zane; the kids were there with those pictures and the bios. They would point to the different dancers. They already felt like they knew them before they came, which was precisely what we wanted to have happen. (Hurtig interview 2005)

A multipurpose Web site was crucial to coordinate and publicize the Hancher's schedule of activities. In 2005, this included nearly fifty events in four different towns; in each town the artists spent three to four days involved in an array of activities. The SPOT project had to transform the traditional artist residency format to engage participants of all ages—toddlers, teenagers, and grandparents—who gathered together in a school gym with Hancher's contracted performers. In one such residency, alternative-rock-icon-turned-romper-rocker Dan Zanes served as grand marshal in a town parade, worked with middle-school bands in their own environment, and jammed in an Iowa cornfield with a musically talented family until two in the morning.

Initial interest in the SPOT Kid Web site was generated by a fairly traditional grassroots-type marketing endeavor. Ads in community papers and links on community library Web sites were two ways that the Hancher

"drove" kids and parents to the Web site. Perhaps the most successful marketing avenue was the double-sided flyers that were distributed to schoolchildren at their schools and libraries. One side of the flyer was an attractive image from the Web site encouraging children to "Be a SPOT Kid" by logging onto the Web site, with the other side offering information for parents about the structure and aim of the project.

During the first season of SPOT, the first hundred children who signed up from each town where a performance was held got a T-shirt—which many of them wore to the events. All registrants received e-mails informing children and parents about performances and venues and inviting them to play around on the Web site. During the second year of the program, the Hancher sent regular e-mail updates before the residencies started, as well as last-minute promotions that included photographs and clips from the previous day's events showing children engaged in art activities.

An important part of the SPOT program has been enabling and showcasing children's creativity—from performing with artists to reporting and documenting their experiences as performers or audience members. Children are encouraged to send the Hancher descriptions of their towns and their experiences at workshops and performances, and family pictures with resident artists are posted on the Web, as are SPOT Kid Reporter articles, interviews, and reviews. One boy, Samuel, from the town of Spencer in northwestern rural Iowa, has been a reporter for the past two years. (See text box "Lights, Camera, Action"). His report reveals what it is like for ten-year-old rural, midwestern kids to learn how to dance, sing, play instruments, and have fun with the engaging performer, Tomas.

The Hancher site has encouraged participation on a number of levels: it works to publicize events; it works to welcome both children and parents; it teaches and prepares children to become members of an art audience; it reinforces what they've learned through games and puzzles; and it links families to other Web sites where they can learn more. Although it was initially used primarily to introduce families to charismatic performers, in subsequent years it has increasingly sought to introduce families to different artistic genres, musical instruments, and artistic media. It has also encouraged and showcased children's creativity, serving as a gallery of photos showing children in the process of creating music and dance with the pros. And it has offered children the opportunity to engage as artists, critics, and reporters. As such, it has played an important role in developing a new generation of cultural participants.

Technology Improving Access for Vision and Hearing Impaired

Technological support designed to create greater access to the arts is finding new uses in a variety of art forms. In theater, individual audience

On Friday, April 28 2006, a performance workshop with Tomas was held at the Spencer Middle School auditorium for students ages 9 to 15. Tomas told us we were the future performers of Spencer and that we have wonderful talents to share. We learned that we are all dancers, poets, singers, and musicians. Our bodies express how we feel about our space. We learned how to use our voice and body to express ourselves. We had fun acting things out. Thanks, Tomas, for being hilarious and motivational.

Since Tomas's favorite number is 13 (he was born on August 13), I decided to ask the thirteen future performers two questions. Here are their answers.

What was your favorite part of the workshop with Tomas?

1. Joel= My favorite part was when I had the opportunity to act.
2. Elizabeth= My favorite part was watching Tomas help others act out their parts.
3. David= I liked acting and introducing the next performer.
4. Cassondra= My favorite part was when we walked up and introduced everybody in our different ways.
5. Abby= I liked Tomas helping me to be Super Monkey Girl.
6. Emily= I liked introducing the next person to perform.
7. Jordan= I had fun introducing the next person to act.
8. Hunter= I enjoyed when Tomas was "the captain."
9. Heather= I liked it all!
10. Tory= It was cool when Tomas did his body bend.
11. Cedar= I thought it was fun when Tomas was "the lieutenant" and "drill sergeant."
12. Wren= I agree with Cedar.
13. Allyster= It was fun when the kids got to be "the captain."

What did you learn from Tomas?

1. Joel= I learned to act the way the person feels.
2. Elizabeth= I learned that your whole body needs to show what you are trying to pretend to be.
3. David= I learned how to be a better actor.
4. Cassondra= I learned the ways to become your character more.
5. Abby= I learned to always be yourself.
6. Emily= I learned that we use our bodies in different ways to act.
7. Jordan= I learned about theater performing.
8. Hunter= I learned to just go with your first instincts to act.
9. Heather= I learned to express myself.
10. Tory= I learned ways to use my voice and body for comedy.
11. Cedar= I learned ways to express myself.
12. Wren= I learned lots of knowledge and inspiration.
13. Allyster= I learned how to do different voices.

—Samuel, age ten, Spencer SPOT Kids Reporter http://www.hancher.uiowa.edu/spot06/reporter/samuel.html

members can use personal hearing devices through which actors' voices are amplified. One elderly woman using the device explained that she had some hearing loss; the audio amplification has helped her to distinguish words more clearly. The same equipment is useful for the vision-impaired; in this case, rather than simply amplifying actors' voices, it transmits an audio description by trained interpreters of the action appearing on the stage.

The Guthrie Theater in Minneapolis has offered both American Sign Language-supported productions and audio-described performances for nearly every major production. During the November 2005 production of the Globe Theater's version of Shakespeare's *Measure for Measure,* both American Sign Language (ASL) and audio-described performances were available at its Saturday one o'clock matinee. Prior to the production, vision-impaired ticket buyers could go on a sensory tour in which they were able to walk on the stage and touch items on the set and costumes to visualize how they might look. During the performance, an interpreter described the actors on stage, a standard practice in Shakespeare's era, providing such useful descriptions as "the actors dance a hop and skip on the table," to note celebratory dance movements. One vision-impaired woman who participated in the sensory tour suggested to volunteers, who were also participating in the tour but found the Globe production hard to understand, that, "if you just relax and listen, in a few minutes you'll realize you understand everything they say."

The Guthrie is part of an extended artistic community in Minneapolis that has been one of the most activist in the nation in advocating for access to the arts for people with disabilities. Since 1986, the VSA (Vision, Strength, and Access) Arts of Minnesota "[has] promoted the creative power of people with disabilities" as an affiliate of the Washington D. C.-based group founded in 1974 by Jean Kennedy Smith (http://www.vsaartsmn.org). In addition to using technology to provide greater access, the Guthrie has regularly featured artists with disabilities in its productions. During the same run as the Globe production, the Guthrie featured Kevin Kling in his one-man performance *Freezing Paradise,* a play with a theme located somewhere between the Coen brothers' film *Fargo,* Garrison Keillor's *Lake Wobegon Days,* and Shakespeare's *Richard III.*

LESSONS—MEETING PEOPLE WHERE THEY LIVE, TECHNOLOGICALLY

As the cases presented in this chapter have suggested, technology is helping arts organizations to meet people where they live. Better management

of transactions allows arts organizations to create an integrated relationship with a customer, while cultivating a donor relationship from the first transaction.

One lesson from the Western Folk Life Center's Web site development and its Deep West blog is that arts organizations can benefit by conducting good market research and paying attention to what this research says about their constituents. Such research can inform an organization—before it invests in a new technology project—that its plans might be too demanding of its target audiences or current constituents, especially in terms of moving beyond the technology with which the audience is most familiar.

Some of the people we interviewed for this project spoke astutely about the seductive nature of technology. However, it is clear that many organizations still have a long way to go in order to take advantage of the array of technology now available. Blind pursuit of cutting-edge, state-of-the-art technology, or even of "standard" technology, does not help organizations connect more effectively to their partners or their audience. Digital tools are not necessary or appropriate to all projects or to all stages of the project. Organizations intent on using technology to reach new audiences need to plan to incorporate step-by-step training sessions with participants and collaborators.

For some organizations located within a tech-savvy community, high-tech approaches may make sense. For others, it is worth figuring out in advance if the target users are ready for the "next big thing" or whether it's worth trying to figure out how to get them there. The barrier might be access to a computer, a PDA, or an MP3 player. It might be acquiring access to the Web, finding high-speed connections, or sufficient power or memory to run the enhanced material that is loaded onto an organization's Web site. It might be more simply a question of finding the right language to describe what is being offered, and of clearly assessing the interests and experiences of arts participants.

As this chapter has suggested, many arts organizations are using technology to improve their ability to manage transactions through Internet marketing and customized database management. Several organizations found innovative ways to use technology to build relationships across generations and across large geographical expanses; but we found little evidence that cyber-communities were being built around any specific artistic genre or across great distances. Rather, technological tools are just that—tools for accomplishing an organizational mission. This is most evident when looking at technology-centered improvements to data management. Such tools are only useful if there are staff members with the skills to make them work, and if the organization is willing to transform

itself in order to enable more interdepartmental coordination. Technology-based programs aimed at increasing arts participation run the gamut, from experimenting with publicity tactics, to distance-learning projects, to community-engagement exercises, to educational programming; the age groups they target range from toddlers to seniors. It is easy to say that we live in an age of digital technology, but, in fact, people live in profoundly different relationships to that technology. Technology can help bridge the expanse of large geographic areas of coverage; it can help engage young, technology-proficient audiences. However, when target groups don't have the interest or skills, efforts to use technology to increase participation can fail. Technology is not a silver bullet, but by pairing high-tech tools with innovative, personalized programming, arts organizations can provide new kinds of access that have the potential to enrich and expand arts experiences.

8 Creative Reinvention
From "One Book" to "Animals on Parade," How Good Ideas Spread Like Wildfire

DIANE GRAMS

New efforts to build relationships among organizations have led to the creation of an organizational context that encourages program sharing and reinvention. Reinvention is a programming concept that seeks to stimulate exponential expansion of participation outside of a single organizational boundary through the collective reuse and reframing of programming themes. Program reinvention is distinct from program replication, where a program model is not intended to be changed. Rather, reinvention occurs because of an implicit or explicit invitation for others to take ownership of the idea by reinventing it in forms relevant to their own organization and local audience. As a form of permissible appropriation, it is accomplished through effective relationship building; it is a highly effective way to distribute a public good broadly. At the same time, it provides arts organizations new opportunities to build participation within and across disciplines and across socioeconomic groups that have been traditionally underrepresented among arts audiences.

The One Book/One City idea was first conceived in 1998 as If All Seattle Read the Same Book, an auxiliary library program involving author visits and discussion groups. The extensive reinvention of the One Book idea by more than 391 different entities worldwide by June 2006 signals substantive change in the way that arts organizations interact. This change was stimulated through an effort to build participation in the arts, and the results have created a phenomenon. Indeed, it could be said that the One Book idea spread like wildfire. This chapter looks at how the idea and the actors implementing it not only encouraged reinvention but fanned the flames.

The One Book project began with a grant proposal by the Washington Center for the Book (WCB) at the Seattle Public Library, drafted by then-director Nancy Pearl, her associate director Chris Higashi, and an arts consultant. Their strategy was "to build audiences for literature." The WCB is a small library program that has never had more than two staff members and has operated its One Book program on an annual budget of less than one hundred thousand dollars, one-third of which covered author fees and travel. The program idea was unabashedly copied by the Chicago Public Library three years later, but, from the start, it was credited to Seattle. This began the ever-expanding process of reinvention in which libraries, nonprofit organizations, cities, states and even nations were granted permission to do the same, according to Higashi who now runs the program:

> We are now in year seven of the series that we call Seattle Reads and formerly called If All of Seattle Read the Same Book. We had done it for two or three years and got more local media attention for it than for anything else we had ever done. But it wasn't until Chicago chose *To Kill a Mockingbird* [in fall 2001] for their One Book, One City project that *they* got national press, a big article in the *New York Times*. That's the point at which the project really went boom all over the country and indeed the world. Chicago made clear that "this was not our original idea, we borrowed it from Seattle." But, that's the point at which it caught the attention of everyone. And so for the last few years, it has been just spreading like wildfire everywhere. (Higashi interview 2005)

One Book activities tie reading, book discussion groups, and library-based programming to an author visit. Promotion and scheduling are set up so that in the months before the author comes to town, bookstores and libraries stock the book, and groups all over the city read and discuss the book in preparation for the visit. This sets up a "perfect storm" of publicity so that when the author finally arrives, the hosting organization's role centers on creating and guiding opportunities for readers and the author to interact. The program is designed to bring people together for a shared experience. The exchange between readers and the author is stimulated by questions that have arisen in the months prior to the visit in activities by sponsored by libraries, bookstores, book clubs, and local radio stations. Such direct interaction between readers and an author has been, until recently, an uncommon activity: "[Our] program provides opportunities for people to come together [over] the shared experience of reading and discussing a work of literature. People are eager to participate because

this program offers a neutral place from which to start a conversation" (Higashi interview 2005).

Although much of the interaction generated by the One Book program is spontaneous, some of it is orchestrated though strategic choices by the organization behind the event. In this case it is the job of Higashi, her volunteers, advisory committee members, and partners to set in motion the probability that a relational experience among participants will indeed occur. And this is no simple task. It involves choosing the right book and author and involving a network of individuals and organizations sufficient to animate the project.

According to Higashi, in the book/author selection process, primary consideration is focused on the skill and willingness of the author to be involved in this type of interaction. An author needs to have the ability to engage in discussion with his or her audiences. He or she has to have some proven track record that is endorsed by someone on the planning committee. The intention of One Book efforts to engage audiences from a wide range of educational and cultural backgrounds in discussion has meant an increased emphasis on such author skills.

> It's important to us that the author is willing to engage with readers. Not just willing to but also [that he or she] likes to interact with his or her readers. I mean there are some great writers and some wonderful books that we [might not consider] because . . . the [author] is not that interested in this kind of interaction with his or her readers. To do a program with [an unwilling author], I just know it would fail. (Higashi interview 2005)

Indeed, the success of this and other programs like it is in part due to the increasing willingness and interpersonal skills being nurtured among writers and their audiences through such expectations. As Higashi indicates, secondary to author choice, but almost as important, is choice of the actual book. She points out that a good book for discussion is one that is well written, has multidimensional characters, and illuminates motivations, decisions, and judgments that add up to life issues readers can identify with. This emphasis on literary qualities that can lead to broader discussion is seen in the choice of Chang-rae Lee's book *A Gesture Life,* Seattle's featured book in 2003. This is the story of a Korean-born Japanese man who spent time in the Japanese army as a medic. He is now in his seventies and lives in a beautiful home in a very upscale suburb of New York. He is beloved and respected in the community, but there is something missing in his life. He's not connected to the people close to him. The book goes back and forth between the perfect life he has crafted and sharing why he is not able to love and be loved:

As it turns out, a lot of people who read the book said, "You know, I can actually relate to this person who strives for perfection." He tries to do everything so perfectly that no one will notice him. That's the way he lives his life—guarded. In the end this is what cuts him off from other people and the things he needs. Because it is a well-written book, readers can find universality, even if on the surface it seems like it has nothing to do with you. (Higashi interview 2005)

Book selection and program implementation of Seattle Reads has been drawn from the preferences of the center's staff, yet it has always included the involvement of an advisory committee of people who not only help make the events possible but also reap benefits from the program. For example, among those involved with Seattle Reads have been the program director for the local public radio affiliate who not only advises but also meets and interviews visiting authors on the air; another is the main buyer for one of the independent bookstores, who began offering such interaction with authors years ago as a strategy to sell more books. An editor who frequents literary conferences and conventions has also been closely involved. Each of these advisors brings broad connections to individuals and groups that have become important to the program. These advisors are themselves avid readers, have firsthand contact with authors, and have connections throughout publishing networks. Involving these people means that when Higashi and advisors are ready to undertake the program, they know they have everyone they need sitting at the table to make the program work. Together, the staff and the advisory committee provide the inner circle of what will become a series of exponentially expanding concentric circles of people involved in the One Book project.

REINVENTION NOT REPLICATION

The interaction among the people involved in producing a One Book project is animated by the invitation to others to take the idea and reshape it to fit their local context and run with it. This invitation distinguishes the One Book programs and the various efforts that have followed them from programs that are designed to be replicated precisely. Individuals and organizations are invited to claim ownership of a piece of the idea and make something out of it that works for them in their own locale and in their own organizational environment. This local act of remaking the cultural event is not simply about delegating duties—someone to do the fundraising, another to do the publicity, and yet another to drive the author around town. It is about giving the permission to reinvent the project. It is this invitation to participate as an organization or individual, to take the

idea or a piece of the idea, remake it, reinvent it in your organization, your city, your state, that has enabled the wildfire effect.

The process of program reinvention is thus not the same as program replication: with replication the model is not intended to be changed. By contrast, organizations that encourage program reinvention engage others in a way of thinking about a program that encourages exponential expansion and transformation of the idea. The planning process involves partners who choose locally relevant themes and who carry out individual programs while coordinating the timing of events and publicity. Again, what animates the process is the ability of each organization to take ownership of the idea and reinvent it in ways relevant to its own organizational context.

Localized Planning

The localized planning process for a One Book event must anticipate the potential for reinvention from the initial selection of the book and author. A report of the planning effort for 2005 shows how the activity moved beyond reading a book and a wide variety of organizations interested in participating because of the timeliness of the theme—the rounding up of a stigmatized group of people during times of war.

> This year's book [2005], I would say is going to be particularly relevant to Seattle. We're doing a book called *When the Emperor Was Divine* by Julie Otsuka. It's the story of a Japanese American family's internment. . . . and portrays the devastation and the dehumanization of the internment experience for this family. There are many organizations interested in this program because the Japanese Americans from Seattle were among those evacuated. . . . We're partnering with two of the area community colleges, Seattle Central and Bellevue Community Colleges, who have seminars on the internment. We will bring [the author Otsuka] to Bainbridge Island across Puget Sound, which happens to be the very first community from which the Japanese Americans were evacuated. We're working with a local group called Densho, the Japanese American Legacy Project, that collects oral histories and is building an archive of stories by survivors of internment. These survivors are in their eighties and older and everybody thinks it's very important to preserve their stories. . . . There's also a stage adaptation of *Baseball Saved Us,* a children's picture book, that has never been done in a public performance. [We are showing a traveling] exhibit by the Wing Luke Asian Museum . . . in the library. We're going to show some films and so there are lots of other things besides the book discussions and chances for people to meet the author this year. . . . It's going to be really great this year because we have so many partners. The topic this year may be closer to Seattle than some of the others we've done. (Higashi interview 2005)

This account points to the sense of shared ownership and the shared publicity of a host of programs closely related to the project. A scan of the Web shows the multiple organizations posting information about the series on their own Web sites. For example, Densho posted the following announcement: "The memorable tale that Otsuka tells in understated prose is one of universal themes. As the New York-based writer has said, 'All throughout history people have been rounded up and sent into exile. The predicament of the family in my novel—ordinary people caught up in extraordinary circumstances beyond their control—is a very human one'" (http://www.densho.org/about/SeattleReads.asp; accessed July 19, 2005).

WCB's strategic choice of topics with broad general relevance and timely appeal and its engagement of the resources of other organizations through relatively informal partnerships illustrate ways to stimulate involvement in the project.

Tracking Change

One Book programs present the same problems for tracking change of any program that is free and not under the control of a single organization. The idea of involving an entire city in a reading activity is bigger than the actual numbers of people who are involved. As Higashi points out, "It's a catchy name, but it is really a misnomer: never really has 'all of Seattle' read the book. But if you consider the number that did, it had big impact and we have followers who do it every year." Although Higashi does not know for sure how many people read the selected book each year, she does know that participation in program events is higher for a One Book program than for other public reading programs hosted by the library, and that this participation has substantially increased since the program began in 1998. Her estimates, in fact, are based on some real numbers. In the first three years of the program (1998–2000), which were funded predominantly from a single source for a single plan by WCB, audience attendance at the live programs featuring the author increased from 1,380 people to 1,800 people. In those first years, she also gathered reports by independent bookstores, where she learned that book sales at some local stores increased from zero to one hundred sales for the featured book. As the program has grown and the funding sources have become more interested in WCB's efforts to diversify readership, she has placed less emphasis on gathering figures that show growth in audience size and more emphasis on establishing partnerships and in administering audience surveys to selected samples in order to assess diversity.

One interesting statistic that points to consistent program growth is the growing involvement by book clubs. Tracking these figures is possible because of the Seattle Public Library's practice of lending uncataloged

paperback books to book clubs registered with the library. Higashi notes the number of books available for loan to book clubs doubled from six hundred paperback copies available the first years of the program in 1998 to eleven hundred books just two years later; moreover, the number of registered book clubs participating in the One Book program increased from 25 groups in 1998 to 150 groups in 2000. By 2006, the registry of book clubs at the Seattle Public Library numbered over 400.

Through the process of establishing an increasing number of partnerships with a range of organizations—including book clubs, art and history museums, theaters, social service and community groups, and community colleges—Higashi can only estimate program participation, a figure she estimates has grown from five thousand annual participants in the early years to twenty thousand or more in 2005.

NATIONAL REINVENTION

Two Organizations Build Infrastructure

Although part of the One Book story is the growth of the Seattle Reads program, the bigger story is the national reinvention. The national diffusion of the program idea is in part attributable to the work of two organizations that provide a national infrastructure of both information and training. The Center for the Book at the Library of Congress (referred to here as "the national center") supports the work of Centers for the Book in every state and provides a national information clearing house by posting all One Book events, featured books, and authors on its Web site. The American Library Association, a national advocacy and education association for libraries, has also developed an instruction manual for library staff to facilitate everything from budgeting to identifying partners, and it hosts training workshops at its national conference. The influence of these two organizations is seen in part in the work of their affiliates in each state. Among the fifty affiliated Centers for the Book, twenty-two have sponsored One Book programs, representing 5 percent of all One Book events. The majority of One Book events, 67 percent, have been sponsored by public libraries. Further analysis of listings on the national center's Web site provides a case study in the diffusion of the One Book idea and provides additional clues to what might have been important to its spreading.

The Center for the Book at the Library of Congress

The mission of the Center for the Book at the Library of Congress provided the early vision around which the One Book programs developed. The national center, established in 1977, promotes books, reading, libraries, and literacy. Each state has a center affiliated with the national center. To

be a state Center for the Book requires a formal application and approval by the Library of Congress. When its application is approved, a state center is granted affiliate status with the national center for three years. Key elements of the One Book idea are drawn directly from the mission statement for state centers:

> These state centers use themes established by the [national] Center and develop activities that promote their own state's book culture and literary heritage, sponsoring projects and hosting events that call attention to the importance of books, reading, literacy and libraries. (See the Center for the Book Web site, http://www.loc.gov/loc/cfbook/ctr-bro.html.)

This national leadership, established by the National Center for the Book, played an important role in the genesis of the One Book idea. By emphasizing the need for state support and promotion of the state's literary heritage, it established one of the repeated themes seen in One Book events—local literary culture.

The American Library Association

Workshops and resource materials developed by the American Library Association (ALA) have helped to facilitate library sponsorship of One Book programs. Mary Davis Fournier, project manager at the Public Programs Office of the American Library Association, remembers fielding her first call about the One Book effort on her second day at work, September 5, 2001. It came from a librarian interested in resource materials for library program staff to stage such events. She remembers many calls after that.

> We really became involved when we started receiving phone calls at our Chicago office. I, along with the other two project directors here at the ALA, began getting calls from librarians asking for advice and guidance tips on specifically doing one book programs. And so we talked to Nancy Pearl and some of the other folks at the Center for the Book and we talked about putting together some sort of a guide or some resources. [We wanted to produce] . . . general resources that would help libraries get a grip on what can be a rather daunting initiative, especially with smaller libraries, or smaller library systems. Nancy [and her colleagues] of course were inundated with requests for information. They were very, very good about putting their resources and discussion guides online and making them available. But they agreed that it would be great if ALA, the Public Programs Office, could take on some of the burden of information dissemination, and come up with some broader-reaching resources. (Fournier interview 2005)

> Like any great idea, when done well it inspires others . . .
>
> MARY DAVIS FOURNIER

As a result of these calls, Fournier took on the project of writing the manual *One Book, One Community: Planning a Community-Wide Read.* Although the manual and the associated workshops at the ALA's national conference provide important support in the network of information dissemination, Fournier states that it is first and foremost the quality and populist nature of the initial idea that has led to its broad appeal.

Like any great idea, when done well it inspires others to emulate it and take the model and copy it. The idea is a fantastic sort of populist idea. It has the potential to capture the imagination of a community, whether that community is a city, a county, a state, or a library system. It is intrinsically literary, but at the same time accessible. It can function across many different reading levels, age ranges. It affords an opportunity for related arts and humanities programming, sort of scene-based programming—programming based around a specific literary work. It's an idea that is particularly well suited for libraries in their role as arts and humanities programmers, that has instant accessibility. It provides a model that is easy to work with for both library program directors and arts administrators. It is also accessible to other partner entities such as city governments and city councils and schools and community organizations, community centers, senior centers, schools, all of those. It affords the potential for partnership, sort of a multilevel partnership for these groups with the library. And because it is a literary-focused initiative it can appeal on every sort of user level from basic literacy, child/family literacy concerns to adult education, continuing education, and lifelong learning focus. (Fournier interview 2005)

These qualities are what made the One Book idea accessible and compelling to a network of people nationally. However, the network of support has emerged through the whole series of events that took place. "Having accessible resources and tips and how-tos and presentations of and access to emerging experts in this particular model to do workshops and professional development programs certainly helped it spread like crazy," Fournier says. By supplying these components, the ALA has played a crucial role in the persistence and well-being of the One Book project.

An Auxiliary Program Transforming a Core Purpose?

The dual influence of these two national organizations has helped to raise the profile of the idea first carried out by the Washington Center for the Book. One Book programs have the potential to expand the core public library purpose from collection and circulation management into a gathering place more akin to a community cultural center or, as envisioned by the Walker Art Center, in Minneapolis, into a town square. The appeal of One Book programming is that it can stimulate other types of programs

within a library or across a community. Moreover, the energy from authors, staff, volunteers, and readers that typically surrounds these events can expand community support of libraries and, overall, the mission of local libraries. Since part of the planning of a One Book program is to court the participation of local government officials, schools, community leaders in the planning and implementing process, the program has the potential to create wide-reaching impacts. According to Fournier,

> [We encourage planners to consider] the big picture . . . the relationship between the library and the community and all the different elements of the community, [such as the] bureaucratic, administrative, social, or artistic with the goal of leveraging greater legitimacy in the community for the library as a cultural center. . . . This is a way that we can be more visible to the community; we can increase our institutional capital in the community, with the government, with the voter base, also hopefully a patron base, which will be voting on referendums for library funding. (Fournier interview 2005)

As she sees it, in the long term, this type of programming is helping to craft an expanded purpose for the library as a place where book clubs and discussion groups culminate in programming that features authors speaking about their work.

> If we can show [our constituents] that we are providing this service and engaging them in a way that goes beyond accessing the collection, checking out books, bringing their children to story time, and accessing the internet and computer resources for free, then this can be very valuable to us. We will be able to parlay this down the line into possibly additional funding, certainly expanding our programming resources in terms of making these partnerships [into long-term] relationships with other community organizations. (Fournier interview 2005)

So, what began as a relatively small, auxiliary program in a single library has not only spread through localized reinvention throughout the United States; according to Fournier, it has enabled some libraries to expand their missions to include elements of a community center or gathering place for the local community.

Thus far we have seen how the Washington Center for the Book initiated the idea and how the infrastructure of two national organizations played key roles in its expansion. Through further analysis of the One Book listings posted on the Web site of the national Center for the Book at the Library of Congress, a case study of the national reinvention of an idea, its extent and scope, begins to emerge. It becomes possible to see how national support in the form of vision, dissemination of information, and

training by the Center for the Book at the Library of Congress and the American Library Association contributed significantly to the potential for national reinvention. Two national organizations were able to dedicate the resources and expertise to support what has become a national programming approach where the small staff of the Washington Center for the Book of the Seattle Public Library could not.

The Story by Numbers

As seen in table 8.1, consistent with Higashi's recollection, the year 2002 represents a watershed year in number of sponsored events. In 1998 and 1999, only Seattle hosted a public reading project. But in 2000, two additional organizations sponsored events: Writers and Books, in Rochester, New York, and the Virginia Center for the Book. Both of these two organizations were directly linked to the Washington Center for the Book through professional networks: Rochester was involved with the National Audiences for Literature Network; Virginia was an affiliated Center for the Book. The next adopter, Arkansas Center for the Book, kicked off its program in August 2001, followed by the first public library, the Chicago Public Library and its One Book–One Chicago program in the fall. By the next year 2002, 126 entities were presenting One Book projects.

Since the initial launch of the program in Seattle in 1998, the 391 One Book events have featured more than two hundred different books (Library of Congress, http://www.loc.gov, accessed June 2006). As shown in table 8.2, following Chicago, *To Kill a Mockingbird* remains the most popular book as nineteen cities, seven counties, and one region have en-

TABLE 8.1. ONE BOOK PROGRAMS BY FOUNDING YEAR

Year	Number of programs	Percentage
1998	1	>1
1999	1	>1
2000	3	1
2001	12	4
2002	126	32
2003	80	21
2004	87	22
2005	61	16
2006	17	4
Other	3	1
Total	391	100.0

(Source: Library of Congress June 2006)

TABLE 8.2. TOP FIFTEEN BOOKS FROM INAUGURAL
ONE BOOK PROGRAMS

Book title	Number of features
To Kill a Mockingbird	27
A Lesson Before Dying	19
Fahrenheit 451	14
October Sky Rocket Boys	12
Tuesdays with Morrie	11
Plainsong	9
Peace Like a River	8
The Color of Water	6
The Giver	6
Pay It Forward	5
Snow in August	5
All Over but the Shoutin'	4
Nickel and Dimed	4
Snow Falling on Cedars	4
The Watsons Go to Birmingham—1963	4

Note: These figures are as of June 2006. For a complete listing see the Library of Congress Web site, http://www.loc.gov/loc/cfbook.

couraged their citizens to read it; *A Lesson Before Dying* was the second-most popular, featured by fourteen cities, three counties, and one region. Coming in third was *Fahrenheit 451* with ten cities, three counties, and one state offering it as their One Book.

Although a Center for the Book housed within a public library initiated the first program, the majority of subsequent programs were sponsored or hosted by public libraries without centers. Among the cooperating partners in funding and sponsorship have been foundations, local entities including public radio, universities, nonprofit organizations, historical societies, newspapers, bookstores, and a local humanities council. Chicago's first effort highlighted some of the successful key features in Seattle, and other structural commonalities emerged as more programs were carried out. Among these commonalities in design, they sought:

- ⇥ To enhance literacy/reading in general.
- ⇥ To bring people together for a shared experience.
- ⇥ To promote local history.
- ⇥ To highlight diversity.
- ⇥ To foreground relevant community issues.
- ⇥ To enlist mayoral or city support.

The program structure itself was also a point of commonality as many programs encouraged or hosted discussion groups prior to the author visit, offered reading guides and curriculum materials for teachers through a program Web site, and distributed buttons for participants announcing "I'm reading [the featured book]" to stimulate public interaction. Most programs chose books suitable for a range of ages, but one-third of the programs sponsored a children's series with a separate book on a similar theme. And nearly half the programs sponsored related activities pertaining to the featured book, such as film screenings, tours, and workshops. The author visit was important to the Seattle program, but only a few of the other programs across the nation included the author visit. However, those programs that did include an author visit have been the best-funded, longest-running programs with the widest attendance. The most common program element was targeting a geographic area for participation by readers. The vast majority of programs (65 percent) targeted a particular city, using localized versions of the title "One Book, One City." Among the other targets were a county or counties, a state, and the nation.

These figures tell an important aspect of the story. They show how program elements shape the characteristics of an idea and how that potential to be reshaped might lead to broad dissemination. However, another very important aspect of this story is how the idea appears transformed in local contexts.

EARLY INNOVATORS

A State Center for the Book

Among the early innovators was a state center for the book that approached the idea as a statewide program. This happened in the southern United States, where Jane Thompson, a program director for the Arkansas Center for the Book, transformed the program so that it would be relevant to audiences throughout the state in both urban and rural Arkansas, areas with little history of arts programming. To carry out partnerships throughout the state, Thompson found she needed to encourage people to be willing to take risks, and she also needed to have patience to see the program grow over the years:

> Just simply doing programming, in a sense where there's been absolutely no programming whatsoever, is a risk. In the context of our program, If All of Arkansas Read the Same Book, it was one of the first of the One Community, One Book programs to follow very shortly on the heels of Seattle [the inaugural One Book program]. And it was a huge risk that we took in doing the program the first time because it hadn't been done [in our region]. We didn't know who our constituency was; we did not know

who our partners were; we needed to spend an exorbitant amount of time on the phones saying to people, "No, no, this is who we are and this is what we're doing. No, I'm not trying to sell you a book; this is what we're doing. This is a program; would you like to be involved in some way, [such as] hosting it?" And really, you know, sometimes even getting telephone calls returned was very difficult. (Jane Thompson interview 2005)

Thompson undertook the project before national program support was underway. Therefore, she had to invent her own path as she went along. In Arkansas, libraries play a vital role in providing the majority of both literary and arts programming found throughout the state. Thompson recalls the fear that arose around her at the prospect of undertaking a program that had never been done before in her community or state, and the difficulty she encountered in getting such programs off the ground. In spite of the fact that it was backed by the library system and the state's Center for the Book, Thompson encountered resistance not only from audiences but from library staff who had never attended or planned "author programming" before.

We had [the Center] backing us [along with its] credibility and finances. [Yet], there were a lot of people out there who said, "We can't do that and this is why." But we just kind of put it out there and took the risk saying, "Oh, well, you know, if we fail we fail." And so far we haven't. . . . It is truly a risk for us to take the program into places that have not had author programming before. But we did it, largely with local authors. It's not just like a baseball field, "If you build it they will come." [When] you have an author come, [putting up] a poster in your library [is not enough to make it] happen. (Jane Thompson interview 2005)

Thompson's efforts highlight why the issue of context makes reinvention not only important, but necessary. A program might work in a metropolitan area such as Seattle, where there is an established tradition of literary programs and the demographic indicators point to the potential for success in arts programming (with the median household income at $45,736 and 47 percent of its population having a bachelor's degree or higher education level). But such a program will not hold the same appeal statewide in Washington where, despite relatively high median income levels, education levels are much lower (with only 28 percent of the state's population having a college degree). Programs must be reinvented to suit local demographic factors outside Seattle. In a more rural state such as Arkansas, for example, with low median household income ($32,182) and low education levels (only 17 percent of the population statewide having a bachelor's degree or higher), there is predictably little competition or demand for the arts and literary programming, including free programming

in public libraries. These different local contexts help illustrate the fact that the message and momentum behind the One Book idea is not that it will work anywhere, but that it can be reinvented anywhere.

A Literary Center

Literary centers such as Writers and Books in Rochester, New York, also were among the early innovators to host a One Book program. Writers and Books is one of the estimated seventy independent nonprofit literary centers throughout the United States. The "literary center" is a category that was established by the National Endowment for the Arts in the 1970s, defined by its role in presenting the work of contemporary authors and offering classes and books in ways that feature and support the work of living authors. Unlike a library, these literary centers were founded in essence as artist support groups, to support the work of living authors. Writers and Books had to reinvent the program to suit its mission. According to its executive director, Joe Flaherty, "We believe that the reader and the writer are equally important. So we have a lot of programs that involve writing. We bring in authors to give classes and workshops and readings and book signings and talks. We have about three hundred classes and workshops in which we teach various kinds of writing to people of all ages and all backgrounds. We also have a number of reading programs and this one, If All of Rochester Read the Same Book, is the largest one of our reading programs" (Flaherty interview 2005).

Although other sponsors have emphasized the new experiences that the programs offer audiences, Flaherty points out that the one book program also provides authors a valuable experience not available elsewhere.

> One of the interesting things is that when the author is here four thousand to five thousand people who have already read the book will come to hear him through various appearances. Those people have all read the book beforehand, so it's not like an author is going in for a book signing [to promote a book at a bookstore] you know, [where] people sort of listen and say, "If this person interests me I'll buy that book." These people have all read it and they've gotten involved with it and they have these very interesting questions to ask the author. All of our authors have commented on this. It's just amazing to have all these people who have read your book ahead of time want to talk to you. (Flaherty interview 2005)

Flaherty has dedicated thirty thousand dollars of his organization's five-hundred-thousand-dollar annual budget to One Book events. Funds for the program have been raised through a combination of earned income and sponsors. The city of Rochester covered one-third of the cost

(ten thousand dollars), and book sales generated another three thousand to five thousand dollars. Colleges, schools, and libraries pay a portion of the author's fee, which ranges from three thousand to five thousand dollars, and they help cover costs associated with author appearances, such as staffing, facility use, and refreshments. Flaherty points out that, although author fees are fairly low compared to authors on commercial book tours, authors also earn royalties from book sales totaling substantially more than their fee.

Following in the footsteps of the Seattle program, Writers and Books has sought to generate discussions through books and makes a concerted effort to structure the program to bring different kinds of people together.

> [Our 2002 featured book] *A Lesson before Dying,* by Ernest J. Gaines, provided a chance to talk about the death penalty because one of the characters was going to be put to death by the electric chair We take whatever themes are in each book and then arrange for a number of kinds of discussions in the months before the author arrives. . . . [For this book] we had a panel discussion with lawyers, judges, the local district attorney, and a nun who is a leader of an anti–death penalty movement. They . . . argued about the death penalty which had been recently reinstituted in New York State. (Flaherty interview 2005)

Flaherty cannot point to a single example of a "great success," but he emphasizes that "there have been so many smaller successes" highlighting how the invitation to reinvent is once again at the core of What If All Rochester Read the Same Book?

> A lot happens because we kind of throw the entire experience out to the whole community. People pick up on it and do things that we never would have thought of doing. So for instance, with *A Lesson Before Dying* . . . an English as a Second Language [ESL] class read the book and then made up a play. . . . [They were] . . . recent immigrants from Africa, Eastern Europe, and Asia, and together they did this play. It turns out that a lot of the themes that were in that play were ones that they felt very strongly themselves. [In the play] the main character is this young man who is inarticulate and is [wrongly convicted for a robbery and murders he did not do] and sent to the electric chair. And so a big point of their play was [empathy, focused on the] . . . inarticulateness of the character. For them it was in terms of not being able to explain themselves in English. So they latched on to this play which [was about] the American rural South in the 1940s and created a universal message in terms of people feeling that, because they are not articulate, they can't find their place and are not recognized for who they are and what they can offer. So that was just fantastic. I went to see it. The

audience was basically their families and other people who were in that class. It was just a fantastic experience. (Flaherty interview 2005)

As this example shows, reinvention is not limited to sponsoring readings and discussion groups but has stimulated other forms of reinvention. In this case, not only did the teacher take the book and move beyond the issues of the death penalty, but she and her students reinvented the main theme to be about the struggle to express and defend oneself as an immigrant using a foreign language. Together they stimulated a recreation of the author's story in a new genre. The class identified with the book's tragic theme about the struggle to express and defend oneself as an outsider. The process of reinvention helped these recent immigrants to learn English, to learn an historical lesson about American injustice, and to learn something about themselves, their fellow students, and their family members.

A Public Library

Chicago Public Library was the first public library to undertake the project. It reinvented the idea from the pensive query "If All Seattle Read the Same Book" to the declaration "One Book/One Chicago," and selected Harper Lee's antiracist novel, *To Kill a Mockingbird,* which had won the Pulitzer Prize for fiction in 1961. The collective reading was scheduled to take place as part of Chicago Book Week, October 8–14, 2001. But in a strategic move to gain publicity for the program, it was announced instead in early August as controversy brewed over a decision by the Muskogee, Oklahoma, school board to remove it from required reading by high school freshman because of its use of racist language. National Public Radio featured Chicago Library Commissioner Mary Dempsey and Muskogee school board member Muriel Saunders, asking them each to comment on offensive passages read on its national program *All Things Considered* (August 7, 2001). By the time the *New York Times*'s fifteen-hundred-word article "Quiet, Please; Chicago Is Reading. The Same Book at the Same Time" ran nearly three weeks later, on August 27, 2001, Commissioner Dempsey reported that the rush was already underway. The library system had stocked four thousand copies of the book, and the *Times* quoted Dempsey as saying, "They're flying off the shelves, and librarians across the country are sending me e-mails saying they want to do the same thing. . . . It's exciting partly because this book deals with important themes like civil rights and social justice, but it's also about creating a culture of reading." (*New York Times,* August 27, 2001)

The *Times* article outlined some of the key structural elements that have since become essential to One Book/One City programs: fervent support from city government; endorsement by local political leaders to promote

literacy; structured as "a communal event rather than a series of private experiences"; massive advance stocking of the book by stores and libraries; distribution of buttons to stimulate "spontaneous conversations." All of this occurred for a relatively inexpensive cost—reportedly forty thousand dollars for Chicago

Chicago claimed a huge readership (according to Higashi, more than one hundred thousand participants), and it also prepared for the event to be big. In addition to stocking substantially more copies of the book for its libraries, it distributed twenty-five thousand "mockingbird" lapel pins, and the city's chief executive, Mayor Richard M. Daley, declared it to be his favorite book from high school.

Just as the Washington Center for the Book had played an important role by initiating the idea, and the two national centers played important roles by providing the vision of supporting local literary heritage and providing national infrastructure to ensure the dissemination of information, these early innovators—another state Center for the Book, a literary center, and a public library system—all played important roles in testing the waters and pushing the scope of what was possible. However, Chicago has played a particularly strategic role in the notion of reinvention. Prior to its One Book/One City project, it already had experience in reinventing another populist idea, Cows on Parade, which had also seen rapid and extensive reinvention.

HAS THE FIRE HAS BURNT OUT?

The spark that ignited the One Book programming boom in 1998 continues to burn. Although some programs fizzled, many new ones have begun, and the One Book program, for most of the early adopters, has begun to function annually as a local literary regeneration rite. Not only did the largest number of new One Book programs start in 2002, but the vast majority (80 percent) of those start-ups organized a second program, and 69 percent organized a third program in subsequent years. It is difficult to gauge the scope of adoption, since some programs involving states may or may not involve all libraries in the state; the same is true for county-wide and citywide programs. Although a more detailed study of program innovation would require gathering detailed information from all libraries to determine how far adoption has gone, charting of the available figures (figure 8.1) reveals an adoption curve, with innovation beginning in 1998, and a peak number of adopters (126) occurring in 2002. The rate of new start-ups has slowed from 42 percent growth in 2003, to 30 percent in 2004, to 9 percent in 2005, with approximately 15 percent of the new start-ups not sustaining their programming efforts for a second or third year.

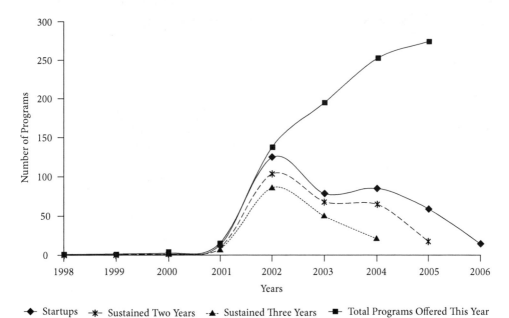

8.1 One Book Programs: Year Started, Second and Third Program years, Total Offered. Source: Library of Congress, June 2006.

The list of early adopters still sponsoring community-wide reads shows the range of local contexts involved early on in this project. Some program sponsors are entering into their fifth or sixth book or, in cases where more than one book is offered annually, their tenth book:

➤ Seattle, Washington—Seattle Reads (initiated as If All Seattle Read the Same Book, 1998)

➤ Lawrence, Kansas—Read Across Lawrence (initiated 1999)

➤ Buffalo, New York—If All Buffalo Read the Same Book (initiated 2000)

➤ Rochester, New York—If All of Rochester Read the Same Book (initiated 2000)

➤ Arkansas—If All Arkansas Read the Same Book (initiated 2001)

➤ Gainesville, Florida—One City, One Story (initiated in 2001)

➤ Boise, Idaho—Read the Same Book (initiated in 2001)

➤ Chicago, Illinois—One Book–One Chicago (initiated 2001)

➤ Johnson County, Iowa—One Community, One Book—Johnson County Reads (formerly All Johnson County Reads the Same Book, initiated 2001)

- Syracuse, New York—If All of Central New York Read the Same Book (initiated in 2002)
- Watauga County, North Carolina—Summer Reading Program (initiated in 2001)
- Racine, Wisconsin—Racine Reads (initiated 2001)

Higashi attributes the rapid spreading of One Book programs to the power of the national press to promote such programs, and Fournier attributes the rapid spreading to the power of a great idea that captured the imaginations of program planners. Both theories point to the national support structures in organizations such as the national Center for the Book at the Library of Congress and the American Library Association. These two organizations are the central links in networks that enable distribution of information, and they also have access to both staff and financial resources to provide structural support, such as the collecting and publishing of information on the Web and in training manuals enabling local planning and implementation of One Book events. There is also relatively broad public support for funding national, state, and local libraries whose missions are in part to stimulate new interest in reading, writing, and the promotion of authors. However, as this case study shows, the value of the One Book idea is found at the core of the idea: it is a spirit of collaboration and exchange that is captured in the notion of reinvention—that is, the invitation and the permission to take the idea and run with it as part of the larger collective effort to increase participation in the arts. The next case study shows that the spirit of reinvention is not contained within the literary field. Similar reinvention processes are becoming more prominent in the visual arts. They are also evident in theater, where actors have to reinvent an idea nightly on stage. Theaters interested in reaching new audiences are more openly sharing ideas that work.

BEYOND THE BOOK: PARADES OF ANIMALS

Populist cultural events are distinct from the blockbuster exhibitions such as Monet at Giverny. Indeed, no one ever asked, "What if all Seattle saw Monet at Giverny?" Blockbusters draw large crowds, but they do not engage local communities in the planning and implementation process, stimulate municipal support of the arts, engage local artists and businesses, and promote local history and culture. However, the idea of Animals on Parade in cities throughout the United States is just such an idea. It is an exhibition of visual art with a populist appeal and has been reinvented over and over in cities and towns according to locally relevant themes.

The early innovator of this idea was the city of Chicago. Its municipally

sponsored exhibition of cows, a project it copied from Zurich, Switzerland, took place in 1999, two years prior to its One Book/One Chicago program. However, once Chicago engineered Cows on Parade, it was fodder for reinventors around the country. This public art piece became a local blockbuster, literally, as tourists tracked down cows on every block to photograph themselves in front of them. The idea was subsequently reinvented in cities large and small: some cities featured cows; others chose different locally significant animals; still others chose inanimate objects as a locally relevant thematic sculpture.

These community-wide exhibitions usually start with a populist local theme; they secure municipal sponsorship early on in the planning process; and they engage artists to design, businesses to sponsor, and tourists to enjoy. The whole process recalls the One Book idea in that the exhibition brings people together for a shared experience, promotes local history, highlights diversity, provides opportunities to discuss locally relevant issues, and stimulates new avenues for municipal support of the arts.

Chicago's Cows on Parade exhibition (June 15–October 31, 1999) brought to reality the idea that artworks can generate extensive popular involvement and interaction. Just as the One Book idea had anticipated

8.2 Cows on Parade exhibition (1999). "Children on Parade," by Judith Raphael. Copyright 1999 the artists and the City of Chicago. Photograph provided by the Chicago Department of Cultural Affairs. Used by permission.

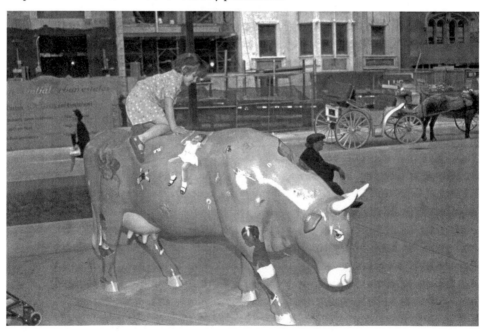

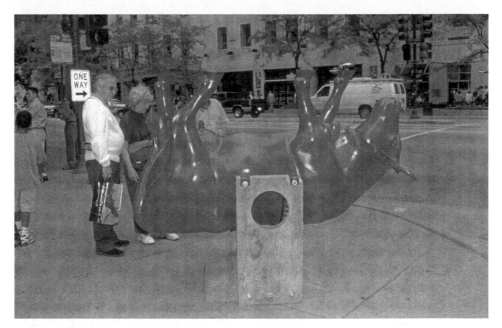

8.3 Cows on Parade exhibition (1999). "Odalisque," by Mike Baur.
Copyright 1999 the artists and the City of Chicago. Photograph provided by the Chicago
Department of Cultural Affairs. Used by permission.

reinvention from the start, this city-sponsored event laid the groundwork
for broad involvement by artists, corporations, city officials, and citizens,
inviting all participants to make something of it for themselves. The origi-
nal idea of placing fiberglass sculptured cows was suggested to Chicago's
Department of Cultural Affairs (DCA) commissioner Lois Weisburg by
Peter Hanig after he witnessed the first such installation in Zurich in 1998.
By chance, the cow was already a symbol of local significance of sorts: lo-
cal myth attributes the Chicago Fire of 1871 to Mrs. O'Leary's cow kicking
over a lantern; cows were also significant representations of the stockyards
and Chicago's meatpacking industry.

The planning and implementation process for Chicago's Cows on Parade
was led by the DCA and included over 300 local corporations, businesses,
and organizations that sponsored sculpted renditions of 320 cows. The ex-
hibit received a one-hundred-thousand-dollar grant from the Illinois De-
partment of Commerce and Community Affairs to purchase the initial cows
and to pay honoraria to the artists who painted, dressed, and accessorized
them before they were placed on display throughout the city. After the ini-
tial exhibition in the summer and fall of 1999, the cows were auctioned off
at a Cows on Parade charity auction for prices ranging from \$2,500 and
\$11,000. This event alone raised more than \$2 million for local charities; an

online auction raised an additional $1.4 million, bringing the total raised at the close of the exhibition to nearly $3.5 million. (Osgood 2000)

Like the flurry that One Book events aspire to achieve, the appearance of the cows on Chicago's city streets created a storm of publicity and tourist dollars. It attracted citizens from throughout the city and state and tourists from throughout the world to see it and be part of it by photographing themselves with cows. It was public art that was highly accessible, playful, and profitable. The exhibition drew more than one million additional tourists to Chicago that year, which translated to roughly one hundred million to two hundred million dollars in revenue, according to the Chicago Office of Tourism. A book was produced to provide an illustrated document with a full narrative of the story. Chicago's story is compelling in itself, but its relevance to this discussion is, once again, national reinvention.

By the next year (2000), eleven more cities sponsored sculptures on parade. The following year (2001), twelve more cities sponsored sculpture on parade events, followed by five new cities in 2002, four new cities in 2003, and two new cities in 2004. Ten cities copied the Cows on Parade model and displayed cows as their chosen animal on parade. They used the same cow supplier and the Chicago program model to re-create the remaining structures, such as local corporate sponsorship, local artist involvement, and a fund-raising finale to benefit one or more local programs. However, other cities reinvented the project by centering it on a locally significant animal, object, person, or event. For example, Buffalo, New York, and Davis County, Utah, both featured buffalo; New Orleans and Erie, Pennsylvania, fish; Toronto, Ontario, and Whitefish, Montana, moose; Cincinnati, Ohio, and Seattle, Washington, pigs. Meanwhile, Washington, D.C., featured (political) Party Animals—Elephants and Donkeys. Among the other animals were Dala Folk Art Horses, alligators, horses, ponies, pandas, and sheep. Other local symbols used included farmers modeled on Grant Wood; corn on the cob; guitars; lighthouses; trains; fictional characters (including Snoopy and Mr. Potato Head); and palmetto trees. All were selected for some local significance. As in Chicago, fund-raising events held in conjunction with the animals and other sculptures on parade raised from one hundred thousand to several million dollars for local charities.

As in the case of the One Book events, many of these populist exhibitions were sponsored by a municipal agency interested in promoting the locale. As populist cultural events, they unabashedly sought to break down elitist barriers often associated with "knowing" history or "understanding" art. Instead, they sought to provide people with a shared experience linked to the local place. They highlighted local history and often spotlighted some aspect of diversity—such as the diversity of artistic styles, ethnic or racial

diversity, or different periods of history. Finally, they had the direct support of the municipal leaders and departments such as mayor, city council, and fire and police departments.

HYPE OR A CORE CREATIVE PRINCIPLE?

Critics of the One Book programs and Animals on Parade have panned the efforts as "trendy" or "all hype"—in short, as having no substance. Others have sought to turn the populist appeal of such activities into broader support for the arts. One way to do this is by showing the process of reinvention as a core creative principle in support of local artists.

Kent Thompson, former artistic director at the Alabama Shakespeare Festival, currently artistic director of the Denver Center Theatre Company and a leading national figure in the commissioning of new plays, argues that reinvention is central to much artistic creation involved in producing plays for the stage.

> [Reinvention] is right at the heart of the new play process, and the unique thing about this process is it's so collaborative. I mean, obviously we rely upon the writer to write the words and make the links, but it's such a collaborative, communal experience. I think one of the things we're trying to do in the theater is reflect the world in a new way, to have a discussion with our audiences about, you know, what it means to be an African-American, what it means to be American, what it means to be white or whatever and find new stories and create new stories; so I think it's really at the heart of what we try to do with new plays . . . a lot of plays are the reinvented expression of some issue or idea or work of art that the writer has experienced, and it means something to them in terms of their culture, their background or their world. (Kent Thompson interview 2006)

> A lot of plays are the reinvented expression of some issue or idea or work of art that the writer has experienced.
>
> KENT THOMPSON

Thompson recounted how the Alabama Shakespeare Festival commissioned a professional play based upon Ernest Gaines's novel *A Lesson Before Dying* (See text box on Negotiating Ownership Rights to Develop a Play).

The process to turn the book into a play began shortly after the book was released in 1993, and it took nearly a decade to come to fruition. However, as Thompson illustrates, in professional theater and moviemaking, the reinvention process has to negotiate through the legal channel of intellectual property rights. Unlike the open invitation to participate involved in the free One Book and Animals on Parade adventures, the creation of

When [*A Lesson Before Dying*] was first published, I had a board member from New Orleans, who literally called me up and said, "This is a novel that you should make into a play for the Southern Writers Project." Then I pursued a two- or three- or four-year odyssey in trying to get the rights. I didn't know Ernest Gaines at the time. [The board member] was on the board of Tulane University. They gave Gaines an honorary degree (in 1995) and the board member went backstage to ask him if we could adapt it, and that's what started the conversation . . .

The book was encumbered with film rights for some time. Every year a different film company would buy the rights and decide not to do it . . . eventually what happened was Ernest Gaines was teaching at the Sewanee Writers Conference, as was Romulus Linney. . . . I got a call from the conference from Romulus asking if I had selected a playwright yet. Ernest had said to me at least verbally he was going to give us the rights, so I said no. Then he said he'd like to do it. And I said, "Well, I think Ernest might prefer an African American," and [laughs] Ernest was also on the line and he said, "Romulus can do it."

Although Ernest is black and Romulus is white, both men are from the South. Ernest grew up in Louisiana, but Romulus grew up in Appalachia, so he knew these stories. When I read the book what I thought was so extraordinary about it was . . . the development of this difficult relationship between this teacher and this student. . . . The issue in the novel is [how] will this young man [who was referred to as an animal during the trial] die with the dignity of a man? And that's important to his community, his relatives and eventually to the teacher. In that way it seemed almost like a Greek tragedy. . . . It was a very popular book at the time and I think it spoke to people in a way that was unique because race was such a huge issue in this book. But the book was about the relationship between this student and this teacher and how to deal with injustice. Ernest Gaines's place in the African American community was far beyond what I had first comprehended. . . .

The process of commissioning a play is, first we would commission a writer to write the first and second draft of a play. We would guarantee a workshop after the first draft where it's just actors holding the text. Then they do a reading in front of an audience. We did that in Alabama with *A Lesson Before Dying* and we did it in Signature Theater in New York with *A Lesson Before Dying* and they also did readings of the piece at Crossroads Theater. And then at that point we decided that we wanted to do [a main-stage production] and Romulus worked on several [more] drafts of the play. [Since then, the play has] been pretty widely produced.

We typically pay the playwright about ten thousand dollars. It varies, if it's a really young writer we pay like five thousand or seven thousand dollars; if it's a really established writer we'll pay more

(*continued*)

than that, more than ten thousand dollars. But I think the eight to twelve-thousand-dollar range is kind of the typical range.

For royalties, we get the industry standard: 5 percent of the author's royalties for the first five years. You don't go into it for making money. Typically in the theater you pay royalties to an author. In this case [the royalty is] probably split fifty-fifty between [the playwright and author because the play originated as a novel.] So I would think Alabama [Shakespeare Festival] has maybe made a few thousand dollars off of *A Lesson Before Dying*.

—Thompson interview 2006

a new play requires addressing a host of ownership issues at each stage of the process—from a book into a play, then a play produced on the stage, or a script turned into a film.

> When you're doing an adaptation the first step is that the writer has to seek the rights for the book. . . . The play belongs to the playwright while the novel belongs to the novelist. The playwright essentially is the one who options the book to write the play. [This becomes] a long process with an author who is as well-known, and as highly coveted, for example, as is Ernest Gaines. His books are coveted [because of the success of] *The Autobiography of Miss Jane Pittman* and some of his other books that have been made into TV movies. It's usually about a two-year process, [but for this book it became] a three- or four-year process. The actual writing of the play, the workshopping, moving it into production was relatively quick, probably compressed into about a year and a half. (Kent Thompson interview 2006)

Theaters recoup the costs of royalties and wages to directors, actors, and other theater staff by generating transactions in the form of ticket sales, donations and sponsorship. As Thompson attests, *A Lesson Before Dying* has not only served as a learning tool for students such as those in Rochester, New York, who reinterpreted it as a story about the struggles of immigrants; but it has been reinvented on stage by professional and amateur actors thousands of times throughout the United States.

CONCLUSION

This case study of If All Seattle Read the Same Book, its national reinvention, and similar efforts in the visual arts with Animals on Parade provide rich details of implementation strategies in wildly successful populist cultural events. The wealth of information publicly available about

One Book and Animals on Parade events enabled this case study to move beyond individual accounts into a broader view of how reinvention has been the core momentum driving the expansion of these two ideas nationally. These data provide evidence that successful efforts to build participation in the arts can spread beyond a single locale. All efforts do not seek this sort of populist outcome, nor do they have to be free. As other efforts illustrated here show, legal and financial issues need not constrain the reinvention process. Rather, projects involving ownership or intellectual property rights and income to pay production costs can also support rather than hinder the reinvention process. As seen in the efforts of organizations involved in this collective project to build repertoires and audiences, the open sharing of artistic ideas, along with strategies to engage local audiences, involve both the creative use and the remaking of ideas. These practices suggest the importance of collaborative work and the importance that "permission to reinvent" might play in all efforts to build participation.

9 Achieving Success

DIANE GRAMS

Success comes in many, many ways. Success is when our publications become text books in art history classes. Or success is when exhibitions we organize travel around the world, so that something like 3.3 million people [outside of Minnesota] have seen Walker exhibitions. . . . Success is when a work of art that we commissioned wins a Bessy Award. Success is when the New York Times does [a three article series]: one on the new building, one on the collection and one on the philosophy that drives this place. I mean those are all kind of conventional measures of success, but those are important. [Grants and donations] are a very important measure of success. Not only do [such contributions] enable us to do something, but they give our dreams credibility. So those are certain types of success we all know about. And then, success is when an institution like this begins to attract a more diverse audience; when the percentage of people-of-color who choose to come to this place begins to track with the local demographic. When I came here fifteen years ago, we didn't even measure whether people of color came to this place or whether teens came to this place.

—KATHY HALBREICH, FORMER DIRECTOR,
WALKER ART CENTER

This book has offered numerous examples of the ways in which arts organizations are building new relationships with communities and with a new base of customers, and in the process adding to the range of support they receive from public agencies, private donors, and various foundations. Unlike the commercial entertainment industry or national markets for the sale and resale of art objects, where profit is the first and most important measure of success, nonprofit arts organizations do not have the luxury of such a straightforward measure of their achievements. Although they also exist within the larger profit-driven economic system, they do so with the contrary purpose of enhancing the public good. Using examples from the Walker Art Center, Arena Stage, and the Loft Literary

Center, this chapter explores how these organizations have nested multiple environments within their organization to achieve multiple types of success. The chapter will also consider why an important aspect of achieving success involves learning to manage failure.

ACHIEVING SUCCESS IN MULTIPLE ENVIRONMENTS

Achieving recognition within the larger cultural field, expanding the range of audience involvement, and generating income are all distinct indicators of an organization's success in meeting its goals (see table 9.1). These measures of success are found within distinctly different organizational environments. The nonprofit arts exist within a larger institutional environment—that is, one guided by artistic standards or conventions established within the cultural sector. By contrast, an increasingly technical environment is necessary to track and tabulate inventories and costs in a consumer-based sales environment, and an increasingly participatory environment is necessary to engage more diverse groups in a changed and changing American society. How do organizations balance the characteristics of these three distinct environments? Success in selling large numbers of tickets may not sway art critics or foundation program officers who are looking for evidence of the legitimacy or artistic value of a work of art. Furthermore, attracting a wide range of nonpaying participants from various age, ethnic, and income groups will not necessarily produce master works or generate needed income. So how do organizations achieve various kinds of success, given all of these competing demands? How can they gauge the magnitude of success or failure? And to what extent is the institutional environment being transformed in the process? This chapter will explore how many successful institutions are nesting technical/transactional and participatory/relational environments within the institutional environment to produce the kinds of success they seek. Success requires the appropriate internal environment to produce the observable results and to gauge change. A summary of the characteristics associated with each type of environment is provided in table 9.1.

Many arts organizations have become quite savvy at collecting and tabulating the kind of data that can demonstrate conventional forms of success. With the right technology in place, transactional efforts that result in income are also relatively easy to record. Within such technical environments, where a fairly substantial variety of data is gathered, tabulated, and tracked, numbers rule. They are easy to come by, and they provide the most efficient gauge of success. However, measuring the success of relational efforts requires gathering evidence of the range of involvement, and this has

TABLE 9.1. TYPES OF PARTICIPATION-BUILDING PRACTICES

	Goal	Environment	Exchanges	Target of activity	Success indicators
Conventional	Legitimacy	Institutional	Authoritative	Experts	Recognition
Transactional	Sales	Technical	Consumerist	Markets	Income
Relational	Human interaction	Participatory	Collaborative	Communities	Range of involvement

proven more difficult for most organizations. One way institutions can begin to understand the range and greater diversity of participation and involvement in their programs is to track diversity efforts within their own internal operations. They might begin by asking, What are the racial and ethnic backgrounds of the staff in support, program, and managerial positions? What proportion of new hires comes from ethnically diverse backgrounds? Is there ethnic, racial, or age diversity among the organization's board, volunteers, and vendors? For each of these groups, such information as age, ethnicity, and geography can be gathered as part of an intake procedure, whether it is in collections management, board recruitment, hiring, or vendor applications. Such information is relatively easy to capture, and it serves as an important interim gauge of success at creating a participatory environment within the organization. Another indicator of broader involvement can be constructed by gathering figures on programming. For example, in a museum, how many pieces in its collection are by artists of color? Are there recent acquisitions by artists of color? What is the proportion of acquisitions of works by artists of color compared to other acquisitions? What is the number of exhibitions or other programs on themes of interest to ethnic audiences and different age groups? Ultimately, it is in attempting to determine the range of involvement by persons who are external to the organization, such as visitors, where most organizations encounter problems. The remainder of this chapter therefore focuses on the intersection of participatory, institutional, and technological environments that define the multiple goals and challenges that many organizations face simultaneously.

THE WALKER ART CENTER
A Participatory Environment within an Institutional Environment

The Walker Art Center was initially founded in 1927 and in the next two decades received public funds from the Works Progress Administration (WPA) and private funds from Mrs. Gilbert Walker. Its operating budget

in 2004 was $17.5 million. It showed consistent growth, from 1999 to 2004, with a 35 percent average annual percent increase in contributions and a 7 percent average annual increase in program services and membership combined. To achieve its participation goals, it nested a participatory environment within its established institutional one.

As Kathy Halbreich points out, the recognition of the Walker Art Center's artistic excellence, in the form of award-winning performances and extensive traveling exhibitions, the growth of its $210 million endowment, and the completion of a $73 million facility-expansion project, are all conventional forms of institutional success in the cultural field. Such measures confer legitimacy in the larger institutional environment within which the arts operate. Such accomplishments, along with the other forms of recognition, such as national awards and high-profile press reports, are important to stakeholders interested in the organization's position in the national and international institutional landscape because of the legitimacy they confer on the organization.

When organizations achieve such conventional successes, the working assumption in the past has been that audiences will follow. But this is not necessarily so. In fact, with new or previously excluded audiences, such accomplishments are likely to have little impact, and they may even set up more barriers to participation. Recognizing that it wanted to break new ground in attracting a broader and more diverse audience, the Walker Art Center sought to create a different, parallel kind of success in order to ensure its future. Like many other organizations profiled in this book, it looked to build participation by establishing new, long-term relationships with local communities and by designing or redesigning products around what people in their specific market(s) wanted to buy. Its struggle, as with many other organizations we visited, was to move beyond conventional measures of success defined within the cultural sector and, instead, to demonstrate results in creating a more participatory environment.

To achieve its participation goals, the Walker Art Center did not abandon standards of legitimacy within an institutional environment; instead, it nested a participatory environment within the daily workings of its institution. For example, it established practices and space within which to build relationships with youth, people of color, and low-income families. One example of how a participatory environment is nested within an institutional one is seen through the establishment of the Walker Art Center Teen Arts Council (WACTAC), discussed in chapter 5. The Walker provided WACTAC with a budget and staff support, at the same time inviting real participation among its targeted group by giving the teenagers relative autonomy and authority. In addition, the Walker leadership made clear its expectation that staff members work closely with the WACTAC

teens in all of their programming efforts. Other evidence of how a participatory environment is nested within an institutional one can be seen in the various ways the Walker has diversified their communications and purchasing, as Halbreich attests:

It all has to do with . . . where, in fact, the institution positions itself outside of the community, who our vendors are. You know this is all early level work that we did, where we really kind of looked at it quite systemically. The corporations in town were very helpful to us. For instance, General Mills had a huge vendor-diversity initiative, and the people who were working on that came and spoke to us. Where we could, we learned [from others]. We couldn't invent it all, and there wasn't a need to. (Halbreich interview 2005)

> Where we could, we learned [from others]. We couldn't invent it all, and there wasn't a need to.
>
> KATHY HALBREICH

The Walker has established a participatory environment by attracting and involving a diverse range of participants, from supply vendors to artists. This is evident in the participatory ethos that pervades the exhibitions, the building design, and the orientation of the staff. It can be seen in the faces, opinions, and decisions featured in organizational documents and publicity. It is evident in the extended community of involvement that now characterizes the organization, including its vendors, visitors, and supporters. The Walker has also cultivated the expertise it needs from within its own ranks through its teen program and curatorial training program. Two of its curators of color came through this diversity initiative; in addition, several of those trained by the Walker have taken positions at other institutions.

During three days of participant observation at the Walker Art Center, I saw the transparency that occurs when organizational goals become visible in daily practice. Participant observation of Random Ruckus, the theme of the Free First Saturday program at the Walker in November 2005, combined with figures from staff reports, yielded several types of observable evidence of success at reaching the target audiences of families, teens, and people from diverse ethnic and racial groups (see text box on Participant Observer of Random Ruckus). Families participated in a wide range of activities, from hands-on opportunities, performances, and conventional tours to wandering through the museum. According to figures tabulated by staff clicking handheld counters who were assigned to count people as they entered, 2,729 visitors came that day. My own spot counts in galleries and activity rooms, using only the most superficial indicators of family or ethnic/racial group membership, yielded estimates that 50 percent of the

9.1 Researchers with General Mills Consumer Insights interview visitors during Free First Saturday as part of the Walker Art Center's efforts to better understand the interests and inspirations of its audiences.
Photograph by Timothy D. Lace © 2005. Used by permission.

visitors came in family groups; additionally, an estimated 20 percent, or 600 people, were from racial or ethnic minority groups. The spot counts in the galleries, combined with observing who participated in which activities, rendered an observable result: a diverse group of people were engaging with modern art during their visit to the Walker Art Center. Yet there was no attempt to tabulate numbers of families or to gather address information that might yield socioeconomic information. In fact, tickets were not issued, limiting the Walker's ability to make accurate admission counts.

Tracking with the Local Demographic

In the quote that begins this chapter, Kathy Halbreich identifies the Walker's participation-building goal, the measurement strategy, and the interim steps necessary in gauging the diversity of audiences. The goal would be met, she asserts, "when an institution like this begins to attract a more diverse audience." But as we will see, measuring such success is difficult. One way to do it could be to compare the composition of the museum's attendees to the population more generally. In this case, she points to the demographic composition of the community served by the Walker, as she puts it, "when the percentage of people of color [and teens]

The three times I entered the Walker, on a consecutive Thursday, Friday, and Saturday in early November 2005, there was a transparent connection between the accounts provided by museum staff and what I observed. I was greeted by enthusiastic staff throughout the building; no one expressed an iota of aesthetic ennui, the expressionless performance made emblematic by pop art icon Andy Warhol. The lobby and galleries were bustling. On Thursday, there were groups of teens; on Friday, professionals for an American Association of Museums' (AAM) meeting; and on Saturday, families, families, and more families, White, African American, African, Arab, African Muslim, Asian, and interracial. Being awash with people on free day at this museum did not feel like being in a train station, that is, the museum as place that people pass through before they get to their real destination, an experience I had at one museum on a Free Friday night. Rather under [a] banner [reading] "First Free Saturdays are for Families" there was a stimulating mix of interaction: social interaction, aesthetic interaction, and the hands-on interaction, with activities to especially appeal to families with young children.

My first clue that the Walker meant business when it set out to engage a target audience was the line of parents waiting to drop $2.50 in a pay box for the park district parking lot that operated on the honor system on Saturdays. Then there were lines of families waiting to enter the theater, and more lines to get into the hands-on activities. All this was part of this Saturday's family programming entitled Random Ruckus.

While the special events appeared successful because of the lines of people willing to wait to enter, most unforgettable was the sense of interaction and engagement throughout the museum, i.e., the interaction these families had in galleries of contemporary art. Interaction was stimulated by exhibits like the Dolphin Oracle in the Best Buy Arcade, which used cutting-edge technology as a tool for group interaction—visitors took turns typing on a wireless keyboard passed through a crowd, then watched as a holographic dolphin answered questions audience members had typed (figure 9.2). Interaction continued through the House of Oracles: A Huang Yong Ping Retrospective. In this exhibition, a mom walked with two boys, each pointing out their favorite taxidermied bat hanging upside down inside Ping's *Bat Cave,* a replica of the cockpit section of a U.S. spy plane that collided with a Chinese fighter jet in 2001 that set off a week-long international standoff; couples viewed lizards, grasshoppers, and other live bugs in Ping's *Theater of the World.* In other exhibits, a blond thirty-something mom sat on the floor with a two-ish baby girl in her lap pointing out objects in Kerry James Marshall's painting, as if it were family reading time. The invitation for engagement was so visceral that the traditional barriers to touching art were broken down, requiring guards to repeatedly intervene. I was enticed by the hand-rubbed wood surface of Ping's monumental snake sculpture, [which]

(continued)

hovered from overhead, then wrapped down to the floor. As I copped a feel as if I were the artist unwilling to let hired help or a machine sander have the final finishing touch, a guard reprimanded me, acknowledging, "Even donors on opening night had to be reminded to not touch." Unapologetic, I asked, "Why? It seems like this is exactly what I am supposed to do." As if we were part of the same sacrilegious skit, she said, "Because it's art. You're not supposed to touch art. The oils in your hand can damage it."

Among the visitors observed that day: a Muslim mom pushing a stroller surrounded by her young girls all wearing traditional head and face scarves; an African American woman and white man, seemingly mom and dad to five young children being interviewed by a video crew (figure 9.1); gay, lesbian, and straight couples, a group of teens with adult chaperones; several tour groups led by museum educators; and countless individuals. My estimate: at least half the visitors this day are family groups; young people, teens to twenties, at least 10 percent; and people of color about 20 percent. The total number of visitors this day, according to staff at the door: three hundred to four hundred people entering every half hour. This number declined as the afternoon wore on, leaving the total number of visitors clicked off by hand clickers this day at 2,729. This day was about average; Walker marketing staff report that attendance for Free First Saturdays ranges from seventeen hundred to four thousand people.

—Field notes, Diane Grams, 2005

who choose to come to this place begins to track with the local demographic." The problem is twofold: (1) how to measure the range of participation within a building that is open to the public and (2) how to determine the overall population the museum serves.

Although the Walker uses relatively sophisticated technology in the presentation of its exhibitions and in its publicity, its technical environment for admission management does not provide the same straightforward tools that are useful for tracking participation as are in place in many theaters and performing arts organizations. Rather, it must implement targeted research efforts specifically designed to capture such data. A 2001 visitor survey drawn from a sample of one thousand visitors to the Walker provided a snapshot for comparison with the demographic composition of its local population. The visitor survey compared the number of gallery visits to sculpture garden visits, and the attendance at events both on- and off-site. It collected self-reported information from visitors, including ethnicity, income, education, age, location of residence, location of work, satisfaction with visit, length of visit, reason for visit, quality of service, publicity source, and membership status. The survey provided the Walker with a general understanding of its visitors, according to Phillip Bahar, director of marketing and public relations:

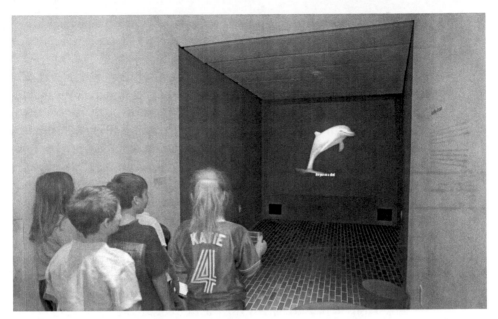

9.2 Children type questions on a wireless keyboard for the *Dolphin Oracle*, an artificial intelligence with computer interface that is both an art project and an educational tool. Photograph courtesy of the Walker Art Center. Used by permission.

In a snapshot, we are about 65 percent local, 35 percent tourists, [with overall] 13 percent people of color. So we track very closely with the actual census. So the rest is fairly typical museum and certainly contemporary art museum-type identifiers. Education is a key identifier: almost 90 percent of our visitors, or maybe just over 90 percent, have at least entered college. [On our visitor surveys] we actually track by place of residence and place of employment. Our weighted total, which includes all of our different program categories [exhibitions, performance, film, education and sculpture garden] comes out to about 32 percent of our visitors are from Minneapolis, 6.5 percent from St. Paul, 27 percent are suburban [from our] MSA [metropolitan statistical area], and the [other] 34 percent [are] tourists. (Bahar interview 2006)

In addition to visitor surveys conducted in 1996 and 2001, the Walker has conducted other research on more targeted geographic areas, including telephone surveys of its surrounding zip codes and focus groups composed of teens and people of color based upon targets established by interested funders. The information from these focus groups has informed programming decisions, but it does not gauge actual change in participation. The visitor survey, begun in 1996 and repeated in 2001, is the only gauge of change available in this set of tools. Because the survey for each

year differentiates between types of participants, it provides a snapshot of the Walker audience that is useful to compare to a "local demographic." But which local demographic does one choose?

As Bahar points out, the U.S. Census provides universal access to a range of demographic data by a broad range of geographic units, including state, metropolitan statistical area (MSA), county, city, census tract, and block. Selecting a different unit of measurement is likely to result in a difference in demographic composition (see figure A.3). The metropolitan area surrounding the Walker Art Center is 87 percent white, whereas the city of Minneapolis is 62 percent white. The ethnic makeup of the zip code area in which the Walker is located is in between—79 percent white. According to its visitor survey, the composition of the Walker's visitorship is 87 percent white. So, in this sense, the proportion of the Walker's audience that is white is comparable to the MSA. However, the demographic breakdown of racial/ethnic groups that visit the Walker does not align with either the MSA, the city, or the zip code; Asian/Pacific Islander and multiracial persons appear to be visiting the museum more often than do the other, larger minority groups that the Walker would also like to attract. The Walker's practice of referring to various racial and ethnic groups under the general rubric "people of color" might enable it to reach participation goals, but it limits its ability to draw more specific conclusions about participation and preferences of the various groups identified by the U.S. Census Bureau as residing in the area.

Nonetheless, if there is a problem, it seems to be with data collection and evaluation techniques rather than with the observable outcomes of the Walker's programs. Participant observations of daily activities at the Walker and reviews of organizational documents indicate that it is reaching its goals of attracting a diverse range of people from the local area. The problem is how to establish accurate baseline measures reflecting the proportion of various population groups and then gauge change based on the delivery of specific programs. The only way to be able to draw conclusions about program effectiveness or ineffectiveness is by making comparable observations. First, baseline observations must be established for existing programming or visitation; then the same methods of measurement that were used to construct the baseline must be applied to the new program. The difference in the various items being measured then attests to the effectiveness or ineffectiveness of the programming intervention.

The Walker is one of the exemplary organizations we identified. So, the fact that its methods and goals leave open too much room for measurement error and are not conclusive points to broader issues of tracking and associated service boundaries facing the culture field. Some cultural in-

stitutions have an advantage in this area because they have built-in measurement processes, such as ticketing for theater and music performances. Similarly, libraries require their patrons to use library cards, which also enable user tracking. Moreover, libraries have clearly defined service areas largely funded by a single municipal or county funding agency. Most arts organizations do not have the luxury of such simplicity. They operate on participation goals rather than mandated service areas, and these goals are often fragmented and likely to vary from year to year, leader to leader, and funding source to funding, source allowing for inconsistent data collection methods and irregular analysis to track change. Without such clearly defined service boundaries and routine data collection, arts organizations can, at best, draw weak conclusions about outcomes, the effectiveness of their effort and the value of the public good they create. One way to address this is to standardize data collection processes. As yet, consistent standards for the measurement of participation have not been established for the cultural nonprofit field.

Analysis of existing demographic data from a variety of arts organizations revealed just how disparate organizational practices are and how difficult it is even for experts to interpret such data. The University of Chicago's Cultural Policy Center study, *Mapping Cultural Participation in Chicago* (LaLonde et al. 2006), involved complicated mapping of 1.4 million addresses from the mailing lists of all Chicago's major cultural organizations and forty-nine other organizations serving Chicago's ethnic and diverse neighborhoods. While addresses for return patrons were routinely documented and often duplicated across participation categories of donor, subscriber/member, visitor/single ticket buyer, data for group, student, and complimentary admissions were largely absent. Analysis of these data showed that either there was not proportionate participation by racial and ethnic minorities in most cultural institutions in Chicago or the data on their participation were not routinely collected by the institutions.

The resulting findings by LaLonde et al. show that higher income and more years of education were the most significant predictors of participating, except in the case of racially or ethnically specific institutions where, clearly, concentrations of participants came from those geographic areas of Chicago dominated by the particular group. These findings are consistent with other studies drawn from individual-level survey data. The major contribution of this study is that it provides both organizations and foundations with empirical baseline data that will be useful for gauging change in the range of participation in the future. It provides a useful way for the cultural field to approach this problem: to track demographic change by specific geographic areas they hope to serve.

THE ARENA STAGE

Technical and Participatory Environments within an Institutional Environment

An examination of organizational practices at Arena Stage (est. 1950) in Washington, D.C., demonstrates how both technical and participatory environments can be nested within an institutional environment. Founded in the mid-twentieth century, Arena Stage is one of the top regional theaters in the nation. It was the first to receive a Tony Award. Its repertoire focuses on American classic plays but also includes regular premieres of new plays that it commissions. With contemporary technology behind its ticketing system, sophisticated market surveys that track audiences by play, and assertive artistic efforts to build the participation of African Americans in its theater, Arena Stage has shown remarkable success by both relational and transactional measures. Tracking of both types of success is facilitated by ticket sales. Its annual budget is $19.5 million. Over the five-year period from 1999 to 2004, contributions to the theater increased an average of 65 percent per year. The theater's program income also increased 4 percent annually.

Arena Stage's local context, Washington, D.C., nevertheless provides some constraints. Since there are few corporate headquarters located in the nation's capital, corporate sponsorship has never been high. However, the group has tapped into the vast reservoir of corporate representatives working in Washington as a means of securing individual sponsorships, and it has succeeded in attracting one or two large donations to support each of its productions. At 59 percent of the local population, African Americans make up the majority in the city of Washington, D.C.—more than twice the white population, which is at 28 percent. Arena Stage has been able to attract some general involvement by African Americans, estimated at 15 percent of its overall audience. But, as this case study shows, these audience members turn out in force for African American–themed plays. Audience surveys show that African American participation for these plays reaches 59 percent—a proportion representative of the local African American community. For productions that are not African American–themed, the African American presence can be as small as 2 percent, according to Arena's audience surveys.

Producing theater in the nation's capital during the difficult time following the September 11, 2001 terror attacks had dire ramifications. Not only did a plane succeed in hitting the Pentagon, but a subsequent anthrax scare and the serial sniper incidents further terrorized many in the D.C. area. Nevertheless, during the period from June 30, 2001, to June 30, 2002, Arena Stage saw a five-hundred-thousand-dollar increase in its pro-

9.3 Display of marketing posters for the 2005–2006 season at Arena Stage in Washington. D.C.
Photograph by Diane Grams © 2005. Used by permission

gram income, and, the following year, nearly an eight-hundred-thousand-dollar increase in program income. It accomplished this increase in part by producing hit plays, by branding plays with consistent graphics, by targeting efforts to increase subscriptions—and by increasing the costs of its tickets (figure 9.3).

Through a survey distributed to subscribers and single-ticket buyers, Arena Stage researched how sensitive its patrons and customers were to changes in ticket costs. It found that it could raise ticket prices on average 5 percent. According to marketing manager Paula Edwards, "[A 5 percent increase] was the kind of sensitivity point that showed up in the study. . . . We averaged [all the sensitivity points for different days and different types of customers] . . . and we came up with about . . . $4.50 per ticket. In some price categories and in some days of the week it was a little higher, and in some a little lower, and so that's an average" (Edwards interview 2006).

Arena Stage attributed $750,000 of its increased annual income directly to this increase in pricing. According Mark Shugoll, the vice president of the board of trustees for Arena Stage and CEO of Shugoll Research,

Most theaters across the country, when they're setting their prices for a particular season, kind of throw darts at a dartboard. They may look at their budget and say, "Well, we need to increase our earned income by 5 percent," and maybe they raise prices 5 percent. But they're doing it in a vacuum; they're not doing it with any understanding of what the consumer is willing to pay. And so we've developed a methodology . . . of asking the consumer what they're willing to pay. We have some proprietary questions in how we do that. [The result is that Shugoll Research makes recommendations for price increases] based on what their audiences are willing to pay. In some cases, theaters are underpricing their tickets. We've worked with a couple of theaters that significantly under-price their tickets in their market place. Arena is . . . the leading nonprofit theater in its market, and its tickets are not inexpensive; but we found that they could raise ticket prices without audience resistance, without any loss of subscribers,

based on this methodology. It was a different situation than at least one or two other theaters [that Shugoll Research has] worked for, where the research suggested that they were under-pricing significantly. In the Arena case it was not an issue of underpricing. . . . [But] with the quality of work that was presented, [we found that] the audience was willing to pay more because they recognized the value. (Shugoll interview 2006)

Arena Stage conducted its research on ticket prices in 2000. It had planned to implement a subscription and price increase in the fall of 2001 and proceeded to do so, even in the face of the September 11 incidents and the subsequent recession of the U.S. economy. It was not just an across-the-board increase, as Shugoll attested. Rather, prices were raised for selected categories based upon the evidence gathered about participants, including their buying patterns and preferences. It was this evidence that enabled Arena Stage to predict better than many other cultural organizations how participants might respond to price changes. Its marketing research also revealed important evidence of the change in buying patterns of its traditional audiences, as well as insight into the buying patterns of its new audience of African Americans.

Assessing Ticket-Buying Patterns

Over the past decade, Arena Stage has seen a reduction in the number of plays its subscribers are willing to commit to attending by purchasing a full subscription series of eight plays (see figure A.4). According to Edwards, Arena Stage has experienced the same trends in this as theaters nationally: full-season (eight-play) subscriptions show a downward trend. The Arena Stage now offers "mini-subs," or subscriptions to three or six plays. It has found that the growth in mini-subs mitigates the downward trend of the eight-play subscriptions. Because they offer the patron more choice and an easier entry point into the season subscription series, the overall number of subscriptions has grown. Both the mini-series subscriber and the single-ticket buyer are driven by programming, in that they only want to buy tickets for plays they want to see. Therefore, seasons with more hit plays produce more income because of higher single-ticket sales. Group sales have also shown a slight increase over the ten-year period. In addition, Arena has begun to offer a family package for some plays that families of four can attend for one hundred dollars. With sponsorship by Target, Arena Stage sold nearly one thousand family packages for *Damn Yankees* (winter 2005–2006), a package that included a gift bag containing a whiffle ball set and other baseball mementos. Group sales and family packages to this production were successful in part because each production involved a different community chorus of children singing "You Gotta Have Heart" as part of a fan club for the star character, Joe Hardy, during intermission.

Shugoll Research works with Arena Stage to conduct regular demographic profiles of its audiences, which allow the theater to interpret the buying patterns of its subscribers and single-ticket buyers much more effectively. The research company surveys audience members on a range of days throughout a given production. Among the variables it surveys for each of Arena's plays are age, resident/visitor status, place of residence, marketing source, date of decision to attend, where tickets were purchased, frequency of attendance, subscription/donor status and reason for subscribing, other theaters most often attended, rating of performance quality, childhood theater experiences, Internet access, day and time of performance, gender, marital status, education, student status, number of children living at home, race, employment status, and household income. A consistent and repeated practice of surveying allows the theater staff to track ticket purchasing patterns by these variables. For each play, it gathers between 250 and 450 surveys, or information on about 1–2 percent of its audience.

Reaching African American Audiences

Participant observation of a midweek performance of *Cuttin' Up* revealed what success might look like, in the case of one of its African American–themed productions. Following a string of successes with African American audiences in the Washington, D.C., area, including the production of Regina Taylor's *Crowns,* Arena Stage commissioned and produced *Cuttin' Up.* The play was written by the African American playwright Charles Randolph Wright and featured an all-black cast of seven men and one woman. During one Thursday night performance I attended, the play and its characters, shaped by the humor, dignity, and depth of the black experience, attracted, entertained, and educated a near-capacity, predominantly white audience (estimated as 80 percent white, 20 percent African American). According to Wright, he almost did not write the play:

> Molly Smith called me and said that she had gotten the galleys to the book *Cuttin' Up* which Craig Marberry did—Craig had done *Crowns,* which was very successful at Arena. And she said, I want you to read this book, I would love to commission you to do this play. And I told her no. And she said you really have to read this book, and I said I really don't want to do that because I felt that it was going to be the same thing as *Crowns,* and it was its own success. I don't want to do the same type of production or the same type of thing. I would really like to do something different. And she said, you should really read this. So finally, she kept calling me, she sent it to me and I started reading it. The stories started taking over, and [suddenly] I was back in my hometown barber shop and at the same time in my New York barbershop and realized it was something I had to tell. It was a story—especially for African American men—it's just a very different way

for us to be portrayed. And it was very necessary for me. And ultimately, I did the production because I wanted to see seven black men on stage in suits. (Wright interview 2006)

Wright's play is a humanistic portrayal of intergenerational interaction among black men at the barber shop. Its images challenge and make fun of superficial stereotypes typical in film and television productions. One way it did this was by showing the intimate interaction found within the barbershop, as one of the play's characters, Howard, points out: "See, this job is not just about skills. You got to know things. You got to know when a customer wants you to lift his spirits . . . and when he wants you to shut your damn mouth. A haircut is a very personal and intimate thing. That's because it involves touching." Wright's portrayal centers on the lives of people who intersect at the barber shop, who largely reflect middle-class African American society.

I often find that the black middle class or the black upper class is ignored. [People think] they don't exist, or we don't exist. . . . I used to lecture at Pepperdine in sociology, and I would say, where do black people live on television? . . . And this was late '80s, early '90s, and I said—*Miami Vice*—where does Phillip Michael Thomas live? You see where Don Johnson lives, literally—I would name every black character on television, and you would never see them go home. [It is] the thing of identity, history. . . . I know my family heritage, that I come from this long line of people who are proud of who they are and where they came from and all these things, and it's that lineage that they kept instilling in me, and that's not unusual! My family is not unusual, but the media and the world around us would have you believe that it's unusual, that [it] doesn't exist. What the norm is, is [to] ghettoize. What the norm is, is a kind of lower-class sensibility, and I don't even mean with money. Because you can have people with no money, who have values, who have strong values and who instill extraordinary goals and dreams into their children. . . . Typically, when people have never seen something, they think it doesn't exist. You know, [we had people say] you couldn't have seven black men in suits in a barber shop. But we went to a barber shop [on Martin Luther King Drive] because I had barbers train [actors in] how to cut hair, and we're sitting in there, and [one of the Arena staff] said, "Oh my god, look at these guys. This is what you're talking about!" And that's going back to the whole thing, critically. I mean, I think it's an important point . . . What bothers me [is] not the opinion of the work. It's the validity—the thing that makes me the craziest is being dismissed, is finding an entire race of people or an entire view being dismissed. And, I see that so often. (Wright interview 2006)

The play reflected Arena's approach to presenting great plays that have universal appeal. Anyone who has ever gone to a barber shop or beauty shop may recognize the experience, but they may also see a part of black life they have never seen before. According to Wright:

They understand that communal experience. The barber shop in a black community is its own unique environment, and I think we obviously showed that, but people understood what that world was. . . . We've become so separatist in what we view and what we portray, I think it's imperative that we realize that we see ourselves in stories, and then we don't see ourselves. We see something new at the same time. (Wright interview 2006)

> We see ourselves in stories, and then we don't see ourselves. We see something new at the same time.
>
> CHARLES RANDOLPH
> WRIGHT

According to the actors in the play, their experience as performers was different depending on the composition of the audience. On this night, the predominantly white audience offered little of the vocal interchange that actors report is typical of predominantly African American audiences attending Arena Stage.

In spite of Wright's early resistance, *Cuttin' Up* followed in the successful footsteps of *Crowns,* which had been based on the book *Crowns: Portraits of Black Women in Church Hats,* by Craig Marberry and Michael Cunningham. The book featured accounts and photographs of African American women who are referred to as "hat queens" because of the hats they wear to church. Both plays represent a winning formula among African American audiences—they are based on a story that provides a powerful cultural hook unique to African American communities; written, directed, and performed by African Americans; and filled with music, dance, and storytelling.

In multiple productions of *Crowns* in three successive seasons (2003–2005), Arena Stage packed in both black and white audiences to nearly 100 percent capacity. The theater was attended by more than forty-one thousand people, and it earned well over two million dollars in the first two seasons alone. For the first half of its 2005–2006 season, *Cuttin' Up* was the only African American–themed play in its repertoire, which also included *Passion Play, Born Yesterday,* and *Damn Yankees.* According to its own demographic surveys, whites represented 90 percent of the respondents for the other plays and 36 percent of the respondents for *Cuttin' Up* and *Crowns.* African Americans represented nearly 59 percent of those surveyed for both African American–themed plays; 21 percent of these

African Americans were subscribers and 78 percent were single-ticket buyers.

As evident from these data, Arena Stage has had some success in reaching African American audiences; African Americans are a significant proportion of Arena Stage's audience when its productions portray themes relevant to African American experience. Through production of African American–themed plays, Arena Stage has nested a participatory environment within its combined technological and institutional environment. This nesting gives it the capacity to attract diverse audiences and then to track them. Some of the key features of this success are having African American involvement at all stages of the play's production; themes that include intergenerational exchanges; cultural themes unique to the black experience, emphasizing black history, music, dance, and, in these two cases, gender-specific stories.

THE LOFT LITERARY CENTER

An Institutional Environment within a Participatory Environment

The case of the Loft Literary Center in Minneapolis highlights how a hybrid organization built upon a participatory environment secured greater institutional legitimacy through the establishment of a permanent home in partnership with two other literary organizations, Milkweed Editions and Minnesota Center for Book Arts. Through their business partnership, the trio was able to make the case to several key foundations that "literature needed a home" in Minneapolis. Rather than becoming landlords or tenants to the other organizations, they put the conventional nonprofit organizational structure to work in their own interests by establishing a fourth nonprofit to serve as a facility-management company in which each organization would have a governing role. The separate nonprofit management company protects each literary organization from the potential failure of other two. In less than a decade, the leading partner of the group, the Loft Literary Center, has grown from a small, struggling literary organization whose annual budget was barely four hundred thousand dollars (1996) to a larger organization with a 2004 budget of nearly two million dollars. Its contributions increased an average 45 percent over a five-year period (1999–2004), and its program revenue increased 17 percent over that same period. It has become a literary center of national stature that engages five thousand people in roughly four hundred writing classes annually and involves an additional twenty-five thousand people in literary events featuring authors reading their own works.

The Loft is representative of the relatively young group of hybrid cultural organizations founded in the late twentieth century. As literary

centers, their efforts include practices that are distinct from libraries—whose founding principles are to serve as repositories for literature and whose missions focus on managing the collection and circulations of books. Libraries have enjoyed widespread public support in many communities for more than a century. By contrast, the mission of these three literary centers is to build participation in the creative literary sector through providing a support system for living writers and the arts of writing and making books. As such, these three organizations are representative of both the struggles and successes of other kinds of artist-focused hybrids founded in the late twentieth century that serve other disciplines. The increased legitimacy, secured through their collective effort to purchase property, enabled each member of the partnership the stability of a permanent home, which ultimately allowed them to fulfill their missions to support artists and writers, writing, and live programming.

The Loft Literary Center was the lead organization behind the partnership idea. It was founded upon a relationship-building ethos—one of building relationships with other organizations, as well as with a broad range of diverse communities through their programs and educational workshops. Without a complex technological environment, it has, nonetheless, demonstrated success at transaction building through enrollment in classes, book sales, and studio rentals. Because of its relatively small size, the organization has been able follow how people actually engage in literary events, from taking classes and participating in workshops to seeking publishing opportunities and even renting writers' studios within their facility.

Literary organizations that actively support the work of living authors and present programs that involve authors in reading sessions and in teaching classes represent a relatively new organizational type. The initial process of securing capital investment from foundations and public agencies, which was once limited to very large institutions, was a difficult task. It was the kind of challenge that possibly only executive director Linda Myers and her chief financial officer, Nancy Gaschott, were up to meeting. Myers left a position as a graduate school dean and a tenured English professor because she saw this as an opportunity to bring to life a place where people could gather together to enjoy the range of pleasures involved in writing, reading, and creating books. Gaschott, a general practice attorney, had both the legal knowledge and formal negotiation skills that were necessary to undertake the project. Together they led various aspects of the project. According to Myers:

This was my dream. When I started at the Loft we didn't have enough money for cookies at the board meetings. Our budget was about four hundred thousand dollars then, I think. And we desperately needed a

reasonable home. At that time the Loft had been around twenty years and it was our fifth home. [We were in] a 105-year-old elementary school. Our classes met in little third-grader chairs in an old elementary school that was part community center, part the Loft. We would host readings of the poet laureate in the stinky gymnasium, so you would hear poetry and smell "l'eau-de-tennis shoes." So it was pretty dreadful. But we didn't have the money. (Myers interview 2005)

The key to fulfilling the dream was a partnership with organizations whose missions complemented the Loft rather than competed with it. Their search for appropriate partners took nearly a year:

[We] convened a number of meetings and we had everybody—from English departments, Friends of the Library, Minnesota Women's Press, to all of the literary presses in town, four of which are national literary presses but just happen to be located here. We had many, many meetings and after about 6 months I said, "Okay, I think we need to write a grant proposal to get some planning money and we need a mission statement, we need . . . etc." And of course the room cleared because it had been fun to get together and talk; but when it was time to do some work [the fun ended]. But luckily [Milkweed] Editions was left and they are the largest literary nonprofit [press] in the country and their mission, of all the literary presses in the Twin Cities, it's the most in harmony with ours. They publish work that they believe can have a humane effect and a transformative effect on humankind. So they have a kind of social mission that works well with our view of how important literature is and what literature can mean in a culture. And then the organization downstairs is the Minnesota Center for Book Arts, and that's one of two of the largest book arts centers in the country. And I guess I wanted them more than they wanted to be with us. I just stalked their major donor and board chair for two years because I really knew that having their great little store with handmade papers and bookmaking classes and bookbinding classes and letter press printing and paper making was so sexy and interesting. (Myers interview 2005)

The partnership was able to secure support for the full scope of their effort—planning, property research, purchase of three adjoining buildings, architectural design, and the rehab of the spaces.

Once we found our two partners, Milkweed Press and Minnesota Center for Books, four foundations gave us planning money to investigate whether we might want to live together, to raise money, to hire a realtor and to hire an architect to design the space. We looked at twenty-eight spaces and ended up looking at this property, which actually is three

contiguous buildings built in the 1880s. And we then did a joint capital campaign and raised $7.7 million dollars. Partnering with the other two organizations helped us make the case for "Literature Needs a Home." (Myers interview 2005)

The process was not an easy task, according to Gaschott, who managed the building projects. Although there was a sense of equity between the partners, it was established through the shared goal of creating a permanent home rather than through an equal financial contribution to the project. The key to the success of this collective effort was lots of communication dedicated to ensuring that everyone's needs were being met:

> I was instrumental in the detailed planning and implementation. [My job was] making sure I was listening well to the partners, making the collaboration work right, and moving it forward. . . . I was in charge of communicating the needs of the [Open Book] Board, which represented the three founding tenants: Milkweed Editions upstairs, Center for Book Arts downstairs, and the Loft. . . . I was responsible for managing the project basically, and making sure we were getting what we needed and the tenants, [i.e. the] collaborating partners were working well together and getting their needs met. . . . One of the important lessons for me about building a collaboration is [that] building the relationship among the collaborators really has to be attended to big time. Having said that, we still had differences as we went forward, and, [each had] different needs. And so part of my job was to make sure that we could address different partners' needs without bogging the project down. For instance, Milkweed needed [to move] before we were ready to have them here, because of their relationship with their landlord. So we had to solve that problem [through funding storage and a short-term lease]. Book Arts had totally different needs because of their heavy equipment. They're very facility oriented. We just needed some classrooms, some places for writers and a performance hall. They needed a place where they could make paper and bound books. They had very specific needs. We had to make sure that everyone was getting what they needed within the resources we had available for them. (Gaschott interview 2005)

In the end, the three complementary literary organizations in Minneapolis purchased property to house all three organizations, a café, and a nonprofit gallery, along with several tenants. The fourth organization they founded, Open Book, manages the property for the three partners and their tenants. Each of the three original partners sits on the board of Open Book and establishes the policies related to the facility.

Through a permanent partnership, the Loft and its literary partners have established the kind of permanence once reserved for only the largest institutions. They moved beyond the struggles faced by many young hybrid organizations that can achieve only limited success through relationship and transaction building. They used the nonprofit organizational mechanism well established in the cultural sector to achieve stability that would have been difficult, if not impossible, for each of the individual organizations acting alone. With a permanent home, each organization now has greater potential to sustain its individual programming efforts while securing institutional status for its work.

The Loft's ability to maintain a participatory environment is evident in its reports on policy making, as well as in the decision making related to daily internal operations. Among these, for example, was the directors' decision to have a four-day workweek as a means to support the work of the writers on their staff. The Loft is closed on Sunday and Monday and open on Saturday for a limited number of workshops only.

Participant observation of several activities at the Loft Literary Center yielded evidence of transparency between its program goals, programs, and outcomes. The center has been able to engage adults, young adults, and youth from diverse backgrounds as authors and audiences. Although a small crowd of fewer than twenty people attended a reading by the Native American writer Heid Erdrich on a Thursday night (November 3, 2005), the center's two-hundred-seat performance hall was nearly full for *Impartial (?), Asian American Artists and Community Response to the Chia Sous Vang Case* the following night (Friday, November 4, 2005). The next morning, the Girls and their Guardians Saturday workshop also reached participation goals, enrolling ten pairs of girls and their guardians, each of whom paid twenty-nine (for members) to thirty-three (for nonmembers) dollars to attend. Most participants in this workshop were white, female, and from the nearby metropolitan area, although one pair—a white male guardian of an African American girl—had driven nearly one hundred miles to attend. Workshop participants were led through a series of exercises that allowed them to sharpen writing skills while they built adult/youth relationships.

As these accounts suggest, arts organizations must balance institutional, participatory, and technical goals and expectations in order to be able to produce expected results in these three environments. By nesting one environment within another, organizations are able to achieve simultaneous forms of success—institutional recognition, expansion of participant involvement, and the generation of more income—each in its appropriate environment.

RECOGNIZING INEFFECTIVE ORGANIZATIONAL EFFORTS

"Failure" Does Not Describe Results

Few people we spoke with wanted to use the word "failure" to describe ineffective organizational efforts. As marketing consultant Donna Walker Kuhne has pointed out, failure is often just "seeing the truth," which might not be all that bad: "The word 'failure' . . . does not describe results. I don't know how you fail at these efforts [to build participation]. I think what happens is, you see the truth. I don't know if that's a failure. The truth could be: [that] people don't like it; [that] they're not interested in seeing it at this time; [or that] there's tremendous competition. I wouldn't use the word 'failure.' I think sometimes the answer is 'not now. Come back, [and] try again. But not now'" (Kuhne interview 2004).

One key point in this perspective is that organizations need to be able to identify what it was that produced unanticipated results. A "failure" can provide an important opportunity for internal discussion and analysis by the organization. Other leaders have pointed to "failure" as being part and parcel of the other successes in their organization. Umberto Crenca, artistic director at AS220, notes that in the process of experimenting, they are bound to fail occasionally. The fact that the café operated by AS220 "barely breaks even" is of little concern, because it provides an important "third space" and opens the organization to the outside world, further contributing to the participatory environment that pervades the organization:

> We have failures all the time—Totally Hip Coupons, Art Services 220— there are all sorts of things that never get off the ground; and that's also sort of the nature of [our] mission, really. We have to laugh at this question, because it's just so much more organic than that. . . . [Things that] failed, failures, things that don't work. [Some examples might be] the café, different attempts to earn income. . . . We've always had this [question] of how can we . . . capitalize on and create a more earned income base here? [We] think about trying to make money off some of the knowledge or some of the talent that's around here and things like that, [yet] it's always kind of extraneous to what the organization really is and what its mission is and what its behavior is. I think those are the riskiest things that we get involved in and least likely to succeed. The café, for example, as a café has never earned a profit. Never made money. It barely breaks even. And we've been running a café in downtown Providence for eleven years, twelve years . . . it's kind of subsidized . . . by the rest of the activities in some way, and it's never been really successful, by a real businessperson's standards;

it's never been really a successful business. But we keep doing it because the café is open during the day, it makes the organization very porous and accessible. All through the day, people meet there and convene there. It's a meeting place. It's just a critical part of the community aspect of who we are. . . . it's a third place for people. So the heartbeat of the building is that café. (Crenca interview 2005)

Examples of Ineffective Efforts

Both Kuhne and Crenca emphasize how an organization might experience and learn from efforts that don't work. One might also recognize a failed or ineffective effort when there is not a transparent connection between participation-building goals and results. The following two examples, City Theater and Factory Theater (both pseudonyms), demonstrate what we mean by "no transparency"—when the connection between what was intended (the organizational goal) and what was observed (the outcome), was unclear, confused, or blocked by unintended outcomes or conflicting outcomes connected to other goals. In both these cases, the organizations did not recognize that their desired results depended upon the creation of a participatory environment.

At City Theater's opening night for a production that targeted teen audiences, there were only ten to fifteen teenagers in the audience out of approximately two hundred people. The production was part of the theater's overall goal of reaching forty thousand teens annually with its programming. The event was listed in the teen section of the organization's Web site, yet there was no other observable evidence that this production was meant for a teen audience. The artistic content did not specifically speak to teen issues; there were no welcoming remarks by teen staff or any sort of volunteer presence by teens or teen actors. In fact, the performance seemed better suited for an adult, alternative performance space. With at least one-third of the seats in the theater empty, it was also unlikely that teens were turned away because of adult interest in this event. The featured performer, a youthful middle-aged woman, did a hip-hop monologue. Comments by teens involved as actors in other productions at City Theater and interviewed during their rehearsal reinforced the impression that, as one teen actor who was interviewed noted, the event was not "marketed to the right age group."

Adult staff members provided both solicited and unsolicited explanations for the obviously low number of teens in the audience. Such explanations included that opening night was typically intended for donors and supporters and that teens would come on other days when ticket prices were reduced. However, both reported and observed evidence points to an ineffective effort. Teens had a relatively limited role and limited authority

in the organization. In this case, there was a lack of integration between the organizational goal of increasing teen participation and the resources allotted to such efforts. Although City Theater was able to persuade teenagers and young adults to commit the time necessary as amateur, unpaid actors to produce plays targeted at children and families, and they had hired teens as staff members, there was no evidence that teenagers were involved in developing programs for teens. The organization did not turn to the expertise of teenagers in developing its productions, nor did it provide them with the resources necessary to carry out the task of teen recruitment.

Similarly, participant observation of College Night at the Factory Theater indicated that it was attended by few, if any, people who appeared to be college-age students. This observation was confirmed by staff reports. Staff members theorized that the date, a Thursday night before the Thanksgiving break, might have been too close to holidays and in competition with term-paper deadlines and final exams. However, another explanation, offered by one of Factory Theater's board members, points to an ineffective effort by the organization. According to this source, the effort invested by the organization was limited to naming this night "College Night" on its Web site and offering discounted tickets for students on this night. This was insufficient for attracting students. This critical internal assessment pointed to the need to structure a social event involving many different college-enrolled student groups or to offer a student discount on any night that students might be more likely to attend. According to the Factory Theater board member,

> In terms of students, I personally have been very critical of some of our efforts in attracting young people to the theater. . . . A "college night" is a great idea if the purpose is to offer low price tickets and make it somewhat of a social experience for college students [involving] a lot of other college students in the house. And, I think, if you do that, you're probably going to have to add some sort of social aspect to the event. I think we need to do a much better job of creating a social environment, whether it is having younger volunteers for that night, whether it's having a social event before or after so people can see that there are other young people there. But, to me, a "college night," if you truly want to attract college students to the theater, or if you truly want to attract high school students to the theater, you can't be doing it only one night during a run. You need to be able to create access to a theater on the student's schedule. Just as subscribers want flexibility, college students want flexibility too. Broadening access, not limiting access [should be the purpose.] If a college student, as an example, wants to go see [this play] and price is an issue, they need to be able to buy their ten-dollar ticket whenever they want to go. If

"college night" was a Thursday night, maybe they have a class Thursday night. Maybe they need to go on Tuesday night or Saturday afternoon, when they can get transportation. It can't just be a one shot offering, unless the one shot is intended to be a social event as we've already talked about. (Board member, Factory Theater)

In these examples, the lack of transparency between stated goals and observed outcomes can provide important clues about the success or failure of organizational efforts to build participation. In each case, there was little evidence of the development of a participatory environment or a sustained attempt at relationship building with a targeted group. There was also little evidence of any organizational interest in assessing, discussing, and acting on these insights—in other words, turning seeming "failures" into opportunities for success in future efforts.

These examples are in stark contrast to similar observations of Free First Saturdays at the Walker, Girls and Their Guardians writing workshop at the Loft, and the performance of *Cuttin' Up* at Arena Stage, all of which revealed more transparency between goals and outcomes. Participant observation can provide important clues about the success of organizational efforts, but sustained and consistent forms of data collection and analysis are necessary to gauge change. Establishing baseline measures and tracking outcomes for specific programming interventions are the only ways to gauge change that is attributable to organizational effort. The general lack of measurement standards within the institutional environment of the cultural field force individual organizations to establish their own measures, which are, at best, limited and often not transferable across organizational boundaries. Having the capacity to examine participation data across organizational boundaries would help the field make a better case for the public goods it provides.

CONCLUSION

The goal of building participation in the arts requires that leaders and organizations rethink the meaning of success. This chapter has focused on distinguishing the characteristics of institutional, participatory, and technical environments within cultural organizations, and on the particular difficulty involved in gauging increased participation. Part of achieving success is the occasional failure to meet organizational expectations, occasionally ineffective organizational efforts, and some resistance to change both within and outside the organization. In fact, many of the executive directors we interviewed provided candid accounts that reveal some aspect of the struggle they encountered in the course of their change projects. As Halbreich reflects, "I think some of the efforts to diversify the in-

stitution early on in my tenure were misunderstood. And maybe I was less politic in how I talked about it than I could have been or should have been or now might be, I'm not sure. I think some people . . . thought they were going to lose something."

Arts organizations are often successful at maintaining multiple environments. Achieving success requires that organizations establish the appropriate environment in order meet their goals. Many museums and hybrid organizations have shown remarkable success in building the relationships necessary to broaden their reach and to achieve broader distribution of the public good they produce, but they may not have the technical environment in place to gauge change. Theaters and performing arts groups, whose art form demands that audiences are present during a specific time for a performance after having purchased a ticket, have a greater capacity to track transactions for particular events. But they have not always been successful in aligning their organizational practices to capture and track participant data with the necessary staff skills and expertise in place to make use of available data-management technology.

To improve efforts to measure success, arts organizations and foundations need to share consistent expectations about the empirical evidence to be gathered. With greater consensus across the field about what to collect, data collection and analysis can become routine while providing substantiated numbers for total admissions and for the proportions of visitors from specific target groups, such as families, teens, or various racial, ethnic, and income groups. Consensus across organizational boundaries will enable organizations to gauge the scope of their success and adjust for their failures. It will also allow the field to make a more solid case for the public good it creates.

Postscript

DIANE GRAMS AND BETTY FARRELL

Leading nonprofit arts organizations throughout the United States are creatively finding ways to involve a broader range of participants, consumers, and partners from their local communities. These leaders are strategically reaching beyond the traditional audiences of the educated elite—the group that has historically supported the arts through their donations and patronage—to build expanded future support on a wider base. This study has shown how nonprofit cultural organizations interested in expanding or diversifying their rosters of participants have now reached a critical moment in the project of change, with the need to move beyond individual approaches to participation building to establish goals and practices that can be shared across organizational boundaries. The project of building participation in the arts is a broad goal that can strengthen the cultural sector as a whole.

KEY LESSONS ACROSS TOPICS

This book has been organized according to topics that have emerged as important to the practitioners involved in building participation: the multiple meanings of building participation; the need for organizational change and more widely distributed leadership; the value of organizational partnerships; important efforts to engage youth and more ethnically diverse audiences; the usefulness yet also the risks of investing in technology in the cultural sphere; creative idea sharing within and across artistic genres; and what it means to achieve success in participation-building efforts. Each of these topics offers its own key lessons, and they are worth restating here.

Multiple Meanings and Approaches to Building Arts Participation

Participation within any organization comes in many different forms, and one important insight from this study is that it is best understood in its variety rather than as a single arts audience. By conceptualizing arts par-

ticipation as a consumerist activity that involves a transaction, a human- ist activity that involves building and sustaining a relationship with indi- viduals and communities, or both, organizations will find they have many untapped resources at their disposal to effectively approach and monitor their success. Just as a database of well-documented and managed transac- tions is a resource that can be mined for new customers, well-documented and nurtured relationships with residents and organizations in their local communities provide organizations with opportunities to mine the cul- tural, human, and financial resources found within the networks of these interactions. The challenge is to recognize that there are different kinds and meanings of participation and that they need to be understood and addressed in different ways.

A Need for Organizational Change

A serious commitment to building broader arts participation also neces- sitates organizational change at several levels. Breaking down barriers— both real and perceived—involves opening the organization's doors more widely to newcomers, as well as retaining its long-term supporters. Creat- ing a more welcoming environment invites a sense of cultural ownership and return visits by new participants. Experimenting with new programs and reconfiguring space opens the institution to more varied uses. Orga- nizations with a widespread commitment to participation-building goals will reveal that commitment in all aspects of their work environments and in the daily activities of the people in leading and supporting roles. Inter- nally, many cultural organizations have also restructured the way that the staff works and communicates across departments. The goal is to create a more supple kind of cultural organization that can respond to the tastes and interests of a broader, more diverse public.

Leadership to Bridge an Institutional Gap

Many relatively young organizations established since 1965 were founded with inclusive and community-based missions and have always employed organizational practices to draw in diverse local communities. Others, however—especially canon cultural institutions established in the late nineteenth or early twentieth centuries—face very different challenges in their attempts to embrace change. These older organizations are more likely to reflect a gap between the cultural services they have traditionally provided and the new interests and concerns of the participants they hope to attract. It is the job of change leaders at various levels of the organiza- tion to identify these gaps and work to overcome them. Effective leadership is less about the consolidation of power than it is about the distribution of authority throughout the organization, as new participation-building

goals are identified and institutionalized. Leadership at many levels of the organization is necessary to carry out the large and small tasks required to sustain the efforts to reach these new goals.

Partnership in Building Relationships Among Organizations

Collaboration across departments and units within any arts organization can result in a broader and more effective distribution of public goods—a task that is fundamental to the nonprofit, tax-exempt status of all cultural organizations. But beyond the individual organization, efforts to build a broader network of relationships can also provide a number of concrete benefits: increased organizational capacity; heightened credibility and legitimacy of the participating organizations; access to new skills, technology, space, and other desirable goods. Such partnerships are not easy to build or sustain. Those that are most successful are the result of a careful choice of partner and an active commitment to engaging in reciprocal, trusting relationships. Partner organizations must encourage open communication to assure that their respective needs are met, as well as to overcome obstacles. Organizations working together in a well-defined partnership can be more effective in their efforts to distribute their public goods. They can also stimulate and enhance a wide variety of other public services, such as reaching youth, promoting adult health care screening and health literacy, building tolerance of cultural difference, and supporting neighborhood-based community development efforts.

Cultivating Young Audiences, Now and for the Future

Engaging young people in the arts at all stages of life requires highly intentional programs and sustained efforts. Effective exposure to the arts starts early, and many parents of young children use the arts as the basis for enriching family-based experiences. Teenagers are especially receptive to creative opportunities and innovative programs in the cultural sphere, and many arts organizations are anxious to tap this youthful market. But teens are also demanding consumers and participants. They want to experience culture through active engagement, rather than as passive audience members. They seek inviting cultural contexts that simultaneously provide guidance and independence, ownership and responsibility. They value cultural participation as a way not only to use their imaginations and build skills but also as a way to work in collaborative environments with a diverse group of their peers. Many of the features of cultural participation that are most attractive to teens are also appealing to young adults. They, too, are eager to find educational opportunities in cultural exchanges and to build social networks through cultural activities. At

250

every life stage, then, young participants challenge arts organizations to expand their programs and approaches. Reaching out to and sustaining relationships with young people require resources, commitment, and new ways of thinking and working within organizations.

Adding Diversity to the Mix

It is not only youth but also a more racially and ethnically diverse range of adults who represent the newcomers to the mainstream arts. Canon cultural organizations that have long been defined by an Anglo-European perspective are now attempting to stretch their repertoire, adding auxiliary programs or expanded programs in order to draw a more multicultural audience. Many ethnic organizations in the cultural sphere, which defined their original mission as diversifying the mainstream art world with a broader range of cultural traditions and artistic products, are also now recognizing and celebrating the diversity represented among their core constituency. Diversifying the arts is therefore a multipronged project that involves new and expanded cultural repertoires, greater representation by diverse artists, and openness to new artistic forms and products, in addition to more inclusive participation. In their efforts to reach out to a more diverse group of new participants, cultural organizations are diversifying their own staffs, programs, and approaches in ways that promise to bring new perspectives to the larger cultural sphere.

High Tech Tools in Cultural Contexts

Many nonprofit arts organizations are now experimenting with the use of technological tools to build participation. Such technologies can be a curse or a blessing: on the one hand they demand more resources and new kinds of expertise; on the other they enable higher-quality program delivery and expanded opportunities for reaching and building relationships with a broader group of potential participants. Use of high-tech tools to build participation requires that arts organizations have employees with skills appropriate to the technology and to their customers' expectations of service. Organizations may also have to realign organizational tasks, do better research, and spend more on software and hardware if they hope to move these efforts beyond short-lived, underutilized experiments. High-tech tools work best when the interface with technology is intrinsic to the organizational mission and of interest to customers or participants who have access to the appropriate technology. Technology is no silver bullet, and expensive digital tools are not necessary for or appropriate to all projects. Yet, where high-tech tools are paired with innovative, personalized programming, arts organizations can provide new kinds of access

that have the potential to expand participation while enriching cultural experiences.

Creative Reuse of Ideas, a Core Creative Principle

Arts organizations frequently share and reinvent ideas that work to build participation. Reinvention occurs when others are invited to take ownership of the idea and re-create it in forms relevant to their own organization and local audience. As a form of permissible appropriation, it is accomplished through effective relationship building; it is a highly effective way to distribute a public good broadly. At the same time, it provides arts organizations new opportunities to build participation within and across disciplines and across socioeconomic groups that have traditionally been underrepresented among arts audiences. As seen in the efforts of organizations involved in the collective project to build repertoires and audiences, the open sharing of artistic ideas, along with strategies to engage local audiences, involve both the creative use and the remaking of ideas. These practices suggest the importance of collaborative work and the importance that the "permission to reinvent" might play in all efforts to build participation.

Achieving Success and Measuring Successful Achievements

Many organizations have multiple environments—institutional, participatory, and technical—within which they operate, and they draw on different resources to build participation depending on that environment. Each involves different sets of standards and may require different metrics to measure success in meeting them. Within institutional environments, for example, the legitimacy conferred through public recognition of artistic efforts has been the ruling standard. Within participatory environments, the range of participant involvement is the best measure of success. Within technical environments, where many different kinds of data can be gathered, tabulated, and tracked, income earned is the most powerful indicator of success. Gauging success requires new kinds of organizational efforts in terms of research and assessment, and it must be measured with tools appropriate to the goals at stake. Many of the leaders interviewed for this study noted that an important part of achieving success is learning to manage failure, whether that is manifested as the incapacity to meet organizational expectations, ineffective efforts, or resistance to change from both within and outside the organization. Success in building participation is by necessity an ongoing process—an activity that will require persistence of effort and the continual fine-tuning of appropriate measurement tools.

252

In addition to the lessons found within each of the chapters of this book, we learned several general lessons about the efforts underway from the organizations involved in the project of building future bases of support for the arts. First, the expansion of the cultural infrastructure has required arts organizations to become more attractive and accessible to a broader spectrum of the public and to become more effective in their efforts to engage these diverse publics. Regardless of artistic genre, size, or age, all cultural organizations are affected, although in different ways, by changes that are local, national, and global in scope. Building participation is something that is happening and must continue to happen at the level of the individual organization and across the institutional cultural complex, with sustained commitment at every level.

Change, however, is not a uniform process. Before establishing specific participation-building goals, arts organizations need to learn much more about their local communities and the new audiences they hope to attract and retain. They need to draw on an array of tools—both quantitative and qualitative—that will help them account for the needs and tastes of participants and the particular challenges the organization will face in addressing them. They need to know, for example, if they have experienced audience attrition, and, if so, why. Responses to attrition will vary depending on whether the cause is the aging of the traditional core supporters, increased competition from other arts organizations, increased competition among household decision makers, or changing tastes and preferences as people transition through the various stages of life. Cultural organizations must become attuned to their participants in new ways that require a full set of measurement tools and the commitment and expertise to use them.

To sustain and build participation, organizations must move beyond simply targeting groups they hope to involve and begin to find ways to incorporate those groups as part of their core constituency. Organizational activities—from the daily contracts with vendors to the composition of the staff, from the governing board to the establishment of specialized advisory councils, from the core exhibition program to institutional capital expansion efforts—must be developed to enable greater, more diverse participation and, ultimately, to reanimate arts organizations as twenty-first-century centers of community activity.

How can they do so? We learned in the course of this study that sustained and innovative leadership is one of the anchors of the most successful efforts for change. A characteristic quality of the leaders cited in this study who run national, regional, or local organizations is their openness

to experimentation and their willingness to try all opportunities to increase participation in the face of declining or static audience size. Leaders must also have stamina to see their visions accomplished.

Finally, as we have argued throughout this book, the project of building participation in the arts is not made up of one-time efforts completed in the short term. They are long-term efforts carried out in the present but guided by the potential of what a transformed cultural sphere might be. They involve multiple efforts over time that may not produce immediate results but that nevertheless need to be tracked, measured, and institutionally sustained. This presents a challenge not only to arts organizations themselves but to the funders and evaluators who are a crucial part of the participation-building process. In talking to many arts practitioners in the course of this study, we came to understand how difficult it can be to gather the kind of reliable quantitative data that tracks changes and rates of success, and that these numbers are all too easily manipulated and often inflated. This is less an indicator of failure than it is a sign that there is not yet an established empirical field in the cultural sector for full and accurate measurement of the success of participation-building activities of many different kinds. Therefore, one clear recommendation arising from our study is that grantors and other sponsoring agencies that support participation-building efforts in the cultural sphere work to provide both the technical and financial support necessary to establish consistent measures, so that organizations can gauge success over time and across organizational boundaries. Such measures will require standardization across the whole cultural sector, rather than at the individual organizational level, as is currently the case. This must be an ongoing and collective project of the cultural world.

The cultural organizations that are engaged in the project to build participation are leading an important social effort. Their individual programs and practices have now begun to accumulate in an impressive record of change that is reshaping what culture means and how it is experienced by many newcomers to the arts. As new participants join traditional arts audiences in crossing the thresholds of established cultural organizations and as these organizations become more deeply engaged with and in their local communities, the activity of "entering cultural communities" is revealed to be a complex, two-way process. The challenge will to be to maintain the balance between many competing demands, in particular to think creatively and expansively about new opportunities to reshape culture as a public good while focusing intently on the small, but crucial, details of new cultural practices at work.

Appendix

TABLE A.1. LIST OF ORGANIZATIONS (WHERE ONE OR MORE INTERVIEWS WERE CONDUCTED FOR THIS STUDY)[1]

	Organization	City	State	Web site	Income 2004
1.	ACCESS, Arab Community Center for Economic and Social Services	Dearborn	MI	www.accesscommunity.org	$16,649,811
2.	Alabama Shakespeare Festival	Montgomery	AL	www.asf.net	8,126,964
3.	Alijira, a Center for Contemporary Art	Newark	NJ	www.aljira.org	1,104,557
4.	Alliance Theatre	Atlanta	GA	www.alliancetheatre.org	151,056,750
5.	American Ballet Theatre/Ballet Theatre Foundation	New York	NY	www.abt.org	35,865,069
6.	American Library Association	Chicago	IL	www.ala.org	45,338,474
7.	Appalshop	Whitesburg	KY	www.appalshop.org	2,127,796
8.	Arena Stage/Washington Drama Society	Washington	DC	www.arenastage.org	19,575,711
9.	Arkansas Center for the Book	Little Rock	AK	www.asl.lib.ar.us	Unavailable
10.	Armory Center for the Arts	Pasadena	CA	www.armoryarts.org	1,531,654
11.	Art Institute of Chicago	Chicago	IL	www.artic.edu	197,463,876
12.	Arts Center	St. Petersburg	FL	www.theartscenter.org	1,470,144
13.	Artworks!	New Bedford	MA	www.artworksforyou.org	397,446
14.	AS220	Providence	RI	www.as220.org	971,336
15.	Asia Society	New York	NY	www.asiasociety.org	32,790,737
16.	Asian Art Museum of San Francisco	San Francisco	CA	www.asianart.org	28,068,300
17.	Aspen Music Festival and School	Aspen	CO	www.aspenmusicfestival.com	20,090,070
18.	Bay Area Video Coalition	San Francisco	CA	www.bavc.org	3,481,689

19.	Bill T. Jones and Arnie Zane Dance Company	New York	NY	www.billtjones.org	2,090,373
20.	Blue Apple Players, Inc.	Louisville	KY	www.blueappleplayers.org	651,138
21.	Cal Performances, University of California	Berkeley	CA	www.calperfs.berkeley.edu	Unavailable
22.	Casa Central	Chicago	IL	www.casacentral.org	13,350,642
23.	Center for Community Arts Partnerships, Columbia College	Chicago	IL	www.colum.edu/ccap	Unavailable
24.	Center for Cultural Exchange	Portland	ME	www.centerforcultural exchange.org	659,150
25.	Center of Creative Arts (COCA)	St. Louis	MO	www.cocastl.org	6,389,491
26.	Chicago Children's Choir	Chicago	IL	www.ccchoir.org	1,881,143
27.	Chicago Historical Society	Chicago	IL	www.chicagohs.org	15,775,129
28.	Chicago Shakespeare Theater	Chicago	IL	www.chicagoshakes.com	13,129,467
29.	Chicago Sinfonietta	Chicago	IL	www.chicagosinfonietta.com	1,297,513
30.	Chicago Symphony Orchestra/Orchestral Assn.	Chicago	IL	www.cso.org	64,438,674
31.	Children's Theatre Company	Minneapolis	IL	www.childrenstheatre.org	13,797,818
32.	Community Music School of Springfield	Springfield	MO	www.communitymusicschool.com	1,859,631
33.	Cornerstone Theater	Los Angeles	CA	www.cornerstonetheater.org	1,588,494
34.	Dell'Arte International	Blue Lake	CA	www.dellarte.com	1,051,244
35.	Des Moines Art Center	Des Moines	IA	www.desmoinesartcenter.org	3,717,911
36.	El Museo Del Barrio	New York	NY	www.elmuseo.org	1,316,072

(continued)

Organization	City	State	Web site	Income 2004
37. Freedom Theater	Philadelphia	PA	www.freedomtheatre.org	1,557,762
38. Guild Complex	Chicago	IL	www.guildcomplex.org	157,900
39. Guthrie Theater	Minneapolis	MN	www.guthrietheater.org	46,323,963
40. Hancher Auditorium, University of Iowa	Iowa City	IA	www.hancher.uiowa.edu	Unavailable
41. Harris Theater / Music and Dance Theater of Chicago	Chicago	IL	www.harristheaterchicago.org	23,817,126
42. Intermedia Arts	Minneapolis	MN	www.intermediaarts.org	1,239,028
43. Isabella Stewart Gardner Museum	Boston	MA	www.gardnermuseum.org	14,302,164
44. Jacob's Pillow	Becket	MA	www.jacobspillow.org	4,700,042
45. KQED	San Francisco	CA	www.kqed.org	56,946,150
46. Liz Lerman Dance Exchange	Takoma Park	MD	www.danceexchange.org	1,592,332
47. Loft Literary Center, The	Minneapolis	MN	www.loft.org	1,934,091
48. Louisiana Philharmonic Orchestra	New Orleans	LA	www.lpomusic.com	4,072,830
49. Marwen Foundation	Chicago	IL	www.marwen.org	1,942,954
50. Mexican Fine Arts Center Museum, The National Museum of Mexican Art	Chicago	IL	www.mfacmchicago.org	4,327,152
51. Mosaic Youth Theatre of Detroit	Detroit	MI	www.mosaicdetroit.org	1,204,696
52. Museum of Fine Arts Houston	Houston	TX	www.mfah.org	262,224,940
53. National Museum of African American History and Culture of the Smithsonian Institute	Washington	DC	www.nmaahc.si.edu	Unavailable

54.	National Museum of the American Indian of the Smithsonian Institution	Washington	DC	www.nmai.si.edu	Unavailable
55.	New Jersey Performing Arts Center	Newark	NJ	www.njpac.org	25,558,871
56.	Newark Museum	Newark	NJ	www.newarkmuseum.org	19,505,714
57.	Old Town School of Folk Music	Chicago	IL	www.oldtownschool.org	7,927,145
58.	Perseverance Theatre	Douglas	AK	www.perseverancetheatre.org	1,160,152
59.	Pittsburgh Ballet Theater	Pittsburgh	PA	www.pbt.org	6,551,111
60.	Prince Music Theater	Philadelphia	PA	www.princemusictheater.org	4,905,781
61.	Real Art Ways	Hartford	CT	www.realartways.org	928,720
62.	Redmoon Theater	Chicago	IL	www.redmoon.org	1,042,427
63.	Repertorio Español	New York	NY	www.repertorio.org	2,289,475
64.	Revels	Watertown	MA	www.revels.org	1,343,618
65.	San Francisco Performances	San Francisco	CA	www.performances.org	2,853,494
66.	San Francisco Symphony	San Francisco	CA	www.sfsymphony.org	56,114,293
67.	Seattle Art Museum	Seattle	WA	www.seattleartmuseum.org	56,285,802
68.	Seattle Opera	Seattle	WA	www.seattleopera.org	20,233,570
69.	Seattle Repertory Theatre	Seattle	WA	www.seattlerep.org	7,301,240
70.	Side Street Projects	Pasadena	CA	www.sidestreet.org	Unavailable
71.	Smithsonian Institution	Washington,	DC	www.si.edu	432,984,481
72.	Speed Art Museum	Louisville	KY	www.speedmuseum.org	7,910,214

(continued)

	Organization	City	State	Web site	Income 2004
74.	University Musical Society	Ann Arbor	MI	www.ums.org	6,748,576
75.	Village of Arts and Humanities	Philadelphia	PA	www.villagearts.org	693,082
76.	Walker Art Center	Minneapolis	MN	www.walkerart.org	39,649,924
77.	Washington Center for the Book	Seattle	WA	www.spl.org	Unavailable
78.	Western Folklife Center	Elko	NV	www.westernfolklife.org	2,445,941
79.	Wing Luke Asian Museum	South Seattle	WA	www.wingluke.org	2,698,716
80.	Writers and Books	Rochester	NY	www.wab.org	578,283
81.	Yerba Buena Center for the Arts	San Francisco	CA	www.yerbabuenaarts.org	6,676,303
82.	Young Chicago Authors	Chicago	IL	www.youngchicagoauthors.org	367,465
	Other organizations				
	National Arts Marketing Project (NAMP)/Arts and Business Council.	New York	NY	www.artsmarketing.org/	Unavailable
	Cultural Policy Center at the University of Chicago	Chicago	IL	culturalpolicy.uchicago.edu	Unavailable
	Institute for Ethnicity, Culture, and the Modern Experience, Rutgers-Newark	Newark	NJ	ethnicity.rutgers.edu	Unavailable

[1]Income information is from the IRS Form 990 for the year ending 2004 (total revenue, Line 12). Those listed as "unavailable" fall under the auspices of another larger umbrella organization such as a university, library, or other nonprofit.

FIGURE A.1. Population of Twelve Cities by Race/Ethnicity

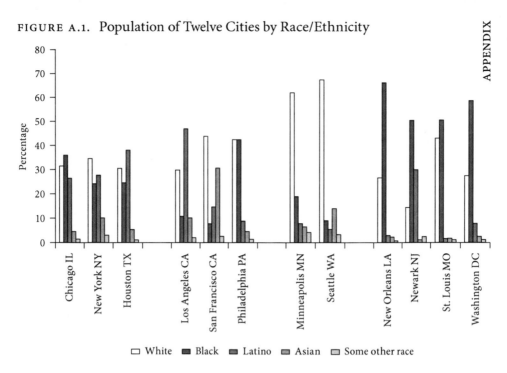

Source: U.S. Census 2000.

FIGURE A.2. Changes in contributions and program/membership revenues among arts organizations in the study over five-year period, 1999–2004 (based on changes in median value)

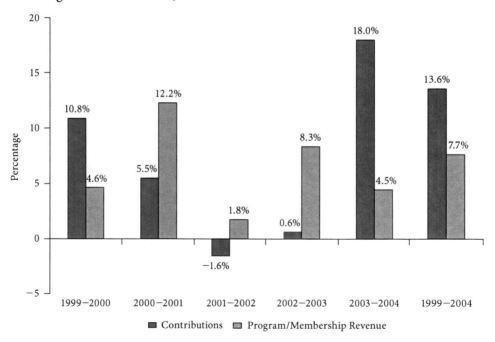

Source: IRS Form 990, Lines 1d, 2.

FIGURE A.3. Comparison of Walker Art Center visitor data to three local geographical units: Minneapolis Metropolitian Statistical Area (MSA)[1], city of Minneapolis, and zip code 55403

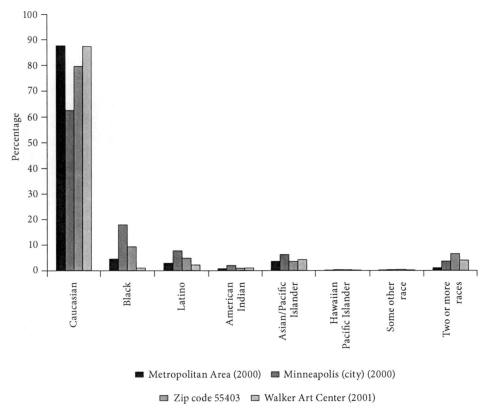

■ Metropolitan Area (2000) ■ Minneapolis (city) (2000)

▨ Zip code 55403 ▨ Walker Art Center (2001)

Source: U.S. Census 2000; Walker Art Center Visitor Data (2001)
1 The MSA spans seventy-five miles in each direction from Minneapolis/St. Paul and covers thirteen counties: Isanti, Chisago, Sherburne, Anoka, Wright, Hennepin, Ramsey, Washington, St. Croix (WI), Carver, Scott, Dakota and Pierce (WI).

Arena Stage Sales Trends

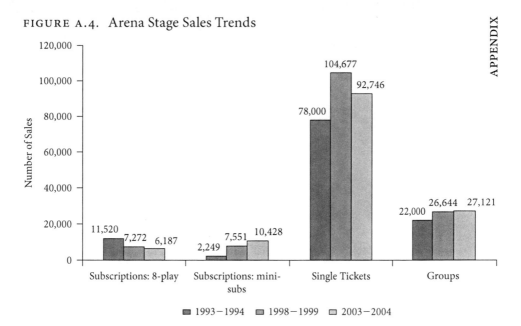

Source: Arena Stage Marketing Surveys.

Bibliography

American Association of Museums. [1992] 1998. *Excellence and Equity: Education and the Public Dimension of Museums.* Washington, DC: American Association of Museums.

Art Institute of Chicago. 1999. *African Americans in Art, Selections from the Art Institute of Chicago.* Seattle: University of Washington Press.

Becker, Howard. 1982. *Art Worlds.* Berkeley: University of California Press.

Bourdieu, Pierre. 1984. *Distinction: A Social Critique of the Judgment of Taste.* Cambridge, MA: Harvard University.

Bunch, Lonnie G. 2005. "The Fire This Time: Race, Memory, and the Museum." *Museum News* (November/December).

Cadwell, Louise Boyd. 2003. *Bringing Learning to Life: The Reggio Approach to Early Childhood Education.* New York: Columbia University Press.

Cherbo, Joni M., and Margaret Wyszomirski. 2000. "Mapping the Public Life of the Arts in America." In *The Public Life of the Arts in America,* ed. Joni Maya Cherbo and Margaret Jane Wyszomirski, 3–21. New Brunswick, NJ: Rutgers University Press.

Chicago Traveler. 2006. http://www.chicagotraveler.com/cows_on_parade.htm (February 2, 2006).

Clark, Terry Nichols. 2004. *The City as an Entertainment Machine.* Oxford, UK: Elsevier

Clearwaters, Deborah. 2005. "The Architecture of Education: Designing Spaces to Fit Programs and Programs to Fit Spaces." Panel presented at the American Association of Museums conference, May.

Cobb, Amanda J. 2005. "The National Museum of the American Indian as Cultural Sovereignty." *American Quarterly* (June).

Contro, Antonia. 2004. "Foreword." In *Fuel: Giving Youth the Power to Succeed.* Chicago: Marwen, ix–x.

Cunningham, Michael, and Craig Marberry. 2000. *Crowns: Portraits of Black Women in Church Hats.* New York: Doubleday.

Dabson, Laura C., and Edwin G. West. 1990. "Performing Art Subsidies and Future Generations." *Journal of Behavioral Economics* 90 (1): 23–34.

DiMaggio, Paul J. 1986. *Nonprofit Enterprise in the Arts: Studies in Mission and Constraint.* New York: Oxford University Press.

DiMaggio, Paul J., and Francie Ostrower. 1992. *Race, Ethnicity and Participation in the Arts: Patterns of Participation by Hispanics, Whites, and African Americans in Selected Activities from the 1982 and 1985 Surveys of Public Participation in the Arts.* Santa Ana, CA: Seven Locks Press.

DiMaggio, Paul J., and Michael Useem. 1978. "Social Class and Arts Consumption: The Origins and Consequences of Class Differences in Exposure to the Arts in America." *Theory and Society* 5 (2): 141–161.

Dore, Ronald. 1983. "Goodwill and the Spirit of Market Capitalism." *British Journal of Sociology* 34:459–82.

Fine, Gary Alan. 2004. *Everyday Genius: Self-Taught Art and the Culture of Authenticity.* Chicago: University of Chicago Press.

Fiske, E. B., ed. 1999. *Champions of Change: The Impact of the Arts on Learning.* Washington, DC: Arts Educational Partnership.

Florida, Richard. 2002. *The Rise of the Creative Class.* New York: Basic Books.

Goldhawk, Sara. 1998. *Young Children and the Arts: Making Creative Connections. A Report of the Task Force on Children's Learning and the Arts: Birth to Age Eight.* Washington, DC: Arts Education Partnership, Council of Chief State School Officers.

Grams, Diane M. Forthcoming. *Producing Local Color: Ethnic Art Networks in Chicago.* Chicago: University of Chicago Press.

Grams, Diane M., and Michael Warr. 2003. "Leveraging Assets: How Small Budget Arts Activities Benefit Neighborhoods." The John D. and Catherine T. MacArthur Foundation. http://www.macfound.org/documents/docs/small_budget_arts_activities.doc (accessed July 7, 2004).

Graves, James Bau. 2005. *Cultural Democracy.* Champaign: University of Illinois Press.

Haithman, Diane. 2005. "Say it Again Omar." *Los Angeles Times.* July 31, 2005, E31.

Halle, David. 1992. "The Audience for Abstract Art: Class, Culture, and Power." In *Cultivating Differences: Symbolic Boundaries and the Making of Inequality,* ed. Michele Lamont and Marcel Fournier, 131–151. Chicago: University of Chicago Press.

Hayes, Christopher. 2006. "Who is Georgia 10?" *The Chicago Reader,* April 28.

Headlee, Celeste. 2005. "Detroit Students Sing Their Way to College," National Public Radio report, http://www.npr.org/templates/story/story.php?storyId=4760837 (accessed August 5, 2005/).

Heath, Shirley Brice, and Adelma Roach. 1998. "The Arts in the Nonschool Hours." Research report, Carnegie Foundation for the Advancement of Teaching, Menlo Park, CA.

Heath, Shirley Brice, with Adelma Roach. 1999. "Imaginative Actuality: Learning in the Arts during the Nonschool Hours," in *Champions for Change: The Impact of the Arts on Learning,* ed. Edward B. Fiske, 19–34. Washington, DC: Arts Educational Partnership.

Heath, Shirley Brice, and Laura Smyth. 1999. *ArtShow: Youth and Community Development: A Resource Guide.* Washington, DC: Partners for Livable Communities.

Heath, Shirley Brice, with Elisabeth Soep and Adelma Roach. 1998. "Living the Arts Through Language and Learning: A Report on Community-based Youth

Organizations." *Americans for the Arts Monographs*, vol. 2, no. 7 (November): 1–18.

Hesselbein, Francis, Marshall Goldsmith, and Richard Beckhard, eds. 1997. *The Organization of the Future*. San Francisco: Jossey-Bass Publishers.

Hilton, Kathleen. 2005. "Changing of the Avant-Garde: AS220 Turns Twenty and Broadens More Than Minds." *Providence Monthly*. July, 17–21.

HistoryMakers. 2006. "Ronne Hartfield Biography." http://www.thehistorymakers.com (accessed February 17, 2006).

Janes, Robert R. 1997. *Museums and the Paradox of Change: A Case Study in Urgent Adaptation*. 2nd ed. Calgary, Albert, Canada: University of Calgary Press.

Kammen, Michael. 2006. *Visual Shock: A History of Art Controversies in American Culture*. New York: Alfred A. Knopf.

Karp, Ivan, Christine Mullen Kreamer, and Steven D. Lavine, eds. 1992. *Museums and Communities: The Politics of Public Culture*. Washington, DC: Smithsonian Institution Press.

Karraker, David. 2001. "pARTners: The ART of Building Community." Final Evaluation Report to the Maine Community Foundation.

Kaufman, Andrea Kayne. 2004. "Experiencing the Developmental Benefits of Marwen." In *Fuel: Giving Youth the Power to Succeed*, 21–25. Chicago: Marwen Foundation.

Kennedy, Randy. 2006. "At Museums: Invasion of the Podcasts." *New York Times*. May 19, E25.

Kotler, Neil, and Philip Kotler. 1998. *Museum Strategy and Marketing*. San Francisco: Jossey-Bass.

LaLonde, Robert, Colm O'Muircheartaigh, Julia Perkins, Diane Grams, Ned English, and D. Carroll Joynes. 2006. "Mapping Cultural Participation in Chicago." Chicago: Cultural Policy Center at the University of Chicago.

Levine, Mindy N. 2002. "Powerful Voices: Developing High-Impact Arts Programs for Teens." New York: Surdna Foundation.

Loukaitaou-Sideris, Anastasia, and Carl Grodach. 2004. "Displaying and Celebrating the 'Other': A Study of the Mission, Scope and Roles of Ethnic Museums in Los Angeles." *Public Historian* 26 (4): 49–71.

Marberry, Craig. 2005. *Cuttin' Up: Wit and Wisdom from Black Barber Shops*. New York: Doubleday.

Marshall, Kerry James. 2000. *Kerry James Marshall*. New York: Abrams.

McCarthy, Kevin, Elizabeth H. Ondaatje, Laura Zakaras, and Arthur Brooks. 2004. *Gifts of the Muse: Reframing the Debate about the Benefits of the Arts*. Santa Monica, CA: RAND Corporation.

McDonald, Heath. 1999. "Melbourne Symphony Orchestra Targeting Youth Audiences." In *Innovative Arts Marketing*, ed. Ruth Rentschler, 48–64. New South Wales, Australia: Allen and Unwin.

Meyer, John W. and Brian Rowan. 1977. "Institutionalized Organizations: Formal Structure as Myth and Ceremony." *American Journal of Sociology* 83(2)340–363.

Milner, Murray. 2004. *Freaks, Geeks and Cool Kids: American Teenagers, Schools, and the Culture of Consumption*. New York: Routledge.

Molotch, Harvey1. 1976. "The City as a Growth Machine." *American Journal of Sociology* 82 (2): 309–330.

Moore, Mark H. 1995. *Creating Public Value: Strategic Management in Government.* Cambridge, MA: Harvard University Press.

"Mosaic: Excellence on Stage and in Life." n.d. Detroit: Mosaic Youth Theatre.

Nagel, Joanne. 1994. "Constructing Ethnicity: Creating and Recreating Ethnic Identity and Culture." *Social Problems* 41 (1): 152.

Osgood, Charles. 2000. Chicago's Cows on Parade. http://www.geocities.com/SoHo/Square/1445/Chicagocows.htm (accessed February 2, 2006).

Ostrower, Francie. 2004. *Partnerships between Large and Small Cultural Organizations: A Strategy for Building Arts Participation.* Washington, DC: Urban Institute.

Ouroussoff, Nicolai. 2005. "An Expansion Gives New Life To an Old Box." *New York Times.* April 15.

Parker, Daniel Texidor. 2004. *African Art: The Diaspora and Beyond.* Chicago: Parker.

Pasles, Chris. 2006. "A Concertino with a Too Familiar Ring." *Los Angeles Times.* June 18. http://www.chicagosinfonietta.org/press/reviews/06oct_latimes_feature.htl (accessed June 25, 2006).

Peterson, Richard A. 1980. "Accounting for Taste: Some First Steps." Paper presented at American Sociological Association conference, August.

Peterson, Richard, and Gabriel Rossman. 2005. "Changing Arts Audiences: Capitalizing on Omnivorousness." Paper presented at the Harris School of Public Policy, Cultural Policy Center Workshop, University of Chicago, October 14. http://culturalpolicy.uchicago.edu/pdfs/peterson1005.pdf.

Peterson, Richard A, Pamela C. Hull, and Roger M. Kern. 2000. *Age and Arts Participation: 1982–1997* [National Endowment for the Arts, Research Report #42]. Santa Ana, CA: Seven Locks Press.

Podolny, Joel, and Karen L. Page. 1998. "Network Forms of Organization." *Annual Review of Sociology* 24:57–86.

Pogrebin, Robin. 2004. "Philharmonic Tests a Stage Thrust Into the Audience." *New York Times.* July 28.

———. 2005. "Light and Airiness for Art Institute of Chicago's New Wing." *New York Times.* May 31

Powell, W. W. 1990. "Neither Market nor Hierarchy: Network Forms of Organization." *Research in Organizational Behavior* 12:295–336

Powell, Walter W., and Paul J. DiMaggio, eds. 1991. *The New Institutionalism in Organizational Analysis.* Chicago: University of Chicago Press.

Presidential Commission. 2003. "The Time Has Come." National Museum of African American History and Culture Plan for Action. April 2.

Quart, Alissa. 2002. *Branded: The Buying and Selling of Teenagers.* Boulder, CO: Perseus Publishing.

Riley, Duncan. "The Blog Herald." March 14, 2005. http://www.blogherald.com/2005/03/14/how-many-blogs-in-china/ (accessed March 30, 2005).

Roberts, Lisa C. 1997. *From Knowledge to Narrative: Educators and the Changing Museum.* Washington, DC: Smithsonian Institution Press.

Rosewall, Ellen, 2006. "Community Assessment and Response: Answering the Arts Building Boom." *Journal of Arts Management, Law, and Society.* November.

Salamon, Julie. 2004. "Scavenger Hunts Go Highbrow." New York Times. March 5.

Salzman, Jack, et al. 1992. *Bridges and Boundaries: African Americans and American Jews.* New York: George Braziller.

Schor, Juliet. 2004. *Born to Buy: The Commercialized Child and the New Consumer Culture.* New York: Scribner.

Schneider, Beth. 1998. "A Place for All People." Houston: The Museum of Fine Arts, Houston.

Scott, W. Richard. 1991. "Unpacking Institutional Arguments." In *The New Institutionalism in Organizational Analysis,* ed. Walter W. Powell and Paul J. DiMaggio, 164–182. Chicago: University of Chicago Press.

Seattle Art Museum. 2003. "How Are We Doing?" Community Survey. July. http://www.seattleartmuseum.org/community/pdf/CommunitySurveyJuly2003.pdf (accessed June 30, 2006).

——. 2005. "Measurements of Success: Outreach and Diversity Efforts, "Deepening the Dialogue: Art and Audience." http://www.seattleartmuseum.org/Community/pdf/DTDMeasurementsOfSuccess.pdf (accessed June 30, 2006).

Siegel, David, Timothy Coffey, and Gregory Livingston. 2004. *The Great Tween Buying Machine: Capturing Your Share of the Multi-Billion Dollar Tween Market.* Dearborn, MI: Trade Publishing.

Simpson, Charles. 1981. *SoHo: The Artist in the City.* Chicago: University of Chicago Press.

Taha, Halima. 2005. *Collecting African American Art: Works on Paper and Canvas.* Burlington, VT: Verve Editions, Ltd.

Tommasini, Anthony. 2005. "New Vigor, New Program, New Stage: The Rejuvenation of Mostly Mozart." *New York Times.* August 31.

von Rhein, John. 2006. "Sinfonietta Puts Forth the Young and the Rowdy." *Chicago Tribune.* March 15. http://www.chicagosinfonietta.org/press/reviews/06mar.html (accessed June 28, 2006).

Wakin, Daniel J. 2005. "New Overtures at the Symphony." *New York Times.* August 21.

Walker Art Center Teen Programs. n.d. "Connecting Young People to the Art and Artists of Our Time." Minneapolis: Walker Art Center (brochure).

Walker Art Center. 1999. "A Teen Programs How-To Kit."

Wallman, Sandra, ed. 1979. *Ethnicity at Work.* London: Macmillan.

Weil, Stephen E. 1997. "Forward." In *Museums and the Paradox of Change: A Case Study in Urgent Adaptation,* ed. Robert R. Janes, ix–xi. 2nd ed. Calgary, Alberta, Canada: University of Calgary Press.

——. 1999. "Introduction." In *The New Museum,* ed. William Peniston. Newark, NJ: Newark Museum Association.

——. 2002. *Making Museums Matter.* Washington, DC: Smithsonian Institution Press.

West, Richard W. 2004. "Foreword: Welcome to a Native Place." *National Museum of the American Indian Map and Guide.* Washington, DC: Published by NMAI with Scala Publishers.

Williams, Alex. 2005. "Do You MySpace?" *New York Times.* August 28.

Yenawine, Philip. 2004. "Addressing the Needs of Youth." In *Fuel: Giving Youth the Power to Succeed,* 3–17. Chicago: Marwen.

Zeller, Tom. 2005. "The Lives of Teenagers Now: Open Blogs, Not Locked Diaries." *New York Times.* November 3.

Zollo, Peter. 1999. *Getting Wiser to Teens: More Insights into Marketing to Teenagers.* Ithaca, NY: New Strategist Publications.

Zukin, Sharon. 1982. *Loft Living: Culture and Capital in Urban Change.* Baltimore, MD: Johns Hopkins University Press.

List of Interviews Cited

These interviews were conducted by a team of eight researchers working with the Cultural Policy Center at the University of Chicago. We interviewed 183 people from 85 organizations and conducted more than 225 interviews. Initial interviews were typically one-hour telephone interviews; the length of follow-up interviews and site visits varied. All first-round interviews were recorded telephone interviews conducted by Diane Grams, Rosemary Polanco, or Susan George. These interviews followed a semistructured format that was mapped out by topics and approved by the full research team. Once an interview was complete, it was fully transcribed and imported into Atlas TI, a qualitative database. Topics of interest to the research team as well as substantive points identified through the interview were coded in this database by research assistants. As it was updated with new interviews, the full database was regularly shared with the entire research team. Follow-up interviews and site visits were also conducted with organizations that were of additional interest to the research team. These were conducted by one of the chapter authors, Diane Grams, Betty Farrell, D. Carroll Joynes, David Karraker, Morris Fred, or Wendy Norris, and were also transcribed, coded, and shared among the entire research team. All interviewees and focus group participants provided informed consent to participate in this research study. Parents of minors also consented to the minor's participation. As part of the consent process, interviewees had the option to remain anonymous or to be identified by name, title, and/or organization. Those people who did not wish to be identified are referred to with a pseudonym.

Adamsick interview 2005. Randy Adamsick, director of development, Mexican Fine Arts Center Museum (MFACM), Chicago (renamed National Museum of Mexican Art, December 2006). Recorded telephone interview with Morris Fred, July 26, 2005.

Afshar interview 2005. Afshin Afshar, chief information officer, San Francisco Symphony. Recorded telephone interview with Diane Grams, August 15, 2005.

Agustín interview 2005. Sandra Agustín, former artistic director, Intermedia Arts, Minneapolis. Recorded interview on site at Intermedia with Diane Grams, November 2, 2005.

Allen interview 2004. Andrea Allen, director of education at the Seattle Repertory Theatre. Recorded telephone interview with Rosemary Polanco, December 14, 2004.

Ameri interview 2004. Anan Ameri, cultural arts program director, Arab Community Center for Economic and Social Services (ACCESS) and later the Arab American National Museum, Detroit. Recorded telephone interview with Susan George, December 2, 2004.

Ameri interview 2005. Anan Ameri, cultural arts program director, Arab Community Center for Economic and Social Services (ACCESS) and later the Arab American National Museum, Detroit. Recorded telephone interview with David Karraker, August 16, 2005.

Anderson interview 2005. Mary Anderson, pseudonym for a staff member who requested anonymity, Isabella Stewart Gardner Museum, Boston. Recorded telephone interview with Rosemary Polanco, January 26, 2005.

Armington interview 2005. Susan Armington, artist and creator of the Talking Suitcases workshop. Recorded interview with Diane Grams on-site at her studio in Minneapolis, November 3, 2005.

Atkinson interview 2005. Christi Atkinson, associate director of education and community programs, Walker Art Center, Minneapolis. Recorded telephone interview with Betty Farrell, August 24, 2005.

Baff interview 2005. Ella Baff, executive director, Jacob's Pillow Dance Festival, Beckett, Massachusetts. Recorded telephone interview with Susan George, January 26, 2005.

Bahar interview 2006. Phillip Bahar, director of marketing and public relations, Walker Art Center, Minneapolis. Recorded telephone interview with Diane Grams, February 8, 2006.

Barber interview 2004. Ann Barber, pseudonym for an advisory committee member who requested anonymity. Recorded telephone interview with Rosemary Polanco, November 15, 2004.

Boisson interview 2005. Catrina Boisson, director of marketing, New Jersey Performing Arts Center (NJPAC), Newark. Recorded telephone interview with D. Carroll Joynes, September 16, 2005.

Boland interview 2004. Maggie Boland, director of institutional advancement, with Ed Spitzberg, associate director of development, Arena Stage, Washington, D.C. Recorded telephone interview with Rosemary Polanco, December 13, 2004.

Bollinger interview 2005. Kelly Bollinger, assistant director of development, Marwen Foundation, Chicago. Recorded telephone interview with Susan George, January 26, 2005.

Boone interview 2004. Dr. Robert S. Boone, author, educator and founder, Young Chicago Authors (YCA), Chicago. Recorded telephone interview with Rosemary Polanco, August 30, 2004.

Buck interview 2005. Gloria Buck, trustee, Newark Museum. Recorded interview with Diane Grams on site at the Newark Museum, November 13, 2005.

Bunch interview 2004. Lonnie Bunch, former president of the Chicago Historical Society (renamed the Chicago History Museum, 2006). Recorded telephone interview with Diane Grams, December 8, 2004.

Bunch interview 2005. Lonnie Bunch, director, National Museum of African American History and Culture, Smithsonian Institution, Washington, D.C. Recorded telephone interview with Morris Fred, September 20, 2005.

Caflisch interview 2005. Sarah Caflisch, community relations director, the Loft Literary Center, Minneapolis. Recorded telephone interview with Diane Grams, July 13, 2005.

Chew interview 2005. Ron Chew, executive director, Wing Luke Asian Museum, Seattle. Recorded telephone interview with Rosemary Polanco, January 7, 2005.

Clearwaters interview 2005. Deborah Clearwaters, manager of public programs at the Asian Art Museum, San Francisco. Recorded telephone interview with Diane Grams, January 12, 2005.

Chinn interview 2005. Cassandra (Cassie) Chinn, program director, Wing Luke Asian Museum, Seattle. Recorded telephone interview with Morris Fred, August 16, 2005.

Cooper interview 2005. Rachel Cooper, director of cultural programs and performing arts, the Asia Society, New York. Recorded telephone interview with Rosemary Polanco, January 12, 2005.

Craft interview 2004. Evelyn Craft, executive director of the Arts Center in St. Petersburg, Florida. Recorded telephone interview with Rosemary Polanco, September 14, 2004.

Crenca interview 2005. Umberto Crenca, artistic director, with Shawn Wallace, managing director, AS220, Providence, Rhode Island. Recorded telephone interview with Diane Grams, January 4, 2005.

Dallas interview 2005. Walter Dallas, producing artistic director, New Freedom Theatre, Philadelphia. Recorded telephone interview with Diane Grams, August 2, 2005.

Edwards interview 2006. Paula Edwards, marketing manager, Arena Stage, Washington, D.C. Recorded telephone interview with Diane Grams, February 8, 2006.

Eyring interview 2005. Teresa Eyring, managing director, Children's Theatre Company (CTC), Minneapolis. Recorded telephone interview with Diane Grams, May 23, 2005.

Fischer interview 2005. Kenneth Fischer, president and chief operating officer, University Musical Society, Ann Arbor, Michigan. Recorded telephone interview with David Karraker, August 25, 2005.

Flaherty interview 2005. Joe Flaherty, executive director, Writers and Books, Rochester, New York. Recorded telephone interview with Diane Grams, June 29, 2005.

Fournier interview 2005. Mary Davis Fournier, project manager at the Public Programs Office of the American Library Association, Chicago. Recorded telephone interview with Diane Grams, May 23, 2005.

Foster interview 2004. Ken Foster, executive director, Yerba Buena Art Center, San Francisco. Recorded telephone interview with Diane Grams January 26, 2005

Gantt interview 2005. Kumani Gantt, executive director, Village of Arts and Humanities, North Philadelphia. Recorded telephone interview with Diane Grams January 18, 2005.

Gaschott interview 2005. Nancy Gaschott, chief financial officer, the Loft Literary Center, Minneapolis. Recorded interview Diane Grams on-site at the Loft, November 4, 2005.

Gumnit interview 2005. Daniel Gumnit, executive director, Intermedia Arts. Minneapolis. Recorded interview on-site at Intermedia with Diane Grams, November 2, 2005.

Halbreich interview 2005. Kathy Halbreich, former director, Walker Art Center, Minneapolis. Recorded interview with Diane Grams on site at the Walker Art Center, November 3, 2005.

Hartfield interview 2004. Ronne Hartfield, former executive director of museum education, Art Institute of Chicago. Recorded telephone interview with Diane Grams, November 23, 2004.

Hartfield interview 2005. Ronne Hartfield, former executive director of museum education, Art Institute of Chicago. Recorded telephone interview with Morris Fred, July 15, 2005.

Henry interview 2006. James Pepper Henry, associate director for community and constituent services, National Museum of the American Indian (NMAI) of the Smithsonian Institution, Washington D.C. Recorded interview with Morris Fred on site at NMAI, March 24, 2006.

Hermann interview 2005. Jeffrey Hermann, producing director at Perseverance Theater, Douglas, Alaska. Recorded telephone interview with Susan George, February 5, 2005.

Higashi interview 2005. Chris Higashi, associate director, Washington Center for the Book, Seattle Public Library. Recorded telephone interview with Diane Grams, February 2, 2005.

Hirsch interview 2004. Jim Hirsch, former executive director, Old Town School of Folk Music, Chicago. Recorded telephone interview with Diane Grams, September 23, 2004.

Hirsch interview 2005. Jim Hirsch, executive director, Chicago Sinfonietta, Chicago. Recorded telephone interview with Morris Fred, October 7, 2005.

Hurtig interview 2005. Judith Hurtig, artistic director, Hancher Auditorium, University of Iowa, Iowa City, Iowa. Recorded telephone interview with Wendy Norris, September 13, 2005.

Jackson interview 2005. Bishop Andre Jackson, chair of the Ministers' Advisory Council at New Jersey Performing Arts Center (NJPAC), Newark. Recorded from a group interview of several advisory committee members with Diane Grams on-site at NJPAC, November 15, 2005.

Johnson interview 2005. Eileen Johnson (pseudonym), advisory committee member, African American Leadership Committee, Art Institute of Chicago. Recorded telephone interview with Diane Grams, December 17, 2004.

Kotler interview 2004. Neil Kotler, former senior official at the Smithsonian Institution. Recorded telephone phone interview with Diane Grams, September 4, 2004.

Kuhne interview 2004. Donna Walker Kuhne, president of Walker International Communications Group, New York. Recorded telephone interview with Rosemary Polanco, August 16, 2004.

Lapointe interview 2005. Jon Lapointe and Otoño Luján, codirectors, Side Street Projects, Pasadena, California. Recorded telephone interview with David Karraker, August 24, 2005.

Litwin interview 2005. Sharon Litwin, senior vice president for external affairs, Louisiana Philharmonic Orchestra, New Orleans. Recorded telephone interview with Diane Grams, January 19, 2005.

Marzio interview 2004. Peter Marzio, director, Museum of Fine Arts, Houston. Recorded telephone interview with Diane Grams, December 20, 2004.

Miller interview 2004. Mary Ellen Miller, former director of development, Pittsburg Ballet Theater. Recorded telephone interview with Rosemary Polanco, January 15, 2004.

Minter interview 2005. Darcy Minter, director of external communications, Western Folklife Center, Elko, Nevada. Recorded telephone interview with Wendy Norris, November 17, 2005

Moreland interview 2005-1. Victoria Moreland, director community affairs, Seattle Art Museum. Recorded telephone interview with Diane Grams, January 6, 2005.

Moreland interview 2005-2. Victoria Moreland, director community affairs, Seattle Art Museum. Recorded telephone interview with Morris Fred, August 8, 2005.

Myers interview 2005. Linda Myers, executive director, the Loft Literary Center, Minneapolis. Recorded interview with Diane Grams on site at the Loft, November 2, 2005.

Parson-Nesbitt interview 2004. Julie Parson-Nesbitt, former executive director, Guild Complex, Chicago. Recorded telephone interview with Diane Grams, July 29, 2004.

Peavler interview 2005. Penny Peavler, director of special projects, Speed Art Museum, Louisville, Kentucky. Recorded telephone interview with Susan George, January 26, 2005.

Peeler interview 2004. Julie Peeler, director, National Arts Marketing Project (NAMP). Recorded telephone interview with Diane Grams, August 3, 2004.

Perkins interview 2004. Julia Perkins, former director of community programs, Art Institute of Chicago. Recorded telephone interview with Rosemary Polanco, August 5, 2004.

Pollock interview 2005. Kelly Lamb Pollock, director of foundation relations at Center for Creative Arts, (COCA), St. Louis, Missouri. Recorded telephone interview with Diane Grams, June 8, 2005.

Price interview 2005. Clement Alexander Price, urban historian, faculty, Rutgers University, and director, Institute for Ethnicity, Culture, and the Modern Experience, Rutgers University. Recorded interview with Diane Grams on-site at Rutgers University, November 16, 2005.

Ramos interview 2005. E. Carmen Ramos, assistant curator for community engagement, with Grizel Ubarry, trustee, Newark Museum. Recorded interview with Diane Grams on-site at the Newark Museum, November 13, 2005.

Roth interview 2005. Don Roth, president and CEO, Aspen Music Festival, Aspen, Colorado. Recorded telephone interview with Susan George, January 6, 2005.

Rubin interview 2005. Jack Rubin, president and CEO of Tessitura Network Inc., Dallas. Recorded telephone interview with Diane Grams and Wendy Norris, October 18, 2005.

Schneider interview 2004. Beth Schneider, former education director (official title, W. T. and Louise J. Moran Education Director), Museum of Fine Arts, Houston. Recorded telephone interview with Diane Grams, November 22, 2004.

Schneider interview 2005. Beth Schneider, former education director (official title, W. T. and Louise J. Moran Education Director), Museum of Fine Arts, Houston. Recorded telephone interview with Diane Grams, July 15, 2005.

Shugoll interview 2006. Mark Shugoll, vice president, board of trustees, Arena Stage, and CEO of Shugoll Research, Washington, D. C. Recorded telephone interview with Diane Grams, January 10, 2006.

Schultz interview 2005. Sarah Schultz, director of education and community programs, Walker Art Center, Minneapolis. Recorded telephone interview with Diane Grams, January 11, 2005.

Seeman interview 2005. Charlie Seeman, executive director, Western Folklife Center, Elko, Nevada. Recorded telephone interview with Wendy Norris, November 17, 2005.

Sele interview 2005. Baraka Sele, assistant director of programming, New Jersey Performing Arts Center (NJPAC). Recorded interview with Diane Grams on site at NJPAC, November 15, 2005.

Gregory Smith interview 2005. Gregory Smith, director of education, Children's Theatre Company, (CTC), Minneapolis. Recorded interview with Betty Farrell on-site at CTC, November 4, 2005.

Melanie Smith interview 2005. Melanie Smith, director of education, San Francisco Performances. Recorded telephone interview with Diane Grams, February 1, 2005.

Sperling interview 2005. Rick Sperling, executive director, Mosaic Youth Theatre, Detroit. Recorded telephone interview with Susan George, January 31, 2005

Sweeney Price interview 2005. Mary Sue Sweeney Price, director, Newark Museum. Recorded telephone interview with Diane Grams and D. Carroll Joynes, December 12, 2005.

Talbott interview 2005. Susan Talbott, former director, Des Moines Art Museum, Des Moines, Iowa. Recorded telephone interview with Rosemary Polanco, January 19, 2005.

Jane Thompson interview 2005. Jane Thompson, a program director for the Arkansas Center for the Book, Little Rock. Recorded telephone interview with Diane Grams, May 15, 2005.

Kent Thompson interview 2005. Kent Thompson, former artistic director, Alabama Shakespeare Festival. Recorded telephone interview with Diane Grams, January 27, 2005.

Kent Thompson interview 2006. Kent Thompson, artistic director, Denver Center Theater Company (former artistic director, Alabama Shakespeare Festival). Recorded telephone interview with Diane Grams, February 10, 2006.

Tortolero interview 2006. Carlos Tortolero, founder and president, Mexican Fine Arts Center Museum (MFACM), Chicago (renamed National Museum of Mexican Art, December 2006). Recorded telephone interview with Diane Grams, November 21, 2006.

Ubarry interview 2005. Grizel Ubarry, trustee, Newark Museum. Recorded interview with Diane Grams on-site at the Newark Museum, November 13, 2005

Villafranca interview 2005. Nancy Villafranca, director of education, Mexican Fine Arts Center Museum (MFACM), Chicago (renamed National Museum of Mexican Art December 2006). Recorded telephone interview with Morris Fred, June 27, 2005.

Ward interview 2005. Scott Ward, executive director, Armory Center for the Arts, Pasadena, CA. Recorded telephone interview with David Karraker, August 7, 2005.

Warr interview 2005. Michael Warr, founder and former executive director, Guild Complex, Chicago. Recorded interview in person at the Harris School with Diane Grams, April 20, 2005.

Wilkins interview 2005. Will K. Wilkins, executive director, Real Art Ways, Hartford, Connecticut. Recorded telephone interview with Rosemary Polanco, June 2, 2005.

Wright interview 2006. Charles Randolph Wright, playwright, author of *Cuttin' Up*, produced in 2005 at Arena Stage, Washington, D.C. Recorded telephone interview with Diane Grams, February 15, 2006.

Zhou interview 2005. Wei Zhou, marketing manager, with Linda Moore, director of development, Newark Museum. Recorded telephone interview with Diane Grams, June 2, 2005.

TEEN FOCUS GROUPS

Alison interview 2005. Alison, teen participant at Children's Theatre Company (CTC), Minneapolis. Recorded focus group of teens at CTC conducted on-site by Betty Farrell and Diane Grams, November 4, 2005.

Conor interview 2005. Conor, teen participant at Children's Theatre Company (CTC), Minneapolis. Recorded focus group of teens at CTC conducted on-site by Betty Farrell and Diane Grams, November 4, 2005.

Emmett interview 2005. Emmett, former member of the Walker Art Center Teen Arts Council (WACTAC), Minneapolis. Recorded focus group with WACTAC alumni conducted on-site by Betty Farrell and Diane Grams, November 3, 2005.

Mike interview 2005. Mike, former member of the Walker Art Center Teen Arts Council (WACTAC), Minneapolis. Recorded focus group with WACTAC alumni conducted on-site by Betty Farrell and Diane Grams, November 3, 2005.

Rachel interview 2005. Rachel, teen participant at Children's Theatre Company (CTC), Minneapolis. Recorded focus group of teens at CTC conducted on-site by Betty Farrell and Diane Grams, November 4, 2005.

Tegan interview 2005. Tegan, teen participant at Children's Theatre Company (CTC), Minneapolis. Recorded focus group of teens at CTC conducted on-site by Betty Farrell and Diane Grams, November 4, 2005.

Notes on Contributors

DIANE GRAMS (Ph.D., sociology, Loyola University Chicago) is an assistant professor of sociology at Tulane University in New Orleans. She teaches sociology of culture, research methods, and an intensive community seminar while continuing to pursue her research agenda in urban culture. Prior to her appointment at Tulane she was a researcher with the Cultural Policy Center at the University of Chicago, where she taught graduate courses in cultural policy and research methods at the Irving B. Harris Graduate School of Public Policy Studies. She is completing a book on arts producers entitled *Producing Local Color: Ethnic Art Networks in Chicago* (forthcoming, University of Chicago Press). She coauthored *Leveraging Assets: How Small Budget Arts Activities Benefit Neighborhoods*, a 2003 report funded by the Richard H. Driehaus Foundation and the John D. and Catherine T. MacArthur Foundation. She was given the *1989* Civil Liberties Award from the Roger Baldwin Foundation of the American Civil Liberties Union of Chicago for her work in support of artistic expression. She was the executive director of the Peace Museum, Chicago from 1992 to 1998.

BETTY FARRELL (Ph.D., sociology, Harvard University) is the associate director of the Master of Arts Program in the Social Sciences and a senior lecturer in the Graduate Social Science Division at the University of Chicago. Her work in historical sociology has focused on U.S. family patterns; gender studies; sociology of culture; and public policy. She is the author of *Family: The Making of an Idea, an Institution, and a Controversy in American Culture* (Westview, 1999) and *Elite Families: Class and Power in Nineteenth-Century Boston* (State University of New York Press, 1993). Her current research project, "Cultural Pluralism in the Chicago Art World," has been funded by the National Endowment for the Humanities and investigates questions of access, diversity, and inclusivity across a range of Chicago's established and community-based cultural institutions.

D. CARROLL JOYNES (Ph.D., University of Chicago) is the executive director and founder of the Cultural Policy Center. An intellectual and cultural historian by training, he previously served as associate dean in the Humanities Division at the University of Chicago and has taught at the University of Chicago, New York University, and the New School University.

279

DAVID KARRAKER is an independent consultant and a former research associate at the Edmund S. Muskie School of Public Service at the University of Southern Maine in Portland. He has done applied research for more than fifteen years. During that time he oversaw more than three hundred comprehensive organizational assessments of groups applying for National Endowment for the Arts (NEA) grants. In addition, he has done organizational planning for an opera company in Chicago (2001–2002), formulated a long-term strategic plan for the Mississippi Arts Commission (2003), and was program evaluator for the Maine Community Foundation's Lila Wallace-Readers Digest Fund–supported *Community Partnerships for Cultural Participation* initiative.

MORRIS FRED (Ph.D., anthropology, University of California, Berkeley; J.D., University of Chicago Law School) is a lecturer in the Master of Arts Program in the Graduate Division of Social Sciences at the University of Chicago. He taught at Stockholm University and has conducted research in Taiwan, Sweden, and the United States. At the University of Chicago, he teaches graduate courses on the Anthropology of Museums, Ethnographic Methods, Ethnography of Law, and the Anthropology of Dis/ability. He served as director of Spertus Museum (Chicago's Jewish Museum), 1986–1994, during which time he chaired the Council of American Jewish Museums (1990–1992). He also worked as senior policy analyst at the Illinois Protection and Advocacy agency Equip for Equality. Among his publications are "Guardianship as a Cultural System: Reflections on the Illinois Guardianship Reform Project," *Elder's Advisor*, 2003; "Law and Identity: Negotiating Meaning in the Native American Graves Protection and Repatriation Act (NAGPRA)," *International Journal of Cultural Property* 6 (2): 199–299 (1997); "Training Cultural Brokers: Practicing Theory in Anthropology," *Ethnos* 3 (4): 246–258 (1986); and *Managing Culture Contact: The Organization and Administration of Swedish Immigration Policy* (Commission on Immigration Research, Swedish Ministry of Labor, 1983).

WENDY LEIGH NORRIS (M.A., intellectual history of modern Europe, University of Chicago) is associate director of the Cultural Policy Center at the University of Chicago. Her graduate work explores how art and music became crucial components of Alsace's regional and national identity struggles during the nineteenth century. Her analysis highlights how art and art practices in this region were interpreted within a framework of multiple national perspectives and reveals the complex relationship between cultural participation, public power, and private initiative in daily life at the height of nationalism.

Index

Italicized page numbers refer to illustrations; T = table/chart.

ACCESS, *see* Arab Community Center for Economic and Social Services
accessibility of teen programs, 118
access security, of databases, 183
Adamsick, Randy, 154, 157–158, 271
advisory committees, 2, 3, 24, 54; from community, 64, 151; constituent-focused, 86–88; of departmental directors, 52; of wealthy Chicago African Americans, 73; youth, in Minneapolis (WACTAC), 114, 118–124, 224–225
African American Leadership Committee (Chicago), 75, 80
African Americans: and the Museum of Fine Arts, Houston, 67, 71; national museum, 169 (*see also* National Museum of African American History and Culture); proportion of Arena Stage audiences, 232, 237–38; as target audience for Seattle Art Museum, 56; wealthy, on Art Institute of Chicago advisory committee, 73; women professionals, 147; youth, and Detroit's Mosaic Youth Theatre, 130–131, 132–133
African expatriate community, New Jersey, 83
The African Presence in Mexico: From Yanga to the Present, exhibit at Mexican Fine Arts Center Museum, 157–159
Afshar, Afshin, 34, 35, 271
Agustín, Sandra, 26, 271
Ajira, a Center for Contemporary Art (Newark), 256

Alabama Shakespeare Festival, 182, 256; commissions play from *A Lesson Before Dying*, 217–219; imposing physical facility, 40; and Tessitura software, 182, 183–184
Allen, Andrea, 141, 272
Alliance Theatre (Atlanta), 256
Always Running: La Vida Loca, Gang Days in L. A. (Rodriguez), 95
Ameri, Anan, 106, 107–108, 272
American Association of Museums, 68, 227
American Ballet Theatre (New York), 256; family-friendly *Rodeo* performances, 137
American Library Association (Chicago), 213, 256; and the One Book project, 200, 201–202
Americans for the Arts, 174
American Sign Language (ASL) support for performances, 191
America's Pastime: Portrait of the Dominican Dream—Works by Freddy Rodriguez (Newark Museum), 83, 85
Animals on Parade, 213–217, 219
Antigone, Children's Theatre production (Minneapolis), 131
AppalShop (Whitesburg, KY), 2, 25, 256
Arab American National Museum (Detroit), 104, 108, 109–110
Arab Community Center for Economic and Social Services (ACCESS), Detroit, 104, 106–10, 256; partnership with University Music Society, 91–92
Arena Stage (Washington, DC), 58, 232–238, 256; sales trends, 263T

281

Breinigsville, PA USA
16 December 2010
251605BV00001B/13/P